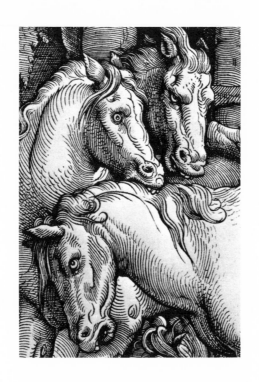

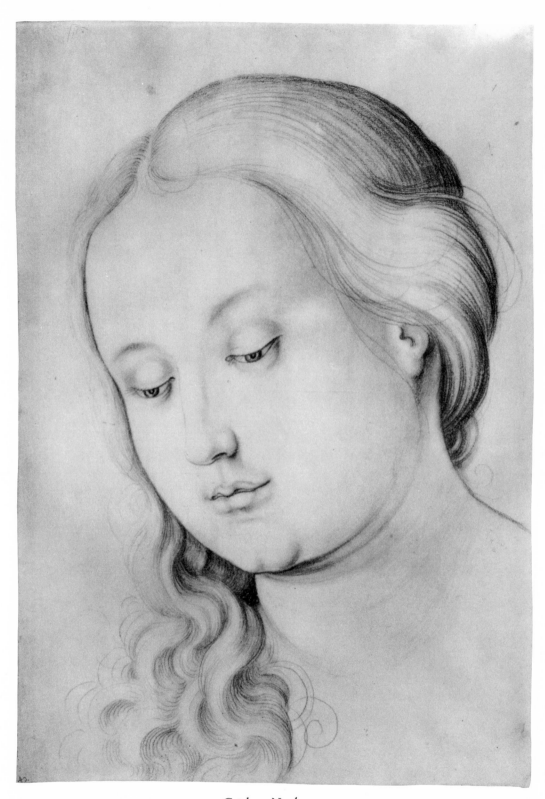

*Catalogue Number 43*

HANS BALDUNG GRIEN · PRINTS & DRAWINGS

EXHIBITION ORGANIZED AND CATALOGUE EDITED
BY *JAMES H. MARROW* & *ALAN SHESTACK*
WITH THREE ESSAYS ON BALDUNG AND HIS ART
BY *ALAN SHESTACK* · *CHARLES W. TALBOT*
AND *LINDA C. HULTS*

NATIONAL GALLERY OF ART · WASHINGTON
FROM JANUARY 25 THROUGH APRIL 5
YALE UNIVERSITY ART GALLERY · NEW HAVEN
APRIL 23 THROUGH JUNE 14, 1981

*This catalogue was supported by a grant from
the NATIONAL ENDOWMENT FOR THE ARTS, a federal agency.*

*Distributed by The University of Chicago Press.*

# CONTENTS

# ❧ FOREWORD

The first three decades of the sixteenth century— the years surrounding the social and political anxieties and disquiet of the Reformation— witnessed a great period of creative energy and artistic expression in the German-speaking lands north of the Alps. A few of the major German artists of the time— Dürer, Grünewald, Holbein, and Cranach— are well known, but other important and fascinating artists of this period have eluded the attention of many, especially on this side of the Atlantic. It is fair to say that, outside of the realm of Dürer prints, no American museum has assembled comprehensive holdings of German art. Many of the masterpieces of German art are still *in situ* in churches, while most of the remainder are in German, French, and Swiss museums.

The purpose of this exhibition is to call attention to Hans Baldung Grien, one of the least known but most creative artists of the early sixteenth century. Baldung has been little appreciated outside of Germany, and he is too often seen in the shadow of his better known compatriot, Albrecht Dürer. Only three of the more than one hundred surviving paintings by Baldung are in the United States— in the National Gallery, and in the museums in Cleveland and Los Angeles— and only five drawings by him or seriously attributed to him are in America. This show focuses on his prints and drawings, not only because the graphic works are relatively plentiful and were available for loan, but also because of the full range of subject matter they embody and because Baldung's prints have never before been subjected to a detailed analysis of style and iconography.

We are grateful to the European and American lenders who have made possible this exhibition as well as the first book-length analysis in English of the graphic work of Hans Baldung Grien.

<div style="text-align:center">

J. CARTER BROWN      ALAN SHESTACK
*Director, National Gallery of Art*    *Director, Yale University Art Gallery*

</div>

This exhibition introduces to the American audience the work of Hans Baldung Grien, a German artist active during the first half of the sixteenth century, who is noted for his unprecedented interpretations of traditional religious subjects and his intriguing explorations of topics which sometimes involve imagery of a demonic or erotic nature. His work reflects the changing subject matter and orientation of art in a turbulent period of European history— one which, at least in Germany, nourished a generation of virtuoso draftsmen-painters.

Since it is impractical to arrange transatlantic loans of a significant body of sixteenth-century panel paintings, the exhibition is focused upon Baldung's graphic works, particularly his drawings and single-leaf prints. Although Baldung also designed hundreds of woodcut illustrations for printed books, most of these were executed by lesser craftsmen and were subject neither to the care nor to the same degree of the artist's control over cutting and printing as were his single-leaf prints. The latter works, like the drawings, are more accurate reflections of his artistic intentions and therefore constitute the most reliable basis for an evaluation of his graphic style.

Most of the genres of Baldung's art are represented in his graphic works and, indeed, he depicted in his prints and drawings many subjects rarely illustrated in his panels. Baldung was, moreover, an inventive and powerful draftsman, whose graphic style has not been studied extensively for many decades. One of the primary aims of the exhibition has thus been to consider this aspect of Baldung's art. This goal dictated the organization of the catalogue, in which we considered the works in approximate chronological sequence, integrating prints and drawings accordingly. We made exceptions to a strict chronological arrangement only where subgroups of works of similar format or subject matter could be considered in sequence without deviating significantly from Baldung's development in time, or, in the special case of portraiture, where an entire genre of Baldung's art could be conveniently isolated for study. There are additional reasons why we were eager to integrate the prints and drawings, for these works are frequently interrelated in style and subject matter. We hoped also to counterbalance the prevalent tradition of recent scholarship, which has been to treat Baldung's works in different media independently.

The text of the catalogue has been conceived with a twofold purpose. The essays are designed to introduce readers and visitors to the exhibition, and to explore selected aspects of Baldung's art. The entries are designed to comment extensively upon the exhibited objects, considering such subjects as technique, style, sources, iconography and expression. The essays provide an opportunity to see Baldung's graphic works in conjunction with his panels, and thus to maintain a focus upon his total *oeuvre* that might otherwise be lost in an exhibition of prints and drawings; they also permitted the authors to consider special problems of Baldung's very personal imagery, particularly in relationship to the historical, cultural and theological issues of his time. In the entries, we hope to have made progress in appreciating the germination of individual

works and their place within Baldung's art and the broader tradition to which he belonged. The woodcuts provide a particularly appropriate body of material for such study, since few of them have previously been subjected to detailed analysis.

As Baldung's work is little known in this country, we have included many collateral illustrations in the essays and entries. Illustrations in the introductory essays are numbered sequentially and are designated by figure references (Fig.); those accompanying the entries are designated as Illustrations (Ill.) and bear the number of the entry itself followed by lower case letters to denote sequence. The headings to the entries provide summary indications of subject, date, medium, size, references to standard corpuses of Baldung's works, and of lender. As much of the task of compiling bibliographies on the individual works and of listing variant opinions on them has already been accomplished, we have made no effort to reproduce this material except insofar as it bears directly upon issues discussed in the text; such references may be found in the standard works cited in the headings and in those in the summary bibliography that follows. Similarly, since questions of attribution and dating are today undisputed for the majority of Baldung's works, we have commented on these matters only where doubts exist or where we wished to develop new hypotheses.

In selecting this exhibition we conducted a search in the print collections of Europe and America for splendid impressions of each woodcut or engraving. Baldung's prints are much rarer than Dürer's, and in a few cases subjects had to be omitted because good examples were either unknown or unavailable for loan; in other instances we requested the best surviving impression we could locate for the show. Drawings, because of their rarity and fragility, were more difficult to procure, particularly those executed in silverpoint or on other types of prepared paper. Nonetheless, thanks to the generosity and consideration of lenders, we were able to assemble a representative sample to accompany the single-leaf prints.

Shortly after the preliminary planning for this exhibition was completed, a graduate seminar on Baldung's graphic art was offered at Yale University in the fall of 1979. Students from Yale, Princeton, Brown, Columbia, and the Institute of Fine Arts of New York University who took this course did some of the basic research and drafted some of the individual catalogue entries. The student work was later edited to avoid redundancy and to integrate component parts of the publication, and was in some cases expanded to take account of observations or interpretations by the editors. The initials of students who wrote or contributed substantial work to any entry are provided at the end of the entries. The participants in the seminar were: Frances Chaves (F. C.), Gregory Clark (G. C.), Howard C. Collinson (H. C. C.), Lynn Jacobs (L. J.), Lorraine Karafel (L. K.), William Keller (W. K.), Daniel Lettieri (D. L.), Cynthia Robison (C. R.), Carol Schuler (C. S.), and Fronia Wissman (F. W.).

Much of the work on the catalogue was completed during the spring of 1980, when the editors were granted sabbatical leaves from their duties at Yale University. James Marrow also benefited from grants for research and travel expenses from the A. Whitney Griswold Faculty Research Fund of Yale University and from an Andrew W. Mellon Fellowship of The Metropolitan Museum of Art.

The editors are grateful to the colleagues who kindly prepared essays for this catalogue: Charles Talbot, Smith College, and Linda C. Hults, University of Tulsa. Some catalogue entries were graciously contributed by colleagues in areas of their special interest and expertise:

Christiane Andersson, Columbia University (Cat. Nos. 55, 76, 89), Linda C. Hults, University of Tulsa (Cat. Nos. 78-82), and Jay A. Levenson (Cat. Nos. 34, 83-88). We are grateful to Leo Steinberg for generously contributing a *précis* of his interpretation of the iconography of Cat. No. 21. Andrew Robison and Charles Parkhurst of the National Gallery provided encouragement to us at a crucial moment by expressing interest in presenting the show in Washington.

In the course of selecting the objects for the show and preparing the manuscript for this catalogue, many other colleagues— especially curators of lending institutions— offered hospitality, wisdom, practical advice and encouragement. We should like to express our gratitude to the following: Clifford Ackley, Fedja Anzelewsky, Johann Eckart von Borries, Albert Châtelet, Tilman Falk, David Farmer, Jean Favière, Ebria Feinblatt, Erik Fischer, Heinrich Geissler, John Gere, Monika Heffels, Colta F. Ives, Dieter Koepplin, Fritz Koreny, Dieter Kuhrmann, August Laube, Sherman Lee, Margaret Lippard, Anne-Marie Logan, Mary M. Mayer, Mary Meyers, Geneviève Monnier, Sue W. Reed, Louise Richards, Alice Rössler, John Rowlands, Eleanor Sayre, Maurice Serullaz, Barbara Shapiro, Margret Stuffmann, Walter L. Strauss, George Szabo, Leonie von Wilckens, Reginald Williams and Hans Zumstein. Sheila Schwartz scrupulously edited the manuscript, preventing many inconsistencies of style and form.

As usual, the Meriden Gravure Company attained the high level of excellence museums have come to expect from that fine printing establishment. The success of an exhibition catalogue is due in no small part to its graphic design. Much credit is due to Greer Allen, University Printer at Yale, for the beautiful design of this book and his expert supervision of its production.

Ethel Neumann, Nan Ross, Estelle Miehle, Michael Komanecky, Diane Hoose and Rosalie Reed, present and former members of the Yale University Art Gallery staff, provided essential assistance in organizational matters. Joseph Szaszfai made numerous superb photographs and graciously responded to our requests for his services. The editors are grateful for the unstinting support and aid of Nancy Jane Shestack throughout the preparation of the exhibition.

Last, but certainly not least, a grant from the National Endowment for the Arts, a federal agency, made publication of this volume possible.

JAMES H. MARROW

ALAN SHESTACK

# ❧ LENDERS TO THE EXHIBITION

BASEL
*Kunstmuseum Basel, Kupferstichkabinett*

BERLIN
*Staatliche Museen Preussischer Kulturbesitz,*
*Kupferstichkabinett*

BOSTON
*Museum of Fine Arts*

CLEVELAND
*The Cleveland Museum of Art*

COPENHAGEN
*Statens Museum for Kunst*

ERLANGEN
*Universitätsbibliothek Erlangen-Nürnberg,*
*Graphische Sammlung*

KARLSRUHE
*Staatliche Kunsthalle Karlsruhe,*
*Kupferstichkabinett*

LONDON
*The Trustees of the British Museum*

LOS ANGELES
*Los Angeles County Museum of Art*

MUNICH
*Staatliche Graphische Sammlung*

NEW YORK
*The Metropolitan Museum of Art*

NEW YORK
*The Metropolitan Museum of Art,*
*Robert Lehman Collection*

NEW HAVEN
*Yale University Art Gallery*

NUREMBERG
*Germanisches Nationalmuseum*

PARIS
*Musée du Louvre*

STRASBOURG
*Musée des Beaux-Arts,*
*Cabinet des Estampes*

WASHINGTON
*National Gallery of Art*

ZURICH
*August Laube*

# ❧ BIBLIOGRAPHICAL ABBREVIATIONS

| | |
|---|---|
| *AB* | *The Art Bulletin* |
| *AQ* | *The Art Quarterly* |
| *BurlM* | *The Burlington Magazine* |
| *CK* | *Christliche Kunst* |
| *JKS* | *Jahrbuch der Kunsthistorischen Sammlungen in Wien* |
| *JKw* | *Jahrbuch für Kunstwissenschaft* |
| *JPKs* | *Jahrbuch der Preussischen Kunstsammlungen* |
| *KChr* | *Kunstchronik* |
| *MüJb* | *Münchner Jahrbuch der bildenden Kunst* |
| *Rep* | *Repertorium für Kunstwissenschaft* |
| *WRJb* | *Wallraf-Richartz Jahrbuch* |
| *ZAK* | *Zeitschrift für Schweizerische Archäologie und Kunstgeschichte* |
| *ZDVK* | *Zeitschrift des Deutschen Vereins für Kunstwissenschaft* |
| *ZfbK* | *Zeitschrift für bildende Kunst* |
| *ZfK* | *Zeitschrift für Kunstgeschichte* |
| *ZKw* | *Zeitschrift für Kunstwissenschaft* |

# ❧ FREQUENTLY CITED SOURCES

|  |  |  |
|--|--|--|
| | Baldass | Baldass, Ludwig. "Der Stilwandel im Werke Hans Baldungs," *MüJb*, N.F. III, 1926, pp. 6–44. |
| | Basel 1978 | *Hans Baldung Grien im Kunstmuseum Basel*, exhibition catalogue, Basel, 1978 (texts by Paul H. Boerlin, Tilman Falk, Richard Gassen, Dieter Koepplin). |
| (B.) | Bartsch | Bartsch, Adam. *Le Peintre-Graveur*, VII, Vienna, 1808. |
| | Baum | Baum, Julius. *Martin Schongauer*, Vienna, 1948. |
| | Bussmann | Bussmann, Georg. *Manierismus im Spätwerk Hans Baldung Griens: Die Gemälde der zweiten Strassburger Zeit*, Heidelberg, 1966. |
| | Curjel | Curjel, Hans. *Hans Baldung Grien*, Munich, 1923. |
| | Curjel, *Holzschnitte* | ——. *Holzschnitte des Hans Baldung Grien*, Munich, 1924. |
| (D.) | Dodgson | Dodgson, Campbell. *Albrecht Dürer: Engravings and Etchings*, New York, 1967 (reprint of London, 1926 edition). |
| | Escherich | Escherich, Mela. *Hans Baldung Grien Bibliographie 1509–1915*, Strassburg, 1916. |
| | Fischer | Fischer, Otto. *Hans Baldung Grien*, Munich, 1939. |
| | Friedländer/Rosenberg | Friedländer, Max J., and Rosenberg, Jacob. *The Paintings of Lucas Cranach*, 2nd ed., Ithaca, New York, 1978. |
| (G.) | Geisberg | Geisberg, Max. *The German Single-Leaf Woodcut: 1500–1550*, revised and edited by Walter L. Strauss, 4 vols., New York, 1974. |
| | Halm | Halm, Peter. "Die Hans-Baldung-Grien- Ausstellung in Karlsruhe, 1959," *KChr*, XIII, 1960, pp. 123–40. |
| | Hartlaub | Hartlaub, G. F. *Hans Baldung Grien—Hexenbilder*, Stuttgart, 1961. |
| (H.) | Hollstein | Hollstein, F.W.H. *German Engravings, Etchings and Woodcuts, ca. 1400–1700*, II, Amsterdam, 1954. |
| | Hugelshofer | Hugelshofer, Walter. "Nachträge zu Baldung," *Oberrheinische Kunst*, V, 1932, pp. 197–212. |
| | Hults-Boudreau | Hults-Boudreau, Linda. *Hans Baldung Grien and Albrecht Dürer: A Problem in Northern Mannerism*, Ph.D. dissertation, University of North Carolina, Chapel Hill, 1978. |
| | Jahn | Jahn, Johannes. *Lucas Cranach d.Ä.: Das gesamte graphische Werk*, Munich, 1972. |

| | | |
|---|---|---|
| | Karlsruhe 1959 | Staatliche Kunsthalle Karlsruhe. *Hans Baldung Grien*, exhibition catalogue, 1959 (texts by Carl Koch, Jan Lauts, Werner Zimmermann, Edith Ammann, and others). |
| | Koch | Koch, Carl. *Die Zeichnungen Hans Baldung Griens*, Berlin, 1941. |
| | Koch, "Katalog" | ———. "Katalog der erhaltenen Gemälde, der Einblattholzschnitte und illustrierten Bücher von Hans Baldung Grien, *KChr*, VI, 1953, pp. 297–302. |
| | R. Koch | Koch, Robert A. *Hans Baldung Grien: Eve, the Serpent, and Death*, Ottawa, 1974. |
| (K.) | Kurth | Kurth, Willi. *The Complete Woodcuts of Albrecht Dürer*, New York, 1946. |
| (L.) | Lehrs | Lehrs, Max. *Geschichte und kritischer Katalog des deutschen, niederländischen und französischen Kupferstichs im XV. Jahrhundert*, 9 vols., Vienna, 1908–34. |
| (M.) | Mende | Mende, Matthias. *Hans Baldung Grien: Das graphische Werk*, Unterschneidheim, 1978. |
| | Nuremberg 1961 | Germanisches Nationalmuseum. *Meister um Albrecht Dürer*, exhibition catalogue, Nuremberg, 1961 (texts by Ludwig Grote, Peter Strieder, Fritz Zink, Stephan Waetzoldt, and others). |
| | Oettinger/Knappe | Oettinger, Karl and Knappe, Karl-Adolf. *Hans Baldung Grien und Albrecht Dürer in Nürnberg*, Nuremberg, 1963. |
| | Panofsky | Panofsky, Erwin. *The Life and Art of Albrecht Dürer*, 3rd ed., 2 vols., Princeton, 1948. |
| | Pariset | Pariset, François-Georges. "Grünewald et Baldung," *Cahiers Alsaciens*, XIX, 1975–76, pp. 147–66. |
| | Perseke | Perseke, Helmut. *Hans Baldungs Schaffen in Freiburg*, Freiburg im Breisgau, 1941. |
| (S.) | Schreiber | Schreiber, Wilhelm. *Handbuch der Holz- und Metallschnitte des XV. Jahrhunderts*, 8 vols., Leipzig, 1926–30. |
| | Térey, *Gemälde* | Térey, Gabriel von. *Die Gemälde des Hans Baldung gen. Grien*, 2 vols., Strassburg, 1896–1900. |
| | Térey, *Zeichnungen* | ———. *Die Handzeichnungen des Hans Baldung gen. Grien*, 3 vols., Strassburg, 1894–96. |
| | von der Osten | von der Osten, Gert. "Zur Ikonographie des Hans Baldung Grien," *Festschrift für Herbert von Einem*, Berlin, 1965, pp. 179–87. |
| (W.) | Winkler, *Dürer Zeichnungen* | Winkler, Friedrich. *Die Zeichnungen Albrecht Dürers*, 4 vols., Berlin, 1936–39. |
| | Winkler, *Kulmbach-Schäufelein* | ———. *Die Zeichnungen Hans Süss von Kulmbachs und Hans Leonhard Schäufeleins*, Berlin, 1942. |
| | Winzinger *Altdorfer Graphik* | Winzinger, Franz. *Albrecht Altdorfer: Graphik*, Munich, 1963. |
| | Winzinger *Altdorfer Zeichnungen* | ———. *Albrecht Altdorfer: Zeichnungen*, Munich, 1952. |

THE ESSAYS

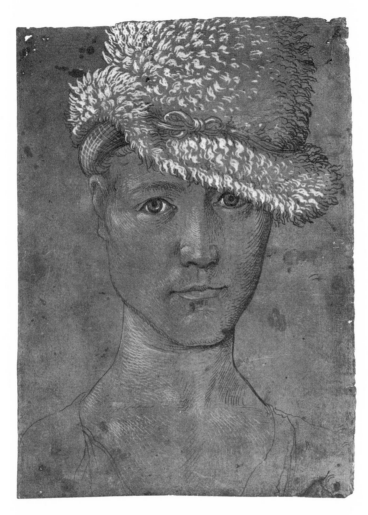

Figure 1. Hans Baldung, «Self-Portrait,» c. 1502–03, drawing,
Kunstmuseum Basel.

# AN INTRODUCTION TO HANS BALDUNG GRIEN
## BY ALAN SHESTACK

In his last full-length book, Heinrich Wölfflin, the well-known and influential historian of artistic style, attempted to define the distinctive characteristics of German art.[1] By comparing German works created between 1490 and 1530 with contemporaneous examples by Italian Renaissance artists, Wölfflin was able to enumerate certain qualities he considered peculiar to the German artistic temperament: a preference for unexpected, expressive configurations; for dynamic tension in individual forms as well as in overall pictorial structures; and for conceptions which seem to wed human figures to their natural or man-made surroundings. The shapes of human figures, landscape elements, and all other accessories tend to become visually entangled; the primary concern of the German artist is not the lucid, tectonic, three-dimensional rendering of the figure or of thematic details found in Italian art, but rather the agitated movement of the aggregate of crowded bodies, drapery folds, and other forms. The impression of movement always overshadows the impression of bodily substance; curves and countercurves in the design overwhelm our interest in proportion, structure, and equilibrium. Furthermore, according to Wölfflin, German artists demonstrate a certain non-objective willfulness which finds its outlet in free, rhythmic, asymmetrical compositions and "eruptions" of expressive line, especially in the treatment of foliage, hair, and complex patterns of swirling, wind-blown drapery. Perhaps the most important quality in German art singled out by Wölfflin is its subjective intuition, its overriding concern with essence or spirit, its devotion to the undefinable inner meaning of any subject. The German artist tries to imbue his work with fervor and passion or, at the very least, with subjective insights.

Given this definition of German artistic style, it is not surprising that the one artist most frequently adduced and illustrated by Wölfflin— the quintessential German artist— is Hans Baldung Grien. Although today we might argue that Wölfflin carefully and purposefully chose his examples— Altdorfer, Grünewald, Baldung, the youthful Cranach, Leinberger— and then articulated the stylistic properties common to these individuals, while de-emphasizing such artists as Flöttner, Holbein, and Peter Visscher, it must be admitted that Wölfflin's perceptions have much validity and that Baldung's art can be seen as a representative embodiment of the dominant expressionistic trend in German art of the early sixteenth century. In terms of pathos and psychological impact, he is surpassed among his contemporaries only by Grünewald, whose work clearly influenced Baldung's style after about 1512 (see Cat. Nos. 44–54). Indeed, in the nineteenth century it was believed that one and the same artist was responsible for Baldung's Freiburg Altarpiece and for Grünewald's Isenheim Altarpiece now in Colmar.[2]

---

1  Heinrich Wölfflin, *Italien und das deutsche Formgefühl,* Munich, 1931; translated as *The Sense of Form in Art,* New York, 1958.

2  See E. Forster, *Geschichte der deutschen Kunst,* Leipzig, 1851–53, II, pp. 317–19, and J. G. V. Quandt,

"Über Martin Schongauer als Maler und seine Werke in Colmar," *Kunstblatt,* XXI, 1840, p. 322. For specific influences of Grünewald on Baldung, see Pariset, pp. 147–66.

Baldung has also been described as a somewhat eccentric imitator of Dürer who borrowed from Dürer's repertory of motifs and eagerly adopted his graphic language, but who lacked Dürer's genius, his unifying vision and imagination, and his technical skill. But Baldung was such an individualist that it makes little sense to compare him to another master or to rate him on the basis of how he measures up to an abstract conception of excellence. If we judge Baldung on the basis of the monumentality of his compositions (or the lack of it), or assess his merits on the basis of how clearly his work approximates Dürer's, we miss the main point. Baldung was, to be sure, the most important and fascinating artist to emerge from Durer's circle; he mastered— as did all of Dürer's pupils and associates— Dürer's technical methods and artistic vocabulary. Especially in Baldung's prints and drawings up to 1510 (Cat. Nos. 1–17) we find indications that Baldung borrowed from Dürer his rational and effective system of hatching and cross-hatching for modeling form. But Baldung's exposure to Dürer and his experience in Dürer's workshop was catalytic, liberating rather than suppressive. More than any other Dürer follower, Baldung was an experimenter, eager to try every medium in which Dürer worked. Baldung made paintings, highly finished drawings, woodcuts and engravings, and designs for stained glass and book illustrations. His exposure to Dürer provided him with the skills and knowledge, and therefore the freedom, to develop along his own unique path. Indeed, within the bounds of period and national styles, no two artists could have been more different in attitude and personality than were Dürer and Baldung. Whereas Dürer's art— stimulated by Italian art and humanistic writing— tends to be dignified, and often concerned with theory, measurement and formal perfection, Baldung's art is impetuous, often intentionally informal, highly spirited, and at times downright mischievous. He could be appropriately witty, earthy, precious, or chillingly grisly, as the occasion demanded. Carl Koch— in referring to Baldung's genius in inventing new, uncommon, or even preposterous interpretations of traditional subjects— suggests that Baldung created each work of art with special delectation, as if discovering the theme for the first time and making it his own.[3]

Although Baldung's work is in some general ways typical of German art of the time, and although he was inspired by both Dürer and Grünewald, he was a unique artist, a free spirit with an extraordinarily fertile imagination. Baldung's dramatic compositional solutions, the expressive range and variety of his linear technique, his insights into human psychology, and his preoccupation with demonic fantasy are unique. No other artist of his time was possessed, as he was, by a vision of women as predatory, powerful, and erotic. The sensuousness and lasciviousness of his supernatural subjects (and even his religious ones!) have no parallel in the art of the period.

Hans Baldung was born in 1484 or early in 1485[4]— some thirteen years after Dürer— most likely in the village of Schwäbisch-Gmünd in southwest Germany. We know that Gmünd was the Baldung family's ancestral home,[5] although Hans' father, Johann Baldung, appears by 1492 to have settled in Alsace, where he was an attorney (*Prokurator*) in the service of the Bishop of

3   Karlsruhe 1959, p. 15.
4   For an explanation of how Baldung's birth date was determined, see the discussion under Cat. No. 80.
5   The Baldung family name appears frequently in the archives of Gmünd. Furthermore, when Baldung

signed the Freiburg Altarpiece in 1516 he identified himself as "Joannes Baldung cog. Grien Gamundianus" ("Hans Baldung called Grien, from Gmünd").

Strassburg. Baldung's uncle, Hieronymus Baldung, a doctor of medicine who moved to Strassburg in 1496, eventually became honorary physician to Emperor Maximilian I. Hieronymus' son, Baldung's cousin, was chancellor of the Tyrol by 1527. Baldung's brother, Caspar, a professor at the University of Freiburg, later succeeded Sebastian Brant as city advocate of Strassburg, and finally became a judge in the Imperial Chamber Court.[6] Thus, unlike most German painters and graphic artists of the early sixteenth century, Hans Baldung did not come from a family of traditional artisans. And it seems that he was the only male member of his family who was not university-educated and who did not serve royalty or a municipal government. It was extremely unusual for one raised in academic and intellectual circles to choose a career as a craftsman, but it may well have been Baldung's familiarity with the learned circles of Strassburg that later made him welcome in Dürer's shop, where humanistic knowledge was highly prized. After all, during his own bachelor journey, Dürer had sojourned in Strassburg in 1493–94 and knew it as a cosmopolitan center.

It is usually assumed that Baldung was apprenticed to a Strassburg artist about 1499 or 1500, since it was customary for young men to begin apprenticeships at about age fifteen. The sensuous refinement of some of Baldung's earliest works, reflecting his acquaintance with the Alsatian tradition, and his specific use of compositions borrowed from the engravings of the great Colmar artist Martin Schongauer (d. 1491) suggest that his early training took place in the Upper Rhine region. Recently, Tilman Falk has made a case for Baldung's early training having taken place in nearby Swabia rather than Alsace,[7] a contention based primarily on the fact that Baldung's youthful *Self-Portrait* drawing of about 1502–03 (Fig. 1) is on prepared blue-green paper with highlights in white and pink in the flesh parts. This kind of drawing is seldom found in the Rhine region, but is common in Swabian drawings from 1450 to 1500. The very same combination of colors used by Baldung appears in the work of the Swabian artist Bernhard Strigel about 1500. It is certainly possible that Baldung received his first professional training in a Swabian workshop; his family surely must have maintained contacts in the region. More important, the Baldung *Self-Portrait* tells us as much about the young artist's personality as it does about his geographic origins. Falk has commented on the uniqueness of this Baldung drawing which, next to Dürer's youthful self-portraits, is the most important example of this genre in German art.[8] The drawing shows the artist as an alert and confident young man, his gaze meeting ours directly. The sensitive modeling of his well-proportioned face with short pen strokes contrasts with the rich effect of the brushstrokes in white, each of which suggests one tuft of his stylish fur cap which protrudes at a jaunty angle over the brow. From the firm jaw and the intent look we can infer that even at the age of seventeen or eighteen, Baldung had a self-assured demeanor. The quality and sophistication of the drawing also give more than ample evidence of a mature sensibility and artistic promise.

By 1503, Baldung made his way to Nuremberg in order to associate himself with Albrecht Dürer, the most highly regarded artist working north of the Alps at the time, and one whose

---

6 For other archival data, see Thomas A. Brady, Jr., "The Social Place of a German Renaissance Artist: Hans Baldung Grien (1484/5–1545) at Strasbourg," *Central European History*, VIII, 1975, pp. 293–315. See also Hans Rott. *Quellen und Forschungen zur südwestdeutschen und schweizerischen Kunstgeschichte im*

*XV. und XVI. Jahrhundert*, III, Der Oberrhein, Stuttgart, 1948.

7 Tilman Falk, "Baldungs jugendliches Selbstbildnis: Fragen zur Herkunft seines Stils," *ZAK*, XXXV, 1978, pp. 217–23.

8 Basel 1978, p. 36.

fame had spread through Europe following the publication of his *Apocalypse* woodcuts in 1498. Even though he had probably completed an apprenticeship elsewhere, it is likely that Baldung became an apprentice in Dürer's workshop, since that was the only status permitted to an unmarried male in a master's household. Because of his experience and the relatively elevated status of his family, however, Baldung was probably held in higher regard by Dürer than were his other apprentices. Whatever their original relationship might have been, it is a documented fact that they developed a close and lifelong friendship. When Dürer journeyed to the Netherlands in 1520–21, he recorded in his diary that he took along some of Baldung's woodcuts to sell and give away. This is probably a reference to the twelve religious woodcuts Baldung executed while in Dürer's shop (see Cat. Nos. 4–10).9 These prints, more than any other Baldung works, demonstrate the artist's attempt to emulate the basic elements of Dürer's early woodcut style. They so closely resemble Dürer's own that the master's monogram was added in the second state (no one knows by whom), probably to make the prints more saleable, the assumption being that few people would be able to discriminate between a design by Dürer and one by his most precocious pupil. After Dürer died in 1528, a lock of his hair was sent to Baldung in Strassburg as a keepsake, evidence that the two artists had maintained contact for almost two decades after Baldung left Nuremberg in 1509. This lock of Dürer's hair was reportedly found among Baldung's effects after his own death in 1545.

It was probably in Dürer's shop that Baldung was given the nickname "Grien." Some say the name derived from the artist's frequent use of the color green in his early work, while others speculate that it was due to Baldung's alleged preference for green attire. Since several of Dürer's apprentices were named Hans— Hans Schäufelein and Hans von Kulmbach, as well as Dürer's younger brother Hans, were all presumably in Dürer's shop in 1503— he may well have invented nicknames to distinguish them. Baldung's early work is signed "HB," but by 1510 the familiar "HBG" monogram begins to appear and is used on virtually every woodcut, drawing, and painting Baldung produced thereafter. Certainly by 1516, when Baldung signed his Freiburg Altarpiece "Johannes Baldung cog[nomine] Grien," the nickname had become an accepted, even semi-official part of his name.

Considering what a commanding and authoritative presence Dürer must have been, it is remarkable how quickly Baldung— after absorbing the conventions of Dürer's formal language — was able to develop his own unmistakable style. A pen drawing dated 1503, the Louvre's *Aristotle and Phyllis* (Fig. 2), shows Baldung clearly under Dürer's spell. Comparing this drawing to a Dürer engraving of the mid-1490s such as the *Unequal Lovers* (Fig. 3), it is evident at once that Baldung adapted to his own purposes an effective and characteristic Dürer composition. Baldung, like Dürer, places the protagonists on a hillock in the center foreground, sets them before a clump of trees which provides a vertical compositional element at the right, adds a view of a fortified town on the horizon at the left, and even indicates the faint silhouette of mountains on a far shore in the distance. Indeed, the costume and headgear worn by Phyllis seem to come from Dürer's repertory. The complex system of parallel curved lines and of double and triple cross-hatchings in the drawing also derives from Dürer, although in Dürer's engravings modeling is utilized in the service of defining texture and three-dimensional form, whereas Bal-

---

9  For an interesting theory of why Dürer took these particular Baldung prints to Antwerp, see Max Geisberg, "Des Grünhansen Ding," *Westfalen*, XXVI, 1941, p. 193.

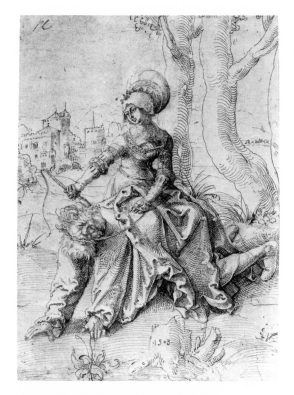

Figure 2. Hans Baldung, «Aristotle and Phyllis,» 1503, drawing, Musée du Louvre, Paris.

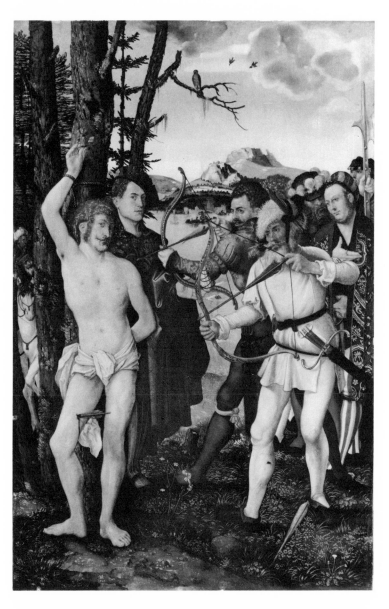

Figure 4. Hans Baldung, «Martyrdom of St. Sebastian,» 1507, panel, Germanisches Nationalmuseum, Nuremberg

Figure 3. Albrecht Dürer, «Unequal Lovers,» c. 1496, engraving.

dung's hatching is more animated and individual lines are drawn with greater energy, as if the artist found satisfaction in the expressive qualities of line itself. Although *Phyllis and Aristotle* is from a very early moment in Baldung's career (in fact, it is his earliest dated work), the expressive intensity which marks Baldung's mature style is found here in incipient form in the agonized, importunate expression on Aristotle's face and in the tension created by the oddly undulating tree trunk, seemingly on the verge of collapsing into the foreground.

By the time he created the *Study Sheet with Head of Christ*, a drawing of about 1507 (Cat. No. 15), Baldung had further developed many of the features of the *Aristotle* drawing. The hypnotic stare, eyes askew, and the set of the slightly pursed lips are typical of the way Baldung invests a face with subtle psychological meaning. This sketch, intentionally incomplete, demonstrates Baldung's confidence in the expressive and ornamental potential of energized line independent of representational form. Curling and curving lines skitter across the surface of the paper, sculpting out three-dimensional substance only on one side of the face, thereby creating a tension between plastic form and linear motion on the paper surface. Even when a Baldung drawing is directly inspired by Dürer, as in the case of the Copenhagen *Head of an Apostle* (Cat. No. 17)—an adaptation by Baldung of a lost Dürer study for the Heller Altarpiece—Baldung's treatment is more expressive and spiritualized.[10] Lines laden with exuberant energy not only become the primary emotive force in this drawing, but actually verge on becoming abstract arabesques, totally divorced from descriptive form.

It is not known what assignments Dürer gave Baldung, and there are no documents to shed light on Baldung's years in Nuremberg. Our knowledge is based on what can be gleaned from the works of art themselves and from later circumstantial evidence. In an exhaustive and extremely useful study of Baldung's affiliation with Dürer, Karl Oettinger and Karl-Adolph Knappe have arranged all of Baldung's work from his Nuremberg years in sequence, although Oettinger sometimes stretches the capacity of stylistic analysis beyond reasonable limits in insisting on the chronological priority of one work over another.[11] He also suggests that Baldung actually took over the management of Dürer's workshop when Dürer went to Venice for the second time in 1505. Whether true or not, Baldung most likely remained in Nuremberg until 1507, at which time he was summoned to the city of Halle. There he received commissions for two altarpieces, one of them a triptych of the *Martyrdom of St. Sebastian* now in the Germanisches Nationalmuseum in Nuremberg (Fig. 4). In this, one of his first major paintings, Baldung included a portrait of himself dressed in green and standing just behind the saint, but peering out at us as if he were concerned only about his own appearance and oblivious to the horrible event to which he is an eyewitness. As Robert Koch has pointed out, "the artist's modish attire, sparkling eyes, and self-assured smile proclaim that the twenty-two year old painter felt that he had arrived as a master in his own right."[12]

In 1509, Baldung returned to Strassburg, the city where he had lived as a boy, and became a citizen. In 1510 he married Margarethe Herlin, the daughter of a middle-class merchant, and opened his own workshop, joining the guild *zur Steltz*, which included painters, printers, goldsmiths, and glaziers. During the following several years he received numerous commissions for paintings and designs for stained glass. He also turned to the medium of chiaroscuro woodcut

10  Compare Dürer's drawings, W. 448-52.          12  R. Koch, p. 12.
11  See bibliography, Oettinger/Knappe.

(Cat. Nos. 18, 19, 24–25), a technique which employs two wood blocks, a key block containing the actual linear drawing and a second block from which the white highlights are cut out and which is then printed in colored ink. The result of the superimposed printing of key and tone blocks is similar to the effect created by drawings on prepared colored paper heightened with white, giving a moonlit, nighttime effect (cf. Cat. No. 33). This technique seems to have been used for the first time in Germany by Lucas Cranach about 1506–08; Baldung was among the first to adopt it, probably because it was appropriate for the mood he was seeking in his famous woodcut of 1510, the *Witches' Sabbath* (Cat. No. 18A–C).

In the years between 1509 and 1512, Baldung became deeply involved in two subjects which preoccupied him for much of the next decade: sorcery and witchcraft, on the one hand; and on the other, the gruesomeness and inevitability of death. In both genres, Baldung found an opportunity to give vent to his apparent anxiety in the face of the forces of nature. The message in his painting of *Death and the Maiden*, c. 1510–11, now in Vienna (Fig. 5) is clear and direct. It combines three themes familiar in German art in a novel way: the Dance of Death, Vanitas, and the Ages of Man. Death, in the form of a decaying corpse, holds an hourglass over the head of a young woman who is adjusting her long tresses as she admires herself in a mirror, unaware that her time is about to come. At her feet, a child who has dropped a hobbyhorse and ball attempts unsuccessfully to hide behind the woman's transparent veil, while an old woman strides into the scene from the left, trying to shove aside the arm of death. The presence of the three generations emphasizes the message of inevitable aging and death. Baldung seems to have been obsessed by this and related subjects, and returned to them many times in the next decade. Then he abandoned the symbolic treatment seen in Figure 5 and adopted a new, more gripping and frightening interpretation in which the leering figure of Death actually embraces the maiden as he claims her life (Figs. 6, 34, 35).

Although man's mortality and the omnipresence of satanic forces preyed on Baldung's mind, it would be misleading not to call attention to his versatility and his adaptability to any given subject. During the very Strassburg years (1509–12) when the frenzy of the *Witches' Sabbath* woodcut and the terror of the painting *Death and the Maiden* would seem to have preoccupied him, Baldung painted, among others, two pictures of traditional themes, entirely different from each other in spirit: the *Madonna and Child with St. Anne* now in Basel (Fig. 7) and the *Trinity with the Virgin and St. John* in London (Fig. 8), dated 1512. As Ludwig Baldass made clear,[13] Baldung's stylistic development is not methodical, with each work growing rationally out of ideas developed in the previous work. Indeed, Baldung's mind was so fertile and his desire for novelty and for unique interpretations so powerful that his work encompasses many forces simultaneously. Certainly the *Trinity* painting, conceived with passionate intensity, differs in emotional tone from the more lyrical Basel painting with its charming and homely family group tucked into the lower right corner and its mischievous frolicking angels picking fruit from the garlands dangling from the rafters. Just as the antics of the angels and their appealing facial expressions help convey Baldung's cheerful interpretation of the Madonna and Child subject, so the ominous dark clouds and the clashing of broad areas of saturated colors in the *Trinity* painting underscore the mystical character of the subject and heighten its psychological impact. Linda Hults[14] has noted that in Baldung's conscious search for the offbeat, he used color not merely as

13  Baldass, p. 32.                     14  Hults-Boudreau, p. 194.

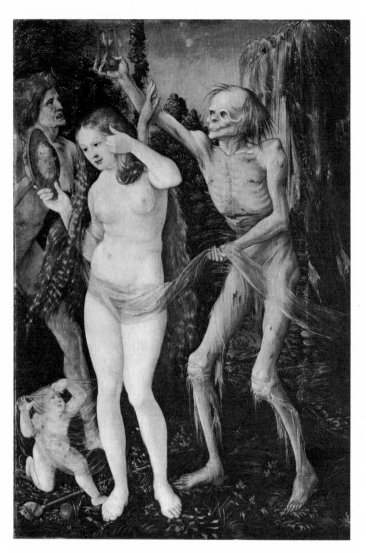

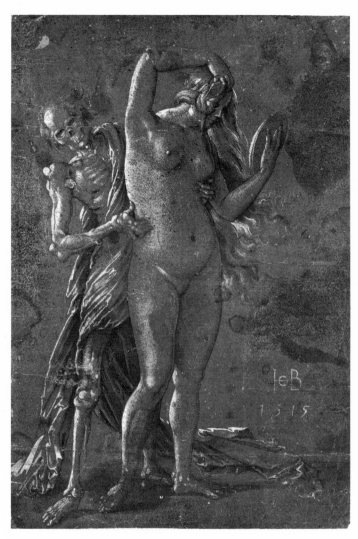

*Figure 5. Hans Baldung, «Death and the Maiden,» c. 1510–11, panel, Kunsthistorisches Museum, Vienna.*

*Figure 6. Hans Baldung, «Death and the Maiden,» 1515, drawing, Staatliche Museen, Berlin.*

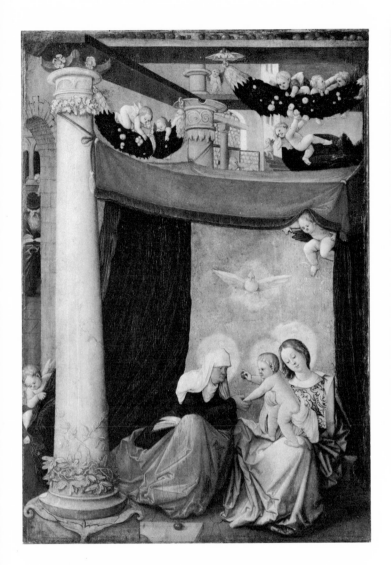

*Figure 7. Hans Baldung, «Madonna and Child with St. Anne,» 1511, panel, Kunstmuseum Basel.*

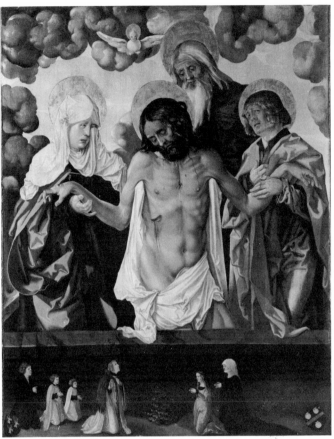

*Figure 8. Hans Baldung, «The Trinity with the Virgin and St. John,» 1512, panel, National Gallery, London.*

a concomitant to form, but adopted anomalous color schemes because they provoke visual and psychological dissonance.

In 1512, Baldung moved with his wife from Strassburg to Freiburg im Breisgau, where he received a contract to paint an altarpiece for the recently reconstructed choir of the Freiburg Münster, then, as now, one of the major cathedrals in the region. We know that he received in payment 340 Rhenish florins in cash and an annuity of 250 florins which yielded an annual income of eighteen to twenty florins.[15] The average commission to a painter for a major altarpiece (based on five documented contracts for altarpieces done between 1462 and 1518) was 550 florins.[16] The remuneration to Baldung was thus generous for the times. When Baldung returned to Strassburg in 1517, he rented a house for seven florins per year and was able to invest in annuities with the civic treasury that yielded fifty-five florins annually. It is thus clear that the commission to paint the Freiburg Altarpiece was a financial boon which assured to the artist a degree of economic security for the rest of his life. Although it is true that Caspar Baldung was teaching in Freiburg at the time and may have had some influence in obtaining the commission for his brother, it seems likely that by 1512 Baldung was already prominent enough to obtain on his own this lucrative and important assignment.

The folding altarpiece, which was not completed until 1516, is still intact and *in situ* in Freiburg and is generally considered Baldung's masterpiece. The central panel, the *Coronation of the Virgin* (Fig. 9), demonstrates that when confronted with the most important challenge of his career, Baldung turned for inspiration to the most reliable and familiar source, the work of Albrecht Dürer. The Freiburg painting contains elements from both Dürer's Heller Altarpiece, now lost (Ill. 17a), and from the upper half of Dürer's *Coronation of the Virgin* woodcut (Fig. 10). Hults has argued that Baldung is essentially a mannerist artist whose work can be understood as a self-conscious reaction to Renaissance (and in his case particularly Dürer's) forms. She refers to the Freiburg period in Baldung's career as a time of expressive mannerism, when Dürer models are used as the raw material in an attempt to create quite a different aesthetic effect. Although dependent on Dürer, it is Baldung's subtle alterations of Dürer's prototypes which endow his work with special meaning. Most Baldung scholarship of the early twentiety century—including that of Curjel, Pinder, and Hugelshofer— found Baldung excessively subjective, naive, or uncomfortably eccentric. Not comprehending that Baldung intentionally formulated subjective and even cryptic responses to both Dürer's art and to specific traditional themes, these historians criticized Baldung's work because of what they perceived as faithlessness to its serious subject matter.[17] Fritz Baumgarten was especially critical of the lack of dignity in the Freiburg Altarpiece, about which he wrote a monograph in 1904.[18] He complained that the Virgin is too self-conscious, God the Father lacks the proper degree of godliness, Christ is weak and effeminate, his gestures unconvincing. Baumgarten was especially vexed by the swarm of angels which "breaks the heavenly silence."

15  Brady, "The Social Place," pp. 298–99.
16  Hans Huth, *Künstler und Werkstatt der Spätgotik*, Darmstadt, 1967, pp. 112ff.

17  W. Hugelshofer, "Zu Hans Baldung," *Pantheon*, XI, 1933, p. 173.
18  Fritz Baumgarten, *Der Freiburger Hochaltar*, Strassburg, 1904, p. 10.

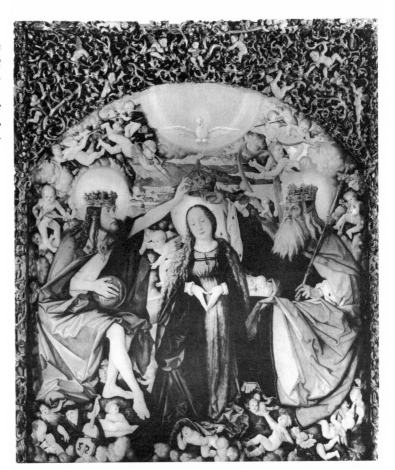

Figure 9. (Above). Hans Baldung, «Coronation of the Virgin» (central panel of Freiburg Altarpiece), 1516, panel, Münster, Freiburg.

Figure 10. (Below). Albrecht Dürer, «The Assumption and Coronation of the Virgin,» 1510, woodcut.

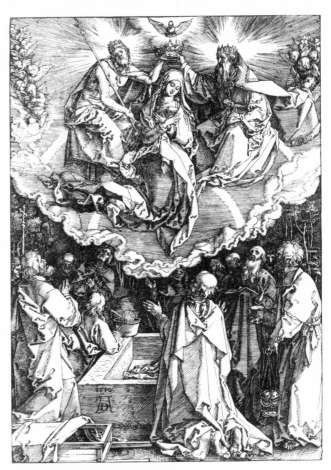

Hults admits that Baldung's *Coronation* lacks the monumentality of Dürer's conception:

> *The purpose is completely different. Far from creating a heavenly stillness, Baldung wanted to depict a raucous, joyful music which would, we imagine, overwhelm the human listener but with which the participants of the Coronation are completely at home. It is this effort to make the scene "audible" that prompts the excessiveness that Baumgarten so dislikes. Baldung's approach to religious iconography is extraordinarily subjective and he lacks the sense of decorum that is always operative in Dürer. Direct impact on the viewer is made by means which seem irreverent at the least and skeptical at the most. In this instance the figures of Christ and God the Father, the more sensuous beauty of Mary, and especially the mischievous angels, all contribute to the greater approachability of the scene. This more humanized version of Mary's Coronation is an expression of an unbounded joy that does not exclude human laughter.* [19]

Although Baldung remained in Freiburg for the better part of four years, his work during that period did not consist only of the famous altarpiece, and influences upon his style were not limited only to Dürer's. The impact of Grünewald also manifests itself in Baldung's works done between 1512 and 1516. The pathos and the dramatic dynamism in such drawings and prints as Cat. Nos. 44–54 clearly reflect Grünewald's influence. Sometimes, as in the case of Baldung's *Madonna and Child with Donor* (Cat. No. 53), one can point to specific sources in Grünewald's Isenheim Altarpiece for details such as the aureole behind the Madonna's head, the way her drapery breaks into folds where it trails on the floor, and even the way she seems to float— a sudden apparition which has burst into the room (or *is* it a room?) amidst clouds and smoke. Similarly, the contorted upraised hand of St. Sebastian (Cat. No. 48) seems to be inspired by the crucified hand of Christ from the central panel of the Grünewald masterpiece, just as the atmospheric light and heavenly splendor of Grünewald's *Madonna and Child in a Landscape* from the Isenheim Altarpiece seems to be the source for the heavenly apparition of God the Father and the endless swarm of angels in the woodcut of *Christ Carried to Heaven* (Cat. No. 50). One can imagine Baldung being tremendously moved at seeing Grünewald's work in progress (the Isenheim Altarpiece was completed in 1515) just as— a decade earlier— he must have savored the opportunity of watching Dürer engrave such prints as the *Fall of Man* of 1504 (Fig. 15), the *Apollo and Diana* (B. 68) and *Satyr Family* (B. 69), all of which affected Baldung's concept of the female form, a concept that found expression in his later renditions of witches and other female nudes.

It is difficult to know whether exposure to Grünewald's paintings and drawings was the only, or even the primary, factor accounting for the dramatic change which occurred in Baldung's woodcuts after about 1512–13. Earlier, by 1510, the mode of woodcut Baldung had developed in Dürer's shop had evolved into a bold and effective personal style. In these mature prints of 1510–13 (see especially Cat. Nos. 18–21, 32, 37), figures on a grand scale tend to dominate their settings. Compositions are clearly and geometrically articulated and figures are clustered in slightly off-center pyramidal groups (Cat. Nos. 21, 22), in rigidly symmetrical arrangements (Cat. No. 20), or along simple vertical axes (Cat. No. 19). In at least one case (Cat.

19  Hults-Boudreau, pp. 42–43.

No. 32), the figure is of absolutely heroic proportions. These woodcuts also have in common consistent and rational systems of hatching which not only suggest degrees of light and dark but which also— because so much is left unmodeled— lead to luministic effects. The methodical modeling also allows for precise cutting of the block which in turn yields a transparent clarity of effect and thematic legibility.

After 1513 this lucidity and restraint disappears from Baldung's woodcuts. In place of the statuary groupings, the subdued mood and the controlled hatching of the earlier woodcuts, prints such as *Man of Sorrows* (Cat. No. 51) and *St. Sebastian* (Cat. No. 48), where emotion is raised to fever pitch, are conceived with totally unprecedented originality; the graphic language has to all appearances become frazzled and chaotic. The images seem cluttered with thousands of undisciplined lines, many of which are laid so closely together that ink clogs the spaces and muddy printing is the inevitable result. In the *St. Sebastian*, each segment— clouds, landscape, the saint's torso— appears to have been modeled without concern for how it interacts, or whether it clashes with adjacent sections of the composition. Is a different cutter at work here, accounting for the drastic change in Baldung's technique, or is it more a matter of a shift in the artist's expressive intent? The collision of uncoordinated sections of curved, paroxysmic clusters of hatching (mostly in the form of concentric semi-circles and parallel curves) certainly adds to the pictorial tension and underlines the mood of uncontrolled grief appropriate to the subject matter. Baldung contorts the pose of the saint to achieve a powerfully expressive undulating contour. The outer boundary from hip to ankle is scarcely modeled, and is rendered in such a way that a thin, unmodeled "sliver," which reads like a fluid white outline, emphasizes the edge and creates a flattened shape, in direct contrast to the insistently modeled inner contour. The resulting tension between plasticity and linear pattern in this example is characteristic of the visual ambiguity which pervades the scene. In the drawing of the figure, as in the manipulation of individual lines and hatchings, Baldung is willing to fracture reality and abandon clarity in deference to expressive ends. Even in a woodcut in which the overall effect is one of orderliness and graphic consistency, the *Expulsion* (Cat. No. 39), Baldung arbitrarily uses hatching lines to create effective linear patterns rather than to describe appearance. For instance, the side of the angel's face (Fig. 11) is rendered by lines which are like the concentric whorls of a fingerprint— clearly the invention of an artist more concerned with abstract line for its own sake than with line as a means of rendering realistic textures and surfaces. Every woodcut, of course, is something of a compromise between the appearances of the natural world and the requirements of a technique which forces the artist to adopt linear conventions. Baldung clearly pushes these possibilities to their outer limits. It may well be that the artistic and technical problems presented by the woodcut medium were what attracted Baldung to Dürer in the first place and which resulted in his own preference for woodcut over engraving.

The Freiburg Altarpiece was completed in 1516; Baldung returned to Strassburg early in 1517 and remained there for the rest of his life. He continued to prosper and to receive commissions for major paintings, such as the *Baptism of Christ* triptych, painted about 1520 for the Dominican church in Frankfurt and now in the Städelsches Kunstinstitut (Fig. 12). This handsome painting seems to blend the stylistic qualities of Baldung's previous phases. The expressive mannerism and psychological penetration of the previous decade fully absorbed, the composition is sculpturesque and monumental, although the forms have become hardened and possess a stiffness and heightened clarity; contours are extremely precise but textures remain undifferen-

[ 15 ]

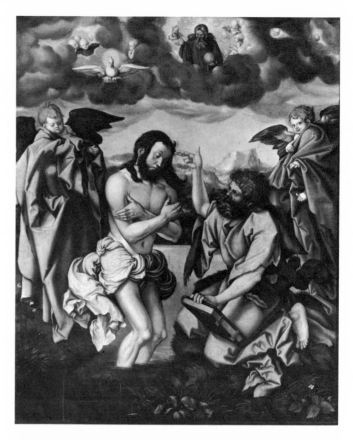

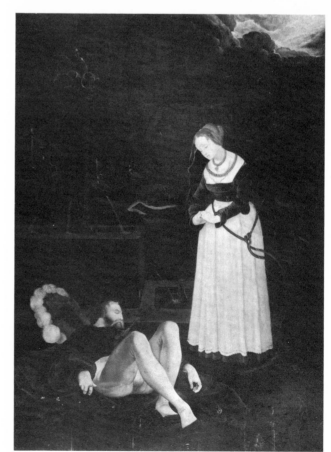

Figure 11. (*Above left*). Hans Baldung, «*Expulsion from Paradise*» (*detail of Cat. No. 39*), *1514, woodcut.*

Figure 12. (*Above right*). Hans Baldung, «*Baptism of Christ,*» *c. 1520, panel, Städelsches Kunstinstitut, Frankfurt.*

Figure 13. (*Below right*). Hans Baldung, «*Pyramus and Thisbe,*» *c. 1530–31, panel, Staatliche Gemäldegalerie, Berlin.*

tiated. The elaborately crumpled drapery might almost be made of some metallic foil. In this work, as in many of Baldung's later works, energy is confined. Powerful emotion lies just beneath the surface, contained within a stringent composition.

The advent of the Reformation had a devastating effect on art and artists in the German-speaking lands. The demand for religious pictures declined as funds were no longer available for the decoration of churches; the primary source of patronage virtually disappeared, and surges of iconoclasm resulted in the ruin not only of contemporaneous works, but also of religious objects produced by previous generations. It is assumed that Baldung's sympathies were with the Reformers and that he, like most of his Strassburg compatriots, was attracted by Luther's ideas. In any event, Baldung was better off than many artists. His masterpiece was in the Münster of Freiburg, in a Catholic city protected by the Austrian Hapsburgs. Strassburg, although a center of Reformist thought and activity, was relatively moderate and did not, as Brady points out,[20] experience the ruthless official campaign against art found in other places. In the mid-1520s, works of art were removed from Strassburg churches, but most of them were carefully wrapped and packed away. So far as we know, only in 1529 and 1530 did iconoclasts ravage the churches in Strassburg and actually destroy paintings and other art objects.

Obviously Baldung would receive no more commissions for altarpieces, but he apparently continued to have an aristocratic clientele with highly refined taste, for whom he painted numerous Madonnas (see Fig. 48), allegorical subjects from classical literature, and portraits. In response to the political realities of the 1520s and to Baldung's increasing exposure to Italian mannerism, the style of his later paintings became hyperrefined, characterized by a kind of affected cultivation and coolness, both in color scheme and expressive content. It would be hard to imagine anyone actually worshipping or venerating the *Madonna and Child with the Parrots* (Fig. 48), given its erotic, even perverse overtones, the detached facial expression of the Virgin, and the obvious aesthetic rather than religious motivation which lies behind the picture. It must be assumed that such paintings were made for sophisticated patrons who understood and enjoyed Baldung's search for new and strange modes of expression. In the *Pyramus and Thisbe* of about 1530 (Fig. 13), Baldung allows the heroine only the most muted expression of despair, the tenuous position of her hands a feeble imitation of the anguished gestures of grief found in Baldung's earlier religious works. She looks down languidly at her dead lover, whose pose is uncomfortably similar to that of the dead Christ in Baldung's own *Lamentation* woodcut of some fifteen years earlier (Cat. No. 49). Baldung confuses our response by allowing motifs and characteristic poses from a Christian subject to intrude into this rather effete rendering of a classical one, thereby endowing it with an ambiguous second level of meaning.

After 1520, Baldung made only a handful of single-leaf prints, but these few late woodcuts rank with the greatest prints of all time. Baldung's obsession with the demonic forces of nature re-emerged in tangible form in 1534 with a series of three compelling woodcuts showing rampaging wild horses in a forest setting (Cat. Nos. 83–85). Their eyes blazing, the horses furiously kick and bite each other, their manes and tails flying. Now almost fifty years old, Baldung once again used the graphic image to express in a metaphorical way his understanding of the frustrations of erotic desire and the pitifulness of the human condition (see discussion under Cat. Nos. 83–85). Like so many of his earlier works, these prints seem to be a correlative of the artist's personal feelings.

20  Brady, "The Social Place," pp. 311–12.

A year before his death, in 1544, Baldung made one last woodcut (Cat. No. 87). It shows a stableman prostrate, his currycomb and pitchfork having dropped to the floor. An old hag or witch brandishing a torch at the window has cast a spell on the groom; or was it the bewitched horse who knocked the man to the ground? The meaning of this powerful image may never be adequately deciphered, but we can note that on the wall next to the witch there is a shield with a rampant unicorn, the coat of arms of the Baldung family. This is Baldung's stable, obviously, and whether or not the groom is a metaphorical self-portrait of the artist, this is obviously a place open to invasion by sorcerers, where evil powers can intrude and cause great injury or death. It may well be that this print symbolizes the worst of Baldung's anxieties, that the powers of evil which had always preoccupied him would one day claim him as a victim. Baldung died the next year, in 1545, and was buried in the new Protestant cemetery of St. Helena just outside one of the Strassburg city gates.

# BALDUNG AND THE FEMALE NUDE
## BY CHARLES W. TALBOT

Eve became a leading figure in German art of the sixteenth century, going beyond her necessary role in the Christian epic of the fall and salvation of mankind and standing forth as a protagonist capable of provoking many levels of response. She owed her new visual prominence especially to the art of Dürer, Cranach and Hans Baldung Grien, but they, like all artists who create paradigms for their time, gave expression to the thoughts and feelings of many. The nude figure was occasion to proclaim, as Renaissance artists everywhere were doing, the physical experience of human life, to acknowledge the attractions of the body and its relation to the mind and spirit. Eve was a natural archetype for the female nude, despite the absence of ancient models on which to base an authentic image of her. The artist's desire to recreate an appearance of the first woman was akin to the Renaissance humanist's search for the purity of an original text, whether biblical or classical. And those of the time who were stirred by the notion of a Golden Age could only take renewed interest in visualizations of the Garden of Eden before the Fall of Man. Striving to find a definitive image of Eve, Dürer turned to classical antiquity for models and for a theory of proportions; then others turned to Dürer. But Eve was a complex figure and did not fit the pattern of any one pagan goddess. She was susceptible in art, as she was in theology, to critical descriptions, which heightened her fascination while often transforming her appearance from a classical norm. It was not as a remote biblical figure that Eve worked on the imaginations of those who portrayed her; she lived in the mind as every woman and, therefore, also as modern woman. More than any other female character in the art of the time Eve mirrors the complex and conflicting attitudes toward women.

Yet she was not alone. These attitudes led to the development of other themes in which the female descendants of Eve also take the principal roles. These are themes that deal in the mysteries of love, beauty, aging and death. Evidently women seemed closer than men to the forces of nature that determined the outcome of these fundamental questions of life. It was not just Baldung's private turn of mind that produced this outlook, although he was tireless in its exploration. For more than three decades he presided over a coven of haunting images: temptresses, witches and maidens caught in the arms of death. What these images have in common, besides the central presence of the female nude, is the expression of forces that defy man's understanding, and even more his control. In each case there is a feeling of anxiety, a threat either by or to the women involved. Like Eve, these women may wield a power over men, but ultimately they cannot escape their own vulnerability.

Baldung's interest in the female nude exceeded the specific demands of any particular theme. Without the identification of costume the figure assumes a certain universal existence unrestricted by narrative. As she gives the appearance of belonging naturally to any one of several scenes, so too does her identity, as established by one theme, tend to merge with others. Her nudity speaks of both power and vulnerability. The power derives clearly enough from sexual attraction, and, to an extent, so does the vulnerability, since sexual attraction does not work se-

lectively. There is no assurance that whoever responds to the attraction will be sympathetic, and carnal desire itself has always been notoriously unruly. Moreover, nudity gives the impression that the woman is relatively defenseless, especially when considered through the eyes of observers who are themselves accustomed to being fully clothed. It is plain enough, however, that Baldung was not in search of a simple ideal of female desirability. His witches, in particular, give evidence to the contrary. They are often formidable women more likely to induce feelings of abhorrence than lust. Witchcraft did cast a powerful spell on Baldung's artistic imagination, but it remains difficult to know his actual persuasion on the subject. Nevertheless his nude witches do remind us of the misogyny that burned in the hearts of inquisitors. These wild, hefty women doubtless did fit a general preconception of the time, even if they were exaggerated to the point of becoming caricatures.

Outright hostility between the sexes is not what we sense in Baldung's art, but the competition and tension there between men and women is hard to overlook. Themes concerning the power of women turn up frequently among prints and drawings during this period. From Baldung's own work we have two of the best examples: *Aristotle and Phyllis* (Cat. No. 37) and *Hercules and Omphale* (Fig. 14). In both, men succumb to the women's charms and are made to appear foolish and unmanly. These were not entirely fresh subjects, but their humor apparently still had its bite. A sudden change in German fashion around 1500 suggests that masculinity was waging a new campaign for superiority. Clothes of the late fifteenth century, designed to emphasize a slender, graceful physique, gave way to a new cut that favored the body's breadth and mass. Shoes, for example, underwent a complete transformation from long, thin, pointed ones, known as *Schnabelschuhe* ("bird's-beak shoes"), to an equally exaggerated type with a wide, blunt toe, fittingly called *Kuhmaulschuhe* ("cow's-muzzle shoes"). The latter were much better suited to long marching, like that required of infantrymen, and it was, in fact, the characteristic dress of the Landsknecht— the mercenary soldier— that inspired the flamboyant, slit-sleeved men's fashion in general. Strictly military considerations, however, did not account for much of the fashion that soldiers and others adopted. The codpiece, for instance, was well on its way to maturity, flaunting and posturing virility for its own sake. Such clothes emphasizing physical prowess are well recorded in the visual arts. Representations of the human body itself underwent corresponding adjustments in shape and movement. A German figure from the 1480s or '90s looks quite puny when matched with one from, say, 1520. In the development from late Gothic to Renaissance art generally, there was, of course, a shift in the preferred standard of human proportions. The Renaissance male figure was likely to be more muscular, more developed across the shoulders and sturdier on his feet than was his immediate predecessor. In addition to expressing such humanistic values as balance and stability, these characteristics also contributed directly to a masculine ideal. We need not pursue this question further in order to verify that the male image in German art of Baldung's time promoted more than physical vigor and mental alertness. The social climate in which this self-conscious masculine identity flourished could not help but also affect the perception of the female figure. Moreover, the perceptions recorded for us were mainly those of men. Under these circumstances one can well imagine that the female nude was a provocative subject in more than one sense.

A new standard for the representation of both Adam and Eve was set by Dürer with his engraving of 1504 (Fig. 15). Dürer had carried out extensive studies for each of the two figures in his search for ideal human proportions, and when he published his findings in this print,

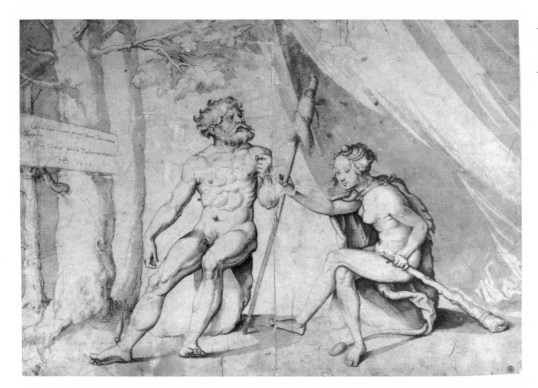

*Figure 14. Hans Baldung, «Hercules and Omphale,» 1533, drawing, École des Beaux-Arts, Paris*

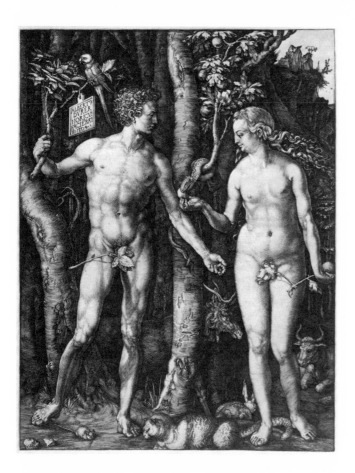

*Figure 15. Albrecht Dürer, «Fall of Man,» 1504, engraving.*

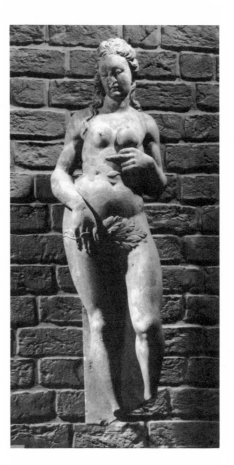

*Figure 16. Lower Saxon, «Eve,» c. 1540, sandstone, Museum für das Fürstentum, Lüneburg.*

he simply placed the figures side by side in a way that best displayed the contours of their bodies poised in contrapposto. The positions of their arms and hands tell the bare facts of their transgression, while the animals in the forested Garden of Eden elaborate on the event by symbolizing man's four humors that were thrown out of balance at the Fall. Although Dürer subordinated the inherent drama of the subject to a highly intellectualized interpretation, the image was so compelling that other German artists could scarcely think of Adam and Eve again without visualizing his engraving. Baldung must have known this print from the day it first came off the press. By 1503, it seems, he had arrived in Nuremberg to work in Dürer's shop and was to become the master's most outstanding pupil.

In 1511, when Baldung made a chiaroscuro woodcut of the same subject, he took a different view of what happened in the forest of Eden (Cat. No. 19). Instead of Dürer's studied bodies, standing apart and unobscured, this Adam and Eve are drawn together by their carnal instincts, and therein lies the story of the Fall of Mankind, as an inscribed tablet overhead proclaims. With one hand wrapped around Eve's breast, Adam reaches with the other to the Tree of Knowledge to pluck its fruit. Excepting the serpent, Dürer's rabbit— symbol of sanguine sensuality— is the only kind of animal visible, but now there are two. Given man's usual preoccupation with sex, Baldung has a point, but one cannot help wondering whether he was being straight-faced about the apple/breast simile. The same idea, however, took a literal form of expression in a serious looking Eve from about 1540— a sandstone figure now in Lüneburg— who herself holds an apple in place of her left breast (Fig. 16).[1]

Baldung narrowed his format to concentrate on just the two figures in a woodcut of 1519 (Cat. No. 75) and a painting from late in his career, c. 1535–38, in Lugano (Ill. 75a).[2] In all three cases Adam advances upon Eve from behind. Her body, the object of his licentiousness, is fully revealed, while his is half or more obscured. There is no subtlety about Adam's intentions, but one cannot read Eve's mind so easily. We sense in her stance and expression, however, that she is aware of her attraction although not necessarily gratified by it. Part of what Baldung seems to find fascinating in Eve is her innate power to attract. He intimates that from the beginning she possessed a force that existed independently of will. Her interest for him clearly overshadows that of Adam, and Baldung did not even bother always to include Adam in scenes with her, at least not directly. A pen drawing in Hamburg, dated 1510 (Fig. 17), shows Eve standing in the forest alone, with only the serpent beside her; her face expresses a growing sensation and awareness of herself as a woman. The National Gallery of Canada's recently acquired panel, *Eve, the Serpent and Death* (Fig. 18), illustrates the license Baldung would take with the biblical narrative as he concentrated on the character of Eve. If Adam is present at all, he is the grisly figure already consumed by his own mortality who confronts an unflinching Eve with hers.[3]

1 Gerhard Körner, *Leitfaden durch das Museum* (Museumsverein für das Fürstentum Lüneburg), Lüneburg, 1975, no. E59.

2 Karlsruhe 1959, no. 71, fig. 28.

3 That Eve, as in the Hamburg drawing, was ever intended as a single figure has been denied by Wolfgang Hartmann ("Hans Baldungs 'Eva, Schlange und Tod' in Ottawa," *Jahrbuch der Staatlichen Kunstsammlungen in Baden-Württemberg*, XV, 1978, p. 8),

contrary to the more convincing opinion of Robert A. Koch (R. Koch, pp. 28–29). Koch proposes that one of the thematic threads Baldung has woven into the Ottawa panel is "Eve alone with the serpent before she induced Adam to join her adventure," but he also recognizes that the "personification of Death may also be seen as a representation of Adam himself. . .".

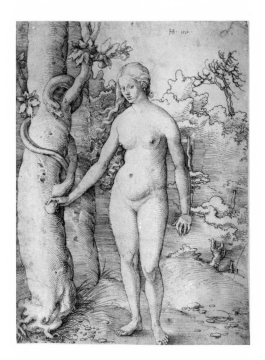

*Figure 17. Hans Baldung, «Eve,» 1510, drawing, Kunsthalle, Hamburg.*

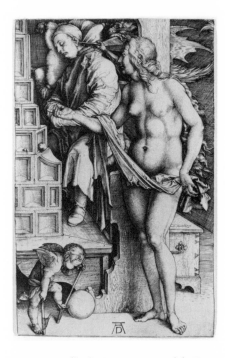

*Figure 19. Albrecht Dürer, «Dream of the Doctor,» 1498–99, engraving.*

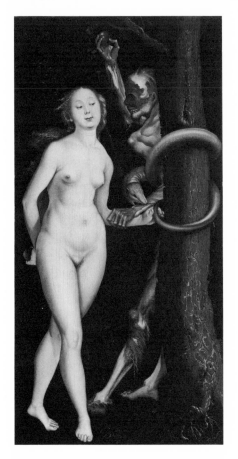

*Figure 18. Hans Baldung, «Eve, the Serpent and Death,» c. 1525, panel, National Gallery of Canada, Ottawa.*

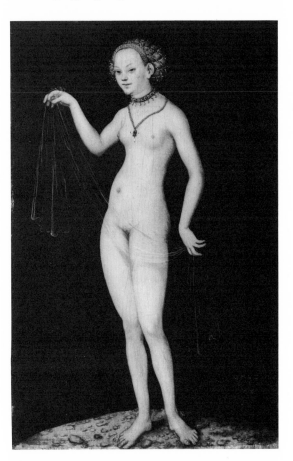

*Figure 20. Lucas Cranach the Elder, «Venus,» 1532, panel, Städelsches Kunstinstitut, Frankfurt.*

Dürer's engraving of 1504 gave Baldung his principal model for Eve. We can easily recognize her in the drawing of 1510, and in the woodcuts of 1511 and 1519. Each time, though, Baldung changed the figure's stance slightly and emphasized the curve of her hips so that the body conveys a greater sense of movement. This is a critical element in the expression of Eve's sensuality, and when Adam is alongside her, it contributes to the feeling of interaction between them. The movement is more pronounced in the woodcut of 1519, where Eve turns in response to Adam's touch. Her position resembles that of another, slightly earlier nude figure by Dürer, namely, Venus in the engraving called *Dream of the Doctor* (Fig. 19). The little putto in the print verifies the nude's identity, and together they represent the kind of dream idleness engenders with the Devil's help. Venus slipped easily into the guise of Eve with little or no concealment of her true personality. Dürer's figure also provides an interesting example of how certain gestures could take on the character of an attribute. The seemingly innocuous position of Venus' arms and hands became a virtual cipher for an alluring disposition in female nudes by Cranach, such as his *Venus* of 1532 in Frankfurt (Fig. 20). Even the Eve in Dürer's engraving of 1504 nearly duplicates this Venus-like gesture, although she, too, it will be recalled, was derived by Dürer from a Venus prototype.

Beauty and expressiveness in the human body are so much a function of how the body moves that strict canons of proportions and set appearances are never wholly satisfying. That which moves changes its appearance in relation to any fixed norm. In the motionless visual arts the human figure may undergo considerable distortion in order to suggest the appearance of the form itself in motion or to lead the eye of the observer on a path that induces a feeling for the intended movement, or to do both together. Even without being forced by requirements of narrative action, Dürer modified his view of Eve, as presented in 1504, to give more expression to the life, movement and allurement of the figure. He still sought to rationalize her proportions and configuration, as the measured side of a figural study in Vienna shows (Fig. 21), but when he traced and completed the figure on the other side of the same sheet (Fig. 22), the figure emerged with a new and evocative freedom of movement. This is one of the several studies that led to the life-size painting of *Eve* from 1507 in the Prado (Fig. 51). Instead of stretching one leg to the side, as she does in the drawing, Eve now steps with her right leg in front of the left. Her silhouette tapers down to the ankles. This narrow base and the lanky proportions draw attention to her delicate balance, which seems to be sustained in this position only for an instant before she moves on. Her step and glance lead us to anticipate a graceful turn, although for the moment we see the entire sinuous outline of her body from the front. This Eve of stylish femininity generated a wave of imitations and variations, but seldom could Dürer's followers, not least among them Baldung, resist the temptation, a constant force in the cycles of fashion, to exaggerate the most identifiable characteristics of the mode he set.

The panel in Ottawa, *Eve, the Serpent and Death*, is a good example of Baldung's gift or, depending upon one's point of view, weakness for sensationalism. One sees this obviously in the scene as a whole but very much in the nude figure as well. Although the figure derives clearly enough from Dürer's painting of 1507, Baldung's modifications have altered her entire personality. The tilt of the head now looks cocky, the glance to the side has become one of seductive deviousness, the lips resemble a smirk. The exaggerated step leaves her equilibrium in doubt, and the increased turn of her body shows a disregard for gracefulness. The cross-legged stance of Dürer's Eve emphasizes her elegant proportions. Baldung, on the other hand, manages to accen-

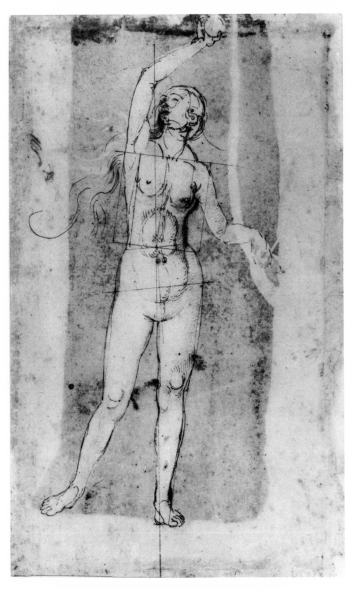

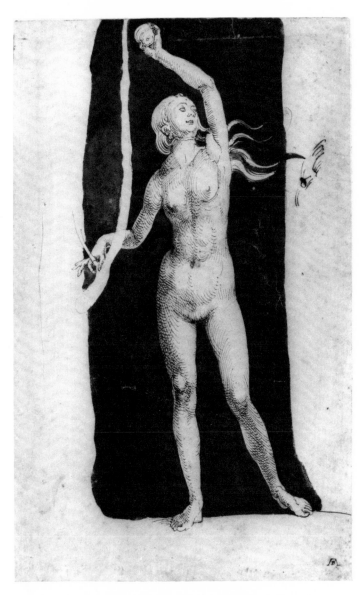

*Figure 21. Albrecht Dürer, «Eve» (recto), c. 1506, drawing, Albertina, Vienna.*

*Figure 22. Albrecht Dürer, «Eve» (verso), c. 1506, drawing, Albertina, Vienna.*

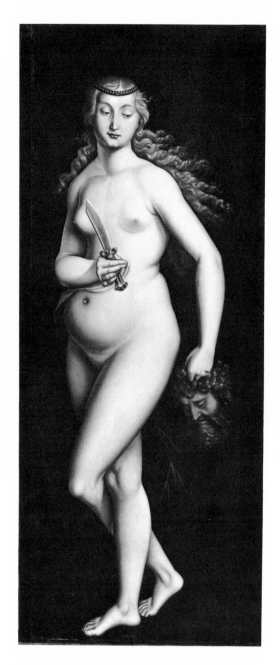

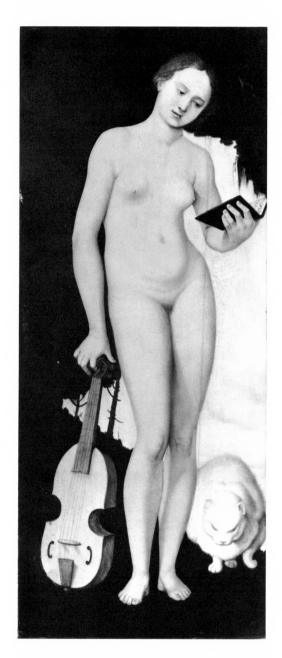

Figure 23. Hans Baldung, «Judith», 1525, panel,
Germanisches Nationalmuseum, Nuremberg.

Figure 24. Hans Baldung, «Allegorical Figure ("Music"),»
1529, panel, Alte Pinakothek, Munich.

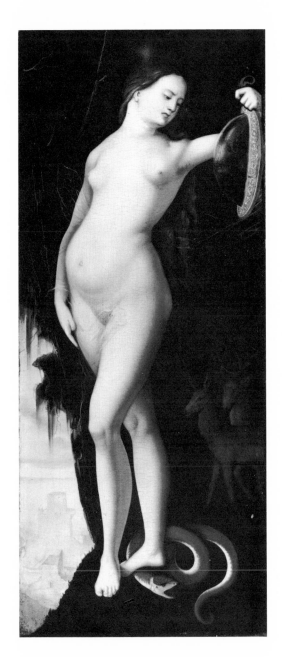

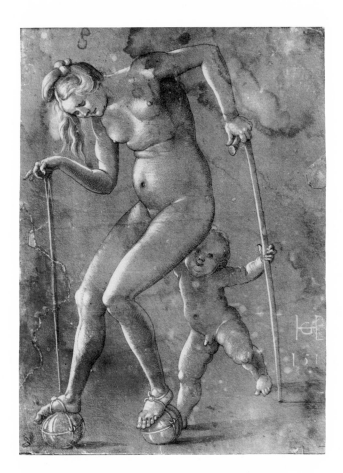

Figure 26. Hans Baldung, «Woman Walking on Balls,» 151?,
drawing, Albertina, Vienna.

Figure 25. Hans Baldung, «Allegorical Figure
("Prudence"),» 1529, panel, Alte Pinakothek, Munich.

tuate the fleshiness of his Eve by the same device. This time the legs cross at the knees so that the thighs, hips and abdomen form a weighty and provocative center to the figural composition. These are sufficient grounds for suspicion that Baldung had a parody in mind.

Like the position of Venus' arms and hands in the *Dream of the Doctor*, so the crossed legs become a frequent attribute of the nude female ostensibly in the full power of her allurement. Cranach and Baldung are the chief exponents of this curiosity. Baldung's life-size *Judith* of 1525 in Nuremberg (Fig. 23) forces the question, why does she stand that way? Holofernes can no longer help us, but he would swear she does it not from shyness. The left leg wraps around the other like the serpent around the tree, leaving the massive torso perched above one supportive foot. Less extreme examples, such as the painting in Munich from 1529, called *Prudence* (Fig. 25) or the drawing traditionally identified as *Venus* in Berlin (Cat. No. 76) from the same decade, show similar contortions of the body accompanying this stance. The meaning in this posture, if any, may reside in the very instability of the figure. The customary way of showing the fickleness of fortune or love was to represent the personifying figure in a state of precarious balance, whether standing on a globe (Fig. 27) or playing on stilts (Fig. 19). Baldung's drawing of a woman, probably Venus, walking on balls tied to her feet is another variant of the same idea (Fig. 26). Even with the aid of two walking sticks, she can scarcely stay upright. It is like a game more appropriate to the child who tries to steady her. The awkward position of her body reminds us of those figures whose crossed legs also probably signify doubtful steadiness in behavior as well as in appearance.

The model on which the drawing of *Venus* in Berlin is based happens not to be one with crossed legs, but it does portray a goddess of fortune. The striking profile of Baldung's nude bears the unmistakable traits of Dürer's *Nemesis*, frequently called *The Great Fortune* (Fig. 27). It was inevitable and probably intended that certain associations of Nemesis should accompany the transfer of her shape to the other figure despite the difference in identity. That identity remains ambiguous, but the apple in her hand limits the possibilities to Eve and Venus. The drapery favors an identification as Venus, and so too, one might think, does the fact that she has her hair done up, since Eve was presumably not yet touched by practices of civilization. Nevertheless, the Eve in Baldung's woodcut of 1519 does wear her hair in a similar fashion, and the seductive expression (more like a challenge, really) of the woman in the drawing seems entirely in keeping with Baldung's thoughts on Eve. Whether a Venus or an Eve or a fusion of both in the artist's mind, the figure appears before us as a woman of presumed sexual irresistibility. How does one then reconcile this fact with Baldung's choice of a model which to modern eyes is better left in her original role of Nemesis?

The question does not pertain only to Baldung. As strange as it may seem today, Dürer's Nemesis found her way into many similar situations. Niklaus Manuel Deutsch borrowed this figure for his painting of the *Judgment of Paris*, c. 1517–18, in Basel (Fig. 28). He presumably could have used Nemesis for the military goddess, Minerva, but chose instead to give her the place of Venus to whom an utterly serious Paris awards first prize for beauty. A drawing in Nuremberg, copied after Urs Graf (Fig. 29), gives a different insight into contemporary perceptions of Dürer's print.[4] This time Nemesis has been replaced on the globe by a woman who

4  Fritz Zink's attribution of this drawing to an imitator of Urs Graf (*Die Handzeichnungen bis zur Mitte des 16. Jahrhunderts*, Germanisches Nationalmuseum, Nuremberg, 1968, no. 141) is misleading insofar as the invention, if not the execution, is surely by Urs Graf himself.

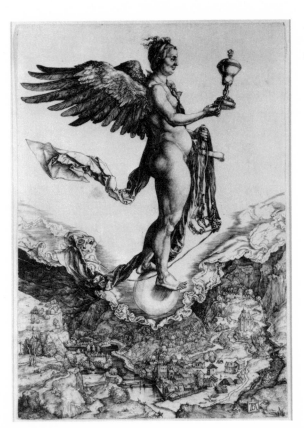

Figure 27. Albrecht Dürer, «Nemesis,» c. 1501–02, engraving.

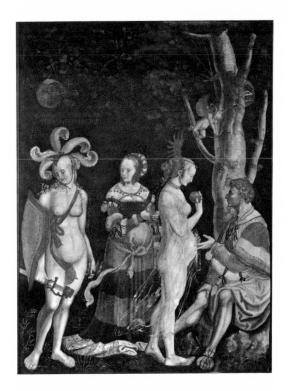

Figure 28. Niklaus Manuel Deutsch, «Judgment of Paris,» c. 1517–18, canvas, Kunstmuseum Basel.

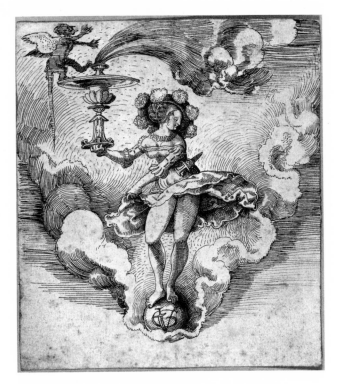

Figure 29. Urs Graf, copy after, «Fortuna,» c. 1520, drawing, Germanisches Nationalmuseum, Nuremberg.

represents herself as Fortuna but who takes no pains to conceal her real identity. Fortuna is a whore, a camp follower like the many one sees in drawings by Urs Graf and Niklaus Manuel Deutsch.[5] There was nothing that Urs Graf would not satirize,[6] and Dürer's subject must have looked ripe to him. But then Niklaus Manuel and Baldung, too, were far from being dry antiquarians. The figure of Nemesis to them was surely no canonical study of ideal feminine beauty, even when transformed into the person of Venus, and that in itself may be the reason she was chosen for this role. There have been many who bowed down at the altar of Venus without rejoicing upon arising. Venus could be defined in the mind by disillusion as well as by desire. On the other hand, the fleshiness of Nemesis was apparently not antithetical to the iconography of a love goddess or of other women with a share of her powers, such as Baldung's Judith. There are too many examples in German art of Nemesis-like women in provocative contexts for us to believe otherwise. Judith does much to explain the paradox. She, who allured and destroyed, was herself a Nemesis of proven ability. It is not surprising that Dürer's engraving should have come into the picture. His print was a mine of visual and figurative imagery for such related themes. And it would have been a remarkable coincidence if by chance alone Dürer had coupled the symbols of reward and punishment— the cup and the bridle— with this particular figure. The Nemesis type entered Baldung's pictorial repertory as a figure inherently expressive of the positive and negative forces perceived in women. The frequent appearance of the type attests to the artist's and his male public's deep ambivalence on a matter that affected them constantly. The distinct element of satire in these figures indicates that Baldung was consciously unveiling this ambivalence.

Satirists like Baldung understood that the power of women existed to a considerable extent because of the folly of men. In one of his earliest surviving works, a drawing in the Louvre, dated 1503 (Fig. 2), he turned to a ready-made theme on this point: *Aristotle and Phyllis*.[7] If a man so wise as Aristotle would submit to childish and humiliating games at a woman's whim, who then could consider himself immune? In Baldung's second version of the subject, a woodcut of 1513 (Cat. No. 37), that childish game of horse and rider exposes more than folly. Both figures are nude, except that Phyllis keeps her modish hat on. Here is Nemesis once again; only this time she has put her bridle to use. In both versions Baldung makes it plain that Aristotle has been brought to all fours by his sexual appetite. In the early drawing Phyllis wears the excessively fancy dress of a prostitute, and in the woodcut Aristotle's masochistic behavior reaches down to the level of a sexual cliché.

If the power of women could make the wisest of men foolish, it could also make the strongest weak. The drawing of *Hercules and Omphale*, dated 1533 (Fig. 14), bears an inscription to this effect: "What can love not conquer, when the fierce hand that subdues lions takes to spinning, work that makes a weakling of the hero." A feline-looking Omphale has persuaded Hercules to let her wear his lion skin, and she trades him her distaff for his club. She is a winsome nude compared to the Judith of 1525 or the Phyllis of 1513. For this figural type Baldung has turned to Cranach, whose Venus of 1532 in Frankfurt (Fig. 20) verifies the influence in face as

5  For a discussion of Nemesis and other possible sources for a drawing like this *Fortuna* or others called "Frau Venus," see Hans Christoph von Tavel, "Dürers *Nemesis* und Manuels *Frau Venus*," *ZAK*, XXXIII, 1976, pp. 285–95.

6  See the enlightening essay by Christiane Andersson, *Dirnen-Krieger-Narren: Ausgewählte Zeichnungen von Urs Graf*, Basel, 1978.

7  Koch, no. 1.

well as body. Baldung seems to have taken a special interest in Cranach's work at this time, and he obviously concluded in this case that a heftier Nemesis-like nude would not have made the right contrast with the muscular Hercules.

Undoubtedly the most remarkable form of expression that the fear and suspicion of women took during the sixteenth century was the witch craze. Both visual and written evidence establish the fact that women were believed to be the main practitioners of witchcraft. "As for the first question, why a greater number of witches is found in the fragile feminine sex than among men; it is indeed a fact that it were idle to contradict, since it is accredited by actual experience, apart from the testimony of creditable witnesses."[8] That categorical statement is the point of departure for the *Hammer of Witches* (*Malleus Maleficarum*), the notorious handbook of inquisitors, written by Heinrich Krämer and Jakob Sprenger, the Dominicans whom Pope Innocent VIII appointed as inquisitors for Northern Germany and along parts of the Rhine. The treatise was first published in 1486, and went through as many as fourteen editions by 1520. Baldung's many essays into this subject provide the most dramatic illustration of the common view about the possession of demonic power. His chiaroscuro woodcut of 1510 (Cat. No. 18), for instance, portrays an exclusively female society. It also suggests another point, on which Krämer and Sprenger were emphatic, namely why this propensity in women: "All witchcraft comes from carnal lust, which is in women insatiable."[9] The objectivity of these authors must be judged in the light of some of their own favorite quotations: "What else is a woman but a foe to friendship, an inescapable punishment, a necessary evil, a natural temptation, a desirable calamity, a domestic danger, a delectable detriment, an evil of nature, painted with fair colours!"[10] Given this rather nervous, if inspired, reaction to the allurement of women, one can imagine Baldung's own devilish pleasure in thrusting a new year's card of three naked witches in lascivious poses before the eyes of men professing such attitudes (Fig. 30). Although the drawing in Vienna appears to be a replica by another hand, it bears Baldung's monogram, the date 1514, and an inscription that rings true: "To the cleric, a good year" ("der Cor Capen ein Gut Jar").

Along with all their diabolical paraphernalia, the witches in Baldung's woodcut betray their possessed state through wild and uninhibited movement. Compared to the movements of his Eve and other of his female nudes, this is more a matter of degree than kind. Recalling again Dürer's drawing of the Eve who stretches and reaches for the fruit (Fig. 22), we can see that Baldung's high-stepping nude in the cleric's drawing is not so unfamiliar, but she has gotten carried away. Her movements and, consequently, the appearance of her entire body, express the presence of forces that lie beyond reason. Baldung's livelier draftsmanship emphasizes this feeling, as we can see in an original drawing of a *Witches' Sabbath*, also dated 1514 (Ill. 18c). There is a frenzy of flailing limbs in these scenes, and hair flies out like the flames from the vessels the witches hold and from those around their cauldrons. This hair was believed to be a source of magic power, and inquisitors took care to shave a witch's head before her trial.[11]

Only Baldung's wild horses in three woodcuts from 1534 (Cat. Nos. 83–85) can match the vehemence and turmoil in the compositions where these witches come together. The woodcut with the horses rearing and fighting in the foreground, their tails and manes flying, makes a

---

8  *The Malleus Maleficarum*, trans. Montague Summers, New York, 1971, pp. 41–42.

9  Ibid., p. 47.

10  Ibid., p. 43.

11  Hartlaub, p. 16.

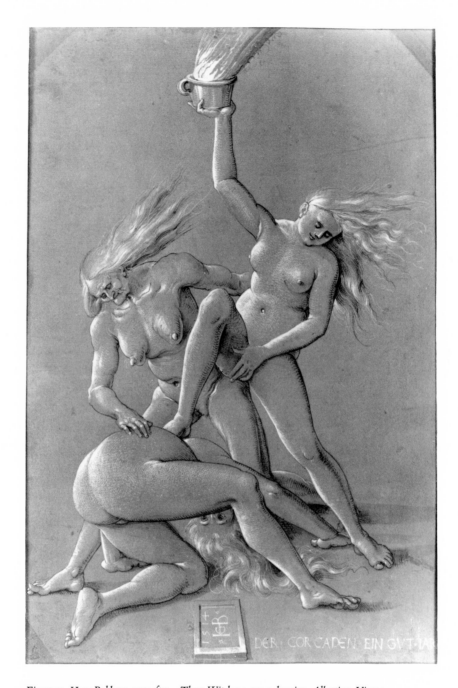

*Figure 30. Hans Baldung, copy after, «Three Witches,» 1514, drawing, Albertina, Vienna.*

striking comparison with the drawing for the cleric. The similarities extend to the fleshy forms themselves as well as to the unrestrained behavior. The horses also look possessed, but they are untamed and wild by nature. In the two companion woodcuts, the horses act according to their instincts in ways that would appear vulgar or obscene if this were human conduct. As a result of the parallels that Baldung has drawn between the horses and the witches, the animalistic nature of these nudes comes more into the open. They are far removed from civilizing influences and from the environments of civilization.

Although Baldung was only minimally interested in landscape as a theme in itself, he repeatedly evoked the presence of nature when representing the female nude. The settings are usually not extensive, but they show a significant pattern of associations. It starts with Eve, who together with Adam steps forth from a forest. This was to Baldung and other German artists— Altdorfer in particular— the primordial setting, but it was not limited to paradise. The forest was easily seen as a place where nature ruled; yet its powers of growth and regeneration, which reached to the many creatures that lived within it, remained mysteries, and its dark ways were forbidding to man. It was a place where certain women, like wild horses, escaped the constraints of civilization. Besides the witches who held their sabbaths there, Baldung's two female allegorical figures, *Music* and *Prudence* (Figs. 24, 25), stand nude in a dark, overgrown opening to a forest as if that is where they belonged.[12] In Baldung's one surviving painting of witches, a panel dated 1523 (Ill. 18e), the forest is replaced by a dark, stormy sky. The two nude women are said to be weather witches who have caused the storm.[13] In any case, they too are undaunted by nature, even in its most threatening form, because they are part of it. In defiance of moral codes prescribed by Christian society, they have stripped themselves of the clothing that signifies civilized life's separation from nature.

The close visual association of the female nude with wild nature reminds us how that ancient belief in an earth/mother goddess came to be buried under layers of civilization. Without intending to revive that belief itself, Baldung alludes to the mystery and power shared by the earth and women to bring forth generation after generation of new life. The figural type that naturally embodied the idea of procreation was for Baldung, as it had been for stone-age man, the woman of substantial thighs, hips and abdomen. This is the type of earthy nude that most conspicuously appears at the witches' sabbaths and which Dürer's Nemesis did so much to define. The awesomeness of that matronly figure did not impede the expression of her fecundity. Although in the eyes of men she appeared intimidating, she was clearly not so for children. In the painting *Weather Witches* (Ill. 18e) and in the *Witches' Sabbath* drawing of 1514, the presence of children reinforces both the maternal connotations of the nude women and the suggestion that the behavior of the women, like that of children, springs from instinct rather than from reason.

The gathering of witches in these works invariably involves a wide range of ages. Old hags revel alongside youthful and mature witches. When children are present, the sequence of ages represents a full life cycle. Here is another of those mysteries of life and nature that defies under-

12  Based on a comparison with the woodcut of the *Dream of Hercules* in the 1497 edition of Sebastian Brant's *Stultifera Navis*, Jean Wirth proposes that the figures called "Music" and "Prudence" are rather personifications of Vice and Virtue (*La jeune fille et la mort: Recherches sur les thèmes macabres dans l'art germa-

*nique de la Renaissance*, Geneva, 1979, pp. 158–62). The comparison reveals undeniable similarities, but it does not, as Wirth acknowledges, explain all aspects of Baldung's mysterious figures.

13  Hartlaub, p. 21.

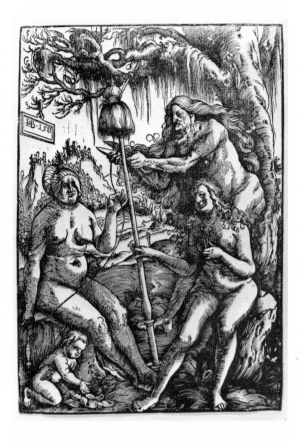

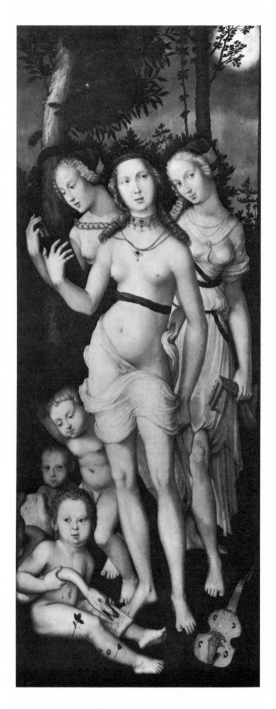

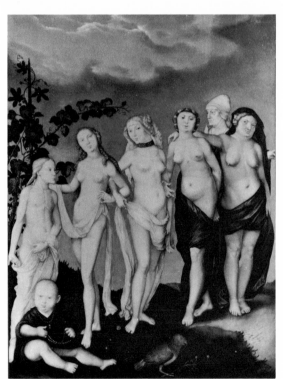

*Figure 33. Hans Baldung, «Three Graces,»*
*c. 1541–44, panel, Prado, Madrid.*

*Figure 31. (Above). Hans Baldung, «Three Fates,» 1513,*
*woodcut.*

*Figure 32. (Below). Hans Baldung, «Ages of Women,»*
*1544, panel, Museum der Bildenden Künste, Leipzig.*

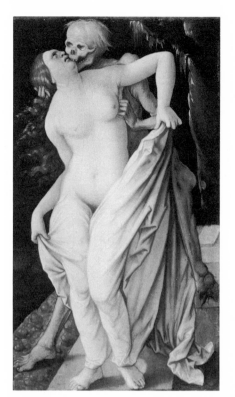

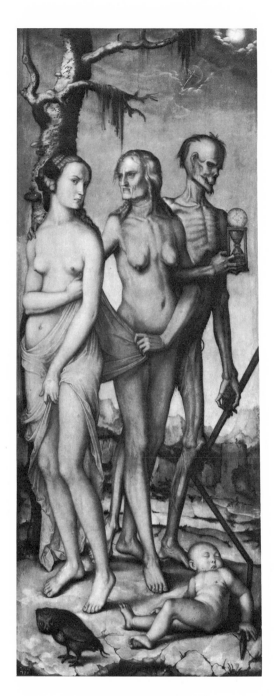

Figure 34. Hans Baldung, «Death and the Ages of Women,» c. 1541–44, panel, Prado, Madrid.

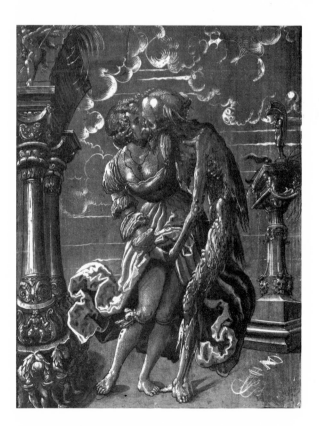

Figure 36. Niklaus Manuel Deutsch, «Death and a Woman,» 1517, panel, Kunstmuseum Basel.

standing. The inevitability of aging made it no less dreaded. It was a natural thread to be woven into the complex fabric of associations concerning witches, whose fleshy, nude bodies fully disclose the effects of time. Having joined in concert with nature, the witches not only represent different stages of life, they also seem to personify that very life process. The transformation of their appearance through wild, uncontrolled motion continues through life in the tempo of equally uncontrollable aging. What distinguishes these witches from other mortals, where aging is concerned, is the suspicion they engender that their familiarity with the erosion of life extends to their being instruments of it. Baldung's representation of the *Three Fates* in a woodcut dated 1513 (Fig. 31) shows three women who are indistinguishable from those we have encountered at the witches' sabbaths. With the additional presence of a small child, the four figures clearly stand for as many distinct stages in life. The oldest is about to snip the thread of someone else's life, while the youngest of the Fates smiles an ambiguous smile.

At least twice toward the end of his own life, Baldung turned explicitly to the theme of the stages of life. In both cases, as in his earlier references to the same idea, the passage through life is represented exclusively by women. A painting in Leipzig, dated 1544 (Fig. 32), portrays a chain of increasingly fleshy female figures from infancy to a grandmotherly age. The continuation of this sequence is probably represented by a painting in the museum at Rennes. It is a copy after Baldung, showing the final stages of life with a decrepit and blind old woman being escorted to the grave by death.[14] One of two companion panels in Madrid from the early 1540s illustrates the same inescapable conclusion to life in more rapid succession (Fig. 34). The joyless span of life begins and ends with only four figures: an infant, lying as if already dead on the parched ground, a young woman, and then an old woman, arm in arm with a cadaverous figure of Death. All the figures are nude except for the young woman, who is partly clad in a flimsy piece of drapery. The old woman looks at her sternly and pulls at the drapery as if to say that there is no protection against the approach of old age and death. This desolate scene contrasts with that of the companion panel (Fig. 33), in which three young women and three children enjoy themselves with music in a verdant setting, disregarding the serpent in a tree behind them.[15] Understandably, the figures that Baldung identified with the pleasures of life were young and healthy. Up to a point, it is also apparent why only women take part in the scenes representing the course of life. Some of life's stages are more distinctly marked biologically in women than men, and then the supple, curving forms of the female body that were particularly associated with her sexuality could least disguise the effects of aging. Beyond that, however, there seems to have been in Baldung's mind a persistent feeling that women had a special relationship with death.

When the figure of Death links arms with the old woman at the final stage of life, one can see in their two bodies a continuity of decline toward the inevitable. But when Death turns suddenly on a woman in the first fullness of her life, as he does in Baldung's painting of about 1510 in Vienna (Fig. 5), the proximity of their bodies makes a ghastly contrast. The young, nude figure in the painting is very reminiscent of Eve in the chiaroscuro woodcut of 1511. Both

---

14  See F. G. Pariset, "Baldung et la Marche à la Mort au Musée de Rennes," *La Revue des Arts*, VII, 1957, pp. 209–14.

15  For an interpretation wherein the *Ages of Women* in Madrid signifies the Christian belief in the triumph of eternal life through death, see Wirth, *La jeune fille et la mort*, pp. 158–62.

women have reached a moment of awareness, not of death, but of themselves. Still oblivious to what the old woman and even the child have seen, the young woman regards only her own face in the mirror she holds. This image of Vanitas warns that the approach of death, however untimely, may have its reason. That the woman could be a victim of her own sensual attraction is precisely the theme of another painting by Baldung of about 1518–19 in Basel (Fig. 35).[16] Seized from behind, as if by a lover, the half-nude woman responds by turning her head, then, in horror, she is kissed by Death. In 1517 Niklaus Manuel Deutsch had portrayed Death as a still more impatient lover (Fig. 36). Shreds of a mercenary soldier's costume still cling to his gruesome body. The double reference of this living corpse, first to death as such and then to the soldier who visits death upon his mistress, recalls Eve's confrontation with death in Baldung's painting in Ottawa, where Adam's expected place has also been taken by a corpse. The Eve, who proved to be a fatal temptation for Adam, is also clearly recognizable in these other young women who allure their own destruction.

Although new standards of beauty, inspired by classical art, led artists of the Renaissance to unveil the human body, it remained a sensitive subject. The ambivalence toward women that we perceive in Baldung's nudes was peculiar neither to this artist nor to his generation. Such conflicting attitudes had long existed, but they became an unavoidable issue at this time. Once the female figure appeared in the nude, it provoked responses that called for expression. Dürer's noble effort to establish a lasting canon of beauty for both the male and female figure in his 1504 engraving of the *Fall of Man* was destined to be distorted despite the enormous influence of this print. In other work, including his writings, Dürer acknowledged that the human body submits to no definitive formulation. Baldung seems to have taken no theoretical position on this question, but his female nudes reveal that their form could not exist independently of meaning, and the meaning was too complex for a single, ideal form.

16  For a discussion of this painting in relation to its companion piece in Basel, *Death and the Maiden*, dated 1517, including technical evidence that the two pictures are not exactly contemporaneous in execution, see Dieter Koepplin, "Baldungs Basler Bilder des Todes mit dem nackten Mädchen," and Paolo Cadorin, "Ergebnisse der wissenschaftlichen Untersuchung der beiden Holztafeln 'Der Tod und das Mädchen' und 'Der Tod und die Frau' von Hans Baldung Grien," *ZAK*, XXXV, 1978, pp. 234–43.

# BALDUNG AND THE REFORMATION
## BY LINDA C. HULTS

Baldung lived in one of the most turbulent periods in Christian history. During his early career, the religious forces were gathering that would eventually be expressed so powerfully by their spokesman, Martin Luther; in his later (post-1520) career, all Europe was reeling from the implications of Luther's ideas. The Christian world was filled with a confusing variety of answers to central questions— how does man achieve salvation and what does it mean to be a Christian in the present world? The purpose of this essay is to suggest some ways in which this spiritual crisis appears, never really to be resolved, in Baldung's art.

Our task is considerably simpler with other contemporary German artists. We know that Cranach, for example, was a close friend of Luther and produced polemical prints on Reformation issues.[1] For Dürer, we have prints and paintings reflecting Lutheran ideas directly or indirectly, and a wealth of written testimony.[2] This documentary evidence regarding Dürer's Lutheran sympathies provides us with valuable insight into the particular character of the times. In 1519 the young artist Jan van Scorel came to Nuremberg to receive instruction from Dürer, but found him so preoccupied with the writings "by which Luther had begun to stir the quiet world" that Dürer did not have time for teaching.[3] And in the Netherlands diary, amid the characteristically mundane notations and matter-of-fact descriptive and economic passages, we suddenly read Dürer's moving response to Luther's "disappearance"in April of 1521: ". . . And whether he yet lives I know not, or whether thay have put him to death; if so, he has suffered for the truth of Christ and because he has rebuked the unchristian Papacy. . . . And if we have lost this man, who has written more clearly than any that has lived for 140 years . . . we pray Thee, oh Heavenly Father, that Thou wouldst again give Thy Holy Spirit to one, that he may gather anew everywhere together Thy Holy Christian Church, that we may again live free and in the Christian manner. . . . Oh, Erasmus of Rotterdam . . . behold how the wicked tyranny of worldly power, the might of darkness, prevails. . . . Hear, Thou Knight of Christ! Ride on by the side of the Lord Jesus. Guard the truth. Attain the martyr's crown."[4]

Baldung left no such eloquent testimonial. We must rely on circumstantial evidence— his

1  On Cranach and the Reformation, see C. Glaser, *Lukas Cranach*, Leipzig, 1921, pp. 148-62. Cranach the Elder produced numerous portraits of Luther, while Cranach the Younger made popular woodcuts that supported the Lutheran cause in a direct, cartoon-like manner (see *The Differences between the Protestant and Catholic Service*, 1545, G. 654-55). For altarpieces by Cranach the Elder reflecting Lutheran ideas, see O. Thulin, *Cranach–Altäre der Reformation*, Berlin, 1955.

2  An extensive bibliography on Dürer and the Reformation is provided by M. Mende, *Dürer-Bibliographie*, Wiesbaden, 1971, pp. 410-13. See especially F. Saxl, "Dürer and the Reformation," *Saxl Lectures*, London, 1957, pp. 267-76, and W. Matthews, *Albrecht Dürer as a Reformation Figure*, Ph.D. dissertation, University of Iowa, 1968.

3  C. Van Mander, *Das Leben der niederländischen und deutschen Maler*, ed. H. Floerke, Munich, 1906, I, p. 286.

4  M. Conway, *The Writings of Albrecht Dürer*, New York, 1958, pp. 158-59.

long residence (1517–45) in Strassburg, a major center of Protestant Reform, the circle of friends and acquaintances suggested by his portraits— and on the interpretation of his art works.[5] Since Baldung's religious works are conceived with the same subjectivity and inventiveness of his secular works, our task of interpretation is considerably complicated. He focuses on the central issues of Christianity with his unique perspective: the nature of man as a willful sinner, the paradox of the resurrected Christ hidden within the crucified Christ, the intensity marking the commitment of the true Christian. These religious notions, particularly in Baldung's very late career, are strange companions to the demonic and sensual content of his imagery. Ultimately, what emerges from a careful look at his work is a picture of the artist as a complex man who viewed the world as an uneasy, tense union of conflicting forces.

We can understand much about the artist by understanding the environment in which he chose to spend most of his life. Baldung had been in Strassburg for a brief sojourn from 1510 to 1512, and he decided to move there permanently after a four-year stay in Freiburg (1512–16).[6] Strassburg attracted numerous new citizens in the early sixteenth century: Baldung's choice of residence follows a pattern. The city had become a thriving center for humanists of diverse backgrounds. They assembled around a nucleus formed by the satirist Sebastian Brant and the historian Jakob Wimpheling. Among their members were the future mayor and most eminent citizen, Jakob Sturm, the director of the school of the Cathedral, Jerome Gebweiler, the poet Thomas Vogler, the jurist Nicolas Gerbel, the Hellenist Luscinius, and many more.[7] This active and diverse intellectual milieu, fostered by a large printing industry, set the stage for the religious reform that was to come, and Strassburg became one of the most important centers of the Reformation in Germany. Wolfgang Capito, friend of Erasmus and Protestant theologian, arrived from Mainz in 1523, and Caspar Hedio of Ettlingen, his close colleague, arrived shortly thereafter to accept the post of preacher in the cathedral, formerly occupied by the fiery Geiler von Kaisersberg.[8] Strassburg's leading theologian, Martin Bucer, also arrived in 1523 to seek protection from the city from which his father had purchased citizenship; Bucer had married a nun and was preaching increasingly Lutheran sermons.[9] Matthäus Zell, the popular preacher, moved from Freiburg, a city which remained fairly provincial and religiously conservative.[10] This nucleus of Bucer, Hedio, Capito and Zell formed the background of the Reform in Strassburg. Along with other like-minded clerics, they organized biblical studies for the faithful to promote better comprehension of Scripture, uncorrupted by the interpretations of the Roman Church. Preaching took on a primary importance. Luther's most powerful tool, the German language, was used to reform the liturgy. By 1525, the Reformation had firmly taken hold in Strassburg, and by 1529, the Mass had been abolished.[11]

5  For a discussion of circumstantial evidence regarding Baldung's position in the Reformation, see F. Baumgarten, "Hans Baldungs Stellung zur Reformation," *Zeitschrift für die Geschichte des Oberrheins*, N. F. XIX, 1904, pp. 245–64.

6  Baldung's stay in Freiburg was probably determined by his finishing the commission for the high altar of Freiburg Cathedral. See F. Baumgarten, *Der Freiburger Hochaltar*, Strassburg, 1904, pp. 10–16.

7  On Brant, Wimpheling and the circle of Strassburg humanists, see M. U. Chrisman, *Strasbourg and the Reform: a Study in the Process of Change*, New Haven, 1967, pp. 45–67.

8  Chrisman, *Strasbourg and the Reform*, pp. 81–97.

9  Ibid., and W. Tillmanns, *The World and Men around Luther*, Minneapolis, 1959, pp. 206–11.

10  Chrisman, *Strasbourg and the Reform*, pp. 91–92.

11  For a concise summary of the progress of Reform in Strassburg, see the introduction to *Humanisme et Réforme à Strasbourg: Exposition Organisée par les Archives, la Bibliothèque et les Musées de la Ville*, ed. P. Dollinger, exhibition catalogue, Strasbourg, 1973, pp. 7–11.

The printing industry in Strassburg, a major attraction for a woodcut artist such as Baldung, played an important role in disseminating Lutheran doctrines.[12] Baldung designed book illustrations over a period of twenty-five years for the printer Johann Schott.[13] Schott, the authors Johannes Indagine and Ulrich Hutten, and the botanist and erstwhile Carthusian Otto Brunfels, seem to have been close friends, and Baldung probably had access to this circle. Schott not only published Hutten's *Gesprächbuchlein*, partly illustrated by Baldung, but he and Hutten helped Brunfels to leave the cloister in 1521.[14] In 1522, Schott published Indagine's physiognomical treatise illustrated with Baldung's powerful portrait of the author (Fig. 37).[15]

In contrast to Schott, Johann Grüninger, another major publisher in Strassburg, remained Catholic. Although Baldung had dealt frequently with Grüninger prior to 1523, the artist apparently severed the connection after this date. Because of his convictions, Grüninger was isolated from the mutual assistance and interchange of ideas that characterized the Strassburg printing industry. The artist's broken relationship with the publisher probably reflects this general situation.[16]

Baldung's election to the Strassburg *Magistrat* in 1545, as well as various economic documents, attest to his wealth and prominence in this predominantly Protestant city.[17] And while the subjects of his portraits after 1520 include both Protestants and Catholics, an overview suggests that he was part of a circle of distinguished humanists, most of whom fostered the Reform.[18] Baldung produced likenesses of Indagine and his friend Otto Brunfels; of Caspar Hedio, a Strassburg theologian second in importance only to Martin Bucer; and of the two political figures, Nicolas Kniebs and Jakob Sturm, whose portrait is lost but reflected in a woodcut by Tobias Stimmer.[19] Kniebs, whose weary visage is preserved in one of Baldung's most exquisite silverpoint drawings (Fig. 38), was instrumental in the abolition of the Mass in 1529 and served as the *Ammeister* (a rotating city manager) four times.[20] Sturm served as *Stettmeister* (a rotating mayor elected from the nobility) thirteen times and is known for his presentation of the *Confessio*

12  M. C. Oldenbourg, *Die Buchholzschnitte des Hans Baldung Grien* (Studien zur deutschen Kunstgeschichte, 335), Baden-Baden, 1962, p. 153.

13  Ibid.

14  Karlsruhe 1959, pp. 370, 381 and 390 and *Humanisme et Réforme*, p. 42. Ulrich von Hutten, as one of the most influential critics of Catholicism among German humanists, was particularly important in inciting German nationalism and using it against the Papacy. See H. Grimm, *The Reformation Era: 1500–1650*, New York, 1954, pp. 75–77.

15  On Indagine's portrait and how it exhibits the formal and expressive principles of *Hedio* and *Brunfels* at an earlier stage, see Hults-Boudreau, pp. 163–64.

16  Oldenbourg, *Die Buchholzschnitte*, p. 152.

17  For early documents on Baldung, see Escherich, pp. 20–27.

18  Curjel, p. 112, designates the portraits of Luther, Hedio, Indagine and Brunfels as "Reformatorenschnitte." Another woodcut that belongs in this group on stylistic and expressive grounds is the portrait of the composer Johannes Rudalphinger from

1534. We are not certain of Rudalphinger's religious affiliation, although many of his friends seem to have been Protestants— see T. Gérold, "Hans Rudolfinger et ses amis artistes," in *L'Humanisme en Alsace*, Paris, 1939, p. 207. The dynamic, plastic qualities of the above portraits may be contrasted with the flatness of two portraits of directors of the Order of St. John from 1528 and 1534; see C. Koch, "Über drei Bildnisse Baldungs als künstlerische Dokumente vor Beginn seines Spätstils," *ZKw*, V, 1951, pp. 61–65. The Johanniters were a highly conservative religious force in Strassburg, and this conservatism may be reflected stylistically in Baldung's portraits (see Hults-Boudreau, pp. 159–60).

19  On Stimmer's woodcut copy of Baldung's painted original, see C. Koch, "Über ein verschollenes Gemälde Hans Baldungs," *MüJb*, N.F. XIII, 1938–39, pp. 107–13.

20  *Humanisme et Réforme*, pp. 51–52.

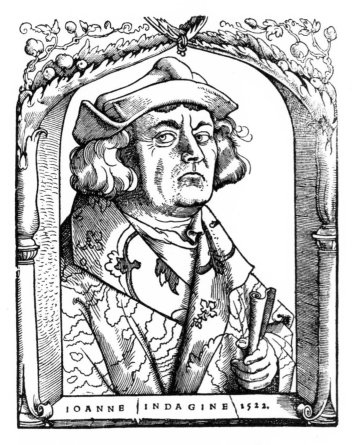

*Figure 37. Hans Baldung, «Johannes Indagine,» 1522, woodcut.*

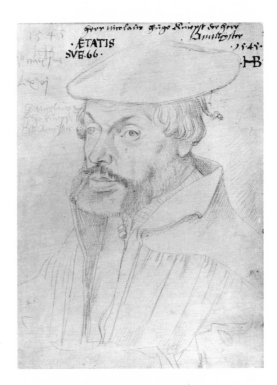

*Figure 38. Hans Baldung, «Nicolas Kniebs,» 1545, silverpoint drawing, Staatliche Kunsthalle Karlsruhe.*

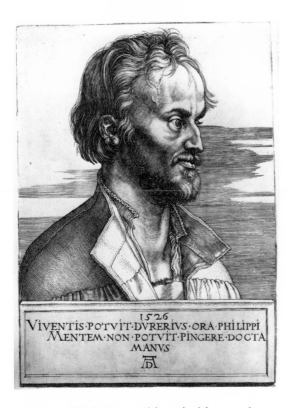

*Figure 40. Albrecht Dürer. «Philip Melanchthon,» 1526, engraving.*

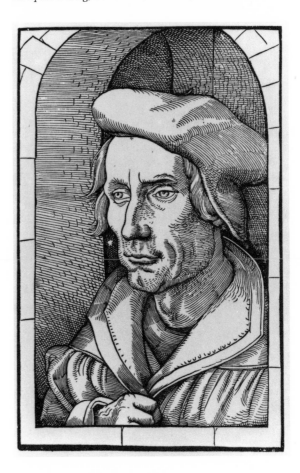

*Figure 39. Hans Baldung, «Otto Brunfels,» c. 1534, woodcut.*

*Tetrapolitana* at the Diet of Augsburg; this document sought to maintain a midway position between Luther and Zwingli on the nature of the Eucharist.[21]

Baldung was thus surrounded by dynamic men who were in the forefront of religious change. The sense of urgent, sweeping reform and the intensity of the common cause that united these men can be sensed in Baldung's portrait of Caspar Hedio. The woodcut (Cat. No. 82) is preceded by a superb preparatory drawing in silverpoint (Ill. 82a). A surprisingly stark expression is achieved in the drawing with light, feathery strokes and a limited range of lights and darks. The resulting print increases this austerity by its emphatic linearity and by the relationship that Baldung establishes between the sitter and the framing elements.

Although Hedio, like other Strassburg Reformers, was known for his mediatory position, nothing in Baldung's print suggests conciliation or open-mindedness. A steadfast militancy, bereft of reason or flexibility, seems to be the only possible interpretation of this print. Part of the excessive dynamism may be related to the date of this woodcut, for in 1543, Hedio, Bucer and Philip Melanchthon were involved in an ultimately unsuccessful attempt to bring the Reformation to Cologne.[22] Hedio's sharp features are surrounded by a thin, leafy border and a narrow parapet on which his hand and a book rest. These elements are weak and recessive, unable to contain the startling energy of the sitter, conveyed through the broad handling of masses and the angular contours.

Surprisingly, Baldung's woodcut of Otto Brunfels, probably best dated in 1534, exceeds that of Hedio in sheer intensity (Fig. 39).[23] The formidable personality and large size of the sitter are again played against a weak, recessive frame, this time an arched masonry window. Brunfels looms behind this constraining opening. His coarse features remain entirely unsoftened, their harshness emphasized by the stark, linear handling. The folds of the cheek, the wrinkles around the eyes and mouth, and the prominent, undulating contour of the mouth and the side of the face are all relentlessly recorded, if not exaggerated. But it is the inner life of the sitter, even more frankly set forth, that is more arresting. Rather than direct the intensity outward as in the Hedio portrait, Baldung concentrates it within his subject. Brunfels, like Hedio, is seen at very close range and forced beyond the surface of the print by a powerful linear technique and simple masses which project spatially. But Brunfels' slightly disjunctive eyes gaze off to the side, unfocused, and his brow is furrowed in thought. The disheveled hair and clothing and the hand gripping the collar add to the impression of distracted thought.

---

21  *Humanisme et Réforme*, p. 51, and Tillmanns, *The World and Men around Luther*, p. 203. On the Diet of Augsburg, see Grimm, *The Reformation Era*, pp. 203–06. The *Confessio Tetrapolitana* was presented by Sturm on behalf of four south German cities—Strassburg, Constance, Lindau and Memmingen. It provoked even more opposition from Catholics than the *Confessio Augustana*, which represented a more purely Lutheran position, albeit softened considerably by Melanchthon in an effort to appease Catholics and to separate the Lutheran point of view more clearly from Zwinglianism and Anabaptism. The *Tetrapolitana* attacked ceremonies more vigorously and placed a stronger emphasis on the authority of Scripture.

22  Tillmanns, *The World and Men around Luther*, pp. 216–17.

23  Curjel, p. 102, believes that the woodcut dates from 1522 and is related to the portrait of Indagine in style. However, the print was used to illustrate Brunfels' works from 1535 on, and an inscription under the print (but not cut into the block) states that the sitter is forty-six. This places the woodcut in 1534, the year that Brunfels died and two years after he left Strassburg; see Karlsruhe 1959, p. 390. The stylistic similarity to the later portraits of Hedio and Rudalphinger makes this date altogether probable, although we must assume that the portrait was made from a sketch done by Baldung at an earlier date.

Baldung's interpretation of the humanist reformer is entirely different from that revealed in Dürer's portrait of Melanchthon (1526; Fig. 40). Like Dürer, Baldung isolates the head and frees the portrait from allegorical trappings— expressing the necessary solitude of the individual before God that was an important tenet of the Reformation.[24] But the solitude that produces an assured, reasonable and dynamic man in Dürer's portrait yields, in Baldung's works, a bizarre intensity (Hedio) and an extraordinary introversion (Brunfels).

Melanchthon conforms to the vertical and horizontal axes implicit in the format. He holds his head erect and his shoulders form a stable triangular base. A plaque at the bottom of the portrait produces additional stability and serves as a spatial indicator, against which the neutral background gains depth and openness. The space sets off the dense textures and meticulously defined volumes of the head, yet gives free rein to the sitter's personality. He gazes out at some point beyond the limits of the engraving, emphasizing a concern for action in the outside world. Yet the furrowed brow also suggests inward contemplation— the sitter does not look out at us, but remains self-assured and self-contained. His slightly wizened, strained appearance acquires an almost Christ-like moral quality that marks him as a martyr for the cause of an enlightened Christianity.[25] The disheveled hair, open collar, the lines and veins of the face imply a concentrated involvement in the world. The dark area in the sky heightens the force of the glance, while the large forehead and windblown hair are silhouetted dramatically against the open sky.

In Baldung's portraits, the backgrounds are not open, but form constraining environments for the sitters. The quasi-architectural background for Brunfels gives the sense of a dark and cramped space, pressing down upon the sitter who is irretrievably lost in his own thoughts. The curved lines behind Hedio do not suggest space, nor even a shadow cast by the sitter. Instead, they seem to define the edges of a volume that presses in upon the contours of the face and shoulders.

Baldung's positioning of the sitters within the space also contributes to the general *malaise* of these portraits. There is an unbalanced relationship of figure to frame. The bordering elements are unable to contain or effectively complement the likeness, and the projecting energy of the sitters is uncontrolled. The hands effect an added tension. In the Hedio portrait, the right arm is given no space in which to exist, but the right hand creeps oddly along the ledge. Brunfels' hand grasps his collar tightly, pulling the drapery down with a powerful gesture that serves as a second focal point to the composition and duplicates the concentration in his face.

The distilled force of intellect evident in Brunfels and the fanatic zeal of Hedio give some sense of the sincerity and intensity of purpose behind the Reform movement. These men felt themselves to be in the vanguard of a spiritual revolution, working toward a true interpretation of Scripture and the purity of faith that could be found in the origins of Christianity. Christ's Apostles, his original followers, embodied the Reformers' desire to go back to the beginnings. The Apostles provided models, since their purpose after all was also to change, to renew, and above all to preach the word of God (*apostolos* — "one sent forth").

Baldung lends his standing Apostles of c. 1516–19 an extraordinary vigor through his handling of drapery and body position, the rays of light streaming from the heads and the exag-

24  D. Kuspit, "Dürer and the Lutheran Image," *Art in America*, LXIII, 1975, pp. 58–59, and A. Hauser, *Mannerism*, New York, 1965, p. 72.

25  See also the portrait of Melanchthon by Lucas Cranach the Younger in C. Harbison, *Symbols in Transformation*, exhibition catalogue, The Art Museum, Princeton University, 1969, pp. 22 and 46.

geration of the relationship between figures and attributes (Cat. Nos. 60–72). Peter strides toward the left, a movement echoed by the drapery itself, which falls in thick, diagonal folds toward the lower right. The key, gripped almost violently, establishes a counter-movement toward the right. The area in back of the figure is not left neutral, but filled with the diagonal lines that radiate from the fierce head, so that different, interlocked directions cover the whole print. Bartholomew is concentrated along a central vertical axis— his brow furrows, his hands and bulky drapery folds group around this line. Again the hands are highly emotive. Here, they are held close to the body in opposite directions and the flaying knife is grasped between the splayed fingers of the left hand. The rays of light suggest a clockwise rotation that is echoed by the position of the hands. Paul is bent in a zig-zag posture, the head cocked to complete this movement. The book seems in danger of being crushed by the grip of the Apostle and the sword is held limply in front of the body. A state of inspiration which distorts the body is conveyed by the pose and especially by the closed eyes and awkwardly inclined head.

The importance of God's word as it is originally expressed in Scripture and the importance of Luther as the true interpreter of Scripture are vividly expressed in Baldung's woodcut *Luther with Nimbus and Dove* (Fig. 41), partly based on an engraved portrait of the Reformer by Lucas Cranach the Elder.[26] Baldung's print establishes a direct connection between Luther, the Holy Spirit and Scripture, asserting that Luther, the lone man who confronts the word of God with a radical immediacy, interprets God's word truly, under the auspices of the Holy Spirit.[27] Baldung gives this assertion great strength through his formal treatment. The play of interrelated, radiating lines in the upper part isolates and emphasizes the bulky, massive head. The crisp folds of drapery, organized into three bands sweeping about the figure, echo the irregular contours of the face and the sharp edge of the book jutting into the lower right corner. The main forms resolve themselves into an off-center, elongated triangle which is held in place by powerful radiating lines at the top, and within which is an active linear play. The stylized roughness of the features, also found in Cranach's portraits of Luther, reinforces the appeal to the common man.[28]

The dynamism of the portraits of men committed to the new order may be contrasted to the defensive and tragic aspects of two portraits of men apparently adhering to the old— the silverpoint drawing of an old Catholic man from 1531 (Fig. 42) and the 1526 portrait of a young Nuremberg nobleman (Fig. 43) who had lost everything in the Peasant Revolt of 1525.[29] The inscription reads: "This was my face and form during the time that took from me all that could be taken— when the peasantry, poorly instructed in belief, took arms against all spirituality and

26  Baldung seems to have used Cranach's 1520 engraving, *Luther as a Monk*, only for the likeness of the Reformer (Jahn, p. 207); expressively, the two portraits are very different. The restraint and simplicity of Cranach's approach contrast sharply with Baldung's extravagant use of line and his intense expressiveness.

27  Harbison, *Symbols in Transformation*, p. 45, remarks that the intention of the print seems to be to present Luther as a Catholic saint. To make Luther a saint among many others, however, would be to totally misrepresent his Christ-centered theology. It seems more likely that Baldung meant the formal treatment as a trenchant expression of Luther's ability to give fresh meaning to Scripture.

28  See Cranach's *Martin Luther as Junker Jörg*, Castle Museum, Weimar, 1521, and Luther's wedding portrait, Kunstmuseum Basel, 1525.

29  On the Peasant Revolt of 1525, see Grimm, *The Reformation Era*, pp. 168–76 and Chrisman, *Strasbourg and the Reform*, pp. 150–51.

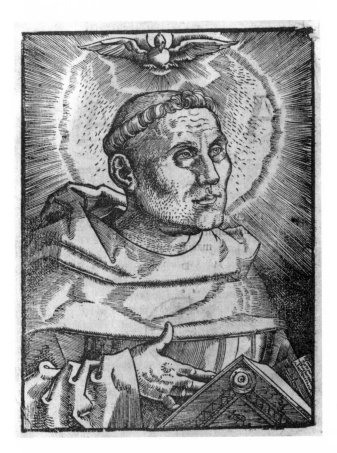

Figure 41. Hans Baldung,
«Luther with Nimbus and Dove,»
1521, woodcut.

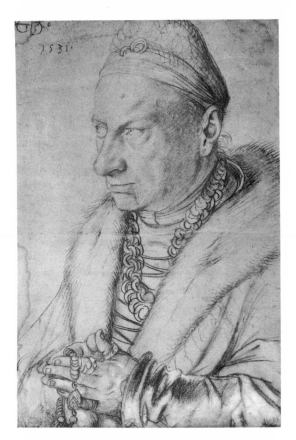

Figure 42. Hans Baldung, «Portrait of an Old Catholic
Man,» 1531, drawing, Staatliche Museen, Berlin.

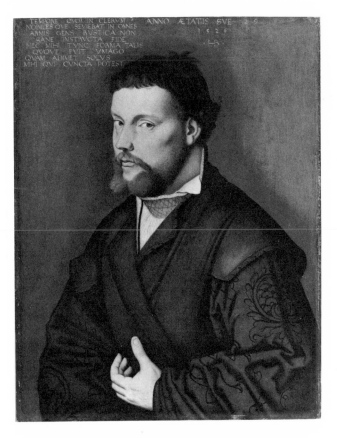

Figure 43. Hans Baldung, «Portrait of a Young Nobleman,» 1526,
panel, Germanisches Nationalmuseum, Nuremberg.

raged madly against all nobility."[30] The sentiments expressed in the inscription are conveyed more trenchantly in the face, keenly wary and haggard, and in the beseeching gesture.

In the drawing of an old Catholic man, the masses of the head are delineated with light parallel strokes, and the distinctive facial features (the bulbous nose, the mole, the thin upper lip and protruding lower one) are reduced to abstract linear components. The nails and joints of the hands become part of an overall pattern of circular shapes established by the rings, links of chain, and the beads of the rosary. The old man seems hardly occupied by the prayer itself, but glances furtively to the side, adamant in his maintenance of the old order, but somehow losing his spirituality in the militancy of his convictions.

Judging from certain works and writings produced between 1515 and 1521, Dürer became deeply involved in and disturbed by the religious changes that were occurring around him.[31] We do not know if Baldung experienced something similar, but two woodcuts from around 1515 suggest an anxiety that parallels his teacher's in intensity, if not in depth and duration. The religious crisis centered around the hiddenness of God's saving power in the ignominious death of Christ and in the anxiety and difficulty of faith, the only attitude bridging the gap between God and a sinful mankind. Through Luther, this crisis was articulated verbally. In him were concentrated the collective anxiety about the profundity of man's sin, the exaggerated awareness of the arbitrary and miraculous nature of salvation, and the conviction that the Roman Church had failed to assuage the former or give adequate expression to the latter.

Dürer's stormy, darkly foreboding etching from 1515, *Christ on the Mount of Olives* (Fig. 44), describes the artist's state of mind as much as Christ's. While nature itself, in the turgid sky and gnarled, windblown branches of the tree, seems to react to Christ's question, he holds his hands apart, not in a gesture of prayer, but of apprehension and doubt. No resolution of this anxiety is suggested, either by an affirmation of Christ's divinity, or by the intervention and support of God the Father. The strange etching, the *Sudarium Held by One Angel*, is even more disturbing (Fig. 45). As Panofsky notes, Dürer has departed from the traditional frontality of the sudarium: ". . . here it is held aloft by a great angel and billows like the sail of a ship on a stormy night. Sharply foreshortened and in deep shadow, the imprint of the Holy Face is barely recognizable, while glaring lights are gathered on the draperies of the angels, on the clouds and on the three smaller angels carrying the implements of torture. Space seems to have dissolved into a darkness pervaded by a long wail of lament, and nothing seems to be left but the accusing symbols of the Passion floating 'upon the face of the deep.' "[32]

30 The Latin inscription reads as follows:
TEMPORE QUO CLERUM / NOBILESQUE SEVIEBAT
IN OMNES FUMIS GENS RUSTICA NON / SANE
INSTRUCTA FIDE HEC MIHI TUNC FORMA
TALIS / QUOQUE FUIT IMAGO QUAM ADIMAT
SOLUS / MIHI QUI CUNCTA POTEST

31 Matthews, *Albrecht Dürer*, pp. 36–61, gives an extensive treatment of the written evidence regarding Dürer's Lutheran sympathies. From a letter written by Christoph Scheurl in 1518, we know that Dürer belonged to a group whose beliefs centered around the sermons of Staupitz, Luther's mentor. Through Scheurl, Dürer would have been among the earliest in Nuremberg to know of Luther's ideas. From 1520 comes Dürer's letter to Spalatin asking for Luther's writings and a complex credal statement written on the back of a drawing. The entry regarding Luther's "disappearance" in the Netherlands diary of 1521 is perhaps the most powerful evidence of Dürer's agitated religious state during this period. For Dürer's spiritual crisis as revealed in works of art, see Panofsky, pp. 196–241.

32 Ibid., pp. 196–97.

Two woodcuts by Baldung from this period concentrate with great immediacy on the humanity and mortality of Christ, so that the divine purpose behind the human anguish seems difficult to conceive— as inaccessible as the fading face of Christ on Dürer's version of Veronica's veil. The *Lamentation* from c. 1514-15 (Cat. No. 49) depends partly on Dürer's *Lamentation* from the Engraved Passion (Fig. 46). One might also speculate that Baldung was familiar with a highly expressive chalk drawing from 1505 by Dürer, in which the radically foreshortened and seemingly disjointed body of Christ makes the viewer doubly conscious of the horror of his death.[33] The foreshortening of the drawing is carried over into Baldung's woodcut. He uses the diagonally positioned body to move us back into depth, but the position also has the effect of reducing Christ to a faceless corpse.

In Dürer's engraved *Lamentation*, it is especially the figure of Mary Magdalen who defines space and offers the stabilizing axis that Baldung denies. Even the heavy post in Baldung's woodcut provides no stability since it disappears ineffectually behind the turbulent figures and drapery. Baldung externalizes emotion through gesture— Mary bends over Christ so that her body is almost horizontal, its lower part lost in drapery. While Dürer attempted to monumentalize the intensely emotional gesture of Mary Magdalen, Baldung flings the hands apart, loses the body in drapery and throws the head back.

Dürer's *Lamentation* is, of course, physically a part of the larger narrative of the Engraved Passion, but the emotional tonality of the individual print carries with it a consciousness of the whole narrative, of the meaning behind Christ's death. The characters as well as the composition are restrained and monumental. Christ is dead, but held upright, and the whole print is unified by the velvety tonalities and the coherent arrangement of forms in space. Baldung's woodcut is, on the other hand, a model of disjunction and turbulence. Not only is it, as a single-sheet print, lifted out of the context of the whole Passion narrative, but it is lifted conceptually and emotionally from the larger meaning. The theme is approached empirically, with Christ presented as a corpse, the composition de-monumentalized, the figures reacting with extraordinary abandon.

In order to appreciate the radical expressiveness of Baldung's *Christ Carried to Heaven by Angels* (Cat. No. 50; c. 1516), one should compare it to Dürer's *Trinity* woodcut of 1511, a print whose restrained pathos serves as a foil for Baldung's violent expressiveness (Fig. 47). The plush chiaroscuro of the *Trinity*, almost incredibly subtle for a woodcut, gives visual form to the tender emotional relationship between Father and Son. For Baldung, however, the point is not to emphasize the unity between them, but to isolate the dead Christ, intensifying his pathetic qualities. Although Dürer's Christ is dead, he is supported by divinity and the unity of the Trinity is never jeopardized. But Baldung removes God the Father to the far distance; no tender relationship with his Son is possible. The elements of the Trinity are no longer unified by a shared vertical axis. The heaviness of Christ's body is stressed by the struggling of the angels as they lift it. As the foreshortened position reinforces the deadness of Christ in the *Lamentation*, so does this awkward, jack-knifed pose. The musculature is rigid and the wounds distended. A gruesome crown of thorns represents the instruments of the Passion. Even though the print is earlier than Luther's developed thought, it is comparably Christocentric— its overwhelming point is the sacrifice of Christ. Elements which might mitigate this sacrifice— such as the supporting love of

---

33 On this drawing, see National Gallery of Art, *Dürer in America: His Graphic Work*, exhibition catalogue, ed. C. W. Talbot, Washington, D.C., 1971, pp. 53–55.

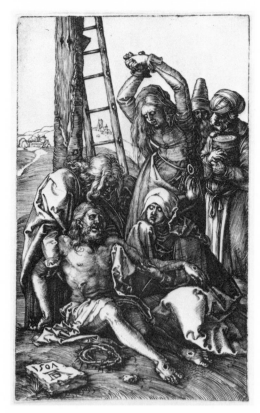

Figure 46.
Albrecht Dürer,
«Lamentation,» 1507,
engraving.

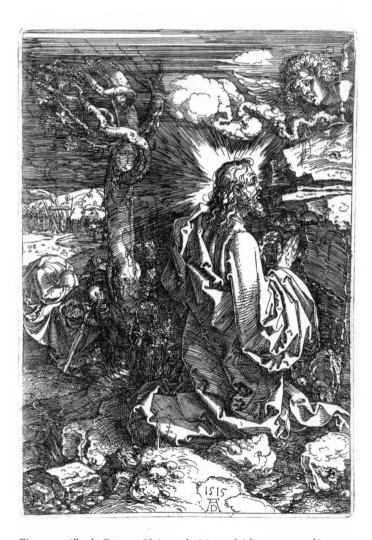

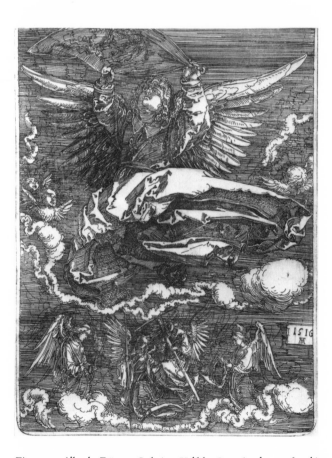

Figure 44. Albrecht Dürer, «Christ on the Mount of Olives,» 1515, etching.

Figure 45. Albrecht Dürer, «Sudarium Held by One Angel,» 1516, etching.

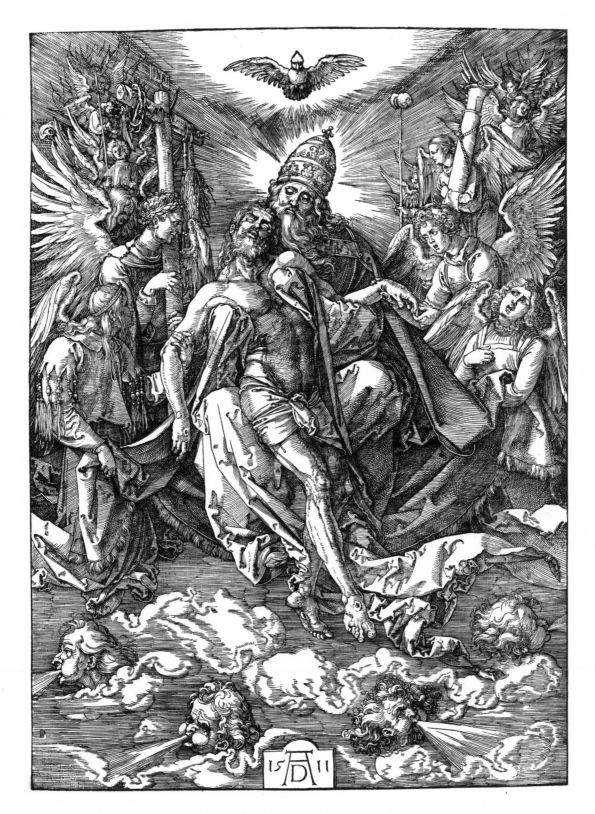

*Figure 47. Albrecht Dürer, «Trinity,» 1511, woodcut.*

God the Father, or the unity of the Trinity, which speaks of Christ's place in an eternal, objective order, the classical beauty of Christ's body, a subtle, harmonious chiaroscuro— are all flatly denied. For Luther, also, God is knowable only through the sacrifice of Christ; to attempt to know him through reason or as an abstract principle apart from his relationship with man established through Christ, is worse than to deny him entirely.[34]

The extreme concentration on the human actuality of Christ's suffering and death not only provides the viewer with a powerful means of identifying with Christ, but it also forces the issue of Christ's Resurrection and redemptive sacrifice back on him. It is not the artist who suggests that there is an underlying order and meaning to this event— the viewer must himself resolve the questions put forth by the image. It is only faith, interpreted not as intellectual assent, but as a receptive, passive acceptance of what seems arbitrary and absurd, that can assimilate this image in a devotional sense. The print has the capacity to induce a spiritual crisis in the viewer resolvable only through faith, and in this sense it finds an analogy in the then developing thought of Luther.[35]

Although graphic works such as *Christ Carried to Heaven* might have provided private devotional experiences reflecting Lutheran ideas, the demand for devotional imagery used in an ecclesiastical context slackened as a result of the Reformation. While Catholicism for the most part had accepted the use of religious images, the tendency of Protestantism was to suspect them as distractions from the one-to-one relationship between the worshipper and God or between the worshipper and the hearing of God's word.[36] Even Strassburg experienced sporadic outbreaks of iconoclasm in the 1520s, during which the presence of religious works in churches was challenged.[37]

Although this immediate physical threat was quelled in Strassburg, one can see the effect of the slackened demand for ecclesiastical images in Baldung's late period. His energy was channeled more frequently into secular subjects. Portraiture, as we have already seen, became a major expressive vehicle in Baldung's post-1520 *oeuvre*. The energy, intensity and vulnerability ex-

34  G. Ebeling, "God Hidden and Revealed," *Luther: An Introduction to his Thought*, trans. R. A. Wilson, Philadelphia, 1970, pp. 226–41.

35  Faith for Luther is the only attitude by which man can assimilate God's purpose, which is always hidden under a contradiction (see ibid., pp. 236–37), much as the saving purpose of God and the Resurrection of Christ is a "concealed" concept in Baldung's print. In his first lectures on the Psalms, 1513–15, Luther asks: "For who could realize that someone who was visibly humbled, tempted, rejected and slain, is at the same time and to the utmost degree inwardly exalted, comforted, accepted and brought to life, unless this was taught by the Spirit through faith?" (ibid., p. 236).

The fact that Baldung's print does not present us with a solution, an objective order and purpose, but is primarily an experience, also corresponds to the existential thrust of Luther's thought. The relationship of grace and faith established between man and God through Christ is not a one-time occurrence that is subsequently taken as an assumption, but an

ongoing process. See Luther's lectures on the Romans, 1515–16 (quoted in ibid., pp. 161–62): "... man is constantly in non-being, in becoming, in being, in deficiency, in potentiality, in reality ... always in sin, in justification, in righteousness, that is, always a sinner, always repentant, always righteous."

Harbison's interpretation (*Symbols in Transformation*, p. 29) of Baldung's print as emotionally excessive and "serving no permanent religious purpose" might be amended by this correspondence to Luther's thought. In *Christ Carried to Heaven by Angels*, the emphasis has been shifted from an objective order within the image to a subjective relationship between the viewer and the image.

36  See Luther's "The Use of Images," from "Eight Wittenberg Sermons," in *Readings in Luther for Laymen*, ed. Charles S. Anderson, Minneapolis, 1967, pp. 51–53.

37  Chrisman, *Strasbourg and the Reform*, pp. 144–45, and G. Williams, *The Radical Reformation*, Philadelphia, 1962, p. 245.

pressed in the faces of his sitters give us great insight into the times. With its stress on the individual and his direct confrontation with God, without the intervention of the vast structure of the Roman Church, Protestantism gave tremendous impetus to the portrait.[38] Ancient history and mythology also acquired an increased importance in Baldung's late career: in 1530–31, he painted five panels, probably part of the same commission, that dealt mainly with Roman history.[39] Baldung's interest in demonic subjects, which reached its height during the Freiburg period (see Cat. No. 18), continued, and he produced some remarkable allegorical works in this vein— the *Weather Witches* in Frankfurt (Ill. 18e), the *Bewitched Groom* and the *Wild Horses* woodcuts (Cat. Nos. 83–85). In these works, demonic creatures, both human and animal, acquire an ominous vitality.

The secular iconographic concept of Vanitas was enormously important for Baldung, both in his earlier and later career. The regret for the tragic loss of beauty, sensuality and the pleasures of worldly existence to time and death is most cogently expressed in his images of Death, in the form of a decaying corpse, attacking a maiden. In two paintings in Basel, of 1517 and c. 1519 (Fig. 35), and in a chiaroscuro drawing of 1515 (Fig. 6), the two antithetical principles are embodied in the most vivid physical forms possible— the ripe, luxurious flesh of the maiden and the rotting corruption of the corpse. Their confrontation is direct, violent and erotic. In Baldung's very late diptychs, the *Three Graces* and *Ages of Women* in Madrid (Figs. 33, 34) and the *Ages of Women* in Leipzig (Fig. 32) and Rennes, this confrontation is combined with the Ages of Mankind, another theme expressing the succumbing of sensual beauty to time.[40] In 1510, Baldung had used this combination of iconographic concepts in *Death and the Three Ages of Women* in Vienna. However, the late paintings of the Stages of Life make the same point with a doggedness that suggests a gloomy, deterministic view of human existence. Humanity marches irrevocably to the grave in these works, with only small signs of Christian redemption and resurrection for consolation.

It is very difficult to gauge Baldung's religious mentality from his works after 1520. Traditional religious themes often merge uncomfortably with secular concepts. The Madonna and Child, one of the most important themes in Baldung's late paintings, becomes an aesthetic exercise in which physical beauty, refined formal structures and sometimes even erotic elements combine uneasily with the devotional content. The Fall of Man continues to provide Baldung with an opportunity to explore sensuality as a deep-rooted, indeed primordial, aspect of human nature that is qualified by its association with sin and its finiteness. While we are able to find correspondences between Dürer's religious etchings from 1515–16 and Baldung's woodcuts of 1515, there is nothing in Baldung's late works which approaches the epic religious statements of Dürer's late years, such as the *Four Apostles* or the *Oblong Passion*.[41] In fact, Baldung's very late

38  Kuspit, "Dürer and the Lutheran Image," pp. 57–58.
39  Bussmann, pp. 67–87.
40  For the panel in Rennes and its correspondence to that in Leipzig, see F. Pariset, "Baldung et la Marche à la Mort au Musée de Rennes, *La Revue des Arts,* VII, 1957, pp. 209–14.

41  On the effect of Dürer's Lutheran conversion on his style, see Panofsky, p. 199: "The lyrical and visionary element was suppressed in favor of a scriptural virility which ultimately tolerated only the Apostles, the Evangelists and the Passion of Christ. His style changed from scintillating splendor and freedom to a forbidding, yet strangely impassioned austerity; and engraving and painting—the media antipathetic to the 'decorative' style and all the better adapted to a non-linear, emphatically three dimensional mode of expression—returned to favor."

works suggest that Christian content was overwhelmed by his awareness of death, sensuality and demonic forces working in man's imagination.

The *Madonna with the Parrots* in Nuremberg (Fig. 48; c. 1528–30) can serve to represent Baldung's late images of the Madonna and Child. These works, beginning from about 1520, show a steady movement toward an increasing formal refinement and a courtly, elegant beauty.[42] Here the parrot, an old symbol of virginity, indicates that the work should ostensibly express the purity of Mary.[43] But the combined effect of certain details presents us not with a vision of innocence, but with a quasi-erotic situation. Mary, posed alluringly and glancing out at us from almond-shaped eyes, holds her hand to call attention to her bared breast. A parrot nibbles at her jeweled neck, while an angel draws a transparent veil across her carefully dressed hair. The child's puckered mouth rests against her nipple. We are struck simultaneously and equally with the remote ideality of the image, the sense of a refined, elegant and distant world, and by the pointedness of the sensual details. We are both kept at a distance and pulled toward the image; it is a vision of a remote world made close and intimate for us, spatially through Mary's location in the foreground plane and psychologically through the acute involvement of our senses.

It seems unlikely that we should interpret the image as a totally secularized version of the Madonna and Child, even though the worship of Mary in Catholic practice drew sharp criticism from Reformers.[44] It is more likely a compromise between the old devotion to Mary and the new awareness of the autonomy of art and an accompanying aesthetic consciousness. The basic operative principle of this image is the notion of an ideal vision to which the viewer is a privileged witness. In her article on Giovanni Bellini's half-length Madonnas, Rona Goffen has pointed out that this pose itself suggests a vision, for we are given a glimpse of a larger, mysterious whole.[45] The parapet, too, with its implications of the altar and tomb slab, of the sacrifice and death of Christ, acts both as a barrier between us and the apparition and as a place where the sacred and profane worlds intersect.[46] Baldung's *Madonna with the Parrots* is a vision directed toward a private, humanistic patron— an "initiated" viewer who could make his awareness of its precious, worldly beauty work as an equivalent to devotion, and his involvement with its sensual details function as intensity of religious experience. The painting no longer reflects the simple devotion to Mary characteristic of late medieval and early Renaissance Catholicism, but now elicits a

42  Bussmann, p. 139: "Die Entwicklung verläuft in ungebrochener Natürlichkeit zu preziöser Idealität und raffinierten artistischen Wirkungen von greifbar gerundeter Körperhaftigkeit zu Flächigkeit und transparenter Unwirklichkeit. Deutlich ist die Entwicklung zum Manierismus von den leisen Anfängen in der Vercellimadonna über die Freiburgerin zu den ausgereiften Stil in der Papageienmadonna abzulesen."

43  E. Panofsky, *Problems in Titian: Mostly Iconographic*, New York, 1969, pp. 28–29.

44  On the Protestant response to the veneration of Mary, see E. Mâle, "L'Art et le Protestantisme," in *L'Art religieux après le Concile de Trente*, Paris, 1932, pp. 29–30. A vivid expression of this criticism of Marian worship comes from Dürer, who, in 1523, wrote on the back of a woodcut representing the Virgin at

Regensburg: "This spectre has risen against the Holy Scripture at Regensburg with the permission of the Bishop and has not been abolished because of its worldly usefulness. Lord help us that we should not dishonor the dear Mother by separating her from Jesus Christ. Amen." (Matthews, *Albrecht Dürer*, p. 50).

45  R. Goffen, "Icon and Vision: Giovanni Bellini's Half-length Madonnas," *AB*, LVII, 1975, pp. 494–99.

46  Ibid., pp. 499–505.

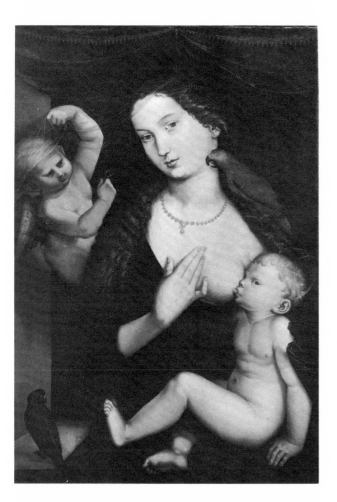

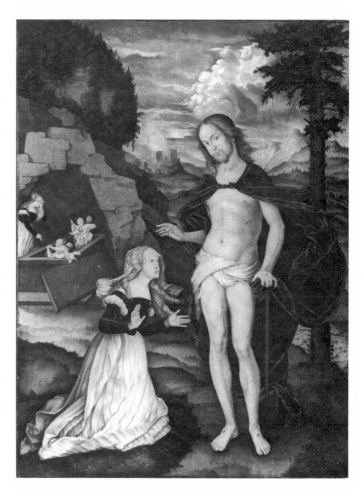

*Figure 48. Hans Baldung, «Madonna with the Parrots,» c. 1528–30, panel, Germanisches Nationalmuseum, Nuremberg.*

*Figure 49. Hans Baldung, «Noli me tangere,» 1539, panel, Hessisches Landesmuseum, Darmstadt.*

complex combination of aesthetic awareness and religious sentiment. It is primarily the aesthetic structure of the image, rather than the iconographic content, that carries the meaning.[47]

The paralleling of devotion and aesthetic response also appears in the *Noli me tangere* in Darmstadt (Fig. 49; 1539). While Baldung's images of the dead Christ are compelling in their pathetic expressiveness, his images of the resurrected Christ seldom provide us with an equally compelling, robust picture of the triumphant Savior (one thinks particularly of the strangely effeminate Christ of the *Coronation of the Virgin* on the Freiburg Altar). The Christ of the Darmstadt painting appears not as solid fact but as an ethereal, precious vision which transfixes Mary Magdalen. As her hands spread apart in awe, her glance remains oddly unfocused. The subtle contrast in scale between her and Christ suggests that he is an immaterial apparition. His body is smooth and sinuous; the inclined head and elegant pose mark him as an inhabitant of the same world as Mary in *Madonna with the Parrots*. Baldung has been influenced here by the figure of Christ from Dürer's *Resurrection* in the *Engraved Passion*, but the curving pose is exaggerated, the musculature refined, and any trace of angularity removed. The intricacy and delicacy of formal handling, the preciousness of the treatment of the clothing of Mary Magdalen and the drapery of Christ, stand for the sacred character of the vision. It is a metaphor intended for the viewer who is conscious of aesthetic values; like the late Madonnas, it does not seek to inspire devotion through immediate impact, but through a refined aesthetic response.

Baldung's versions of the Fall of Man vividly describe a humanity caught between a positive, vital sensuality and its moral and temporal restrictions. As primordial man, Adam and Eve also have something to do with potential man, what he is capable of being. And Baldung does not seem to have considered innocent sensuality a possibility. For him, it is always amended by a constraint and a self-consciousness. The *memento mori*, too, haunts any pleasure humanity takes in the senses. The awareness of these limitations on sensuality does not seem to have come, for Baldung, with the consumption of the forbidden fruit. Even before the fruit is eaten, the gestures and facial expressions of Baldung's first couple reveal that there is no innocence. Baldung's statements about man's beginnings, and about his possibilities, reflect the heightened consciousness of sin characteristic of the Reformation as well as his own recognition of the power of man's sensual drive.

If we compare Baldung's *Fall of Man* in Budapest (Fig. 50; c. 1525) to its source in Dürer's work, the Prado panels of 1507 (Fig. 51), the difference in attitude becomes abundantly clear. While Dürer's figures are touched with a blushing anticipation and hesitance, Baldung's are patently lewd. Adam is satyr-like; Eve's glance is sly and knowing. The gestures of both figures call attention to the genital areas they presumably want to conceal. The Budapest panels are preceded by a number of woodcut versions of this theme that also describe the first couple in these terms. The prints of 1511 and 1519 (Cat. Nos. 19 and 75) suggest an original lack of innocence— through gestures, facial expressions and symbols of sensuality (rabbits) in the earlier work, and through the predatory character of Adam and the painful awareness on Eve's part of the meaning of the event in the later work. The correspondence in format and figure position of the 1519 *Fall* to the *Death and the Maiden* images (see Figs. 6, 35) cannot be ignored. Adam ap-

47  See S. Freedberg, "Observations on the Painting of the Maniera," *AB*, XLVII, 1965, pp. 187–97, for a discussion of the relation of aestheticism and devotion in Mannerist art, particularly with respect to Parmigianino's *Madonna of the Long Neck*.

proaches Eve as the corpse would approach the maiden, as a symbol of man's mortality which encroaches perniciously on man's sensual life, symbolized for Baldung by the robust, female nude.

The conflict of death with sensuality is most vividly expressed in Baldung's versions of *Death and the Maiden*. But in a strange work in Ottawa (Fig. 18), the succumbing of sensuality to time and death is closely interwoven with the Fall of Man. The work, probably dating from the mid-1520s, depicts the Temptation of Eve, when the serpent induces her to eat the fruit.[48] This is a fairly straightforward theme which Baldung complicates enormously by the presence of the corpse and by the relationship between Eve, the corpse and the snake. Eve is the same lusty, willful protagonist found in the Budapest *Fall*, here fondling the snake suggestively. The corpse can be read both as a personification of Death (such as the corpses who attack the maidens) and as Adam, who holds the fruit above Eve's head as a gesture of warning against her disobedience. His attempted intervention in her deadly pact with the serpent is of course to no avail; he is shown in his future state— a gruesome reminder of the mortality brought about by the original sin. The lurid actuality of the corpse, contrasted to the relentless sensuality of Eve, and the way in which the characters play out the complex nuances of the drama could not be more telling. The forces revealed here are basic to the human condition as Baldung sees it. Her undaunted hedonism gives life and even a certain sympathetic quality to Eve; she seizes life as a full sensual existence, even though it clearly involves the implications of sin and mortality. The attempted intervention of Adam, the grisly vision of death, stop her no more than the serpent's bite can stop Adam's warning. For Baldung, man is caught in the knotty relationship of the senses, evil, and death symbolized visually by the "knot" of forms in the center of the image. Conspicuously absent from this deterministic struggle of conflicting forces, each of which qualifies or renders the other impotent, is any comforting suggestion of Christ's salvation.

In the very late, paired paintings of the Stages of Life, the Vanitas theme is again combined with Christian references. One of these pairs of paintings, the *Three Graces* and *Ages of Women* in Madrid, has a difficult, obscure iconography (Figs. 33, 34). Baldung seems to have set two as-

48  R. Koch, pp. 16–18, dates the work 1510–12 on the grounds that it is an active, dramatic conception similar to *Death and the Three Ages of Woman* in Vienna (1510). Other authors, however, have dated the work in the mid-1520s, relating its compact, vigorous plasticity to Baldung's nudes from that period and noting its more sophisticated composition. See Hults-Boudreau, p. 107; P. Boerlin in Basel 1978, p. 29, n. 15; and J. Wirth, *La jeune fille et la mort: Recherches sur les thèmes macabres dans l'art germanique de la Renaissance*, Geneva, 1979, pp. 146 and 162.

The exact subject of the Ottawa panel is very difficult to determine. Interpretations range from those which maintain some Christian content, however compromised (R. Koch, pp. 22–29 and Hults-Boudreau, pp. 107–10), to those which deny any Christian content or affirm an anti-Christian meaning (see Franz Nahm, "Baldung's 'Bilderrätsel'— eine häretisch-gnostische Verfremdung," *Die Welt-*

*kunst*, XL, 1970, pp. 102, 104). Wirth, pp.163–64, interprets the work as a "free allegory of sorcery," with Eve making a pact for immortality with the diabolic corpse.

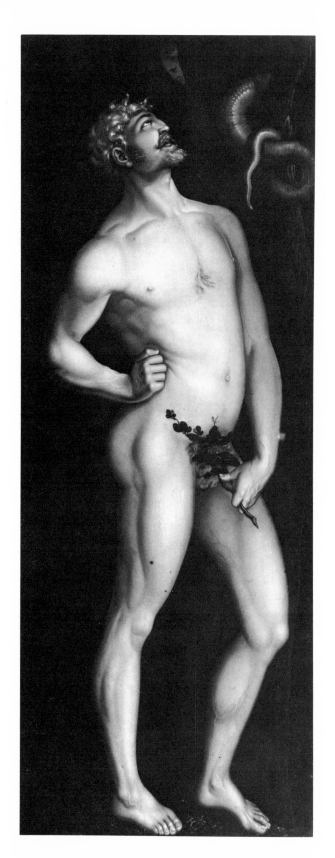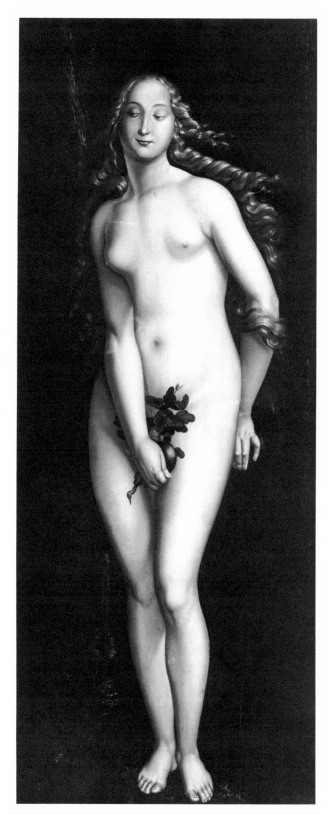

*Figure 50. Hans Baldung, «Fall of Man,» c. 1525, two panels, Museum of Fine Arts, Budapest.*

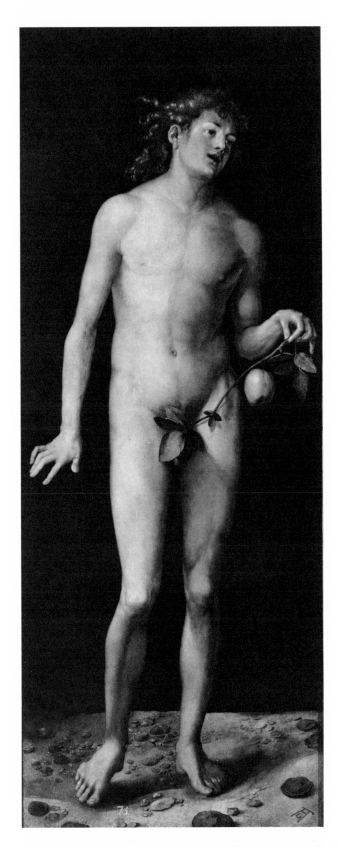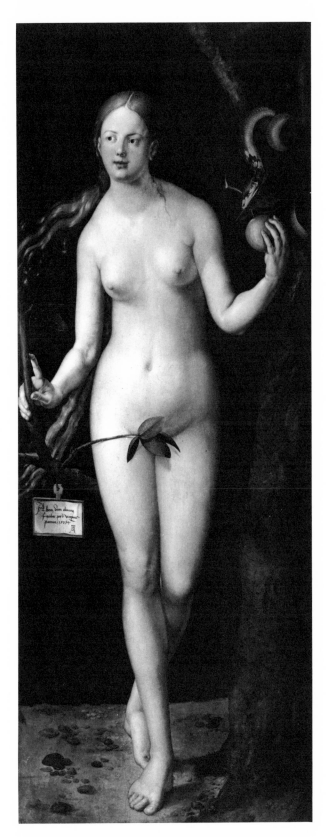

Figure 51. Albrecht Dürer, «Fall of Man,» 1507, two panels, Prado, Madrid.

pects of the human condition into absolute opposition.[49] On the one hand, there is that aspect of man which aspires toward immortality through music and poetry, and toward fulfillment in worldly beauty and pleasure. On the other hand, there is the Christian aspect which, remembering the sure movement to the grave and the finiteness of life in the world, defines man's purpose in terms of redemption and resurrection. The *Three Graces* recreates a pagan Golden Age— the musical instruments, the swan (also a musical symbol) and the laurel tree, symbol of poetry, combine with the sensuous delicacy of the nudes and the presence of the children to suggest a world full of youth, beauty and the joys of music.[50] The panel has also been interpreted by Carl Koch as representing man in the state of innocence, while the *Ages of Women* reveals mankind in the state of damnation.[51] But the innocent reverie of aesthetic pleasure evoked by the *Three Graces* may be threatened by the serpent coiled around the tree— a symbol of sin couched inconspicuously in paradise.[52]

The *Ages of Women* offers a total contrast to the *Three Graces*. Death with his jagged staff leads two women through a desolate landscape to the grave.[53] The contrast of the young and old woman expresses the theme of the Ages of Women and the dead child reminds us that not only the old succumb to death. While the mouth of hell waits in the distance, the owl, harbinger of death, sits prominently in the foreground.[54] The only hopeful note in the painting is the divine light and crucifix in the sky. Man in this work is given two possibilities— hell or salvation through the cross. But the relentless movement toward death and the sense of the tragic loss of youth, innocence and beauty for man is certain. Through his persistent contrast of ephemeral, verdant luxury and arid desolation, Baldung leaves no doubt about the tragedy of this loss, and the symbols of hell and redemption seem inconspicuous compared to the process of aging and dying. The prospects of man under the reign of grace seem unappealing, indeed. The brittle frigidity of Baldung's late style conveys a melancholy bleakness— the painting is all sharp contour and attenuated forms. Curjel speaks of the "strange, hollow sound," emitted from this

49 Pariset, "Baldung et la Marche à la Mort," pp. 209–10, interprets the panels as pagan and Christian solutions to death. The coiled serpent, for him, signifies eternity, while the swan symbolizes a resignation toward death. In his interpretation of the right-hand panel (p. 210), he stresses the serene acceptance of death and the lack of violence in Death's approach to his victim. The panel's reflect "une unité faite non de férocité et de sensualité, mais de douceur, et de sérénité . . .". The child is identified by Pariset as Christ, who breaks the staff of Death, rendering it impotent.

Wirth, *La jeune fille et la mort*, pp. 158–62, also sees the panels as contrasting pagan and Christian solutions to death, but for him, Baldung represented the pagan solution as positive and the Christian solution as negative or false. The *Three Graces* represents an idyllic paradise of immutable beauty in which the knowledge of poetry and music leads to immortality. The *Ages of Women* represents the negative values of Christianity—the vision of hell and death, the decomposition of the flesh and the ignorance of music, poetry and beauty.

50 This interpretation is offered by Bussmann, pp. 51–53.

51 Koch, p. 46.

52 Both Pariset, "Baldung et la Marche à la Mort," p. 210, and Wirth, *La jeune fille et la mort*, p. 161, interpret the serpent as a symbol of immortality or eternity and not as the Christian symbol of sin. Wirth extends this interpretation into Baldung's images of the Fall of Man and to the Munich allegories—see pp. 160–61 and 164.

53 Pariset, "Baldung et la Marche à la Mort," p. 210, interprets the jagged staff of Death as a sign that Christ has vanquished death, but it may be in part compositionally determined. Its jagged form corresponds to the overall angularity of form in the panel.

54 Wirth, *La jeune fille et la mort*, p. 160, suggests that the owl might be a symbol of ignorance, particularly of music. It is the antipode of the swan in the *Three Graces*, a symbol of music, or, more specifically, a reincarnated musician.

panel, "that fearful, brassy sound of the late sixteenth century, whose acute sharpness seems to come out of the world of lifeless form."[55]

The concept of Vanitas that assumed such an overwhelming significance for the artist is, in the last analysis, not reconcilable with the Christian concepts of redemption and resurrection. The sense of tragedy in the loss of sensual and aesthetic pleasure cannot be merged comfortably with the Christian stress on the spirit and its relationship with God as the climactic aspect of human existence. The Madrid panels express the antithetical view of the world that is suggested by the uneasy combination of aestheticism and devotion in the Madonnas, of hedonism and moralism in the Eden images. If we interpret the *Bewitched Groom* and the *Graces-Ages of Women* as profound reflections of the artist's own attitudes, we might conclude that, at the end of his life, Baldung's imagination was dominated by other than Christian concepts. What became of the intensity of the religious woodcuts from about 1515, or the zeal implied by the Reformer portraits and the Apostles from 1519, is impossible to say; Baldung's late works only give us ambivalent answers.

The intensity of the artist seems to have been redirected toward other aspects of the human condition, aspects which conflict not only with Christian ideas but also with each other. Man's sensual drive conflicts violently with his mortality, while this whole struggle contrasts sharply with Christian solutions. Baldung presents demonic forces with a power and verisimilitude as convincing as that of Christ's sacrifice in the c. 1515 single-sheet woodcuts. In the Madonna and Child images, the implications of his sacrifice must compete with the artist's deepening aesthetic consciousness. This lack of resolution among conflicting qualities defines the essential character of Baldung's mentality and contributes to the excitement of his art. The Reformation loosened the grip of traditional religious imagery on the artist and, in doing so, it opened the door even wider to this collision of ideas. Concomitantly, the Reformation bolstered the growing autonomy of art. Baldung is a prime example of an artist who vigorously exercises this new artistic freedom. In an image like the *Bewitched Groom*, the artist attains an expressive liberty that is unprecedented in the German Renaissance. Dürer, who had insisted on personal expression in graphic art and whose weariness with the restrictions of the traditional religious commission underlies the petulance of his letters to Heller, had not abandoned the notion that the artist's creativity is but a reflection of God's creativity, and that the highest duty of the artist was to put the Passion of Christ into images.[56] We suspect that, for Baldung, the separation between Christianity and art has become wider, and the artist's imagination becomes more exclusively the determining force behind the work of art.

55  Curjel, p. 131.

56  Dürer's conviction that the artist had a responsibility toward Christianity is best conveyed by his works— his numerous representations of the Passion of Christ in graphic art and his presentation of orthodox Lutheran ideas in the *Four Apostles*, for example. But the close link between the artist and religion also appears in his theoretical writings. In the introduction to his never completed treatise on painting, Dürer justifies the artist's concern with beauty and proportion thusly: "For the art of painting is employed in the service of the Church and by it the sufferings of Christ and many other profitable examples are set forth" (see Conway, *The Writings of Albrecht Dürer*, p. 177). For Dürer, the artist's creativity itself was not to be divorced from the creativity of God; see Panofsky's discussion of Dürer's artistic theory, pp. 279–80.

# THE CATALOGUE

## St. Bartholomew

DATED 1504

Pen and ink
309 × 211 mm. (12³⁄₁₆ × 8⁵⁄₁₆ in.)
Koch 3; Karlsruhe 1959, no. 101; Basel 1978, no. 9.
Lent by the Kunstmuseum Basel, Kupferstichkabinett

Produced during his stay in Dürer's atelier in Nuremberg (c. 1503–07/8), this pen drawing is one of the earliest dated works from Baldung's hand. The young artist's debt to Dürer is apparent in his graphic technique: the clear and strong contours and the systematic patterning of the interior modeling of the drapery recall the disciplined linear vocabulary of earlier works by Dürer,[1] particularly intaglio prints (e.g., Ill. 1a). Baldung departs from Dürer by giving greater emphasis to angular and geometric out-line, using more rectilinear and occasionally broader hatching and cross-hatching, and— even at this early stage in his development— by the boldness and strength of his emphatically inscribed lines. These tendencies to abstraction and concentrated expression constitute one of the enduring hallmarks of the artist's graphic style. Char-acteristic also of Baldung is the curvilinear stylization of the saint's hair and beard, which has analogies in works produced throughout the artist's career, and the energeti-cally sketched clump of grass to the right of the figure, which reappears in other works from the Nuremberg period (Cat. No. 2).

Baldung's St. Bartholomew is represented as a cult figure, posed in three-quarter view to the right and dis-playing both the instrument and the emblem of his mar-tyrdom: the knife with which he was flayed alive and his excoriated skin of which we see the face. Frederick the Wise, Dürer's patron as early as 1496, possessed a speci-men of the entire flayed face of St. Bartholomew in his collection of relics at Wittenberg; the prominence given to this feature in Baldung's drawing may thus reflect his knowledge of the relic, which was represented in a wood-cut by Lucas Cranach the Elder published in 1509.[2] However that may be, the flayed face is an important ex-pressive focus of the drawing, moving the viewer by its grotesquely distorted form, which is echoed in the pa-thetic features of the pained glance and the downturned mouth of the living saint's physiognomy. By means of this resonance, Baldung thus transforms an emblematic attri-bute into a trenchant statement concerning the physical and psychological reality of Christian martyrdom.

The purpose of this early drawing is not known, but the facial type of the Apostle reappears in a modest

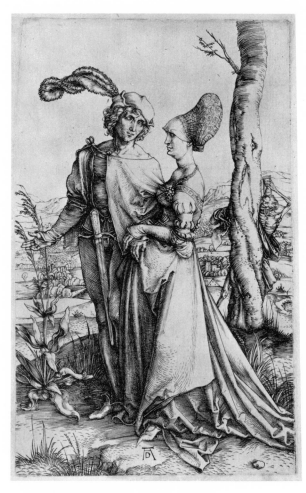

1a. Albrecht Dürer, «Young Couple with Death (The Promenade),» c. 1497, engraving.

woodcut designed by Baldung for Ulrich Pinder's *Der beschlossen Gart des Rosenkranz Mariae*, published in Nuremberg in 1505 (M. 211), and the entire figure is re-called in one of Baldung's woodcuts for the *Hortulus animae*, published at Strassburg in 1511 (M. 370).

1  See Hanspeter Landolt, "Zur Geschichte von Dürers zeichnerischer Form," *Anzeiger des Germanischen Natio-nalmuseums*, 1971–72, pp. 143–56, esp. 152–53 for the re-lationship of Baldung's early graphic style to Dürer.
2  See Leo Steinberg, "The Line of Fate in Michelangelo's Painting," *Critical Inquiry*, VI, 1980, p. 423, fig. 16 and n. 14, and Jahn, p. 518 (the woodcut of 1509) and p. 206 (an engraving of c. 1510, showing Frederick the Wise in prayer before St. Bartholomew, while angels hold the excoriated skin).

I

## 2

*Madonna and Child in a Landscape*

DATED 1504

Pen and ink
308 × 198 mm. (12⅛ × 7¾ in.)
Koch 4; Karlsruhe 1959, no. 102; Nuremberg
1961, no. 7; Basel 1978, no. 10
Lent by the Kunstmuseum Basel, Kupferstichkabinett

Baldung's early pen drawing of the *Madonna and Child in a Landscape* continues a prominent representational tradition in German art of the fifteenth and early sixteenth centuries. While German artists of the early fifteenth-century frequently placed the Virgin and Child in the symbolic landscape of an enclosed garden (the *hortus conclusus*) or a rose bower,[1] those of the two generations preceding Baldung increasingly situated the members of the Holy Family in worldly settings, evoking the realm and the experience of the viewer. Examples of the latter type possibly known to Baldung include a charming drypoint engraving by the Master of the Housebook (Panofsky, fig. 18) and a noteworthy series of representations in different media by Dürer (Ills. 4a, 4b; W. 30, 187, 296). Baldung's drawing summarizes various elements of this tradition, but the artist also breaks new ground in his exploration of hierarchical and informal aspects of the subject.

Baldung invests his composition with new dignity and formality by transforming the traditional frontal representation of the Madonna and Child into a profile depiction of severely ordered geometric elements. The blocky form of the Virgin's bench is reflected in the principal outlines of her lower body and, indeed, in the systematic angularity of the artist's cross-hatching. Baldung's concern for spatial and structural order here was inspired by Dürer's contemporary works, including the master's woodcuts for the *Life of the Virgin* series (c. 1503–05) and paintings executed in his shop in the period just prior to 1504, the date of Baldung's drawing. Dürer's *Adoration of the Magi* in the Uffizi, completed in 1504 (Ill. 2a),

apparently furnished Baldung with the principal ingredients of his composition, although in reverse orientation: that is, the profile representation of the Virgin, the geometrically structured forms that order and demarcate diagonal lines of recession into depth, and the arches that terminate the spatial recession— a gateway in Dürer's painting and a fountain in the Baldung drawing.

The motif of angels or cherubim crowning the Virgin derives from a hieratic tradition exemplified by Schongauer's famed painting in Colmar (Baum, fig. 145) and Dürer's woodcut of c. 1498 (Ill. 2b), but Baldung abandons the symmetry of flanking figures for a single cherub who smiles at the viewer with fetching insouciance.[2] The Christchild and the cherub in the left background also mediate the formality of the severe pose of the Virgin. Aligned with the principal crossing diagonals of the composition, these figures are engrossed in active, physical exertions: both turn their backs to the viewer, the Child reaching spontaneously into the Virgin's bodice and the angel climbing into the fountain.[3] There is, finally, a striking contrast between the systematic modeling of the figure of the Virgin and the lively, improvisational character of the freely sketched and energetic elements of Baldung's landscape.

Executed in the same year as the St. Bartholomew (Cat. No. 1) and similar to it in format and technique, the *Madonna and Child in a Landscape* is both more ambitious compositionally and more pronounced in its contrast between imposed geometrical form, realized through systematic hatching, and dynamic, expressive line.

1  See E. M. Vetter, *Maria im Rosenhag*, Düsseldorf, 1956.
2  As Tilman Falk has recently observed, traces of a second set of hands and an arm are visible at the left side of the crown, indicating that Baldung originally planned two flanking angels to crown the Virgin; Basel 1978, p. 49.
3  The figures of the Christchild and the cherub seen from the rear have been related to the putti in Dürer's engraving, *The Witch* (Ill. 18a, B. 67), datable c. 1500-05 (Koch, p. 70); see also, however, other representations by Dürer of active infants seen from this viewpoint (W. 83, 158).

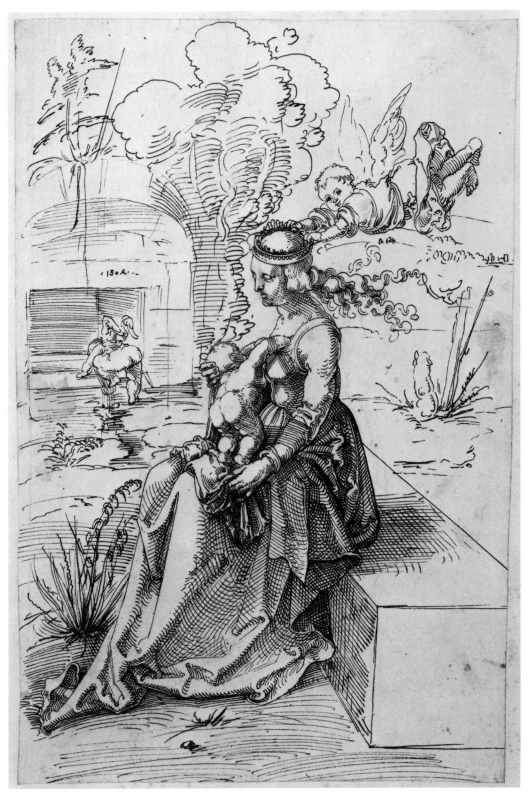

2

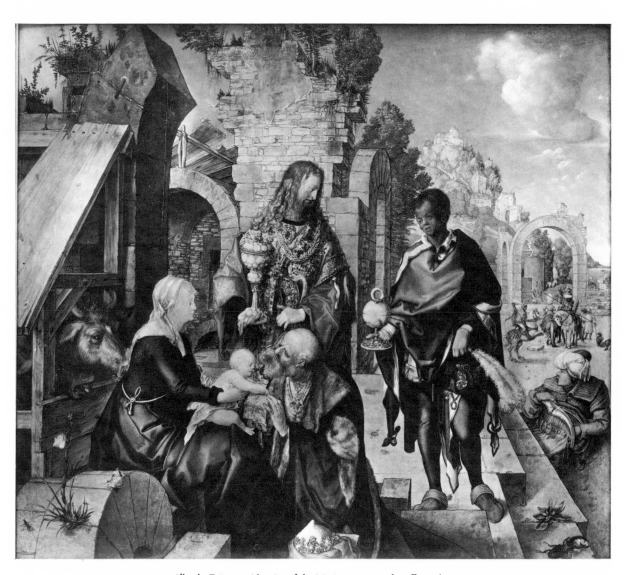

*2a. Albrecht Dürer, «Adoration of the Magi,» 1504, panel, Uffizi, Florence.*

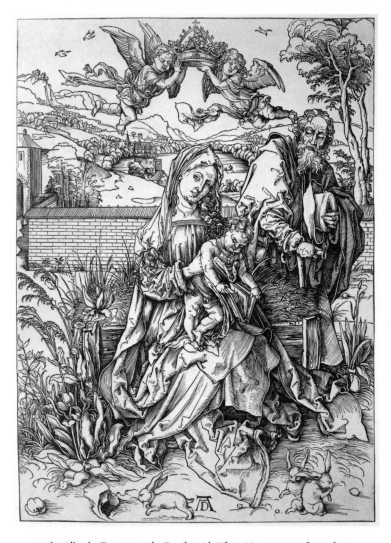

*2b. Albrecht Dürer, «Holy Family with Three Hares,» c. 1498, woodcut.*

3

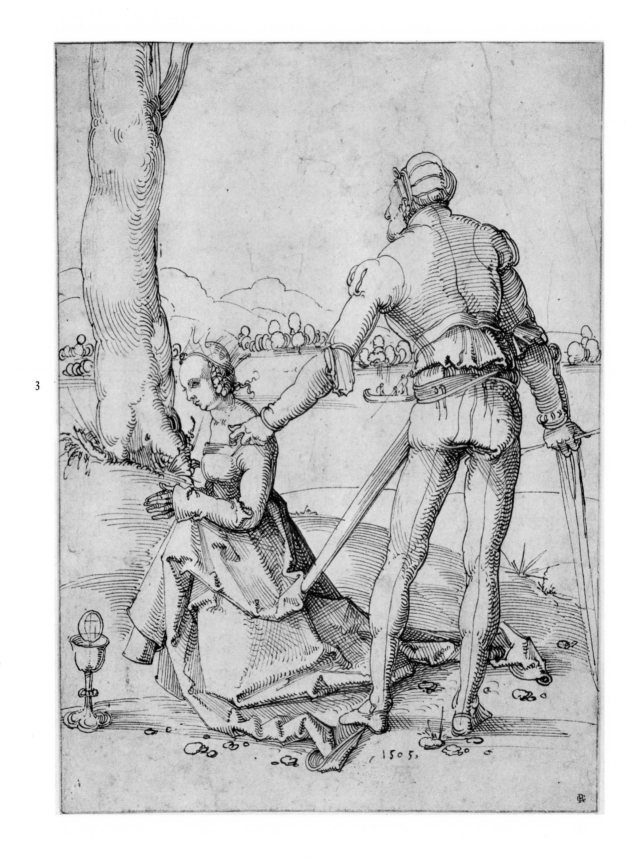

1505

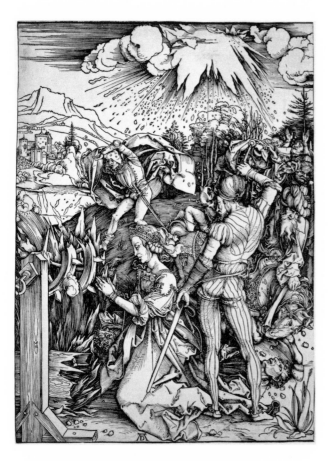

3a. *Albrecht Dürer, «Martyrdom of St. Catherine,»*
*c. 1498, woodcut.*

<span style="font-variant: small-caps;">&#126; 3</span>

*Beheading of St. Barbara*

<span style="font-variant: small-caps;">DATED 1505</span>

Pen and ink
294 × 208 mm. (11⅞/₁₆ × 8³/₁₆ in.)
Koch 6; Karlsruhe 1959, no. 105; Nuremberg
1961, no. 9
Lent by the Staatliche Museen Preussischer Kulturbesitz,
Kupferstichkabinett, Berlin-Dahlem

The figures of this drawing are derived from Dürer's woodcut of the *Martyrdom of St. Catherine*, datable c. 1498 (B. 120; Ill. 3a), a work exceptional for its high drama and wealth of narrative detail. By comparison, Baldung's conception is simpler and more direct, imbued with an atmosphere of quiet dignity that is surprising in such a youthful work. The angular forms of Dürer's henchman are replaced by those of a more supple figure (Barbara's father according to the *Golden Legend*), animated by a gentle lateral sway as he prepares to strike. The kneeling saint's drapery has been rearranged and her arms contracted in order to create the triangular massing of her form. Also, her head, unlike Dürer's Catherine, appears less bowed, for she glances demurely upward to reveal an expression of contemplative devotion. When viewed together, Baldung's figures express an eloquent visual dialogue between tranquil stasis and solemn, measured movement.[1] The graphic style of the work, moreover, in which the bold and angular lines of the two 1504 drawings (Cat. Nos. 1–2) are softened and restrained, enhances the mood established through compositional means.

    The landscape also contributes to the distinctive mood of this drawing. Delicately and summarily sketched, its elements subtly echo such features as the gently swaying pose of the executioner (the tree) and the angle formed at the juncture of his left arm and torso (in the mountains). Here also Baldung takes inspiration from his teacher, for the landscape formula— large figures in the foreground set off against a tree on a hillock to one side in the middleground, and an expansive, light-filled panorama beyond— is essentially that employed in Dürer's engraving of c. 1497 depicting a *Young Couple with Death* (B. 94; Ill. 1a). This landscape type appears again in Baldung's pen-and-ink drawing of *St. Catherine* (Koch 11), a work that has frequently been associated with the *St. Barbara* and dated to the same period because of similarities in composition and technique.

    Baldung's achievement in this drawing is to have taken disparate figural and compositional elements from his master's work and to have reformulated them into a

representation possessing its own expressive integrity. The young artist also introduces his own types in this work, for the facial features of his St. Barbara are analogous to those of the Virgin and St. Agnes in the Epiphany Altarpiece in Berlin (Oettinger/Knappe, figs. 6, 9), and the St. Dorothy of the Sebastian Altarpiece in Nuremberg (ibid., fig. 17). The lost profile of the executioner seen from behind reappears in the drawing of a *Banner Carrier* (Koch 9) and in a figure in the left foreground of a *Calvary* from *Der beschlossen Gart* (M. 89), published in 1505. — D. L.

1   The representation of the *Martyrdom of St. Catherine* in the right wing of Dürer's Heller Altarpiece (1508–09), painted by an assistant, agrees more closely in expressive and formal characteristics with Baldung's *Beheading of St. Barbara* than with Dürer's print of the *Martyrdom of St. Catherine* (Ill. 3a); as in Baldung's print the figures are more relaxed and vertical, and the executioner stands with his right arm lowered and his left resting upon the saint's shoulder (see Nuremberg 1961, no. 252e, pl. 47, and A. Pfaff, *Studien zu Albrecht Dürers Heller-Altar,* Nuremberg, 1971, pp. 109ff.). If the design of the wing of the Heller Altarpiece does not reflect knowledge of Baldung's sketch, both may go back to a variant figural group by Dürer that has not survived.

## 4·10

## Seven of a Group of Twelve Devotional Woodcuts

When Baldung arrived in Nuremberg in 1503, Dürer had already achieved notable success in the production of woodcuts as independent images (the single-sheet woodcuts of the *Apocalypse* and of the *Large Passion,* both of c. 1496–98) and as book illustrations (the cycles produced in Basel in the early 1490s for such publications as the *Ritter vom Turn* and the *Ship of Fools,*[1] and a series of prints executed for devotional books in Nuremberg before 1503[2]). During his four years in Dürer's shop, Baldung was active in the production of both types of woodcuts. With his co-workers Hans Leonhard Schäufelein and Hans Süss von Kulmbach, among others, he contributed woodcuts to *Der beschlossen Gart des Rosenkranz Mariae* (1505) and to the *Speculum passionis domini nostri Jesu Christi* (1507), both published in Nuremberg by Ulrich Pinder.[3] The group of twelve devotional woodcuts (M. 1–9, 11–13), of which seven are included in this exhibition, represents Baldung's major effort in the production of single-leaf woodcuts during his Nuremberg period.

The likely "model" for this group of prints was a series of related woodcuts produced by Dürer in the years immediately preceding his second trip to Italy in 1505.[4] Both groups consist of prints of popular devotional subjects: the Madonna and Child or Holy Family, scenes from the Passion, and representations of saints. Baldung's woodcuts are slightly larger than Dürer's, by about 20 mm. (¾ inch) in each dimension. If the young artist's prints are somewhat more ambitious in size, they are also in style, for in these woodcuts Baldung clearly strives to equal or surpass his master in the monumentality and clarity of his forms and in the care with which the blocks were designed, cut and printed. The latter considerations are particularly relevant because Dürer's prints are believed to be those he later referred to as "schlechtes Holzwerk" ("slight," or "modest woodcuts"). Made for widespread and simple devotional use, they were therefore executed with far less care than such well-known series as the *Life of the Virgin.*[5]

Unlike Dürer's group of woodcuts, all of which bear his monogram, Baldung's are unsigned. This has been attributed to the fact that as a member of Dürer's shop Baldung could not, according to guild laws, issue prints under his own signature, and that the works produced under these circumstances were considered Dürer's property. Dürer recorded selling and making a present of prints by Baldung during his trip to the Netherlands in 1520–21, for which reason Max Geisberg has suggested

the plausible hypothesis that it was these Baldung wood-
cuts, to which Dürer was referring in his diary.[6] There is,
in any case, circumstantial evidence that the woodblocks
remained in Nuremberg after Baldung's departure in
1507–08, for later impressions are known in which a
Dürer monogram was added to the blocks.[7]

Like Baldung's contemporaneous works in other
media, these prints show close study of models by Dürer
and of the master's graphic style. From Baldung's choice
of models, from relationships between the prints, his
dated drawings and woodcuts in dated books, and from
the progressive emergence of his own formal and compo-
sitional idiom, it has been estimated that the work on this
group proceeded from c. 1505 to 1507, commencing
about the time of Dürer's departure for the second Italian
trip.[8] The project for the woodcuts may have been con-
ceived under Dürer's supervision, for eight of the twelve
prints are known in impressions that include Latin and
German inscriptions in two columns beneath the repre-
sentations (M. 1, 2, 4, 6, 8, 11–13), and these texts have
been attributed, respectively, to Dürer's friend Benedictus
Chelidonius, who composed the verses for the book edi-
tions of Dürer's *Life of the Virgin* and the *Large* and *Small
Passions*, and to Dürer himself.[9] It is not certain, however,
that the verses were part of the original project. Although
they are not, apparently, known on the later impressions
with the added Dürer monogram, they might well have
been supplied only after the creation and initial use of the
woodblocks, for example, following Dürer's return from
Italy. Final judgment on this matter should be postponed
until all the extant impressions, with and without the
verses, are compared and their watermarks identified, but
in the meantime it is worth noting that the verses are
placed somewhat awkwardly, extending laterally beyond
the frames of the representations, and that they differ in
their precise location from one impression or subject to
another. Such aesthetic incongruities might suggest that
the verses were an afterthought, added only subsequently
to the completed illustrations. However that may be, the
inscriptions, in six-line verse, are intended to enhance the
devotional character of the prints, with laudatory remarks
in Latin and rhyming "prayers" in German appealing for
aid and intercession.

The woodcuts of this group were designed with
their devotional function in mind. In them Baldung sup-
presses or simplifies narrative elements, employing monu-
mental forms organized in geometrically structured
compositions. Although the expressiveness of individual
prints differs somewhat according to their subjects, the
group shares a similar graphic style of relatively broadly
cut and evenly spaced lines. The style is less descriptive
than that of Dürer's woodcuts prior to 1505, less con-
cerned with realizing light-dark contrasts and movement

into depth than with emphasizing surface properties.
Nonetheless, in their formal clarity— particularly in com-
parison with the so-called "schlechtes Holzwerk"— Bal-
dung's woodcuts show some influence of Dürer's *Life of
the Virgin* series, executed between c. 1503 and 1505.

—L. K.

1   See F. Winkler, *Dürer und die Illustrationen zum Narren-
    schiff: Die Baseler und die Strassburger Arbeiten des Künstlers
    und der altdeutsche Holzschnitt*, Berlin, 1951.

2   See C. Dodgson, *Holzschnitte zu zwei Nürnberger An-
    dachtsbüchern aus dem Anfange des XVI. Jahrhunderts*, Berlin,
    1909. The precise relationship of these works to Dürer
    and the members of his shop is as yet unclarified.

3   Karlsruhe 1959, nos. II B II and II B IV.

4   The number of woodcuts in the Dürer series differs
    somewhat according to different authors: J. Meder,
    *Dürer-Katalog*, Vienna, 1932, pp. 39–40, lists B. 59, 99,
    100, 104, 107, 108, 110–12, 118 and 121, but M. Geis-
    berg, "Des Grünhansen Ding," *Westfalen*, XXVI,
    1941, pp. 193–94, omits B. 100 from his list.

5   Meder, ibid., Geisberg, ibid.

6   Geisberg, ibid.

7   The date of the impressions with the Dürer monogram,
    or the date at which they were added to the woodblocks,
    is apparently uncertain: Meder, *Dürer-Katalog*, p. 51 and
    n. 2, places the extant impressions in the 1590s, while
    Mende, p. 43, no. 1, suggests that the monogram was
    added under Dürer's supervision. While not settling the
    issue, we may note that the placement of many of the
    added monograms, floating obtrusively in such areas as
    the sky, is not typical of Dürer. Because of the impres-
    sions with the added monogram, this group of prints
    was, until 1903, attributed to Dürer (Karlsruhe 1959,
    II H 8); the attribution to Baldung is now unchallenged.

8   For the most ambitious attempt to date the individual
    prints, see Oettinger/Knappe, pp. 14ff.

9   See B. Denecke in *Albrecht Dürer 1471–1971*, exhibition
    catalogue, Germanisches Nationalmuseum, Nuremberg,
    1971, pp. 188–89, no. 357. For the texts of the German
    verses attributed to Dürer, see H. Rupprich, *Dürers
    schriftlicher Nachlass*, I, Berlin, 1956, pp. 128–45, nos. 8,
    16, 17, 20, 21, 23 (presumably for the woodcut of *St.
    Martin*, M. 9, not yet recorded in an extant impression
    with Latin and German verses), 31–33.

## 4

*Madonna and Child on a Grassy Bench*

C. 1505-07

Woodcut
235 × 160 mm. (9¼ × 6⁵⁄₁₆ in.)
B. VII, p. 178, no. 13 (as Dürer); G. 66; H. 65;
Karlsruhe 1959, II H 18; M. 1
Lent by the National Gallery of Art,
Rosenwald Collection

The Madonna and Child on a Grassy Bench was a popular theme among German printmakers, and Baldung's early woodcut of this subject owes much to his predecessors. The best known and most obvious borrowings in this work are from two engravings by Dürer: the *Virgin with a Monkey* of c. 1498 (Ill. 4a), and the *Madonna and Child on a Grassy Bench* of 1503 (Ill. 4b). From the former print Baldung took inspiration for features of his setting, including the grassy bench and the view across a placid lake to a house on the shore in the right background; from the latter, Baldung adapted the arrangement and folds of the Virgin's garments and the principal patterns of light and dark which model these forms. Baldung's figures, however, depart from those in similar representations by Dürer,[1] and seem to have their closest analogues in an engraving by Martin Schongauer (Ill. 4c). While there is no question in this instance of direct borrowings, one should note similarities in the position and pose of the Christchild, who holds or reaches for an apple, and in the round-faced, curly-haired type of the Virgin. Despite all these probable influences, Baldung alters his models: his Child is larger and fixes his stare at the viewer; the curls of his Virgin's hair have a life of their own as they fly in the air in calligraphically animated lines; and the monumental and pyramidal forms of Baldung's figures fill and truly dominate the picture field and landscape of his composition. Surprisingly, many of these characteristics reappear in Dürer's engraving of the *Madonna and Child on the Crescent*, dated 1508 (Ill. 4d); if both works

do not go back to an earlier model by Dürer, now lost, we may suspect a rare instance in which Dürer took inspiration from his assistant.

Only relatively recently was it recognized that two other works in Baldung's early series of devotional woodcuts were designed as pendants to the *Madonna and Child on a Grassy Bench*. In 1959 Peter Halm first suggested that the prints of *St. Catherine* (Cat. No. 5) and *St. Barbara* (Cat. No. 6) were designed to flank the *Madonna and Child on a Grassy Bench* "in the manner of a triptych."[2] The compositional relationship between the three prints is indicated not only by the unusual seated profiles of the female saints, which require a focus, but also by the diagonal lines of Catherine's sword and Barbara's arms, which reiterate elements of the pyramidal form of the central figures. The relationship is also attested to, however, by an iconographic tradition. Fifteenth-century woodcuts provide a precedent for depictions of the Madonna and Child flanked by seated figures of precisely the two saints thus represented by Baldung (Ill. 4e).[3] This tradition inspired not only the choice and general arrangement of the figures but also the crown on the Virgin's head, which is not common in other representations of the Madonna and Child on a Grassy Bench.[4] A comparison with the fifteenth-century woodcut also helps to explain another distinctive feature of Baldung's ensemble: it was presumably to compensate for having divided the unified composition of the earlier tradition into three separate parts that Baldung transformed the seated female saints into pure profiles with active diagonal and horizontal lines that force the viewer's gaze toward a central axis. —L.K.

1  See also Ill. 2b, the engraving B. 44 (D. 4), the woodcut B. 99 (K. 200), and the drawings W. 22–25, 30, 187–91, 290, 295–97, etc.
2  Halm, p. 131, repeated by Oettinger/Knappe, p. 21.
3  S. 1151, from the region of the Upper Rhine, Swabia or the Bodensee, c. 1440–60; see also S. 1150, 1153, 1154.
4  See, however, Ill. 2b, where two angels hold a crown suspended above the Virgin's head.

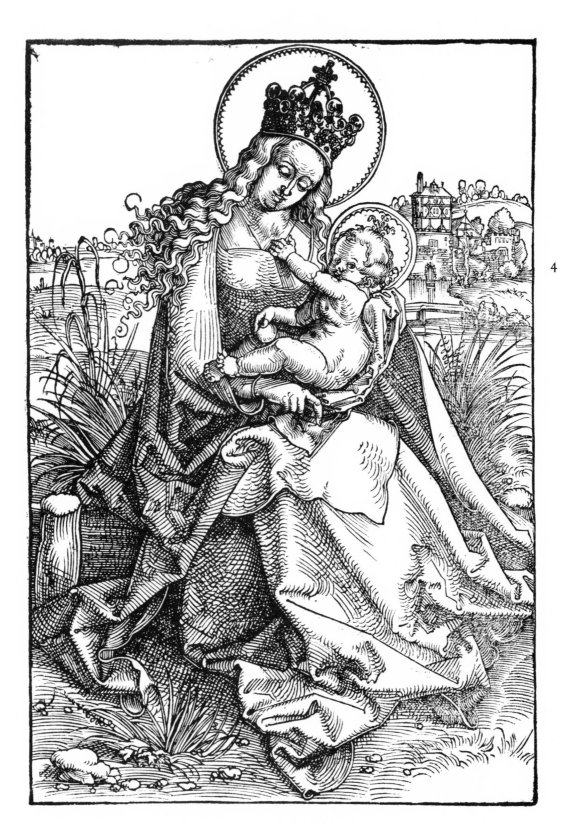

4

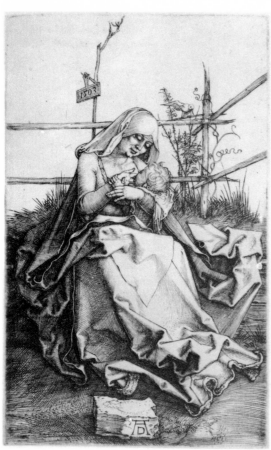

4b. Albrecht Dürer, «Madonna and Child on a
Grassy Bench,» 1503, engraving.

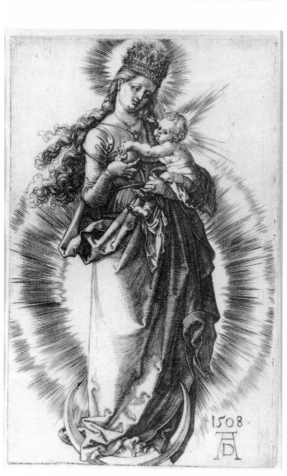

4c. Martin Schongauer, «Madonna and Child on a Grassy
Bench,» c. 1475–80, engraving.

4d. Albrecht Dürer, «Madonna and Child on the
Crescent,» 1508, engraving.

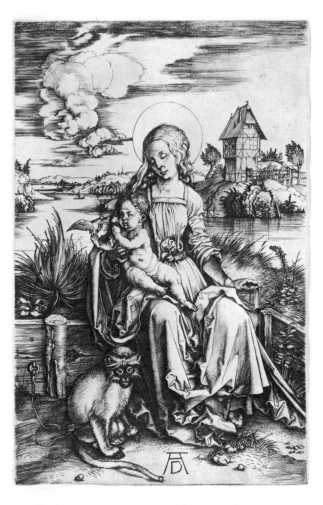

4a. Albrecht Dürer, «Virgin with a Monkey,» c. 1498, engraving.

4e. Anonymous, Swabia or Bodensee region, «Madonna Between Sts. Catherine and Barbara,» c. 1440–60, woodcut.

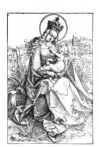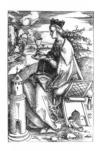

4f. Triptych arrangement of Cat. Nos. 4, 5 and 6.

## 5

### St. Catherine

c. 1505–07

Woodcut
235 × 161 mm. (9¼ × 6⁵⁄₁₆ in.)
B. VII, p. 181, no. 25 (as Dürer); G. 73; H. 135;
Karlsruhe 1959, II H 68; M. 12
Lent by the Metropolitan Museum of Art,
Harris Brisbane Dick Fund, 1924

St. Catherine of Alexandria, patron saint of scholars, students, artists and wheelwrights, was the highly educated daughter of King Costas of Alexandria. Condemned to death by the Emperor Maxentius for her Christian beliefs in 310, she was beheaded after an initial attempt to kill her with knife-studded wheels was aborted through divine intervention. Three of Catherine's attributes are represented in this illustration: the book, held in her hands, signifies the learning and faith with which she confounded the enemies of Christianity, while the broken wheel below her throne and the sword that rests across its arm refer to the instruments of her martyrdom.

Represented in profile upon an imposing throne, St. Catherine is the very embodiment of dignified regality. Such details as her fur-trimmed robe and fanciful crown complement this appearance, but the effect is achieved primarily through her massive, hieratically fixed form and through the regularity of the systematically hatched lines with which she is represented. A precedent for these formal characteristics occurs in Baldung's 1504 pen-and-ink drawing of the *Madonna and Child in a Landscape* (Cat. No. 2), but the scale of the figure is now more monumental and the profile absolute, confirming the later date of the print.

It is tempting to see another possible allusion to Catherine's elevated status in Baldung's placement of her martyr's wheel directly below her throne. Although not explicit, the conjunction of forms can be read as a subtle evocation of a chariot. The logic of such a visual homonym would be to associate the image of the saint with representations of divine and heroic figures also depicted in Baldung's time seated in profile upon chariots, that is, with representations of the gods of the planets (*Planetenbilder*) and of figures in triumphal processions.[1] The association would complement the Latin inscription found below untrimmed versions of the print, which salutes the heavenly nature of the immortal and triumphant saint,[2] and the artist seemingly implies forward motion for his seated figure by the hair that flies back behind her head.

Catherine's flying hair is only one instance of the emphatic lines of motion Baldung employs to formally relate the saint to the *Madonna and Child on a Grassy Bench,* with which it was grouped together with the *St. Barbara* into a tripartite ensemble (see Cat. Nos. 4, 6). The diagonal lines of the receding wall at the left, and of the sword, reinforce the horizontals of the saint's hypnotically fixed gaze, of her right arm and of the wall in the middle ground before her to direct the viewer to the right. These forms, answered by opposing diagonals and horizontals in the *St. Barbara,* powerfully reassert the focus and symmetry that was explicit in fifteenth-century representations of the Madonna and Child flanked by Sts. Catherine and Barbara (Ill. 4e). —L.K.

---

1 For examples of the *Planetenbilder* in German illustrated books of the fifteenth century, see A. Schramm, *Der Bilderschmuck der Frühdrucke*, XXIII, Leipzig, 1943, figs. 119ff. Illustrated copies of Petrarch's *Trionfi* were published in Italy from the 1480s (R. van Marle, *Iconographie de l'art profane au Moyen Age et à la Renaissance*, II, The Hague, 1932, pp. 14ff., and G. Carandente, *I Trionfi nel Primo Rinascimento*, Turin, 1963). A Venetian edition of the *Trionfi* was available to Dürer in 1494 when he returned to Wolgemut's shop in Nuremberg after his bachelor's journey (Panofsky, p. 31). Although the planned German edition by Wolgemut never appeared, Dürer, along with other of his German contemporaries, demonstrably drew from the iconographic tradition in the projects for the *Triumphal Procession of Maximilian I* and the independent scene of the *Triumphal Chariot,* works in progress from c. 1512 to 1526 (Panofsky, pp. 179–81).

2 The inscription, from the Stuttgart impression reproduced in Geisberg, reads in full:

*Vicisti fautore Deo Catarina tyrannos*
*Armatasque rotas: Costia progenies.*
*Iamque immortales animosa Virago triumphos*
*Coelicolas inter ducis: & astra colis.*
*Hostibus a cunctis igitur nos Diva tuere.*
*Postque obitum nobis posce perenne bonum.*

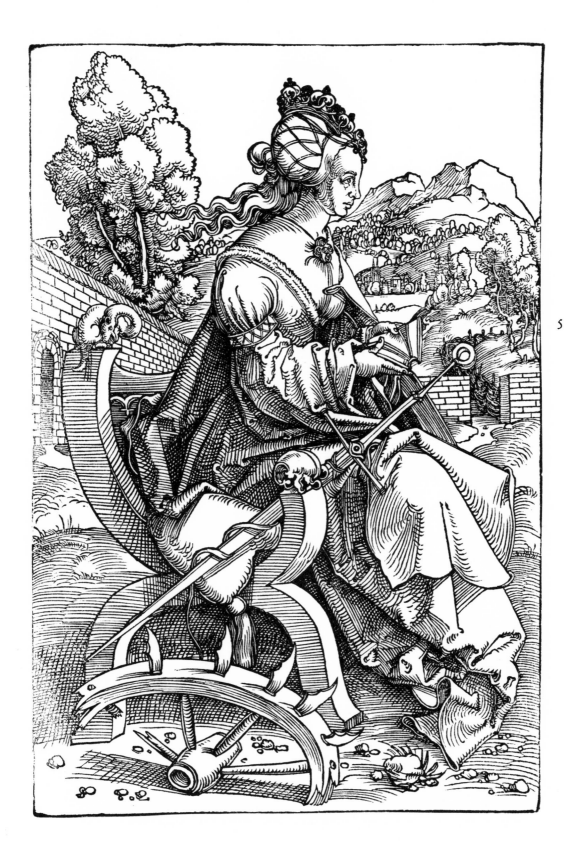

S

## 6

*St. Barbara*

c. 1505–07

Woodcut
236 × 160 mm. (9⁵⁄₁₆ × 6⁵⁄₁₆ in.)
B. VII, p. 181, no. 24 (as Dürer); G. 72; H. 134;
Karlsruhe 1959, II H 67; M. 13
Lent by August Laube, Zurich

St. Barbara, patron saint of armorers, gunsmiths and architects, was the daughter of Dioscurus of Heliopolis and lived in the third century. Secluded by her father in a tower (to discourage suitors), she turned to Christianity, and after resisting all his efforts to dissuade her of the new faith, she was decapitated at his hands. In this illustration, Barbara's best known attribute, the tower, is represented in diminutive form before her. She holds a chalice surmounted by a wafer of the Host (represented on the ground at the left in Baldung's pen-and-ink drawing of her martyrdom, Cat. No. 3) because she was commonly invoked for protection against the danger of dying without benefit of the Holy Sacraments.[1]

Like the *St. Catherine* and the *Madonna and Child on a Grassy Bench* (Cat. Nos. 5, 4) with which the *St. Barbara* was grouped in a tripartite arrangement, Baldung's woodcut illustrates the artist's efforts at this stage of his development to adapt Dürer's vocabulary of form to his own compositional and expressive ends. A detail such as the large, relatively unshaded section of the cape that covers Barbara's shoulder in the shape of a rhombus has analogies in the robe of St. Anne in Dürer's woodcut of the *Meeting at the Golden Gate* from the *Life of the Virgin* series, dated 1504 (B. 79, K. 177), while the profile face, with its high forehead and flying hair, recalls the Eve of Dürer's engraving of the *Fall*, from the same year (Fig. 15). Here, within a few short years of the appearance of Dürer's prints, Baldung shows his talent for assimilating the types and forms of his master into compositions imbued with the hieratic rigor that he deemed appropriate for this ensemble of devotional woodcuts.

The *St. Barbara* shares the same general compositional elements with the two prints with which it is matched, but is somewhat looser and less disciplined in its line. It differs also in its setting, which adds indications of clouds and shading in the sky, but is less detailed in the treatment of land forms and trees. As both landscape types have counterparts in earlier works by Dürer and in later ones by Baldung, it is difficult to equate these distinctions with a discrete development in the artist's style; haste of execution alone might account for such differences. —L. K.

1 This aspect of the saint's protection is mentioned in the German verses by Dürer that accompany impressions of Baldung's print with Latin and German inscriptions (e.g., Vienna, Albertina); see H. Rupprich, *Dürers schriftlicher Nachlass*, I, Berlin, 1956, p. 133, no. 8:

> O Barbara, du raine mayd,
> Komm mir zu hilff inn gröstem laidt.
> Ich bitt, du wollest mir erwerben,
> Auf daz ich nimmermehr mag sterben,
> Ich werd dann sacramentlich bericht,
> Vnd hab mein sündt gegen gott geschlicht.

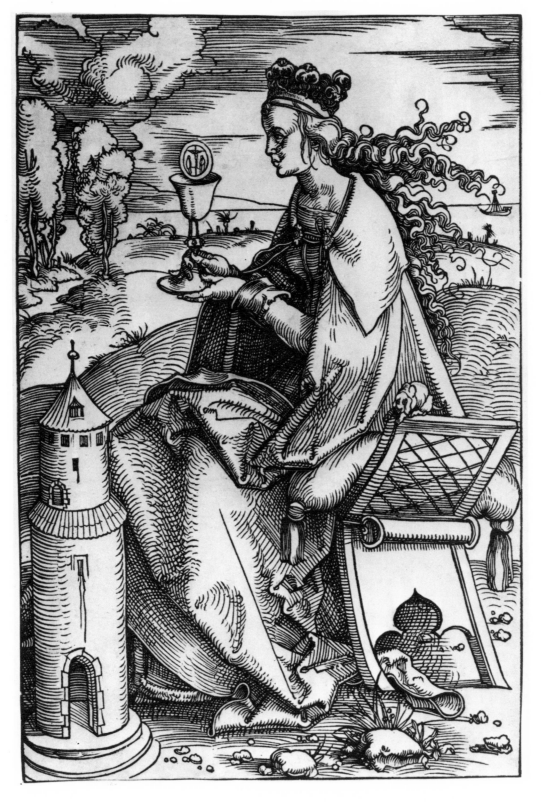

6

## 7

*Crucifixion*

c. 1505–07

Woodcut
238 × 162 mm. (9⅜ × 6⅜ in.)
B. VII, p. 175, no. 6 (as Dürer); G. 63; H. 12;
Karlsruhe 1959, II H 8; M. 2
Lent by the Museum of Fine Arts, Boston,
Purchase Fund

Within Baldung's twelve devotional woodcuts of c. 1505–07, the *Crucifixion* forms part of a subgroup with two other representations from the Passion, the *Descent from the Cross* (Ill. 7a) and the *Lamentation* (Cat. No. 8). The three events comprise a narrative sequence and, indeed, it has been suggested that, like Cat. Nos. 4–6, they were designed as a kind of triptych.[1] This hypothesis is supported by the compositions of the three prints: the *Descent from the Cross* is centralized in the triangular arrangement of its principal structural lines, while the main diagonal of the *Crucifixion* runs from the top left to the bottom right, and that of the *Lamentation* reverses this direction. The three scenes thus seem to be organized into the symmetrical and structurally stable shape of the letter "W." But it should nonetheless be noted that the resulting arrangement constitutes an iconographically unusual ensemble; thus far no comparable examples of representations of the *Descent from the Cross* flanked by scenes of the *Crucifixion* and the *Lamentation* have been identified.

Baldung pays homage to Dürer in the sources for all of the major elements of his *Crucifixion* composition: the figures of the Virgin and St. John at the right and of Stephaton, holding the reed and sponge at the left, are derived from the corresponding scene in the *Green Passion*, produced in Dürer's shop in 1504 (Ill. 7b);[2] the Magdalene embracing the cross is excerpted from Dürer's *Calvary* woodcut of c. 1500–02 (Ill. 7c); the personifications of the sun and moon have precedents in woodcuts executed in Dürer's shop during the 1490s (K. 88, 125); and the obliquely positioned Christ occurs in the panel of the *Crucifixion* from the *Seven Sorrows of the Virgin*, produced in Dürer's shop c. 1496 (Ill. 24a), before appearing in one of the modest and schematic woodcuts attributed to Baldung himself in *Der beschlossen Gart*, published in Nuremberg in 1505 (M. 169).

Although Baldung borrowed the principal elements of his print from compositions of dramatic and narrative intensity, his treatment is fundamentally different in character. Focusing upon the main protagonists, enlarging the scale of his figures, and locking them into a simplified, geometrically fixed composition, he creates an image of restrained contemplation, rather than narrative action. His technique contributes to this mood, for he employs a graphic system of orderly hatching and cross-hatching, and makes considerable use of regular parallels. The composition and figures are also subdivided into relatively large and visually coherent areas of light and dark, a device that reflects Baldung's knowledge of Dürer's *Life of the Virgin* woodcuts of c. 1503–05. —L. K.

1  Oettinger/Knappe, p. 15; Mende, p. 43, no. 2.
2  Baldung's appropriation of these two figure groups was somewhat too literal —compositionally at least, if not in details of costume, props and posture —for their positions relative to the cross are reversed in the woodcut, thereby violating the iconographic norm according to which Christ looks upon the holy figures to his right or "good" side.

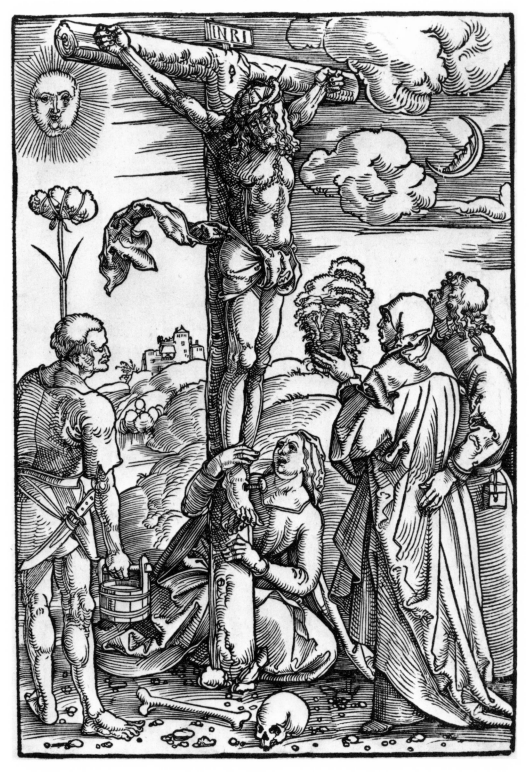

7

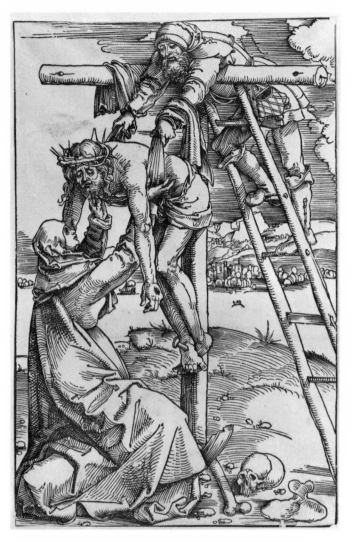

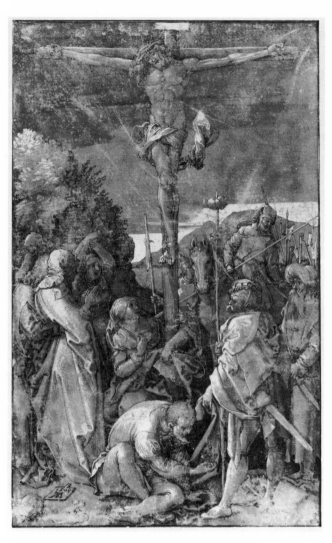

7a. Hans Baldung, «Descent from the Cross,» c. 1505–07, woodcut.

7b. Albrecht Dürer, «Crucifixion» (from the «Green Passion»), 1504–05, pen on green prepared paper, Albertina, Vienna.

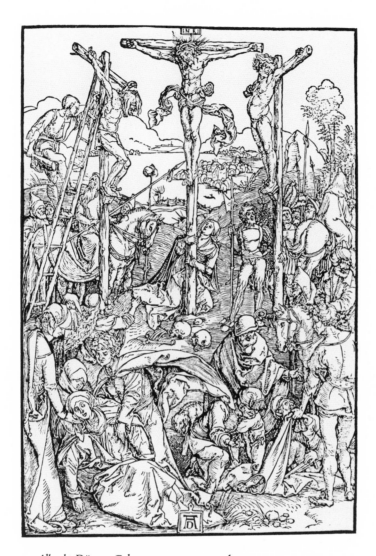

7c. *Albrecht Dürer, «Calvary,» c. 1500–02, woodcut.*

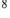8

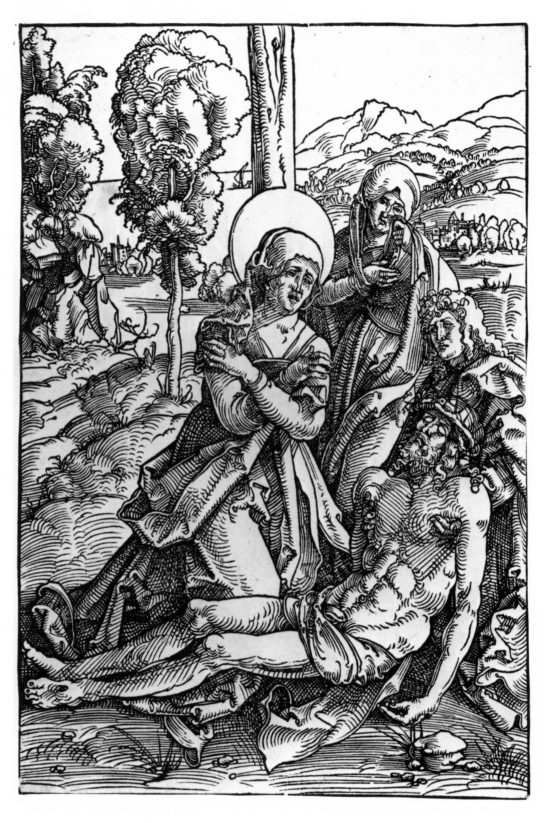

## 8

*Lamentation*

C. 1505–07

Woodcut
239 × 162 mm. (9⅜ × 6⅜ in.)
B. VII, p. 179, no. 7 (as Dürer); G. 65; H. 52;
Karlsruhe 1959, II H 11; M. 4
Lent by August Laube, Zurich

Baldung's *Lamentation* is composed of a dense triangle of foreground figures, anchored axially by the shaft of the cross that bisects the picture space behind the Virgin's head. The composition draws upon two earlier works by Dürer, the *Lamentation* painted around 1500 for the Holz schuher family, now in the Germanisches Nationalmu seum, Nuremberg (Ill. 8a), and the large woodcut *Lamentation* of c. 1498 (Ill. 8b). Specifically, the reclining corpse of Christ, with its three-quarter, profiled torso and lolling head, the youthful St. John supporting the Savior under his armpits from behind, and— although to a lesser extent— the mourning Virgin kneeling to the left of Christ are all modeled upon the corresponding figures in the Holzschuher *Lamentation*. From the earlier woodcut, Baldung seems to have taken inspiration for the standing Magdalene, who blots her tears with a portion of her mantle, and for the general disposition of the landscape setting, comprising a rising hillock supporting the foreground actors and a large body of water that flows behind the figures, moving diagonally into the distance from right to left.

Here, as in other works of this group, Baldung reduces the number of figures in his models, enlarges them to fill the picture space, and confines them within a simple geometric outline to create a stable composition of monumental gravity. Baldung adds expressive focus to his representation through such features as the white halo behind the Virgin's head and her crossed arms, which meet at the exact center of the composition. —G. C.

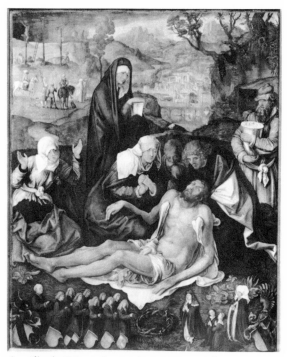

*8a. Albrecht Dürer, «Lamentation,» c. 1500, panel, Germanisches Nationalmuseum, Nuremberg.*

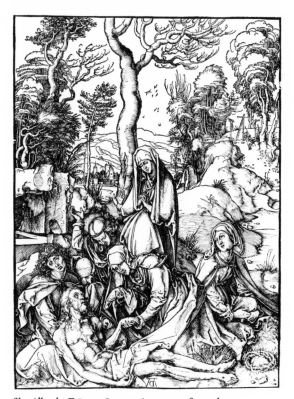

*8b. Albrecht Dürer, «Lamentation,» c. 1498, woodcut,*

9

## 9

### Last Judgment

c. 1505–07

Woodcut
258 × 174 mm. (10¼ × 6⅞ in.)
B. VII, p. 142, no. 124 (as Dürer); G. 74; H. 58;
Karlsruhe 1959, II H 17; M. 5
Lent by the Metropolitan Museum of Art,
Gift of Henry Walters, 1917

The *Last Judgment*, stylistically the most animated of Baldung's early group of devotional woodcuts, is also the largest, exceeding the average size of the others by approximately ten percent. The composition is built up about turbulent curved and arcing forms and emphatic diagonals, all pressed close to the surface and played off against the flickering light and dark patterns of the clouds that fill the picture space. The differences in style and size between this print and the other devotional woodcuts could be explained by placing the execution of the *Last Judgment* at the very beginning of the series.[1] Although this explanation is plausible, the same differences might be attributable to the expressive requirements of the theme or to the nature of the models that underlie the composition.

In its principal forms and component parts, Baldung's *Last Judgment* presupposes knowledge— direct or otherwise— of the central portion of Rogier van der Weyden's Beaune Altarpiece (Ill. 9a), created during the second quarter of the fifteenth century. Baldung revises the work of the Flemish painter, but there are distinct echoes of the earlier composition in the Christ figure, in the angels carrying instruments of the Passion, in the facial type and the veil of the Virgin, and in the billowing clouds which fill the scene and provide a base for the two intercessors in the foreground. Baldung translates Rogier's forms into a graphic language that has its closest analogy, although less precise and controlled, in Dürer's woodcuts of the *Apocalypse*, datable c. 1498. Both artists represent their visionary and dramatically animated scenes with dense patterns of line and vibrant dark and light contrasts.

Differences notwithstanding, comparisons have frequently been made between Baldung's *Last Judgment* woodcut and that by Dürer in the *Small Passion*, datable c. 1509–10 (B. 52; K. 258). Two hypotheses have been put forth to explain the similarities: either Dürer's work builds upon the composition by Baldung,[2] or else both go back to a common model by Dürer, now lost.[3] The second hypothesis seems preferable, if only because Dürer

almost certainly traveled to the Netherlands during his *Wanderjahre* (1490–94), and because he is known to have copied, or to have possessed a copy, of at least the Christ figure from Rogier's Beaune Altarpiece (W. 15).

There are additional relationships between Baldung's print and other Dürer works. Thus the muscular, nude figure of one of the dead, seen from the rear as he rises from his grave between the two intercessors, recalls Dürer's studies of nude figures, also seen in backview, made in the 1490s (W. 82), including some who stand in a similar position with a raised right leg (see in particular the dancing child in the lower register of W. 83). And the figures of Baldung's *Deësis* group are related not only to those of Dürer's woodcut from the *Small Passion*, but even more closely in some respects to the corresponding figures in the spandrel of the frame in Dürer's sketch for the All Saints Altarpiece of 1508 (W. 445a). The most likely explanation for this pattern of interrelationships, and for the pronounced Rogerian elements of the representation, is that Baldung's woodcut reflects an early composition of the *Last Judgment* by Dürer that has not survived.

1  Oettinger/Knappe, pp. 14–15.
2  Mende, p. 43, no. 5.
3  Oettinger/Knappe, pp. 14–15.

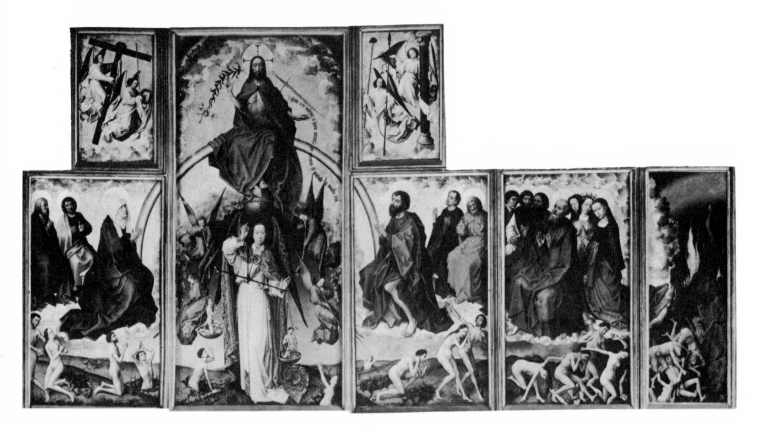

*9a. Rogier van der Weyden, «Last Judgment,» c. 1433–50, panel, Hôtel-Dieu, Beaune.*

10

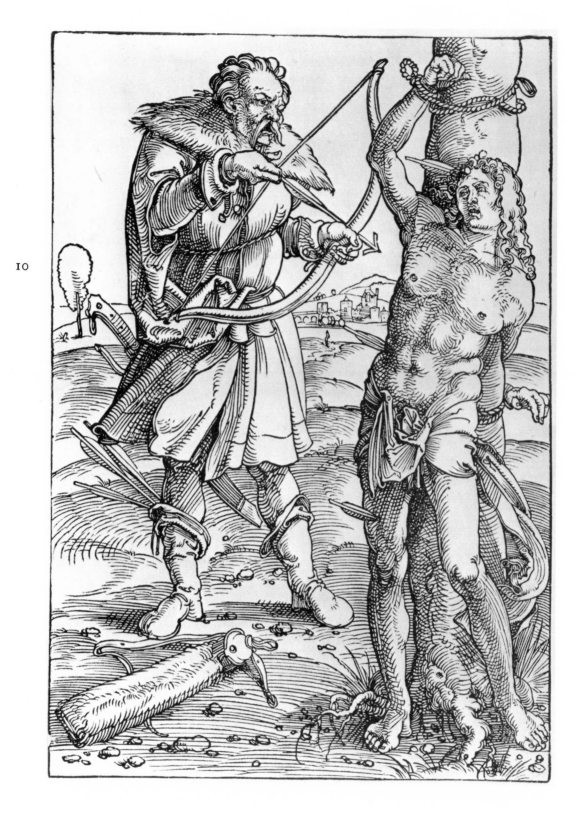

## ❧ 10

*Martyrdom of St. Sebastian*

c. 1505–07

Woodcut
231 × 161 mm. (9⅛ × 6⁵⁄₁₆ in.)
B. VII, p. 180, no. 22 (as Dürer); G. 70; H. 130;
Karlsruhe 1959, II H 64; M. 11
Lent by the Metropolitan Museum of Art,
Harris Brisbane Dick Fund, 1927

In German art of the fifteenth and early sixteenth centur⁄ies, St. Sebastian was normally represented either as an object of devotion— that is, as a single figure, bound to a tree and shot through with arrows— or in a narrative com⁄position, in which two or (usually) more figures of on⁄lookers and archers play active roles. Baldung combines aspects of both traditions in this print, retaining a refer⁄ence to the narrative in the active figure of the archer, but restricting his composition to two monumental figures in order to invest it with the focus and impact of a devo⁄tional image.

In his position and general posture, the St. Sebas⁄tian recalls that in a woodcut of c. 1495 attributed to Dürer (Ill. 10a). Both demonstrate interest in the study of ideal nude form, introduced so dramatically into German art through Dürer's encounter with the Italian Renais⁄sance, but Baldung's figure is more animated and com⁄plex in its contrapposto, suggesting the artist's contact with more advanced figure studies by Dürer, as exempli⁄fied by the Adam in Dürer's 1504 engraving of the *Fall* (Fig. 15). Baldung's figure lacks the controlled detail and the equipoise of Dürer's, but there are echoes of the mas⁄ter's form in the extended and raised right leg of the saint — corresponding to the left leg of Dürer's Adam— and in the exaggerated and bunched musculature on the right side of the midsection of both figures. Less than a decade later, in a woodcut of 1512, Baldung was to fur⁄ther exaggerate the torsion and motion of this figural type to create a St. Sebastian of even greater dramatic pathos (Cat. No. 31).

The archer in Baldung's woodcut, with his drawn and downturned bow, is reminiscent of the corresponding figure in the right foreground of the artist's St. Sebastian Altarpiece, dated 1507, in Nuremberg (Fig. 4). In the woodcut, the archer is a more active and monumental form, which has led at least one scholar to suggest that the print "revises" the panel, thereby postdating it.[1] The em⁄phasis upon starkly focused drama in the print allies it particularly to two other woodcuts of this early group, the *Stoning of St. Stephen* (M. 7) and the *Conversion of St. Paul* (Ill. 52a).

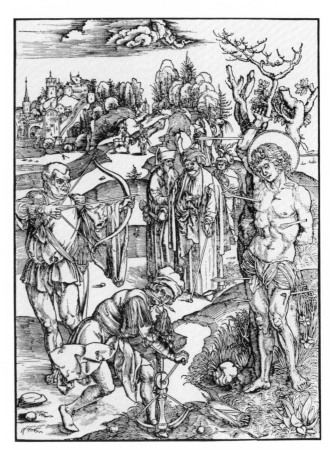

*10a. Albrecht Dürer (?), «Martyrdom of St. Sebastian,» c. 1495, woodcut.*

Baldung's composition takes on its dramatic force through the contrast the artist draws between the rela⁄tively passive figure of the saint, anchored to the vertical tree, and the more dynamic form of the archer. A series of diagonals formed by the quiver on the ground, the archer's bow and arrows, and even the fur trim of his collar create powerful lines of movement to the right, while the figure of the would⁄be executioner, aiming downward at the saint, seems to press upon him in his helplessness. Al⁄though standing further back in space, the archer visually dwarfs the saint through his greater breadth and by the silhouetting of his upper body against the blank sky. The result of all these formal and compositional devices is a representation that casts passive and active, good and evil figures into sharp relief. —L. K.

1  Oettinger/Knappe, p. 42.

11

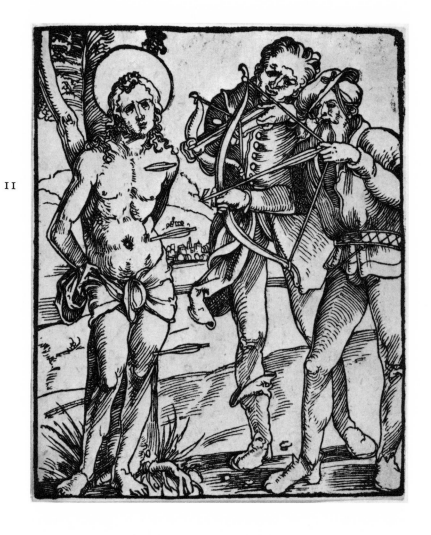

∾ II

*Martyrdom of St. Sebastian*

C. 1507

Woodcut
125 × 99 mm. (4¹⁵⁄₁₆ × 3⅞ in.)
H. 131; Karlsruhe 1959, II H 87; M. 553
Lent by the Metropolitan Museum of Art,
Harris Brisbane Dick Fund, 1924

Often ascribed to Baldung,[1] this modest woodcut has at
best a dubious claim on Baldung's authorship. Although
it was obviously designed by an artist in Dürer's— and
possibly also Baldung's— sphere of influence, it does not
manifest stylistic traits which justify an attribution to a
known artist. Previous attributions to Baldung were based
primarily on the general similarity of the poses and ges-
tures of the two archers to the analogous figures in Bal-
dung's St. Sebastian Altarpiece of 1507 (Fig. 4). This
superficial parallelism might be explained in several ways.
The designer of this print may have had access to Bal-
dung's preliminary drawings for the altarpiece or even to
a lost prototype by Dürer which was used by Baldung as
well. Connections with Dürer and his shop are in any
case certain since the figure of St. Sebastian is reminiscent
of that in an engraving by Dürer of c. 1498 (B. 56; D. 23);
moreover, the woodcut also exists in a second state with
Dürer's monogram added in the sky at the right. The
poor quality of the cutting makes it difficult to come to a
definitive judgment, but the lack of energy in individual
lines and the lifeless composition speak against the pres-
ence of Baldung's hand.

1   Campbell Dodgson (*Catalogue of Early German and
    Flemish Woodcuts . . . in the British Museum*, I, London,
    1903, p. 561) accepted the print as an early effort by
    Baldung. Curjel, Geisberg, and Hollstein concurred
    with the attribution, but it was questioned in the Karls-
    ruhe 1959 catalogue and removed from Baldung's *oeuvre*
    by Mende.

## Study of a Head in Profile

C. 1505

Pen and ink
169 × 145 mm. (6⅝ × 5¹¹⁄₁₆ in.)
Koch 22; Karlsruhe 1959, no. 117
Lent by the Staatliche Museen Preussischer Kulturbesitz,
Kupferstichkabinett, Berlin-Dahlem

This ink sketch, formerly assigned by some scholars to Dürer, is now generally considered a school piece by the young Baldung. The work reflects Dürer's interest in ideal types, as manifested in a series of male and female studies from c. 1500–04, and is particularly close to the profile of Adam from the engraved *Fall of Man* of 1504 (Fig. 15). Comparisons have also been suggested with a drawing by Dürer of a *Head of a Man in Profile* in Frankfurt (W. 287),[1] but Baldung's figure is more generalized in its features, lacking the specificity or portrait-like traits of Dürer's. Since Dürer executed a series of preparatory sketches for the figures of the *Fall of Man*, this drawing may be based upon a study for the head of Adam that has not survived.

The identification of this work as a school piece follows not only from the hypothetical relationship with a Dürer model, but also from the *mise-en-page* and the style. All of Dürer's drawings of heads contain indications of such features as hair, the back of the head or the neck lines; they thus possess an organic wholeness that is lacking in this face and ear, which seem mask-like, excerpted and incomplete. The graphic style has analogies with that in a Dürer sketch in the Musée Vivenel in Compiègne of a *Head of a Woman in Profile* (Ill. 12a), a work that Winkler considered a possible preparatory study for the Eve of the *Fall of Man* (W. 281). Both sketches recall the engraving technique in their complex patterns of inscribed line, but the two differ significantly in *ductus*, reflecting the differing degrees of mastery achieved by teacher and pupil. Thus, where the female head is constructed from finely ordered patterns of flexible hatching and cross-hatching that create an impression of rounded, plastic form, the line of the male head is overworked and dry, and lacks the fluid, form-defining qualities of the other sketch. The contour also seems exaggerated in the sketch attributed to Baldung, and there are awkward passages in front of and below the eye, beneath the lower lip, and in the entire ear, which is overly large in proportion to the face. As the weaknesses of this drawing stand out in comparison with the relative fluency and

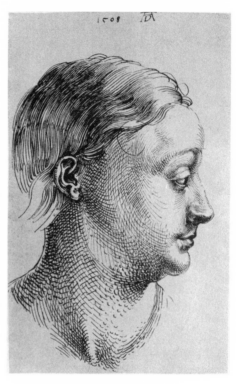

*12a. Albrecht Dürer, «Head of a Woman in Profile,» c. 1503–04, pen, Musée Vivenel, Compiègne.*

energy of other Baldung heads of this period (e.g., Koch 8, Cat. Nos. 15–16), the attribution to him depends upon seeing it as a student exercise, in somewhat labored imitation of Dürer. The inscription *licht* ("light") adjacent to the ear has actually been attributed to Dürer,[2] which would be consonant with a master's critique or correction of the work of one of his assistants. —H. C. C.

1  Oettinger/Knappe, p. 17.
2  See W. Strauss, *The Complete Drawings of Albrecht Dürer*, New York, 1974, II, 1104, appendix no. 10.

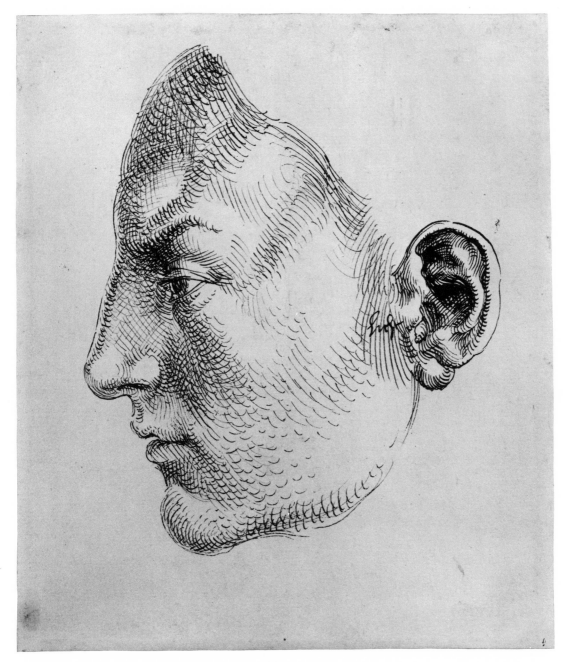

12

13

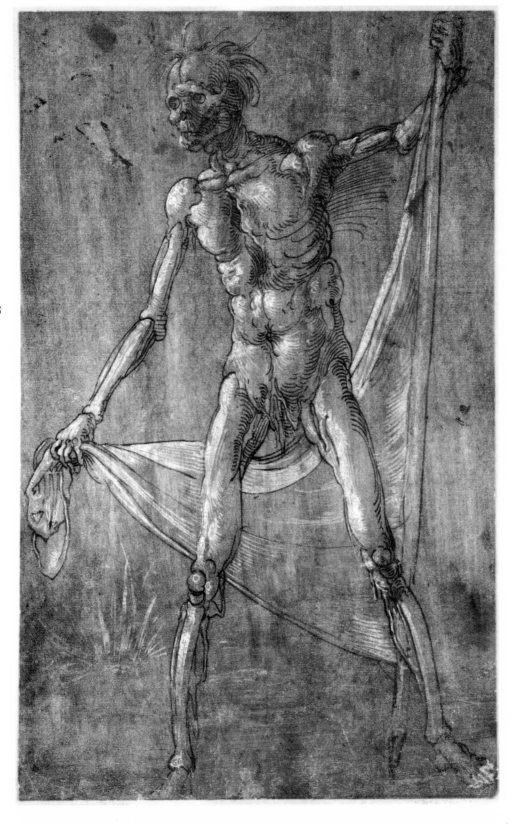

## Death with an Inverted Banner

C. 1505–07

Pen and ink, heightened in brush with white,
on light brown tinted paper
298 × 185 mm. (11¾ × 7⁵⁄₁₆ in.)
Koch 15; Karlsruhe 1959, no. 110; Basel 1978, no. 13
Lent by the Kunstmuseum Basel, Kupferstichkabinett

The presence and reality of death were treated with new directness by Northern European artists of the late Middle Ages and the early Renaissance, and Hans Baldung was assuredly one of the keenest interpreters of the theme.[1] In this work, Baldung takes up two subjects particularly popular in his time, the *memento mori*, or reminder of death, and the life of the soldier. The striding skeleton is an unambiguous reference to the coming of death, but the image is given special focus by the inverted banner, its point resting on the ground and its loose end held in the manner of a shroud. The banner was a conventional attribute of soldiers, and indeed, Baldung depicted armed banner carriers in two drawings of this period, one dated 1504 (Ill. 13a) and another of c. 1505 (Koch 9). In a narrow sense the inverted banner signifies military defeat; held as it is here by a skeleton, it becomes an emblem of the end that awaits those who live by the sword, or, in a still broader sense, of the ravages of war.

Baldung's sketch must be seen against the background of contemporaneous images that seemingly glorified the status of soldiers; that is, in representations of proud and virile banner and spear carriers. Historical circumstances contributed to the emergence and popularity of this subject matter in art: in the wake of the defeat of the mounted Burgundian forces of Charles the Bold at the hands of Swiss, Swabian and Alsatian pikesmen and halberdiers in 1477, mercenary footsoldiers or *Landsknechte* assumed great importance on the European scene; the Emperor Maximilian I, celebrated in poetry and saga as the last knight and the first *Landsknecht*, further spread the fame of these swaggering soldiers by forming great armies of them for deployment in his battles about Europe.[2] In consequence, many of the prints of *Landsknechte* and standard-bearers by such artists as Dürer (B. 87, D. 27), H. S. Beham (G. 273–82), Wolf Huber (G. 886) and Hans Schäufelein (G. 1098–1105)— to name only some of the better known— reflect public fascination with and a certain romantic attitude toward the life of these soldiers of fortune.

Baldung's drawing is a notably early example of an explicitly moralizing backlash against the glorification in art of military life, a critical theme that, in the related form of a confrontation between soldiers and Death, was to attract the talent of Dürer in a woodcut of 1510 (B. 132, K. 210) and that is reflected in the work of Urs Graf, a sometime mercenary soldier himself.[3] Baldung first treated the subject in a drawing of 1503 (Ill. 13b) in which a skeleton stands facing a *Landsknecht*. The representation is built up about the visual parallel between the footsoldier's halberd and the skeleton's lance of bones, and is dispassionate, save for the contrast between the anguished facial expression of the *Landsknecht* and the mocking grin of the cadaver. The Basel drawing, however, presents us with what is possibly Baldung's first example of an activated figure of Death, a subject for which he is justly famed (Figs. 5–6, 35). Directed intently to the left, the skeletal figure is a visual and symbolic counterpart to the *Banner Carrier* who seems caught in mid-stride to the right in Baldung's drawing of 1504 (Ill. 13a). Jean Wirth has suggested that the Basel drawing may have been part of a larger composition[4]— perhaps one in which Death faced a living soldier of the type in the 1504 drawing. However that may be, the imagery of *Death with an Inverted Banner* is sufficiently explicit to communicate its moralizing theme with compelling directness.

The skeleton is more animated than the artist's earlier figures and assumes a more complicated pose. True, Baldung had attempted to suggest rhythmic articulation or motion in his previous representations of *Landsknechte* (Ill. 13a; Koch 9, 13), but this figure is more fluent in its motion and more highly developed in its counterpoise. The impetus to this development and a measure of the degree to which Baldung kept pace with his teacher can be seen in the source for this distinctive pose: Baldung's figure of Death was inspired by the Adam of Dürer's *Fall of Man* engraving of 1504 (Fig. 15), or by one of Dürer's studies for the Adam showing him in the same orientation as the skeleton (e.g., W. 333). Baldung altered the pure profile of Adam's head, but the positions of the load-bearing and extended, slightly raised legs are analogous, as are the extended arms and the ones that grasp a branch or staff, respectively. Although it may seem ironic that Baldung appropriated the posture of what is probably the best known Northern European example of a study of idealized masculine form for his representation of a decaying cadaver, the choice is of possible iconographic significance, if only on an associational level, because of the significance of the Fall of Man as the cause of human death (Genesis 2:17). Baldung's capacity for such an association is shown in his panel of *Eve, the Serpent and Death* (Fig. 18), in which Adam's place in a representation of the Fall is taken by or combined with a representation of a skeletal, partly decayed figure.

In graphic style and expression, as well as in icono-graphic complexity, the Basel drawing represents a considerable advance over the works of 1503–04. The anatomy of Death is more carefully observed than that of the skeleton in the drawing in Modena (Ill. 13b), and the artist makes a greater effort to suggest the condition of physical decay. This is achieved in part coloristically, for the light and grainy brown tone of the prepared paper is itself suggestive of dessication, and the white highlight-ing — brushed on in chalky, mat patterns rather than in fine networks of linear hatching — lends the surface a pe-culiarly inert character that is appropriate for the repre-sentation of a corpse. In addition, Baldung replaces the relatively long and regularly cross-hatched black lines that in his earlier drawings suggest continuously modeled form with series of short, parallel modeling strokes that

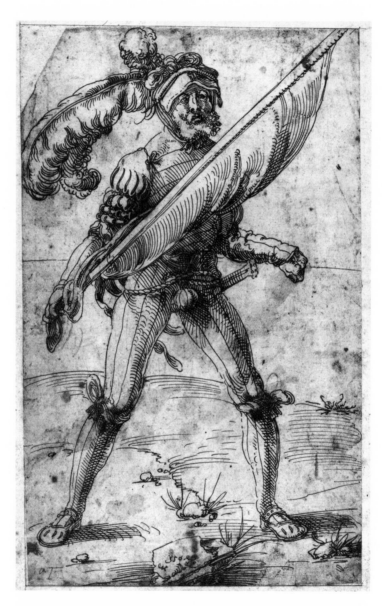

13a. Hans Baldung, «Banner Carrier,» 1504, pen,
Schwarting Collection, Delmenhorst.

suggest the loss of organic fluidity and the surface frag- ment ation of the flesh and bones of a cadaver. It is no accident that the closest analogies for these technical and coloristic features occur in a sketch of another dead figure, the *Thief on a Cross* (Koch 14), that bears Baldung's monogram and the grape leaf that he employed as a form of emblematic signature from c. 1505 to 1511. —W.K.

1  See Jean Wirth, *La jeune fille et la mort: Recherches sur les thèmes macabres dans l'art germanique de la Renaissance,* Geneva, 1979.
2  See M. Nell, *Die Landsknechte: Entstehung der ersten deutschen Infanterie,* Berlin, 1914, pp. 85, 171, 195, 285, and *passim.*
3  Wirth, *La jeune fille et la mort,* p. 132, figs. 116–17.
4  Ibid., p. 46.

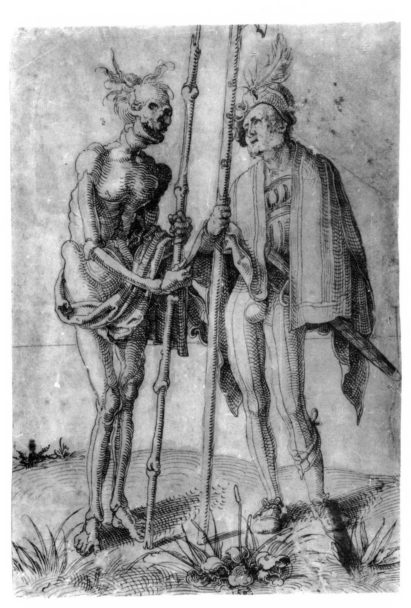

*13b. Hans Baldung, «Death and a Landsknecht,» 1503, pen,
Galleria Estense, Modena.*

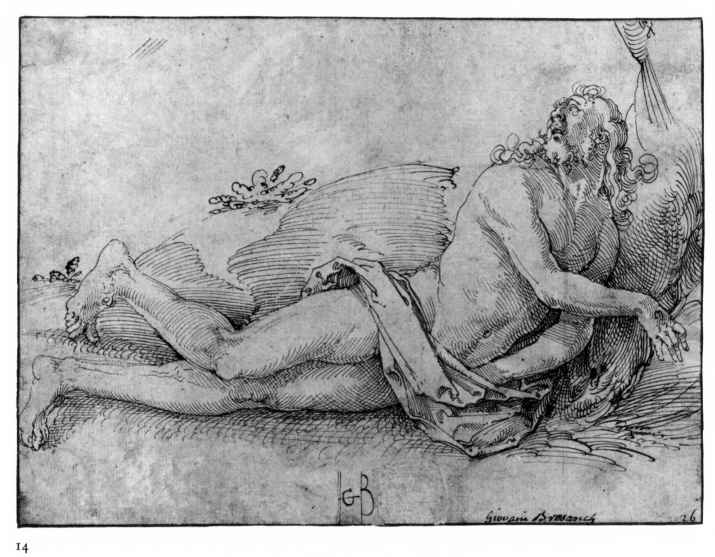

14

## 14

*Dead Christ*

C. 1507

Pen and ink
169 × 240 mm. (6⅝ × 9⁷⁄₁₆ in.)
Karlsruhe 1959, no. 112
Lent by the Metropolitan Museum of Art,
Robert Lehman Collection

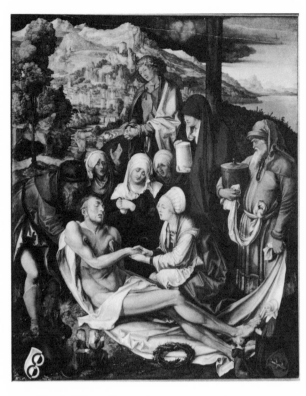

*14a. Albrecht Dürer, «Lamentation,» c. 1500, panel,
Alte Pinakothek, Munich.*

Ernst Buchner, who first published this drawing in 1950, correctly recognized it as one of the last works from Baldung's stay in Nuremberg.[1] The graphic system and the bold line ally it with other works of this period, but it is distinguished from the drawings of c. 1503–05 (Cat. Nos. 1–3) by its concentrated energy and its heightened pathetic expression. Baldung creates a sense of swirling intensity in the freely sketched, curved lines that define the hill behind and above the figure of Christ (compare the ground at left in the drawing of a *Madonna and Child* in the Louvre, Koch 19), and he shows new graphic freedom in the long lines that sweep up in rhythmic parallels across Christ's shoulders and neck into his face. The oblique viewing angle of the face, seen from below, with the mouth opened, has analogies in two of the study sheets of c. 1507 (Cat. Nos. 15ᵛ and 16) and became one of Baldung's characteristic devices for expressing pathos in suffering and dead figures (Cat. Nos. 27, 29, 31).

The drawing is unusual iconographically for its representation of the prone figure of Christ without attending figures. Buchner saw a possible source of inspiration for the body of Christ in Dürer's panel of the *Lamentation* for the Glimm family of c. 1500 (Ill. 14a), a traditional work in which other figures support Christ and hold his raised right hand. By omitting all subsidiary figures and such narrative references as the cross or other instruments of the Passion, Baldung isolates the body of Christ from a familiar thematic context, and thereby forces the viewer to confront the issue of his death in fresh terms. The impact of the figure also derives from its posture. Karl Oettinger has called attention to the evocative ambivalence that Baldung creates between the fact of Christ's death, indicated by the wounds in his feet and his right hand, and the intimations of life suggested by the positions of the unsupported right hand, the partially raised right leg, resting on its toes, and of the upturned head and open mouth.[2] He relates the pose of the figure to that in a drawing of a reclining female nude either by or after Baldung (Oettinger/Knappe, fig. 90), itself a free copy in reverse of a drawing by Dürer of 1501 (W. 260; Oettinger/Knappe, fig. 119). There are also analogies,

however, with a sketch of a reclining male figure, evidently drawn from life, in Baldung's Karlsruhe Sketchbook,[3] and in the reclining figures found in three modest woodcuts designed by Baldung for *Der beschlossen Gart des Rosenkranz Mariae,* published in Nuremberg in 1505 (M. 90, 101, 155). The first two of these woodcuts, which contain analogies for the positions of Christ's feet and crossed arms, respectively, represent Adam during the stages of creation; even if Baldung merely intuited reminiscences of these figures rather than intentionally quoted them, they take on special interest in a representation of the dead Christ because of the Christian doctrine that he suffered the Passion in order to atone for Adam's transgression. However that may be, it is apparent that the pose of Christ, like the view of his upturned face, constitutes one of the elements of Baldung's emerging vocabulary of form.

In this sketch, these elements are welded together by means of Baldung's bold and energetic line to create an arresting devotional image that has something of the intense pathos of the artist's small engraving, the *Man of Sorrows tied to the Column* (M. 545) and the large woodcuts of the dead Christ of c. 1515-17 (Cat. Nos. 50-51). Even at this early date we see Baldung departing from tradition and searching for newly evocative forms to represent the theme of Christ's human suffering and death.

1   See Ernst Buchner, "Eine unbekannte Zeichnung von Hans Baldung Grien," *Die Kunst und das schöne Heim,* XLVIII, 1949-50, pp. 447-50, and George Szabo, *XV-XVI Century Northern Drawings from the Robert Lehman Collection,* exhibition catalogue, The Metropolitan Museum of Art, New York, 1978, no. 26. The drawing was recently removed from its old mat, revealing a watermark of a crown with cross similar or identical to Briquet 4953, dated 1507. The sketch might conceivably have been dated to the right of Baldung's monogram, as in the *Eve* of 1510 (Fig. 17), but a rectangular segment has been torn from the paper at this spot and replaced in a later restoration.

2   Oettinger/Knappe, p. 26.

3   See K. Martin, *Skizzenbuch des Hans Baldung Grien: "Karlsruher Skizzenbuch,"* Basel, 1950, fol. 17ʳ. The sketch, visible only under ultraviolet light, was considered by Koch (p. 42, n. 7) as a later addition, and was therefore omitted from his corpus of Baldung's drawings.

## ❧ 15 recto

## *Study Sheet with Head of Christ*

c. 1505-07

Pen and ink
160 × 145 mm. (6⅜ × 5¾ in.)
Koch 16; Karlsruhe 1959, no. 113
Lent by the Cabinet des Dessins, Musée du Louvre

In contrast with the labored touch of Cat. No. 12, this sketch is noteworthy for its linear grace and restraint. Here Baldung explores the descriptive and expressive character of different types of line, juxtaposing passages of systematic hatching and cross-hatching in the face with long, rhythmically articulated strands of hair and coiled beard. The improvisational and experimental character of the sketch is underscored by its spare ease, and above all by its avoidance of contour, elsewhere one of the mainstays of Baldung's art. Instead, with a striking economy of line, Baldung suggests forms subtly emerging from the page, an effect heightened by the tension he creates between the planar calligraphy of the hair and beard and the greater depth and solidity of the facial modeling.

Although formerly catalogued as a "Portrait of a Man," this drawing has been convincingly identified as a head of Christ. Its closest analogies are with the Christ figure of the stained-glass window depicting *Christ and the Adulterous Woman* in Grossgründlach,[1] datable c. 1505, one of several compositions from this ensemble thought to be based upon a design by Baldung; as the points of agreement include not only the full frontal view but also some details of the hatching, the sketch in Paris may represent Baldung's initial idea for this figure. The facial type is also recalled in the Christ figure of Baldung's chiaroscuro drawing of c. 1512, *Christ and the Doubting Thomas* (Koch 30), where the artist again suggests a mood of introspection and gentle sadness, in part through a similarly unfocused gaze. In this later work the Christ figure is somewhat diaphanous in its form, especially in comparison with the more heavily contoured and modeled figure of Thomas. In both drawings Baldung seems almost to mitigate the finite character of Christ, as if to suggest something of the dematerialization appropriate for the representation of a spiritualized figure. —H. C. C.

1   Oettinger/Knappe, pp. 64-65, figs. 38-39.

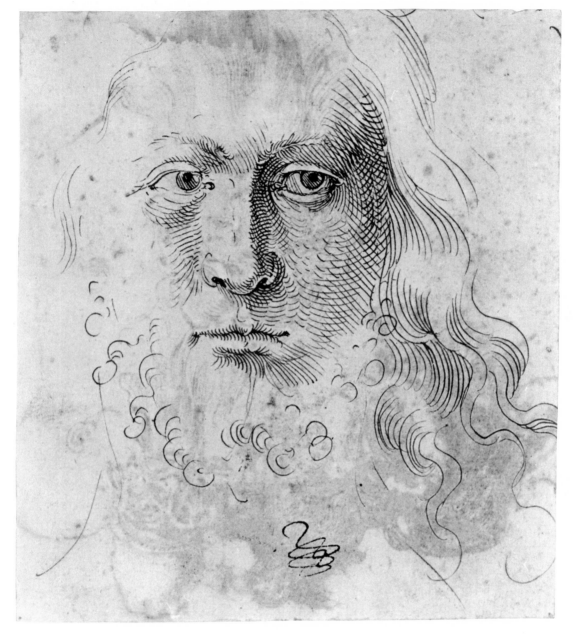

15 verso

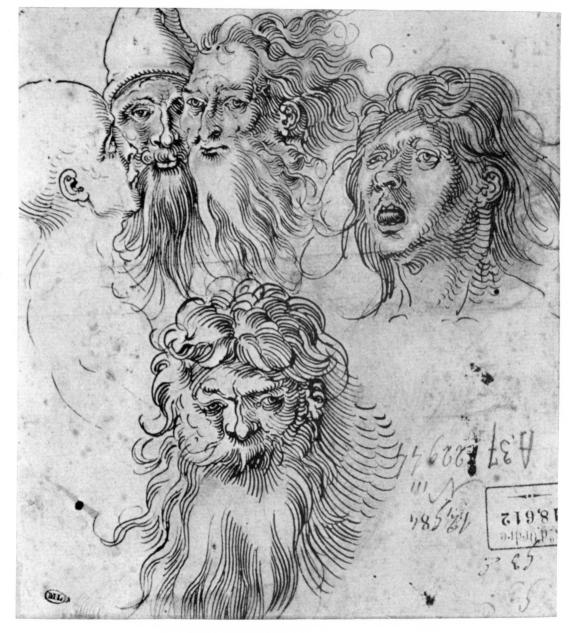

*Study Sheet with Five Heads*

C. 1507

Pen and ink
160 × 145 mm. (6⅜ × 5¾ in.)
Koch 17; Nuremberg 1961, no. 13
Lent by the Cabinet des Dessins, Musée du Louvre

Like Cat. No. 16, with which it is related in style and date, this side of the small study sheet in the Louvre contains a series of physiognomic studies of character types. The page has its roots in the tradition of late medieval model books, or sheets, in which artists collected diverse figural and physiognomic types for reference and subsequent use in their own compositions.[1] As in most model sheets of heads, the figures on this leaf do not derive from a known single work or series, but represent a random assemblage of facial types that apparently interested the artist at this time. Many model sheets depict patriarchal types that bear a general resemblance to the bearded figures on this page. Indeed, earlier examples provide precedents for such components as the upturned head of the figure at the right,[2] and the group in the upper left section in which a figure in frontal view is flanked and partly overlapped by two figures in partial or full profile.[3] Closer to Baldung's time, certain of the figures in this sketch echo types from the figural vocabulary of Dürer— for example, the bearded man at the top center, whose face recalls that of the "Sea Monster" in the engraving of that name (B. 71; D. 30), or Zacharias in the woodcut of the *Visitation* from the *Life of the Virgin* (B. 84; K. 182). The young man at the right in Baldung's drawing, with upturned face and open mouth, has his counterpart in the figure of St. John devouring the book in Dürer's woodcut from the *Apocalypse* (B. 70; K. 114). Having thus rehearsed these types, Baldung could adapt them for use in his own works: the bearded, patriarchal type at the top center, for example, has numerous parallels in Baldung's art,[4] while the expressive and anguished expression of the youth at the right is reinterpreted, as it were, in the face of several of the artist's St. Sebastians (see Cat. No. 10 and Koch 24).

One characteristic that differentiates this page from most similar model sheets, including the *Large Study Sheet* (Cat. No. 16), is its strong spatial sense. Whereas in the *Large Study Sheet* the figures all emerge from a common plane, here the forms seem to move forward in space along a clockwise, circular path from top left to lower center. The spatial quality of this sheet has a curious analogy in Leonardo da Vinci's famed drawing of *Five Grotesque*

*Heads* in Windsor Castle, datable in the 1490s (Ill. 15ᵛa).⁵ Here, too, five figures, including one with an upturned head and an even more anguished, open mouth, are represented in a quasi-circular arrangement in depth. Although differences between the two leaves far outnumber similarities, precluding any direct influence from Leonardo's sketch, Panofsky has brought forth strong evidence that Dürer studied Leonardo's figural types during his second Italian trip;⁶ if, as is generally assumed, this drawing postdates Dürer's return to Nuremberg at the beginning of 1507, Baldung might have had access to some of Leonardo's ideas through Dürer. This hypothesis takes on special interest because Baldung's sheet also contains a bald-headed figure represented in profile at the left who has no real parallel in his own *oeuvre*⁷ or that of Dürer, but who recalls one of the distinctive figure types favored by Leonardo.⁸ Although this suggestion of indirect contact with Leonardo is no more than a tentative one, it would help to explain some of the special aspects of this leaf and to account for its important distinction from the *Large Study Sheet*.

Whatever the compositional and figural sources for the *Study Sheet with Five Heads*, it is noteworthy for its confident, bold line and for the concerted intensity of its figures. Where most of the drawings of c. 1503–05 are characterized by a somewhat scratchy drawing style and by complex patterns of cross-hatching, including regular passages of straight parallel lines, here the forms are defined almost exclusively by more flexible, rhythmically animated parallels. The resulting figures are thus more three-dimensional in their substance and more dynamic in expression. Baldung cultivates this sense of vital energy in the expressive contortion of the face of the youth at the right, in the forceful projection of the head at the top center, where the hair and beard stream back to the right, and in the almost animal vitality of the mass of mane-like hair and beard that frames the face in the lower section of the page. In their dramatic expression and sheer linear force, these figures are worthy forerunners of the better known *Apostles* (Cat. Nos. 61–72) and character studies (Cat. Nos. 55–59) of the second decade of the sixteenth century. —H. C. C.

1 See R. W. Scheller, *A Survey of Medieval Model Books*, Haarlem, 1963.

2 See H. Kreuter-Eggemann, *Das Skizzenbuch des Jaques Daliwe*, Munich, 1964, text vol., figs. 66 (with mouth also open) and 67, both of the early fifteenth century.

3 Ibid., plate vol., pl. XIb (early fifteenth century) and F. Winzinger, *Die Zeichnungen Martin Schongauers*, Berlin, 1962, fig. 109 (drawing attributed to the Master BM, a follower of Schongauer active in the late fifteenth century).

4 See Oettinger/Knappe, pp. 54, 62, figs. 26, 28, etc.

5 A. E. Popham, *The Drawings of Leonardo da Vinci*, New York, 1965, pl. 133.

6 Panofsky, pp. 114–15.

7 The only analogy I have noted in Baldung's *oeuvre* is a partial one, with the angle of view and facial contour of the figure of Stephaton at the left of the early woodcut of the *Crucifixion* (Cat. No. 7), but this figure is not bald, and the overall impression made by the two figures is quite different.

8 Popham, *The Drawings of Leonardo da Vinci*, pls. 139a, 140b, 141, 191, 216, etc.

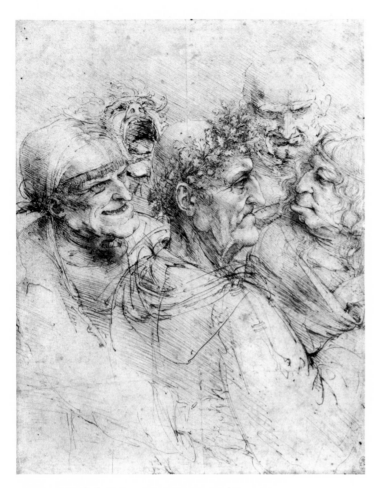

15$^{verso}$ a. Leonardo da Vinci, «Five Grotesque Heads,» c. 1490, pen,
Windsor Castle.

16

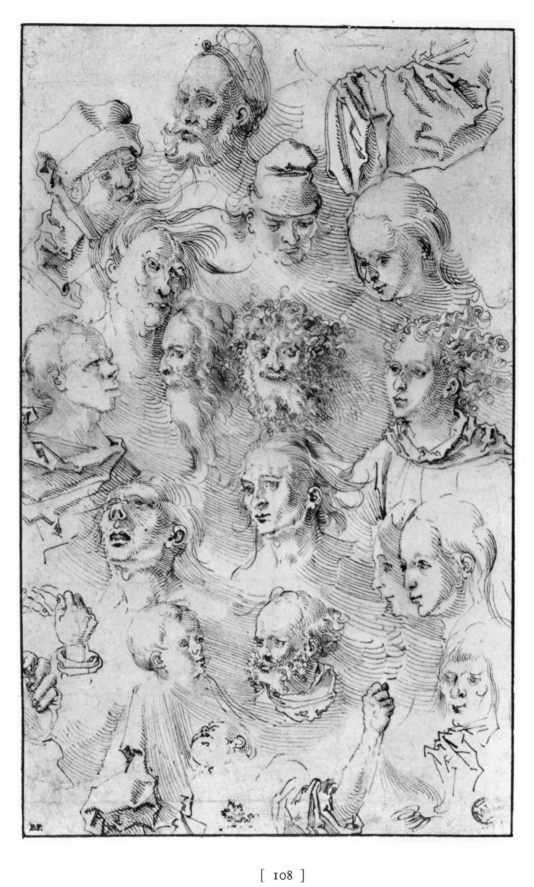

## 16

*Large Study Sheet*

c. 1507

Pen and ink
290 × 180 mm. (11⅜ × 7¼ in.)
Koch 18; Karlsruhe 1959, no. 111
Lent by the Cabinet des Dessins, Musée du Louvre

In this work Baldung records a fascinating sample of fa-cial types, hand and drapery studies. The physiognomies range from infancy to maturity, from secular to sacred, and from coarse, if not ugly, to the beautiful and ideal. Identifiable types include a St. Peter, located above the arm in the lower center of the sheet, an angel, probably Gabriel from an Annunciation, at the middle of the right margin, and the Virgin Mary, just above the angelic fig-ure, recognizable from other contemporaneous depictions by Baldung (Koch 19). There are also "stock" types of a more general kind, especially ethnic and character types employable in diverse contexts. An apparently retrospec-tive element may be seen in the capped figure at the top left corner, a distinctive exotic type found particularly in representations of Christ's enemies in German panel painting of the fifteenth century.[1] More up-to-date charac-ters also occur— for example, the bearded and capped man at the top center, who recalls figures employed by Dürer in his woodcut *Knight and Landsknecht* of the late 1490s (B. 134; K. 100), or in his engraving of a standing *St. George* of c. 1503 (B. 53; D. 46). Dürer's influence may be assumed for the pug-nosed figure at the left center, who has a close counterpart in the tormentor kneeling be-fore Christ in the *Crowning with Thorns* of the *Green Pas-sion*, dated 1504 (W. 306), and is likely for the inclusion of the details of studies of hands (cf. W. 47, 336) and of infants' heads (cf. W. 387, 393–400). While such mun-dane subjects as hands and babies were of course sketched by many artists, the analogies with related works by Dürer go beyond mere subject matter to include the fea-tures chosen for study (e.g., clenched fists) and the view-point. Thus, the eccentric view of the head of an infant in the lower center, seen in sharp foreshortening from below, is similar to that in a drawing by Dürer in the Biblio-thèque Nationale, Paris (W. 387). As Dürer's drawing was executed in Venice in 1506 and could not have been seen by Baldung until the master's return to Nuremberg in 1507, this possible evidence of a *terminus post quem* helps to support the date of 1507 that has been suggested for this sketch on other grounds (Koch, p. 24).

The *Large Study Sheet* is not of interest solely as a repository of figures inspired by earlier artists, but also

contains embryonic forms of physiognomic types em-ployed by Baldung throughout his career. For example, the upturned head of a man, just below and to the left of center, is echoed in a chalk drawing of c. 1516 in Stock-holm (Koch 47), in the bad thieves (to Christ's left) in two *Crucifixion* panels of 1512 (Curjel, pls. 14, 15), and in the Antaeus in a 1531 panel in Cassel (Ill. 78a). Simi-larly, the head of a man in the top left quadrant, with his hair blown to one side, is recalled (despite changes) in the *St. Sebastian* woodcuts of 1512 and 1514 (Cat. Nos. 31, 48) and in the angel of the *Annunciation* in the Freiburg Altarpiece of c. 1516 (Curjel, pl. 30). Other figures and figure types— e.g., the idealized women at the right below the angel, and the curly-haired man in frontal view at the center— occur as *leitmotifs* virtually throughout Baldung's *oeuvre*.

While this sketch derives from the same tradition of model books or sheets as Cat. No. 15ᵛ, it stands out from all earlier examples of the genre in its striking and ani-mated *mise-en-page*. The heads in earlier study sheets are customarily unrelated to one another visually— drawn in different scale, with varied lighting systems, distinctly separated by inviolable contours— or are set down ac-cording to rudimentary principles of opposing profiles or hieratically regular registers. In contrast, Baldung employs a consistent system of lighting, scale and modeling, and he welds his figures together into a unified yet complex and dynamic composition. The figures are organized into a series of circles about the vertical axis of male heads at the center of the sheet. Indeed, these are no static forms, for Baldung interrelates his figures and leads our eye around the circles by such devices as the inclination of the heads and the directions of their glances, and he empha-sizes this movement through the blowing hair and the ac-tive, diagonal hatching that serves as a foil for the compo-sition. The result is a series of circular subgroups that interlock along clockwise and counter-clockwise paths, simultaneously animating and focusing the composition.

Although there is no narrative content to this sheet, there is a strong sense of mood. The faces are not the blank masks seen in most model sheets, but possess a vital psy-chological presence and an emphatic sculptural one. Both these factors contribute to the knotted turbulence of the sheet, as do the powerful currents of line in the back-ground hatching. The heads seem to precipitate from this linear matrix, as if the diffused energy of the hatching had concentrated and materialized in human form. This bold use of hatching is essentially unprecedented. While it derives from the practice of indicating a shaded and solid ground plane either beneath or behind a figure, here Baldung frees this ground from its traditional representa-tional function and expands it for use as a dynamic but general field.

Typically, Baldung does not use this abstract device in a straightforward manner. The figures are not simply placed in front of the hatching, but simultaneously emerge from and merge with it. Thus, the lines modeling the forehead of the infant in the lower left break through the contour of his head to become the ground; the hair of the man immediately above the infant blends into the hatching; and the head of the young man just below the center of the sheet also shows this play as the hatching to the right of his neck seems to suggest, without actually becoming, a shoulder. Most of the figures participate in this ambiguity in varying degrees. In an almost ironic fashion, Baldung uses the hatching to contradict the very plasticity which it creates, indicating that the same lines which give sculptural presence to the figures also create the flat background. At the same time that he acknowledges the different levels of illusion of the graphic medium, he creates another effective means of unifying the disparate elements of his composition.

Baldung's emerging sense of artistic autonomy, visible in the growth of confidence and invention in his works, is also reflected in the grape-leaf insignia that appears as a form of emblematic signature in this (at the center of the lower edge) and other drawings of the period c. 1505–07/8.[2] Although Koch interpreted the signature as an indication that Baldung might have left Dürer's shop by 1505 when the master departed on the second trip to Italy,[3] it is noteworthy that it occurs only on drawings during these years— on private works of art, that is— not appearing on woodcuts until 1510–11 (Cat. Nos. 18–19),[4] after Baldung had been admitted to the guild in Strassburg as an independent master. As Baldung appears to have copied at least one drawing produced by Dürer after his return from Italy in 1507 (Cat. No. 17), we follow Oettinger and Knappe in assuming his presence in Dürer's shop until at least 1507. The insignia, then, need be seen only as a statement of artistic self-consciousness, not as a sign that Baldung had established his own shop in Nuremberg by 1505. —H. C. C.

in Nuremberg in 1507 (M. 290), but here the artist places it unobtrusively on the ground in the lower right corner, much as other natural objects in the same work (e.g., the small rock and grass in the left corner), thereby disguising its role as a personal emblem. In contrast, the grape leaf is prominently placed and visually isolated in the woodcuts of 1510–11 and the earlier drawings, and is adjacent in some of these to dates or to the artist's initials, all of which call attention to its role as a form of signature.

1   See A. Stange, *Deutsche Malerei der Gotik*, VII, Berlin, 1955, figs. 81 (figure facing Christ in an *Ecce Homo*) and 219 (the figure at the front of the crowd beneath the crosses in the Housebook Master's *Calvary*).

2   See also Koch, nos. 12, 14 and 19. (Like the authors of the Karlsruhe catalogue, no. 114, and Oettinger/Knappe, cat. no. 33, Koch does not mention the grape-leaf insignia of his no. 19, just to the left of an added Dürer monogram; although the insignia is smudged and abraded, its traces are still clearly visible in the original and in good reproductions.)

3   See Koch, p. 75 (commentary for no. 14).

4   The grape leaf also occurs in Baldung's woodcut of the *Raising of the Cross* from the *Speculum passionis*, published

## ❧ 17

*Head of an Apostle*

C. 1508

Pen and ink, heightened in brush with white,
on blue-green tinted paper
124 × 177 mm. (4⅞ × 6¹⁵⁄₁₆ in.)
Koch 44; Karlsruhe 1959, no. 190
Lent by the Statens Museum for Kunst, Copenhagen

Long considered a problem work within Baldung's *oeuvre*, and assigned by some scholars to Dürer, this drawing was convincingly explicated by W. Guthmann in 1959 as a copy by Baldung after a lost study by Dürer for the Heller Altarpiece.[1] Although the central panel of the altarpiece, executed c. 1508–09, was destroyed by fire in 1729, its composition is known through a painted copy of 1614 by Jobst Harrich, and Dürer's plans for many of the individual figures survive in his famous chiaroscuro studies for the commission (W. 448ff.). Baldung's drawing is based upon a study by Dürer, which has not survived, for the head of the figure who kneels in the right foreground of the central panel (Ill. 17a). The heads are similarly positioned, looking upward, and they show an identically foreshortened view, with the eyes obscured by the oblique angle of the head, which projects into depth. Dürer's study for the head of the Apostle who looks upward in the left foreground of the Heller Altarpiece is extant, however, and can be taken as a stylistic surrogate for the lost study (W. 448). The differences in style and technique between the two drawings are essential ones. Where Dürer employs line to define three-dimensional form in powerful relief, using white only to accent limited areas of highlight, Baldung creates abstract patterns of curvilinear forms through an overall use of white and by stressing pure calligraphic forms in the hair and beard. Baldung negates the solid, sculptural effect which was Dürer's goal, emphasizing instead animated and forceful lines that tend to assert the planarity of the figure on the surface. Although Dürer omitted necks from some of his studies of heads for the Heller Altarpiece (W. 449, 451), Baldung further flattens and abstracts his figure by omitting not only the neck but also the ear and the entire back of the head. Baldung's figure, and many of the lines of which it is composed, seem thus to float on the surface of the page without cohering into a solid whole.

As Dürer's preparatory sketches for the Heller Altarpiece date from 1508, Baldung's drawing should be placed in the same year. The dependence upon Dürer is shown not only in the compositional borrowing, but also in the color of the paper, which is reminiscent of the

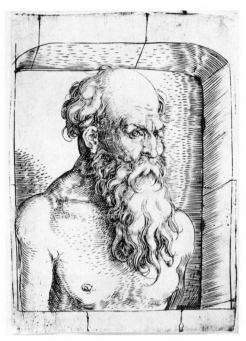

17b. Hans Baldung, «Bearded Old Man,»
c. 1508, engraving.

greenish-gray of Dürer's sketches for the altarpiece. Baldung's drawing was formerly dated to c. 1515, but Guthmann has pointed to compelling stylistic analogies with the study of a *Head of Christ* in the Louvre (Cat. No. 15ʳ), and Oettinger has noted formal similarities, particularly in the representation of the hair and beard, to the head of Joachim in one of the stained-glass windows in Grossgründlach, designed by Baldung about 1506 (Oettinger/Knappe, p. 42, fig. 61). Baldung's drawing may also be compared with his engraving of a *Bearded Old Man* of c. 1508 (Ill. 17b):[2] although the hair and beard of the engraved figure are not as freely drawn as that in the sketch, the figures display similarly expansive foreheads, furrowed brows, and hooked noses.

Baldung's drawing furnishes important evidence that he remained in Nuremberg, and in contact with Dürer, until at least 1508. Despite his dependence in this work on a study by Dürer, he also uses the opportunity to demonstrate his independence as a draftsman. Baldung here confidently indulges his tendencies towards virtuoso calligraphic line, freely translating Dürer's forms into his own formal idiom. —H. C. C.

1 See W. Guthmann, "Zur Kopenhagener Kopfstudie Hans Baldung Griens," *Marburger Jahrbuch für Kunstwissenschaft*, XVII, 1959, pp. 193–96, and A. Pfaff, *Studien zu Albrecht Dürers Heller-Altar*, Nuremberg, 1971, pp. 63ff. and Anhang, p. IV, no. 9.
2 For the date of c. 1508, see Karlsruhe 1959, II K 6, and Oettinger/Knappe, p. 41.

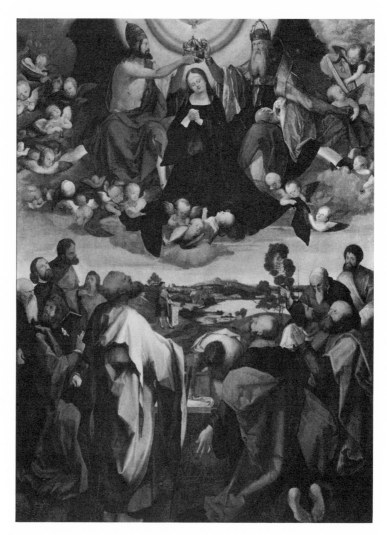

17a. Jobst Harrich, «*Assumption and Coronation of the Virgin,*» 1614,
panel, (*after Dürer's lost Heller Altarpiece, 1508–09*), Historisches
Museum, Frankfurt.

17

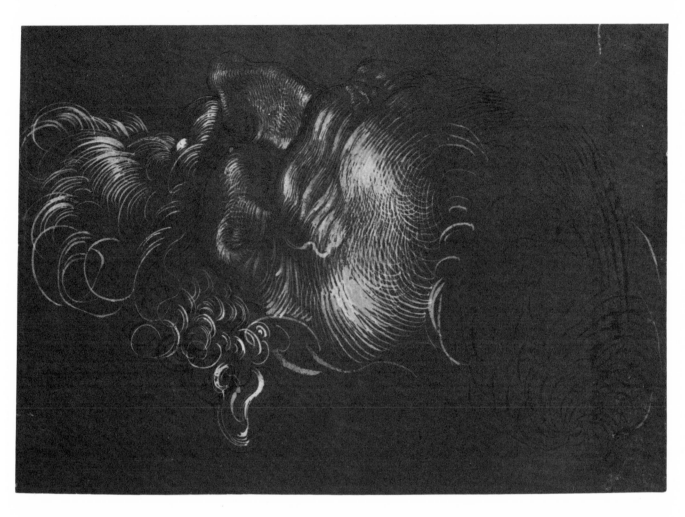

## 18

*Witches' Sabbath*

DATED 1510

Chiaroscuro woodcut
379 × 260 mm. (14¹⁵⁄₁₆ × 10¼ in.)
B. 55; G. 121; H. 235; Karlsruhe 1959, II H 76;
M. 16

A. Key block: Lent by August Laube, Zurich
B. Chiaroscuro with gray tone block:
   Lent by the Museum of Fine Arts, Boston,
   Bequest of W. G. Russell Allen
C. Chiaroscuro with orange tone block:
   Lent by the Trustees of the British Museum

This work, one of the artist's best known prints, is possibly Baldung's first single-leaf woodcut as an independent master in Strassburg. Equal in size to the largest of his woodcuts, it breaks new ground in subject matter, expression and technique, unmistakably signaling the emergence of a distinctive artistic personality. Baldung proclaims his authorship in the tablet with his initials (HBG) which hangs from the tree at the right in imitation of Dürer's method of signing prints; the date 1510 appears on the tree trunk, just below the grape-leaf insignia that Baldung employed as a form of emblematic signature in several works from the Nuremberg period.

An assembly of naked witches is shown in a nocturnal landscape. Two figures are seated in the foreground, one with her back toward the viewer, the other holding a vessel with exotic (pseudo-Hebraic?) lettering which spouts a great cloud of vapor. A frightening old hag appears between them with arms outstretched, screaming a command to one of her younger companions. Above is a fourth figure seated backwards on a flying goat as in Dürer's engraving, *The Witch* of c. 1500-02 (Ill. 18a). Two other witches are also represented: one, behind the hag, extends a flaming vessel on a staff beneath the hindquarters of the flying goat, while another apparently flies through the air on a cloud of vapor in the upper left corner. At the far right is a rotting tree, its gnarled surface and decaying limbs echoing forms of the central figure and contributing to the mood of bleak desolation. Baldung has integrated these larger motifs and a variety of smaller details into a coherent pictorial whole: the three main figures, arranged in a triangle, dominate the foreground action; a series of short diagonals radiating from the center connects the group with the surrounding areas; and the horizontals of the pitchfork on the ground and that held by the witch on the flying goat combine with the vapor clouds at the left and the vertical of the tree at the right to impose stable framing elements on the otherwise active composition.

Witchcraft was rarely represented in art before 1500, for during the Middle Ages the subject was suppressed by Church doctrine. This began to change during the fifteenth century with the appearance of several demonological treatises, most notably the *Malleus Maleficarum*, or "Hammer of Witches," first published about 1486.[1] The witch, usually a woman, was portrayed as Satan's agent in human affairs: a sexual deviant who flew through the air on brooms, pitchforks and goats, concocted strange potions to induce hypnotic trances, engaged in vile eating habits, including cannibalism, and worked *maleficia* upon the Christian faithful (e.g., raising storms, causing famine or impotence). These ideas found fertile ground in popular superstitions of the day and also received widespread civil, ecclesiastical and intellectual sanction, especially in German-speaking lands. In Strassburg, for example, such leading figures as Sebastian Brant, Johann Geiler von Kaisersberg and Thomas Murner all wrote or preached on the subject of witches during the early sixteenth century.[2] In art there was a corresponding rise in witchcraft as a subject. Baldung's woodcut— perhaps the first single-leaf print to treat the theme— reflects these changing attitudes at the beginning of the century: the stark nakedness and indecorous postures of the figures are in keeping with the new emphasis placed upon the witch's lascivious nature; the figure on the goat relates to the growing interest in the power of witches to fly; the dense, seething vapor carrying vermin into the air may refer to their baneful influence on the weather; the figure holding a goblet suggests their ingestion of hallucinogenic potions; and the plate of bird-like or reptilian victuals held by the hag may allude to their revolting diets.[3]

Such unusual thematic material, with its explicit reference to the fantastic, stimulated Baldung to employ new formal and technical means. In earlier works he relied upon a system of cross-hatching in imitation of Dürer. However, this system did not always convey a convincing sense of volume, tending rather to degenerate into areas of abstract surface pattern. This is not the case with the *Witches' Sabbath*. Cross-hatching is used sparingly, only in the darkest shadows; parallel hatching plays the main role in achieving plasticity. Fluent, uninterrupted lines and contours create a pulsating rhythm that animates the composition and adds to the impression of demonic phantasmagoria, while the murky shadows of the landscape from which the forms emerge are suggested by lighter hatching. Similarly, the bizarre subject was a factor in Baldung's choice of medium. In such works as *Death with an Inverted Banner* (Cat. No. 13), an earlier drawing heightened with white on colored paper, Baldung had begun to explore the expressive characteristics

of a colored ground; the new medium of the chiaroscuro woodcut, of which Baldung's print is one of the first examples, allowed artists to exploit similar coloristic effects in reproduceable form. The chiaroscuro woodcut was never employed by Dürer. Baldung may have learned it from Hans Burgkmair, who applied a colored woodblock (*Tonplatte*) to an original black-and-white design as early as 1508, or from Lucas Cranach the Elder, who did so by c. 1507–09.[4] But Baldung uses the medium more evocatively than any of his contemporaries: his prints of the *Witches* in gray enhance the mysterious nocturnal mood of the scene, while those in orange are otherwordly and eerie in effect, much as in his later panel of 1523 in Frankfurt of two *Weather Witches* (Ill. 18e). In all the chiaroscuro versions white highlights provide an added painterly accent as light dances across the surfaces of forms otherwise enveloped in tinted half-shadow. The resulting impression is that of a nightmarish vision, far removed from the realm of the commonplace.

The introduction of color into a traditionally black and white medium is consonant with Baldung's development as a painter, for it is his delight in luminous color which distinguishes his early paintings from those of his contemporaries in Nuremberg. In later years his concern for coloristic effects subsided as he began to focus greater attention upon aspects of composition and the rendering of the human figure. The *Witches' Sabbath* is an early work showing a balance between these opposing interests.

The closest thematic parallel to this print is found in a chiaroscuro drawing of witches in a landscape by Albrecht Altdorfer, dated 1506 (Ill. 18b).[5] The disposition of certain figures, the emphatic gestures, the chiaroscuro medium and the subject itself suggest familiarity with Altdorfer's work, or with a similar drawing or print. But whereas Altdorfer devotes considerable space to elements of landscape receding into distance, Baldung minimizes landscape detail and spatial recession, concentrating instead on turbulent and physically active forms that fill the picture space. The figure types, plastic and actualized, clearly derive from Dürer, yet the breadth of these forms, filling nearly half the composition with their mass and gestures, is more typical of Baldung, as are their active, indecorous poses.

Baldung's exuberance in the treatment of this theme was due at least in part to the opportunity it afforded for portraying the female nude— a growing concern in his art, beginning with this print and culminating in the large and somewhat mannered painted nudes of the 1520s (Curjel, pls. 64–67, 69–71). Here, as in many of the later works, Baldung's nudes are fundamentally evil in character, powerful figures who forcefully intervene with and alter the world about them. This is seen, for example, in his representations of Eve as a sensual protagonist in the *Fall of Man* (Cat. Nos. 19, 75), and in such figures as Phyllis (Cat. No. 37) and Judith (Fig. 23), who similarly illustrate the pernicious power of women over men. Within this broad thematic context, however, Baldung maintained a longstanding interest in the subject of witchcraft. The chiaroscuro drawings of witches of 1514 (Ills. 18c, d) and the panel painting of two *Weather Witches* of 1523 (Ill. 18e) attest to this; they also demonstrate increased concern with the sensual character of these figures in their virtuoso portrayal of the female nude. Baldung's famed images of Death menacing nude women (Figs. 6, 35) represent a parallel theme which allowed further exploration of the artist's macabre fantasies while implicitly returning to the subject of the evil nature of women.

Thus, while drawing from his contemporaries for aspects of his theme, motifs, figure types and technique, Baldung created a work of striking individuality. In the *Witches' Sabbath* the new focus upon the monumental nude, the economical use of cross-hatching, the strong contours and the remarkable coloristic effects all contribute to a work of compelling visual impact. By virtue of its size and sheer expressive force, moreover, this print gave concrete form to images of the fantastic which were current both in the popular imagination and in the vital personal imagination of Baldung. It is little wonder, then, that Baldung's print inspired a series of copies and derivative illustrations in his time[6] and that it has stimulated a tradition of interpretive commentary that continues in our day. —D. L.

1   For background, see W. G. Soldan and H. Heppe, *Geschichte der Hexenprozesse*, rev. ed. M. Bauer, I, Munich, 1911; H. R. Trevor-Roper, *The European Witch-Craze of the Sixteenth and Seventeenth Centuries and Other Essays*, New York, 1956; and E. W. Monter, *Witchcraft in France and Switzerland: The Borderlands during the Reformation*, Ithaca, N.Y., 1976. Baldung's representations of witches have been treated most fully in relation to historical and artistic traditions by Hartlaub and by G. Radbruch, "Hans Baldungs Hexenbilder," *Elegantiae Juris Criminalis*, 2nd ed., Basel, 1950, pp. 30–48.

2   Radbruch, "Hans Baldungs Hexenbilder," p. 31.

3   For the fullest analysis of these and other motifs and objects in the print, see ibid., pp. 33–35.

4   The exact origin of the technique and Baldung's contact with it are unclear; see W. Strauss, *Chiaroscuro: The Clair-Obscur Woodcuts by the German and Netherlandish Masters of the XVIth and XVIIth Centuries*, New York, 1973.

5   Hartlaub, fig. 5, and Winzinger, *Altdorfer Zeichnungen*, no. 2.

6   Four copies of Baldung's print are noted in Karlsruhe 1959, p. 276; for derivative works inspired by the print, see Hartlaub, p. 24, and Soldan-Heppe, *Geschichte der Hexenprozesse*, pp. 211 and 244.

18A

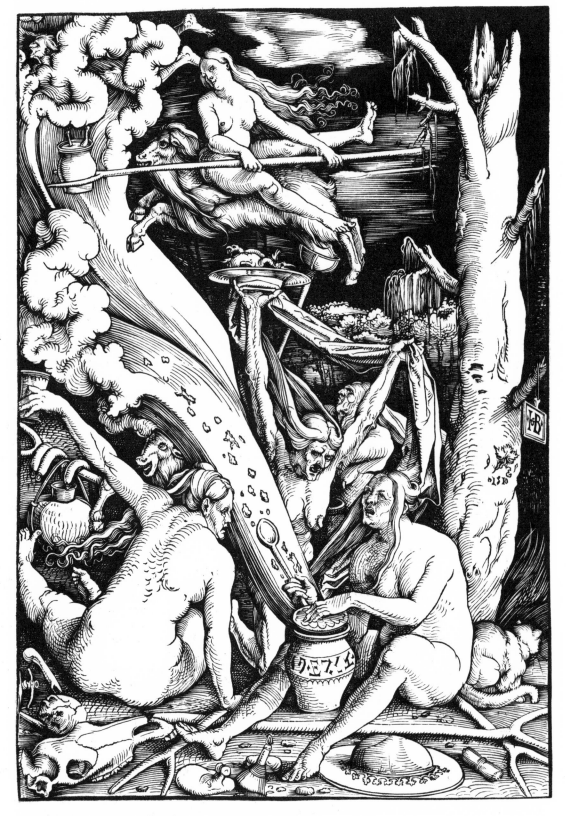

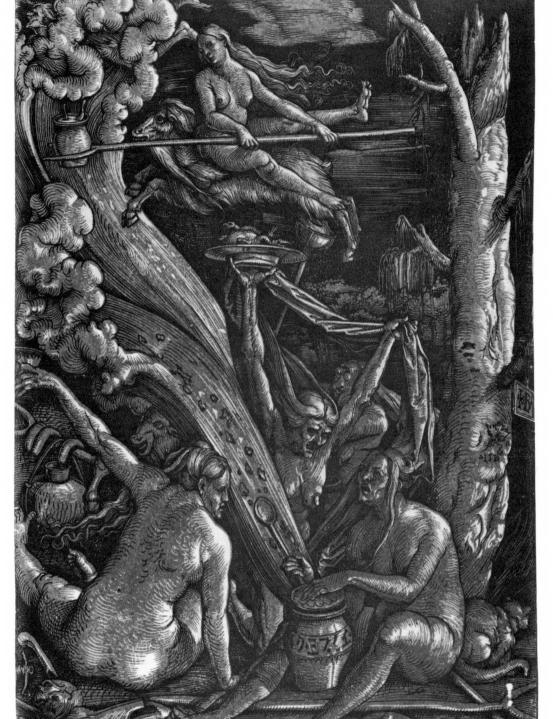

18B

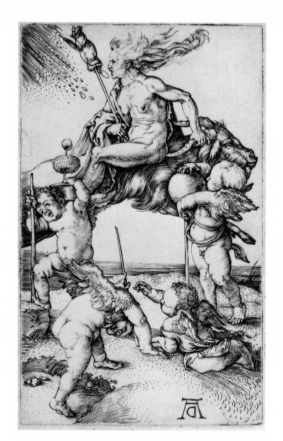

*18a. Albrecht Dürer, «The Witch,»*
*c. 1500–02, engraving.*

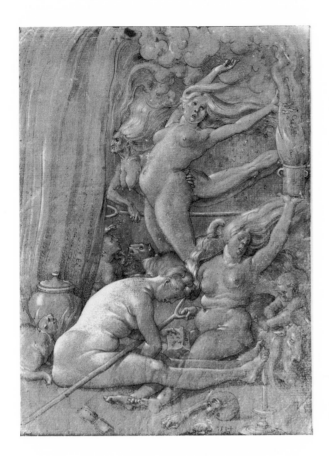

18b. (Far left). Albrecht Altdorfer, «Witches' Sabbath,» 1506, pen on pale brown tinted paper, Musée du Louvre, Paris.

18c. (Center). Hans Baldung, «Witches' Sabbath,» 1514, pen on green tinted paper, Musée du Louvre, Paris.

18d. (Right). Hans Baldung, «Witches' Sabbath,» 1514, pen on red-brown tinted paper, Albertina, Vienna.

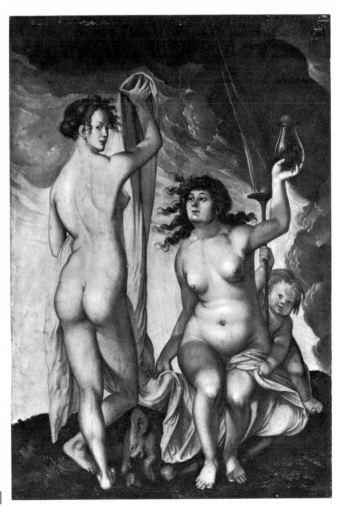

18e. Hans Baldung, «Weather Witches,» 1523, panel, Städelsches Kunstinstitut, Frankfurt.

19

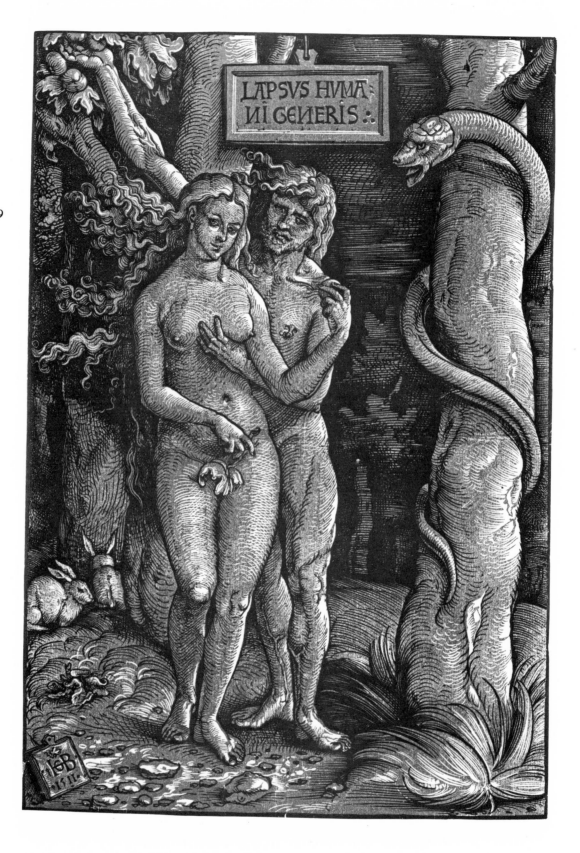

*Fall of Man*

DATED 1511

Chiaroscuro woodcut
371 × 251 mm. (14⅝ × 9⅞ in.)
B. 3; G. 59; H. 3; Karlsruhe 1959, II H 3; M. 19

A. Chiaroscuro with olive-gray tone block
   Lent by the Staatliche Museen Preussischer
   Kulturbesitz, Kupferstichkabinett, Berlin-Dahlem

B. Chiaroscuro with tan tone block
   Lent by the National Gallery of Art,
   Rosenwald Collection

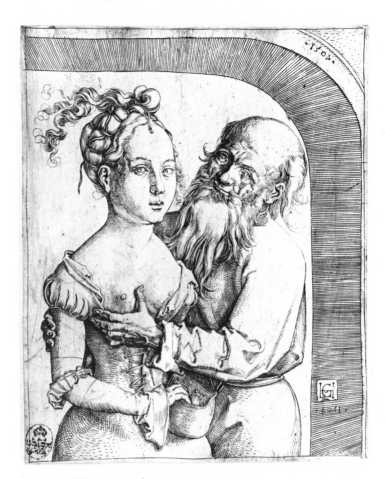

*19a. Hans Baldung, «Unequal Lovers,» 1507, engraving.*

In this, the second of his monumental chiaroscuro wood-cuts produced in Strassburg,[1] Baldung invests a representation of the *Fall of Man* with new shades of meaning and unprecedented psychological depth. For apparently the first time in art, the Fall is represented as an overtly erotic act.[2] Adam grasps Eve's breast with his left hand, recalling the gesture of the old man in Baldung's engraving of *Unequal Lovers*, dated 1507 (Ill. 19a), while he reaches with his right hand to the fruit on the branches in the upper left. Certainly Baldung exploits the well-known breast-fruit metaphor in this visual analogy, but the more important purpose of the paired gestures is to give pictorial form to currently emerging theories of the sexual substance and implications of the Fall from Grace;[3] indeed, as if to identify the significance of Adam's gesture, the artist places a plaque directly above his head with the inscription "the fall of mankind." Baldung thus interprets the Fall as a surrender to lust, and he reinforces this idea by including two rabbits at the left. The meaning of the rabbits is partly explained by Dürer's engraving of the *Fall of Man* of 1504 (Fig. 15), in which the Nuremberg master included a group of animals that represent the four humors, or temperaments, all said to have been in equilibrium before the Fall of Man; in Dürer's print, the rabbit to the right of the Tree of Knowledge thus figures as a symbol of sanguine sensuality.[4] Baldung presumably echoes this notion, but by omitting the complementary figures which in Dürer's print constitute part of a program of interrelated ideas, and by representing a pair of rabbits instead of one, he seems to use these figures on a more mundane level, as exemplars of animal lust.[5]

Baldung also redefines the role of Eve, in part by giving her a position of unusual prominence. Abandoning the predominant representational tradition, in which Adam and Eve are given equal compositional emphasis, usually flanking the tree, Baldung places Eve in front of Adam, partly obscuring his form. Adam is relegated, as it were, to the background, and Baldung underscores his position of inferiority by the lack of volition implied in his disheartened expression (recalling that of the old man in the *Unequal Lovers*, Ill. 19a) and by his curiously stiff stance. In contrast, Baldung represents a vital and animate Eve, thereby identifying her as the true protagonist of the Fall. Some idea of Baldung's aims in the Eve may be gauged by considering his choice of models. His Eve is based in part upon the figure in Dürer's 1504 engraving (Fig. 15). But Baldung's Eve is also influenced by Dürer's monumental painted Eve of 1507 (Fig. 51), in which scholars have noted the introduction into Dürer's art of a more fluent and sensual female type.[6] Baldung's figure recalls Dürer's version of 1507 in her flexible and sinuous contrapposto, in her rounded, swelling breasts, in her lower, sloping shoulders, and in the position of her left hand, gently curved upward to grasp the fruit. But Baldung departs significantly from both of Dürer's figures in having Eve look directly out of the image, addressing

both her coy, seductive smile and the apple which she seems to present to the spectator. Baldung's achievement, therefore, consists not only of redefining the role of Eve in relation to Adam, but also of altering the focus and character of the image: in place of the cool objectivity and the conceptualized symbolism of Dürer's 1504 engraving, and of the narrative concerns of most other representations of this scene, Baldung personalizes his representation for the viewer by making him the object of Eve's seductive sensuality. His Eve is no longer just the figure who seduced the biblical Adam at some remote point in time; instead, she is shown as an active and omnipresent carnal force that elicits our response now and for all time.

Baldung sharpens our response to his image by introducing dramatic elements of differing character. His Eden, for example, like the setting for the *Witches' Sabbath*, is ominously dark. Adam and Eve pose quietly in this somber landscape, but Baldung energizes the scene through the menacing and atypically large serpent at the right, whose mouth— open as if hissing— is in direct line with the figures' hair, which flies into the air in the opposite direction. Baldung uses other formal analogies to reinforce this confrontation and to extend its significance. By suggesting similarities between the tree trunk at the right and the legs and torsos of the figures, he creates an anthropomorphic resonance that encourages us to relate the snake coiled about the tree to the persons of Adam and Eve. The prominently raised veins on Adam's legs contribute to this association by echoing the serpentine form on the tree trunk, and they serve the concomitant purpose of emphasizing the mortal rather than the idealized character of Adam. In addition, by aligning Adam's raised right arm with the branches of the tree in the upper left, Baldung again associates the figures with their setting. The sum effect of all these analogies, heightened by the overall tonality of the chiaroscuro printing technique, is to extend the impact of the Fall beyond man to include all of nature as well.

Many of the themes introduced so provocatively in this woodcut retained their fascination for the artist. In Baldung's case this issue deserves more than passing attention, for his highly personalized art can sometimes be interpreted adequately only by taking account of significant interrelationships within his own *oeuvre*. It is no accident, for example, that Baldung echoed his own representation of the *Unequal Lovers* (Ill. 19a) in aspects of the pose and expression of his Adam, for both works deal with the theme of the pitfalls of lust. Almost all of Baldung's Eves show varying degrees of self-consciousness of their sensuality (cf. Figs. 17, 18), and if Baldung first introduced an explicitly erotic element in the action of Adam in this woodcut of the *Fall*, he developed it even

further in a panel in Lugano (Ill. 75a), in which Adam is still more ardent in his embrace of Eve, and in a composition known only through the intermediary of a copy in outline drawing, in which Adam's caress is patently obscene (Koch, A 27). In the panel in Lugano, as in a pair of panels representing the *Fall* in Budapest (Fig. 50), Baldung gives his Adam the facial characteristics of a satyr, thereby alluding to the depths of human lust and to its bestial character. Baldung may also be alluding to man's reduction to a bestial state as a result of the Fall by having Adam embrace Eve from behind in this woodcut of 1511, in one of 1519 (Cat. No. 75) and in the panel in Lugano.[7] However that may be, it is noteworthy that the figure of Death similarly approaches and embraces nude females from behind in some of Baldung's best known compositions (Figs. 6, 35).[8] Since Baldung elsewhere demonstrates a heightened awareness of the doctrinal implications of the Fall from Grace as the cause of human mortality (Fig. 18), this compositional echo seems also to provide insight into the range of ideas that underlie some of his most singular works. The sensual power of women, their capacity to corrupt and dominate men, the depths of lust, man's bestial nature, sin and death— these themes appear to have complemented and reinforced one another in Baldung's imagination, and thus to have conditioned the complex visual associations that inform his art.

While it would be unwise to see allusions to all of these ideas in the woodcut of 1511, it nonetheless introduces many of these issues with particular force. To be sure, the effectiveness of this print is related to such stylistic features as its robust figures, its monumental forms and its mood-setting atmosphere. Baldung's real insight, however, was to have created an image that works simultaneously on an abstract level, in which the figures are conceived as embodiments of fundamental human characteristics, and on an individualized one, in which they provoke— indeed, demand— a personal response from the viewer. The moral issue that Baldung forces upon the viewer in this work is thus a universal one, but Eve's seductive offer, and its corrollaries, are presented to us with undiluted immediacy.[9]

1  This is the last of Baldung's works to contain the grape-leaf insignia that he employed as a form of emblematic signature from c. 1505 to 1511 (here placed above his initials in the tablet in the lower left). Baldung signed his later works with his initials or name alone, or— possibly— with a quatrefoil flourish (see Cat. No. 33).
2  See the perceptive discussions of this topic and the print by E. M. Vetter, "Necessarium Adae Peccatum," *Ruperto-Carola*, XVIII, 1966, pp. 144–81, esp. 153–54, and L. Silver and S. Smith, "Carnal Knowledge: The

Late Engravings of Lucas van Leyden," *Nederlands Kunsthistorisch Jaarboek*, XXIX, 1978, pp. 239–98, esp. 247–48.

3  The sexual nature of the Fall of Man is discussed extensively in the tract *De originali peccato*, written in 1518 by Agrippa of Nettesheim (cited by Vetter, "Necessarium Adae Peccatum," n. 11, pp. 145 and 155), and this aspect of the event occupies a prominent place in works of art produced in the 1520s by the Netherlander Jan Gossaert (ibid., pp. 154–55, and Silver-Smith, "Carnal Knowledge," pp. 249–50). See also Leo Steinberg, "Eve's Idle Hand," *Art Journal*, XXXV, 1975–76, pp. 130–35.

4  Panofsky, pp. 84–85.

5  Paired rabbits are thus interpreted in Titian's *Sacred and Profane Love* by E. Panofsky, *Studies in Iconology*, New York, 1962, p. 150. For literary and artistic background to the idea that the Fall reduced man to the animal state, see Vetter, "Necessarium Adae Peccatum," pp. 153–54, and H. W. Janson, *Apes and Ape Lore in the Middle Ages and the Renaissance*, London, 1952, pp. 91ff.

6  See Hults-Boudreau p. 105, and Silver-Smith, "Carnal Knowledge," pp. 246–47, and 285, n. 35.

7  The bestial overtones of the sexual approach from the rear in Baldung's work, evocative of animal copulation, have been commented upon by Hults-Boudreau, pp. 103 and 142, n. 6.

8  The formal analogy has been noted by P. H. Boerlin in Basel 1978, pp. 25–26, and by D. Koepplin, "Baldungs Basler Bilder des Todes mit dem nackten Mädchen," *ZAK*, XXXV, 1978, p. 234. Its significance is more fully interpreted in the introductory essay by Charles Talbot, *supra*, p. 22, and especially by Hults-Boudreau, pp. 104ff.

9  Cf. a derivative copy of Baldung's print in relief sculpture by Loy Hering of Eichstatt, datable c. 1520–30, in which a series of alterations of the basic composition—some quite subtle— deprive it of precisely those features that give Baldung's work its distinctive thematic and dramatic thrust; see M. Baxandall, *South German Sculpture 1480–1530* (Victoria and Albert Museum, Museum Monograph No. 26), London, 1974, p. 68, no. 18.

20

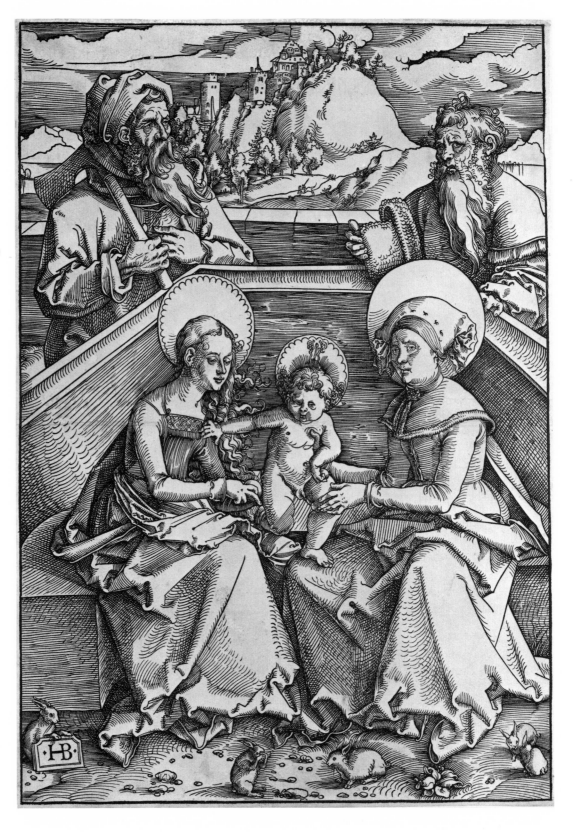

## ❧ 20

*Holy Family with St. Anne and Joachim*

C. 1510–11

Woodcut
385 × 265 mm. (15⁹⁄₁₆ × 10⁷⁄₁₆ in.)
B. VIII, p. 467, no. 6 (as Hans Brosamer);
G. 83; H. 60; Karlsruhe 1959, II H 23; M. 17
Lent by the Staatliche Museen Preussischer
Kulturbesitz, Kupferstichkabinett, Berlin-Dahlem

In addition to his iconographically innovative *Witches'
Sabbath* and the *Fall of Man*, Baldung produced a series of
equally large but more traditional religious woodcuts dur-
ing his first years in Strassburg. Two of these represent
expanded groupings of St. Anne, the Virgin and Child,
a subject of particular popularity in Baldung's work from
1510 to 1515. Besides the other large woodcut, dated
1511 (Cat. No. 21), Baldung's representations of this
theme include: a modest woodcut designed for the *Hor-
tulus animae*, published in Strassburg in 1511 (M. 332);
paintings datable from 1510 to c. 1512 in Karlsruhe
(Curjel, pl. 13), Washington (Karlsruhe 1959, pl. 6),
and Basel (Fig. 7); and a design for one of the stained-
glass windows of Freiburg Cathedral, dated 1515 (Cur-
jel, pl. 91);[1] still other versions of this subject by Baldung
are believed to be reflected in copies (Koch A7, A14).

Baldung's many variations on this theme, like those
of other artists of his day, reflect contemporary interest in
the cult of St. Anne, whom one writer has described as
the *Modeheilige*, or fashionable saint, of the late fifteenth
century in Germany.[2] The most important stimulus to
devotion to St. Anne at this time, and to its artistic mani-
festation in a hieratic image of the three generations of St.
Anne, the Virgin and Child, was the growing accept-
ance of the doctrine of the Immaculate Conception of the
Virgin.[3] In Germany, devotion to St. Anne received
special impetus through the publication at Mainz in 1494
of a tract by Johannes Trithemius, *De laudibus sanctissimae
matris Annae*, which argued forcibly in favor of Mary's
Immaculate Conception and for the veneration therefore
due to St. Anne; this early German humanist also pro-
moted the cults of Joseph and Joachim,[4] one or both of
whom are added to the central group in Baldung's two
large woodcuts of c. 1511 and in many other works of art
of the period. Frederick the Wise of Saxony, who ac-
quired a relic of St. Anne's finger in 1493, was also an
active champion of devotion to the saint: it was at his be-
hest that Pope Alexander VI elevated her feast day to
first-class status in Germany in 1496,[5] and that Pope
Julius II established new indulgences for her cult at the

Elector's Stiftskirche at Wittenberg in 1509.[6] In Strass-
burg itself, the Franciscans founded a confraternity de-
voted to St. Anne, Joseph and Joachim in 1508.[7]

Representations of St. Anne, the Virgin and Child
are known from the late thirteenth century, but reached
their apogee in Germany between c. 1490 and 1520, be-
fore losing ground with the onset of the Reformation.
The earliest depictions focus upon St. Anne, who usu-
ally holds small figures of the Madonna and Child. Bal-
dung employs a later compositional type, especially popu-
lar in Germany, in which the seated figures of the Virgin
and St. Anne hold the Child between them; this core
was then frequently enlarged by the addition of other
members of the Holy Family, ranging from one or both
of the women's husbands to large group scenes, known as
the Holy Kinship, which include additional relatives and
children.

Baldung's arrangement of the principal figures, en-
throned frontally, with subsidiary figures behind the arms
of the throne, was commonplace in his time. This com-
positional formula may be exemplified by an engraving
of the late fifteenth century by Israhel van Meckenem
(Ill. 20a) which shows the same general disposition of the
figures and a similar hieratic rigidity. Baldung omits the
symbolic figures of the Father and the dove of the Holy
Spirit,[8] found in many representations of this subject, and
contemporizes his treatment by setting the scene outdoors,
with a picturesque view to a cityscape on a hill. His
women are dressed more modishly, and the figures of
Joseph and Joachim are shown as hearty, rustic types.
Where other artists, including van Meckenem, strive to
relieve the formality of their representations by showing
some of the figures in motion or conversation, Baldung
seems to emphasize the artificial stiffness of the composi-
tion in the suggestion of discomfort on St. Anne's face
and in the poses struck by the two male figures. Joachim
is particularly self-conscious as he holds his hat— appar-
ently doffed for the occasion— and casts an uneasy glance
at the viewer; the Christchild and St. Anne likewise
look outward, as if also aware of the existence of an audi-
ence. Baldung reiterates these ideas with the rabbits in the
foreground: one at the left strikes a formal pose, holding
the tablet with the artist's monogram, while another to his
right shyly peeks out at the viewer while covering part of
his face with his paws.[9] It is, in fact, only the playful rab-
bits in the foreground and the hilly landscape beyond the
wall that relieve the strict formality of the composition.

If Baldung echoes the iconographic tradition exem-
plified by van Meckenem's engraving, other elements of
his representation may be found in works by Dürer and
elsewhere in his own *oeuvre*. The horizontal wall that
divides the foreground figures from the landscape behind
was probably inspired by that in Dürer's woodcut of

c. 1498 of the *Holy Family with Three Hares* (Ill. 2b); al/
though Baldung's wall is simplified in form and is used
for more explicitly structural purposes, the debt to this
source is confirmed by the playful rabbits in the fore/
ground of Dürer's print. Baldung's picturesque land/
scape, with its hills dotted with castles and its cloud/filled
sky, also recalls works by Dürer, particularly woodcuts
from the *Life of the Virgin* series of c. 1503–05 (e.g., the
*Visitation*, B. 84, K. 182). Prints of this series help to ac/
count for the accent upon geometrical structure in Bal/
dung's woodcut, and especially for the graphic style of
long parallel lines and of concentrated areas of light and
dark that contribute to the ordered regularity of the whole.
The physiognomic types in Baldung's print, while gen/
erally reminiscent of those by Dürer, now show a greater
debt to his own repertory of figure types. The smiling,
beautiful Virgin, for example, recalls the figure in the
upper right section of the *Large Study Sheet* in the Louvre
(Cat. No. 16) or the Virgin in a sketch of the *Nativity* of
c. 1510 in Frankfurt (Ill. 20b). The Joseph of this draw/
ing may also have provided a model for the figure of
Joachim in the print, for both similarly hold their hats
before them, and they are similar in physiognomic type.

These indications of disparate sources help to ex/
plain certain disjunctive features of Baldung's composi/
tion. There are awkward passages in the construction and
the perspective of the bench/like throne, which seems to
project back into space almost to the horizontal wall, and
in the scale of the figures of Joseph and Joachim, who
seem overly large in relation to the space allotted them be/
tween the bench and the wall and in comparison to the
foreground figures. In addition, Joseph is somewhat
larger than Joachim and seems psychologically unrelated
to the other figures in the composition. The lack of inte/
gration of these parts suggests that Baldung constructed
his composition in an additive manner.

Despite these formal anomalies, Baldung's compo/
sition was successful enough to have inspired two copies
in prints[10] and at least one derivative panel painting.[11]
Although the subject was a traditional one, Baldung re/
interpreted the popular iconographic type by adding ele/
ments that contemporize the scene, by investing the
figures of Joseph and Joachim with new dignity, and—
most importantly— by commenting upon the character
of the scene in a manner that humanizes it for the viewer.
For the self/conscious poses and glances of Baldung's fig/
ures, tellingly re/enacted in playful form by the rabbits in
the foreground, are means that the artist uses to exaggerate
the artifice of this "group portrait." Their discomfort,
their stiffness and their self/consciousness evoke our ex/
perience, and their glances relate them directly to our
world. Baldung thus gives the viewer new means of ac/

*20a. Israhel van Meckenem, «Holy Family,» c. 1475–80,
engraving.*

cessibility to what is, after all, a family gathering, while
still working within the conventions of a traditional hier/
atic image. Baldung's efforts in this regard should be con/
trasted with those of Dürer, who represented the same
subject in a woodcut produced within a year of Baldung's
(Ill. 20c). Dürer places his figures in what appears to be
an intimate wooded landscape, he lowers the vantage
point and brings us closer to them, he virtually abandons
the strict geometrical organization, and he relates the fig/
ures to one another in both a narrative and a psychological
sense (only the figure of Joseph at the right, holding his
hat as does Joachim in Baldung's print, seems somewhat
remote from the loving scene in the foreground). The two

*20b. Hans Baldung, «Nativity,» c. 1510, pen, Städelsches Kunstinstitut, Frankfurt.*

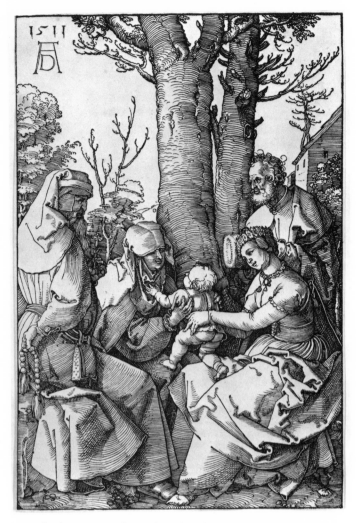

*20c. Albrecht Dürer, «Holy Family with Joachim and St. Anne,»*
*1511, woodcut.*

artists thus use fundamentally different means of relating us to the holy figures: Dürer by relaxing the iconic structure, by augmenting the narrative character of the scene, and by involving us spatially; Baldung adheres more closely to the hieratic tradition— he relates us to the figures in psychological rather than narrative terms, by exploring the tensions inherent in the very formality of this tradition. —C. S.

1 See Perseke, pp. 119ff., 132, no. 2. Although the glass painter altered Baldung's design in some details, two copies of his sketch for the St. Anne, the Virgin and Child apparently survive; see Perseke, p. 110, nos. 6–7, figs. 15–16, and Karlsruhe 1959, nos. 247–48.

2 B. Kleinschmidt, *Die heilige Anna: Ihre Verehrung in Geschichte, Kunst und Volkstum,* Düsseldorf, 1930, p. 165.

3 Ibid., pp. 161ff. and 217ff., and G. Schiller, *Ikonographie der christlichen Kunst,* 4², Gütersloh, 1980, pp. 157ff.

4 See Kleinschmidt, *Die heilige Anna,* p. 150ff.; K. Arnold, *Johannes Trithemius (1462–1516),* Würzburg, 1971, pp. 51, 103ff.; and R. Gauthier, "Un ouvrage inédit de Jean Trithème sur saint Joseph," *Cahiers de Joséphologie,* XXI, 1973, pp. 8–16.

5 Kleinschmidt, *Die heilige Anna,* p. 378. The date of 1494 is given by Schreiber, VII, p. 122, but this may derive from prints of *St. Anne, the Virgin and Child* with inscriptions recording indulgences confirmed by Alexander VI in this year for prayers recited before an image of St. Anne (S. 1191, 1195).

6 D. Koepplin and T. Falk, *Lukas Cranach: Gemälde, Zeichnungen, Druckgraphik,* exhibition catalogue, Kunstmuseum, Basel, Basel and Stuttgart, 1974–76, I, pp. 188–89; II, p. 523.

7 L. Pfleger, "Les origines du culte de saint Joseph en Alsace," *Bulletin ecclésiastique de Strasbourg,* XXXII, 1920, p. 78 (cited by J. Wirth, "Sainte Anne est une sorcière," *Bibliothèque d'Humanisme et Renaissance,* XL, 1978, p. 478).

8 Baldung retains the apple offered to Christ by Anne in the print by Israhel van Meckenem, but it is held by Christ and the Virgin in his own print; this common symbol refers to Mary as the New Eve and to Christ as the New Adam who will redeem mankind for the sin of the first parents (see E. Guldan, *Eva und Maria: Eine Antithese als Bildmotiv,* Graz and Cologne, 1966, pp. 108ff.). Baldung adds one sacred reference lacking in Israhel's print, namely the halos of the central group that are ordered according to a hierarchical sequence of plain, scalloped, and scalloped plus floreated (for St. Anne, the Virgin and Christ, respectively).

9 Mende, p. 44, no. 17, interprets the rabbits as a Mariological fertility symbol.

10 The copies are by Georg Erlinger (G. 811) and by the monogrammist PS; impressions noted in Karlsruhe 1959, II H 23.

11 See the panel of 1516 by the Master C. W. in Stuttgart, Staatsgalerie (Kleinschmidt, *Die heilige Anna,* pl. 14 opp. p. 272) which combines borrowings from Baldung's print (aspects of the features of the Virgin and St. Anne, the rabbits in the foreground and the background landscape) with elements taken from Dürer's woodcut of the *Holy Family with Five Angels* (B. 99; K. 200). Although the figure of Joseph in the panel is based upon that in Dürer's print, the Master C. W. shows him with the attribute of an axe, as does Baldung. Baldung's figure of Joseph holding an axe over his shoulder is also reflected in a drawing of the *Holy Family with St. Anne and Joachim* in Karlsruhe (Koch 69) which otherwise depends upon a woodcut by Hans Wechtlin (G. 1483; Karlsruhe 1959, no. 332). Although Koch originally attributed portions of the drawing to Baldung, including the figure of Joseph, he subsequently reassigned it to Baldung's circle; see Karlsruhe 1959, no. 256.

## 21

*Holy Family with St. Anne*

DATED 1511

Woodcut
375 × 250 mm. (14¾ × 9⅞ in.)
G. 84; H. 59; Karlsruhe 1959, II H 22; M. 18
Lent by the Trustees of the British Museum

The *Holy Family with St. Anne* is probably the later of Baldung's two monumental woodcuts of this subject (see Cat. No. 20). Inscribed 1511 on the edge of the wall in the upper left, it has proven a central work in the dating of a number of Baldung's Mariological works of this period, including the woodcuts Cat. Nos. 20 and 22 and panels containing similar representations of St. Anne in Washington (Karlsruhe 1959, pl. 6) and Basel (Fig. 7).

In contrast to the earlier woodcut, in which Baldung presented a rigidly structured and iconic version of this family portrait, here he creates a scene of greater intimacy and informality. The central group of St. Anne, the Virgin and Child is no longer enthroned, but placed directly on the ground; instead of facing the viewer, they sit at an oblique angle to the picture plane, in an off-axis composition underscored by the raking angle of the wall behind them. St. Anne and the Virgin are more mundane types than their counterparts in Baldung's earlier woodcut; more stockily built, they are also attired in less ornate costumes. Whereas the figures in the earlier print pose stiffly and self-consciously, they seem more at ease in the rustic setting of this work: Joseph rests casually upon one arm, while the Christchild, lying on his back, reaches spontaneously towards his mother's face and hair. For the figure of the Child, Baldung apparently took inspiration from his drawing of the *Madonna and Child* in Leiden, dated 1510 (Ill. 21a), where Christ again lies on his back, although covered by, rather than reaching for, strands of the Virgin's hair. The informality of the print is conveyed by graphic as well as by narrative and compositional means: in place of the meticulous and geometrically ordered line of Cat. No. 20, which contributes to its iconic character, Baldung employs a sparer linear system that contrasts broadly unarticulated areas with concentrated passages of dense shading.

In addition to its informal elements, the *Holy Family with St. Anne* incorporates motifs of probable doctrinal significance. The cracked wall behind the Virgin and Child, for example, may figure not only as a bit of rustic setting but also as a reference to the passing of the Old Law with the Incarnation and birth of Christ. The grape vine wrapped conspicuously about the dead tree trunk at the right presumably serves a similar function: the grape vine is a venerable symbol of Christ (John 15:1), both for its Eucharistic associations, predicated upon Christ's sacrificial death, and as a reference to the fruitfulness of the Virgin.[1] In this print, however, the grape vine should also be related to St. Anne. She is the dominant figure of the representation, located at the apex of the triangular group in the foreground, and the dead tree stump and vine appear at her side, rather than adjacent to the Madonna and Child. Baldung may thus have intended to extend the reference to her fruitfulness, particularly as she conceived the Virgin at an advanced age when apparently barren. Given the context of devotion to St. Anne which underlies Baldung's contemporaneous representations of St. Anne with the Virgin and Child (see Cat. No. 20), this interpretation seems historically appropriate and relevant.

St. Anne's importance in the composition is also underscored by her unusual gesture, touching the Christchild's genitalia. Koch suggested, although without adducing textual or artistic evidence, that the motif represents a folk tradition of the casting of a "miracle-working spell" on the child.[2] Jean Wirth has extended this interpretation, seeing the spell as an evil one intended to enforce chastity upon Christ; he finds the image scandalous and proposes that Baldung represented St. Anne as a witch in order to criticize excessive devotion to St. Anne at this time.[3] Most recently, Leo Steinberg has interpreted the gesture as a revelation of the sexuality of Christ, that is, as a means of acknowledging God's assumption of manhood through the Incarnation.[4] Steinberg has compiled a corpus of contemporaneous works by other Northern and Italian artists in which attention is drawn to Christ's genitalia, if by different means; he thus sees the motif in Baldung's print as of current relevance and as consonant with Christian belief and doctrine. Whatever the precise meaning of St. Anne's gesture and its possible roots in the traditions of doctrine, folklore and art, it should surely be seen in conjunction with the devotion to the saint that underlies this print. If Steinberg's interpretation is correct, Baldung chose to associate St. Anne with Christ's Incarnation not only through the traditional representation of their ancestral lineage but also by the privileged role he grants her in revealing the Child's manhood; Steinberg further suggests that she might have been so honored because of the presence of a relic of her finger among the prized treasures of Frederick the Wise at Wittenberg. Thus interpreted, St. Anne's gesture would complement the allusions to the Incarnation suggested by the decaying wall at the left and the grape vine at the right. In freely intermingling doctrinal references with

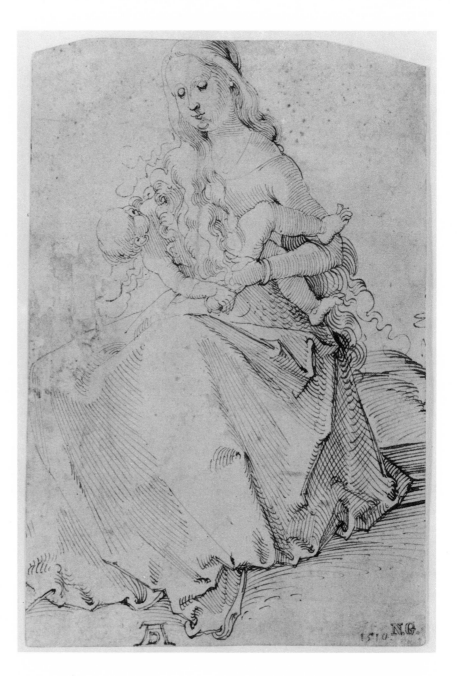

*21a. Hans Baldung,*
*«Madonna and Child,»*
*c. 1510–11, pen,*
*Prentenkabinet,*
*Rijksuniversiteit, Leiden.*

homey and informal elements in this print, Baldung appeals simultaneously to the intellect of his viewers and to their sentiments. —C.S.

1 Mende, p. 44, no. 18, suggests the latter meaning for this motif, citing Ecclesiasticus 24:23. For the literary and artistic traditions, see E. Guldan, *Eva und Maria: Eine Antithese als Bildmotiv*, Graz and Cologne, 1966, pp. 99–100, 143 and fig. 159.

2 Karlsruhe 1959, p. 17.

3 Jean Wirth, "Sainte Anne est une sorcière," *Bibliothèque d'Humanisme et Renaissance*, XL, 1978, pp. 449–80.

Wirth's arguments rest upon slight evidence and somewhat convoluted reasoning; he takes inadequate account of the manifest importance of St. Anne in Baldung's art and of the traditional means he employs to allude to her sanctity (e.g., her compositional importance and halo).

4 See Leo Steinberg, "Thoughts on an Old Woodcut and the Sexuality of Christ," *Arts Magazine*, December 1980. We are grateful to Professor Steinberg for providing us, prior to the publication of his article, with a *précis* of his arguments concerning Baldung's work.

21

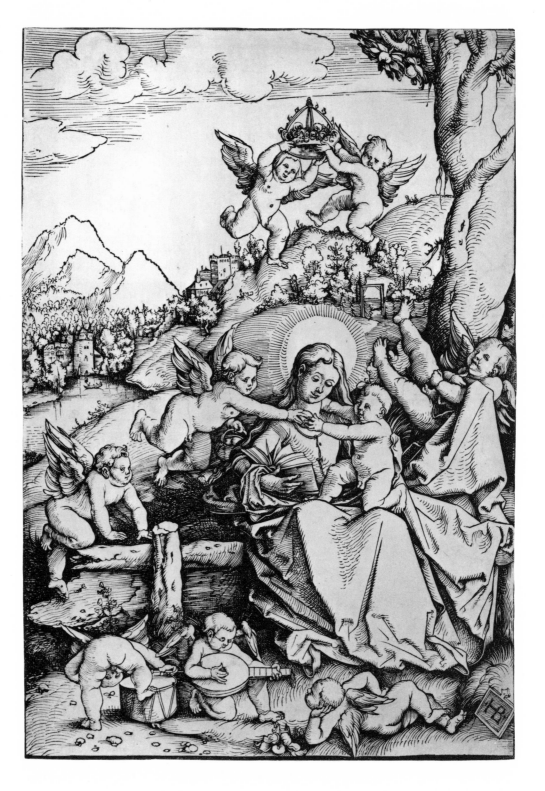

### 22

*Madonna and Child with Angels
in a Landscape*

C. 1511

Woodcut
382 × 260 mm. (15⅟₁₆ × 10¼ in.)
G. 87; H. 62; Karlsruhe 1959, II H 19; M. 20
Lent by the Metropolitan Museum of Art,
Harris Brisbane Dick Fund, 1924

Although undated, the *Madonna and Child with Angels in a Landscape* is universally assigned to the year 1511 because of its similarities to the dated woodcut of the *Holy Family with St. Anne* (Cat. No. 21). Both represent relatively informal treatments of members of the Holy Family in a landscape, and the two prints are also comparable in size and graphic style and in their portrayals of the facial type, simple dress and radiating halos of the Virgin. Together with contemporary works in other media, these prints demonstrate Baldung's particular interest in Mariological subjects at this stage of his career.

The tradition of representing the Madonna and Child in a landscape was a longstanding and popular one in Germany, and occurs among Baldung's earliest works (Cat. Nos. 2, 4). In this print, Baldung situates the figures in a detailed and panoramic landscape of evident Düreresque derivation and enlivens the scene by adding a group of active, putti-like angels. Such angels occur frequently in German art of the early sixteenth century, and possible sources of inspiration for this print include Dürer's woodcut of the *Holy Family in Egypt* of c. 1502 (B. 90; K. 188) and Cranach's *Rest on the Flight into Egypt* of 1509 (Ill. 22a), which, like this work, was also issued in chiaroscuro impressions.[1] In representations like those by Cranach and Baldung, the angels appear not so much in their traditional roles adoring Christ, but almost as his playmates.[2] Baldung treats these figures with particular energy and humor, both in their arrangement about the holy figures in an undulating circle[3] and in individual characterizations, for example, the pose of the reclining angel in the right foreground, who leans lazily upon his left hand, or that of the playful one in the left foreground, who momentarily ignores his toy-like drum to peer, almost mischievously, at the viewer from between his legs. Baldung clearly appreciated the full range of expressive possibilities of such figures: while he uses them here to evoke a playful, childlike atmosphere, he later employed them to create a lush, heavenly concert in the Freiburg Altarpiece (Fig. 9) and to express powerful grief in an impressive series of prints (Cat. Nos. 29, 31, 48, 50).

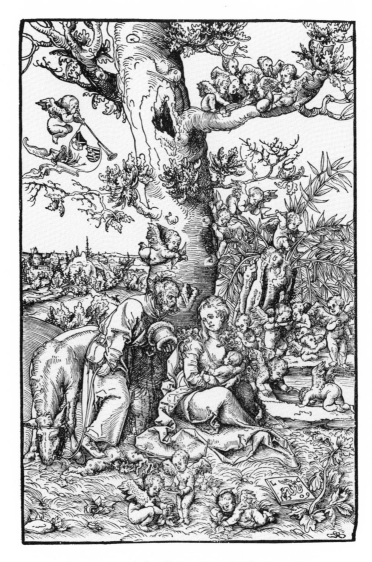

*22a. Lucas Cranach the Elder, «Rest on the Flight into Egypt,»
1509, woodcut.*

In all these works the angels also sanctify the scenes. Here the angel to the left of the Virgin hands an apple to Jesus, alluding to his task of redemption for the sin of Adam, while the two angels in the sky hold a crown that refers to Mary's coronation and to her role as Queen of Heaven (cf. Cat. No. 2). There may be another reference to Mary's privileged status in a motif apparently invented, or at any rate popularized by Baldung,[4] namely, the angel who lifts an edge of the Virgin's gown, here shown at the right. Besides providing greater formal breadth and interest to the figure of the Virgin, this motif may foreshadow her Assumption, for the angels thus occupied in Baldung's works usually look upward and seem almost to want to raise the Virgin from the ground (cf. Koch 38; Cat. Nos. 23, 41).

The lively informality of this scene, evident in the relaxed demeanors of Mary and Christ and the activity of the angels, is reinforced through such landscape elements as the rolling hills, the twisted tree, and the swirling clouds in the upper left. While there are relatively large white areas in impressions of the key block only, the work was also issued as a chiaroscuro woodcut colored with gray, olive green and brick-red tone blocks. In the chiaroscuro versions, white highlighting is used to model the sky, the mountains, the garments and the angels even more extensively, and Mary's halo contains an inner row of white rays, augmenting its glowing effect (Ill. 22b). The colored grounds tend to give the scene a warmer, more painterly quality in keeping with its charming informality. In both the chiaroscuro and line block versions,

*22b. Hans Baldung, «Madonna and Child with Angels in a Landscape,»
c. 1511, chiaroscuro woodcut.*

these correspondences in style and subject result in a unified and engaging interpretation of the traditionally popular theme of the Madonna and Child in a landscape, one in which Baldung simultaneously intermingles and evokes the realms of the sacred and the worldly. —C.S.

1 See the color reproduction in *Lucas Cranach d. Ae. 1472–1553: Graphik aus dem Kupferstichkabinett der Kunstsammlungen der Veste Coburg*, exhibition catalogue, Coburg, 1972, fig. 1.

2 Mende, p. 45, no. 20, refers to the angels as Christ's "Spielkameraden."

3 In a second woodcut of the *Rest on the Flight into Egypt*, Lucas Cranach the Elder represents a group of putti-like angels dancing in a circle about the Virgin and Child (G. 541, Jahn 357); Cranach's later woodcut also departs from that of 1509 and agrees with Baldung's in the placement of the Virgin and Child on a grassy bench, in her general position and radiant halo, and in the more active demeanor of the Child. If the current estimates of c. 1513–20 for Cranach's print are correct, Baldung's *Madonna and Child with Angels in a Landscape* may have inspired these details of his second woodcut of the *Rest on the Flight into Egypt*.

4 In addition to the examples cited below, see also works believed to be copies after Baldung by Urs Graf (drawing of 1513, W. Hugelshofer, *Schweizer Handzeichnungen des XV. und XVI. Jahrhunderts*, Freiburg i. Br., 1928, pl. 25, and Karlsruhe 1959, no. 289) and Nikolaus Kremer (drawing of 1519, *infra*, Ill. 41a, and Karlsruhe 1959, no. 292).

23

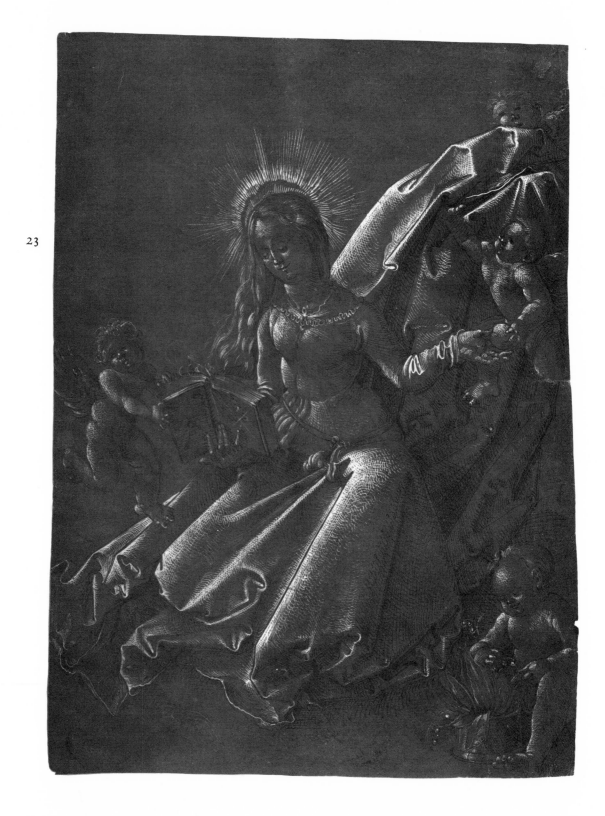

## 23

*Madonna Reading with the Child and Angels*

C. 1511

Pen and ink, heightened with white,
on dark reddish-brown tinted paper
280 × 210 mm. (11⅟₁₆ × 8¼ in.)
Koch 31; Karlsruhe 1959, no. 125
Lent by the Statens Museum for Kunst, Copenhagen

Baldung's chiaroscuro drawing of a *Madonna Reading* re-iterates many features of his woodcut of the *Madonna and Child with Angels in a Landscape* (Cat. No. 22). Both rep-resent the Virgin reading, with a radiant halo (compare particularly with chiaroscuro impressions of the wood-cut), accompanied by active, putti-like angels. The ap-ple, symbol alternatively of Mary's role in the process of redemption as the New Eve, or of Christ's as the New Adam, is handed to the Virgin in the drawing, rather than the Child, as in the print. In both works Baldung includes a favored personal motif of an angel who lifts a corner of the Virgin's garment as if to carry her heaven-ward, and there are additional similarities in the clear, geometrically ordered massing of the major forms of the robe that cover her legs.

Despite these similarities, which suggest a common date of execution, the two works differ in focus and mood. Whereas in the woodcut the figures are placed into a vast and detailed landscape, here they are brought close to the surface and dominate the representation. There are fewer angels depicted in the drawing, and the composition is simpler, based upon the crossing diagonals of the Vir-gin's robes and of her upper torso, which is aligned with the Christchild in the lower right. Baldung thus creates a more focused devotional image in which the narrative activities of the figures are subordinated to underlying stabilized forms.

In part owing to its greater focus and its lack of scenic details, the mood of the drawing is more intimate than that of the print. We are closer to the Virgin, who kneels on the ground rather than sits upright beneath angels with a crown, as in the woodcut. Carl Koch re-lated the Christchild, who is separated from his mother picking flowers in the foreground, to a general Upper Rhenish tradition, but his observation also holds for the lyrical character of the whole. The round-faced, smiling Virgin, similar to those in Baldung's approximately con-temporary panel in Basel (Fig. 7) and a drawing in Leiden (Ill. 21a), recalls not only the types of Schon-gauer, but also more distant works, such as the famous

early fifteenth-century panel known as the *Little Garden of Paradise* (Frankfurt, Städelsches Kunstinstitut)[1] in which a smiling Christchild also sits among flowers, including lilies of the valley.[2] The lyrical mood of Baldung's draw-ing depends also on its graphic style, and particularly on its effects of light. The white heightening of the sketch is executed in exceedingly delicate networks of hatching, with aqueous passages essentially limited to portions of the sleeve of the Virgin's left arm. This fine web of white lends the figures a shimmering, luminescent quality that is also expressed through the pulsing effect of the slender rays of the Virgin's halo.[3] The divine character of the light on the figures is suggested not only by its glowing luminescence but also by the fact that the angels look up to the left toward its source. Set off against the warm tones of the prepared paper, the light effects of this draw-ing are at once poetic and ethereal, complementing the characterizations of the figures.

Baldung employed the technique of chiaroscuro drawing on numerous occasions, frequently for self-sufficient compositions, rather than mere detail studies, suggesting that he conceived of many such sketches as au-tonomous works of art. Dedicatory inscriptions on some of these drawings seem to verify their use as presentation pieces (see Koch 30 and Fig. 30), a function which is also confirmed by the high degree of finish Baldung lav-ished upon them. For a virtuoso draftsman such as Bal-dung, the medium allowed the artist to display his command of line while simultaneously cultivating the painterly effects of color and light. Although the tech-nique was not uncommon in German art of the late fif-teenth century, it enjoyed unparalleled popularity in Baldung's time, which may be reckoned as a golden age of draftsmanship in Germany. Baldung's expertise in this medium is reflected in works by some of his followers, for example, Hans Leu the Younger (see Karlsruhe 1959, nos. 302–07). The technique achieved such prominence that it was even used for some panel paintings, most notably in a series of works of 1517 by Niklaus Manuel Deutsch.[4] Manuel's works in this technique, like Bal-dung's, are relatively small in scale and exploit the mood-setting characteristics of this linear yet coloristic medium. Baldung's *Madonna Reading with the Child and Angels* is one of the artist's earliest efforts in this technique, but it remains one of his most effective characterizations of the Madonna because of its warmth, its intimacy and its striking luminosity.[5] —c. s.

1  See A. Stange, *Deutsche Malerei der Gotik*, IV, Berlin, 1951, fig. 87; color reproduction in Hanspeter Landolt, *German Painting: The Late Middle Ages (1350–1500)*, trans. H. Norden, Geneva, 1968, p. 65. The probable con-nections of this panel and a group of related works with

Strassburg have recently been stressed by Martha Wolff, *The Master of the Playing Cards: An Early Engraver and his Relationship to Traditional Media*, Ph.D. dissertation, Yale University, 1979.

2  The lily of the valley is traditionally associated with the Virgin; see L. Behling, *Die Pflanze in der mittelalterlichen Tafelmalerei*, Weimar, 1957, p. 117. There is an apparent echo of the figure of the Christchild in this drawing in the child who kneels on the ground picking flowers in the lower left corner of Baldung's woodcut of the *Three Fates* of 1513 (Fig. 31).

3  Cf. Baldung's chiaroscuro drawing of *Christ with Doubting Thomas* of 1512 (Koch 30).

4  See *Niklaus Manuel Deutsch*, exhibition catalogue, Kunstmuseum, Bern, 1979, nos. 76–78, figs. 21 (color) and 36–38.

5  Cf. Baldung's later treatment of this theme in a drawing of c. 1516 in London (Koch 38).

## 24

### *Crucifixion*

C. 1511–12

Chiaroscuro woodcut with gray tone block
368 × 258 mm. (14½ × 10⅛ in.)
B. VII, p. 125, no. 57 (as Dürer);[1] G. 75; H. 11;
Karlsruhe 1959, II H 7; M. 37
Lent by the Museum of Fine Arts, Boston,
William Francis Warden Fund

This is Baldung's largest known print of the *Crucifixion,* and one of his most impassioned representations of the subject in any medium. The compositional type is one in which the cross is set off-center and at an oblique angle to de-emphasize hieratic qualities and stress the emotional reactions of the holy figures to Christ's death on the cross. The formula appears in one of the panels of the *Seven Sorrows of the Virgin*, produced in Dürer's shop c. 1496 (Ill. 24a), where the devotional character of the commission made this interpretation thematically appropriate; echoed in Lucas Cranach's dramatic panel of the *Crucifixion* of 1503 (Friedländer/Rosenberg, no. 5), and in many later works, particularly those by artists of the Danube School, it was employed by Baldung about 1505–07 in one of the devotional prints he executed while still a member of Dürer's shop in Nuremberg (Cat. No. 7). By the time he designed this chiaroscuro woodcut, Baldung may also have known Dürer's 1508 engraving of this subject (Ill. 24b): this work may have inspired the frozen angularity of the figures at the right and the nocturnal treatment of the theme, emphasized in the woodcut by the chiaroscuro technique.

Although rooted in this tradition, Baldung's chiaroscuro woodcut is starker and more intense in its drama than all the earlier examples. He reduces the number of figures accompanying Christ to only three, all of whom are now racked with grief, their agony echoed in harshly

angular, zig-zag forms. The composition is energized by the flying hair of the figures, by the arching lines of the hills, which interconnect with areas of shading and lines in the arms and midsections of St. John and the Virgin, and by the dramatically highlighted and assertive forms of the clouds that fill the sky and obscure portions of the landscape behind the figures. Baldung's greatest departure from the earlier works, however, is in his positioning of the cross in the extreme foreground, where it is overlapped by the frame at both the left and lower edges. The figure of Christ is removed from his position parallel to or within the group of accompanying mourners and seems to be thrust upon the viewer. Baldung dramatizes this effect by means of dislocations in the perspective. Whereas in the earlier works the viewpoint is a relatively consistent one, in which we look up at the figure of Christ on the cross, here Baldung adopts this angle for the upper portion of Christ and the cross, but contradicts it by cutting off its stem at the lower frame and by representing the landscape and figures as if seen from above; the figure of Christ thus seems to loom out of the picture space while the mourners appear to fall back and off into the heaving masses of the landscape. The guiding principles of Baldung's reinterpretation of this iconographic type were therefore twofold: to stimulate the observer's emotional response to the scene by means of animating and dramatizing the composition, and to heighten the degree of interaction between the viewer and Christ.

There has been disagreement about the date of execution of this print, which scholars have placed either at c. 1511–12 or 1514.[2] The distinction is a significant one, for Baldung resided in Freiburg from 1512 to 1516, and it is universally recognized that works produced during the Freiburg period differ from those he created in Strassburg from 1509 to 1512. Helmut Perseke, the author of the fullest study of Baldung's activity in Freiburg, assigned this work to c. 1511, adducing persuasive evidence:[3] the format of the print matches that of undisputed works of c. 1510–11 (Cat. Nos. 18–22) and is larger than that common in works of the Freiburg period; the type of halo in chiaroscuro impressions of this print, with scalloped trim, occurs in the *Holy Family with St. Anne and Joachim* (Cat. No. 20) and is unknown in later works; the representation of woods in the background has its closest analogies in the prints of the *Holy Family with St. Anne* (Cat. No. 21) and the *Madonna and Child with Angels in a Landscape* (Cat. No. 22), both of 1511; the graphic style, with its passages of broad and regular cross-hatching, is still that of the other large prints of c. 1511; and the angular forms of the figures and their garments, and the types of the Virgin and St. John have their closest parallels in the panel of the *Crucifixion* of 1512 in Basel (Basel 1978, pl. 6). Other observations support those advanced by Perseke: illustrations designed by Baldung for the *Hortulus animae*, published at Strassburg in 1511, contain parallels for the type of Virgin seen here (M. 334, 339), for the combined scalloped and radiant halos (M. 331, 337), for the pronounced zig-zag angularity of some of the figures (M. 337, 344), and for the distinctive form of the robe that wraps about the kneeling Magdalen's waist and flows down over her legs (M. 361). The stylistic argument is the decisive one, however, for Baldung no longer employed the technique of the chiaroscuro woodcut in Freiburg, achieving tonal effects instead by means of overall, intensive parallel hatching and strongly varied and dense patterns of cross-hatching. In format, style and expression, this dramatic representation of the *Crucifixion* is still allied to the chiaroscuro woodcuts of the *Witches' Sabbath* (Cat. No. 18) and the *Fall of Man* (Cat. No. 19) of 1510–11.

1  Bartsch based the attribution upon an impression of this print in Vienna with a falsified Dürer monogram (Perseke, p. 166). See also a woodcut copy of Baldung's print by Georg Erlinger (G. 810).

2  The early opinions are summarized by Perseke, pp. 166–67 and in Karlsruhe 1959, II H 7; more recently Mende adopts the date of 1514.

3  Perseke, pp. 166–67.

24

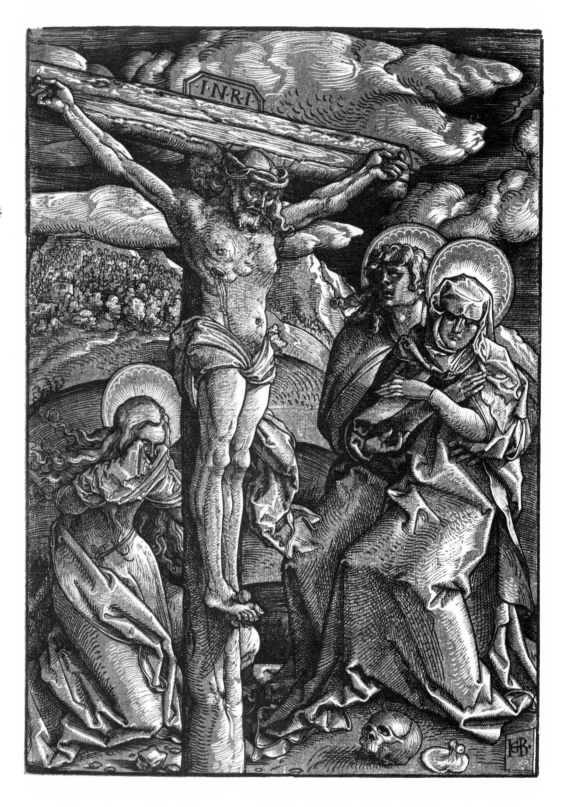

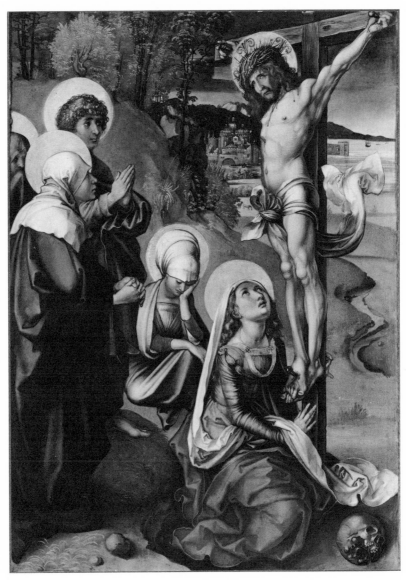

*24a. Workshop of Albrecht Dürer, «Crucifixion,» c. 1496, panel,
Gemäldegalerie, Dresden.*

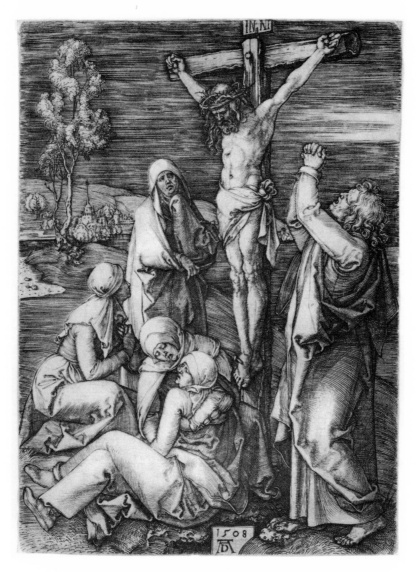

*24b. Albrecht Dürer, «Crucifixion,» 1508, engraving.*

## 25

### St. Jerome in the Wilderness

C. 1511

Woodcut
193 × 139 mm. (7⅝ × 5⁷⁄₁₆ in.)
B. VIII, p. 468, no. 7 (as Hans Brosamer);
G. 107; H. 120; Karlsruhe 1959, II H 53; M. 22

A.  Key block
    Lent by the Trustees of the British Museum

B.  Chiaroscuro impression with
    light brown tone block
    Lent by the Staatliche Kunsthalle Karlsruhe

## 26

### St. Jerome in the Wilderness

DATED 1511

Woodcut
128 × 88 mm. (5¹⁄₁₆ × 3½ in.)
B. 34; G. 108; H. 121; Karlsruhe 1959,
II H 54; M. 21
Lent by the Staatliche Kunsthalle Karlsruhe

Of the four Latin Church Fathers, St. Jerome (c. 342–420) is the one most often represented in art; he is portrayed in a number of different roles, testimony to his rich and varied life and to the different aspects of his temperament. He is known to have been a man of tremendous discipline, intellect, and spiritual devotion. He was extremely learned, and while serving as secretary to Pope Damasus in Rome (382–85), he undertook the preparation of a new Latin Bible, now known as the Vulgate, translating the Scriptures afresh from Hebrew and Greek, and improving upon the earlier Latin versions. Because of this great scholarly accomplishment, Jerome is often depicted surrounded by books, at work in his study.

Several times during his life, a penitent Jerome retreated to the wilderness to devote himself to prayer. This aspect of St. Jerome's personal history— his yearning for the spiritual life and hermit-like solitude— was revered in the late fifteenth and early sixteenth centuries; as this was a period of upheaval in the Church, Jerome's legendary return to nature to escape from a sinful world took on particular appeal. In Germany, woodcuts and engravings of the penitent saint proliferated as the puritanical religiosity of St. Jerome struck a responsive chord.

In these two prints, Baldung shows the saint in a forest setting, similar to that depicted in prints by artists of the Danube School. He kneels before a small crucifix inserted in a tree, and, torso bared, he holds a rock in his outstretched arm in anticipation of inflicting pain upon himself. By his side is the tame lion which, according to legend, became his faithful companion after Jerome removed a thorn from its paw. The cardinal's hat, a reference to Jerome's service to the Papacy, lies on the ground. In Cat. No. 26, the Bible lies open on the ground, whereas in Cat. No. 25 it is still contained in the book pouch in Jerome's right hand. Baldung depicts churches in the backgrounds of the two prints, reinforcing his other references to the spiritual life and possibly also recalling the situation of monasteries in the foothills and mountains not far from Strassburg.

In general format, Baldung's two woodcuts appear to have been inspired by Dürer's engraved *St. Jerome* of c. 1496–97 (Ill. 26a), especially in the placement of the saint in the immediate foreground (occupying only the lower half of the space), the gesture of the outstretched arm, the configuration of drapery about the waist, and, not least, the facial type and the long, stringy beard. However, whereas Dürer places the saint in a psychologically neutral landscape, meticulously observed from nature, Baldung's figures occupy fanciful settings. In Cat. No. 25, the drooping branch of the tree at the upper left seems to echo the gesture of the supplicant saint, while the cropped spiky branches on the smallest tree underscore the mood of severity and deprivation. To make the pain as well as the solitude of St. Jerome all the more poignant, Baldung adds a tone block, implying that Jerome is alone in the woods at night, and intensifying the exotic, isolated character of the setting.

25A

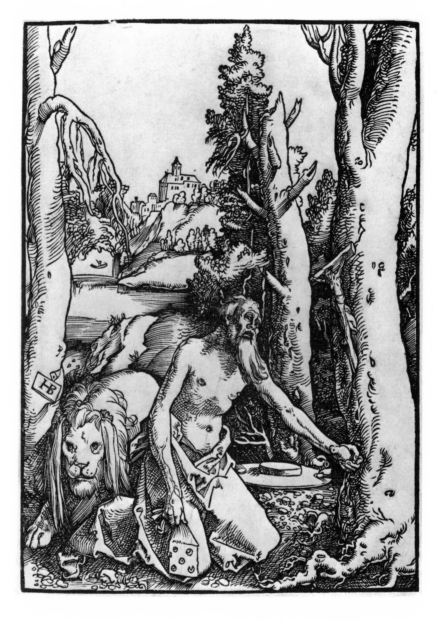

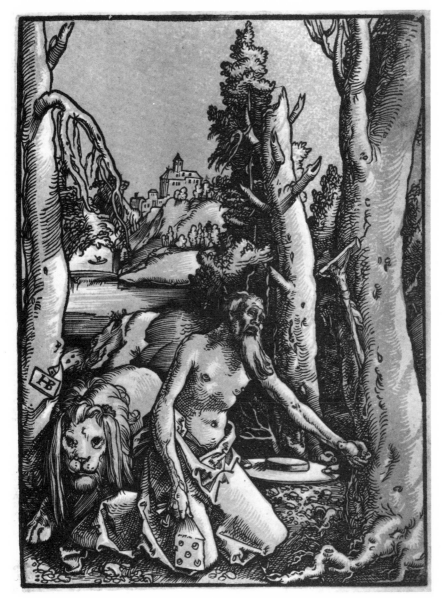

25B

26

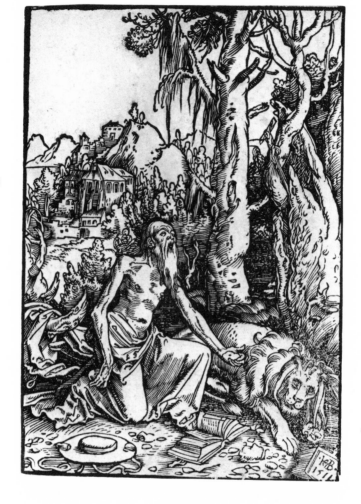

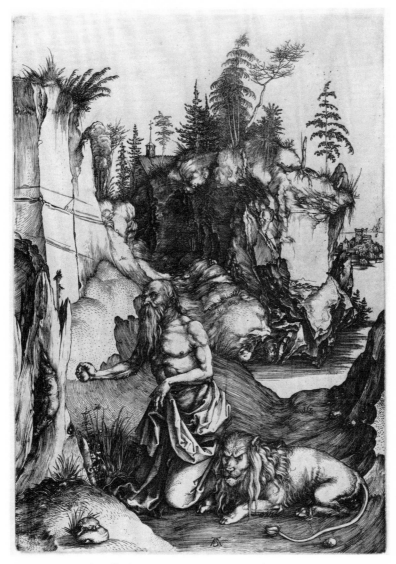

*26a. Albrecht Dürer, «St. Jerome,» c. 1496–97, engraving.*

## 27

*Salome*

C. 1511–12

Woodcut
128 × 88 mm. (5⅟₁₆ × 3⁷⁄₁₆ in.)
B. 32; G. 110; H. 115; Karlsruhe 1959,
II H 70; M. 26
Lent by the Kuntsmuseum Basel, Kupferstichkabinett

About 1511–12, during his first Strassburg period, Baldung made a group of relatively small woodcuts virtually identical in format and size (c. 128 × 88 mm.), and essentially devotional in character. These prints (Cat. Nos. 26–31 and M. 30) are characterized by compact compositions, dense modeling, and dramatic use of abrupt contrasts in light and dark. Although in iconographic terms the subjects of the prints do not comprise a cohesive series, most of them are hieratic in mood. It may be that in preparing these woodcuts, Baldung was responding to a particular market or to a demand for small, expressive, and immediately comprehensible devotional images.

The unusual half-length format of this representation of Salome suggests that Baldung was familiar with paintings of the same subject by Lucas Cranach (Ill. 27a). The slender, elegantly coiffed and costumed Salome, as well as her gently curved posture, recall Cranach's schema for the representation of women, particularly evil ones. Salome's elaborate necklaces and sixteenth-century courtly attire imply a relationship between the wicked Salome and contemporary ladies of fashion. The bemused, half-smiling face, without trace of remorse, makes a striking contrast to the grimacing face of St. John's severed head.

Nowhere in the Scriptures is Salome described as holding the salver with the head of St. John the Baptist. The subject is a later invention that appealed to Baldung and his clientele for at least two reasons. First, since St. John is regarded as Christ's precursor, his execution presages the sacrifice of Christ. The placement of his head on a platter had Eucharistic implications for Christians of the early sixteenth century, calling to mind the placement

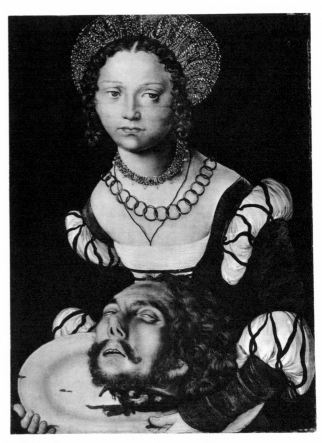

27a. Lucas Cranach the Elder, «Salome,» c. 1510, panel, Bayerisches Nationalmuseum, Munich.

of the Host, symbolizing Christ's body, on the communion paten.[1] Second, as St. John's decapitation came about because of the machinations of an unscrupulous woman, the theme must also have appealed to Baldung's misogynous tendencies. The subject of this print is therefore related to topics which attracted Baldung's attention throughout his career.—C.R.

1 For a thorough discussion of this subject, see Hella Arndt and Renate Kroos, "Zur Ikonographie der Johannesschüssel," *Aachener Kunstblätter,* XXXVIII, 1969, pp. 243–328.

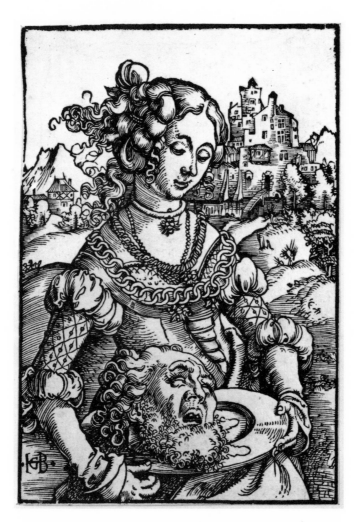

27

28

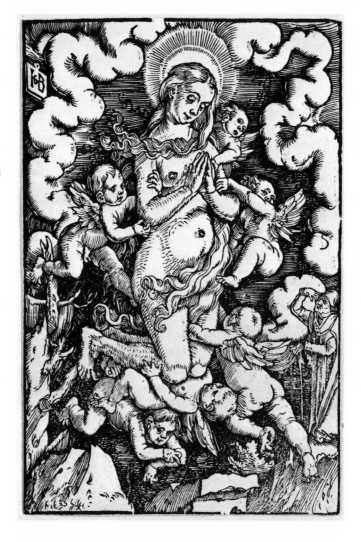

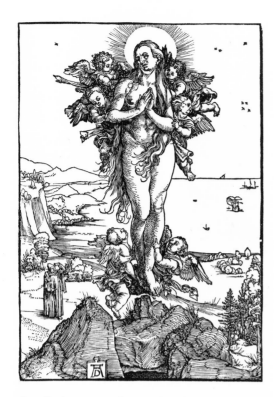

*28a. Albrecht Dürer, «Elevation of St. Mary Magdalen,» c. 1504–05, woodcut.*

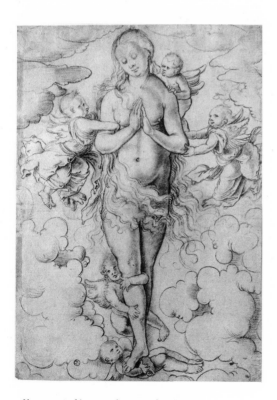

*28b. Hans Baldung, «Elevation of St. Mary Magdalen,» c. 1510, chalk, Kunstmuseum, Basel.*

### Elevation of St. Mary Magdalen

C. 1511–12

Woodcut
129 × 86 mm. (5 1/16 × 3 3/8 in.)
G. 116; H. 137; Karlsruhe 1959, II H 69; M. 25
Lent by the Kunstmuseum Basel, Kupferstichkabinett

It is said that for the last thirty years of her life, St. Mary Magdalen became a hermit and lived in a cave in the wilderness near Marseilles. Although she denied herself food and drink, she was— according to the *Golden Legend*— carried heavenward by angels seven times each day for celestial sustenance. This print shows the Magdalen as she is borne aloft by a group of acrobatic angels. She kneels in prayer in a posture slightly awkward for a heavenly ascent. Indeed, the angels seem to exert great effort to boost her on her journey. One angel, flat on his back, with the saint's knees on his chest, even tries to push her up from below. The elderly man at the right is the priest described in the legend who was allowed to observe this miraculous event. The visionary character of the scene is enhanced by the sharp contrasts of light and dark which do not appear in most other artists' versions of this subject. By placing the event in a nocturnal setting filled with the active forms of dense, rolling clouds, Baldung dramatizes the story of the saint's elevation, making it both more mystical and evocative.

Baldung's print is a visual paraphrase of two earlier versions of the subject, Cranach's woodcut of 1506 (Jahn, p. 326), in which the Magdalen genuflects slightly as she ascends toward heaven, and Dürer's woodcut of c. 1504–05 (Ill. 28a). About 1510, Baldung made a drawing after Dürer's woodcut (Ill. 28b), preserving the praying figure with her long, flowing hair, but transforming Dürer's well-behaved and coordinated team of angels into a more eccentric group, marked by somewhat peevish expressions. In the drawing, Baldung introduced the idea of a prone angel who supports the Magdalen's feet, a motif which is elaborated on in the woodcut, where a number of angels support her from below.[1] In the drawing fluffy clouds enframe the figural group. These are repeated in the woodcut, but are hardened into the intestine-like formula for clouds often seen in Baldung's prints. The drawing, then, is intermediate in the transition from the pious dignity of Dürer's conception to Baldung's more dynamic interpretation. In the woodcut, Baldung avoids the tectonic solidity of Dürer's nude. The figure of the Magdalen, with her protruding abdomen, looks back to Gothic interpretations of the human form, and her face expresses not saintly nobility but a charming naiveté. By

turning the figure at an angle to the picture plane, by filling the space with clouds, cavorting angels, and other forms, and by emphasizing the awkward pose and peasant-like features of the Magdalen, Baldung rejects the axial symmetry and monumentality of Dürer's print. Just as Baldung's Freiburg Altarpiece is a playful reworking of Dürer's Heller Altarpiece (see p. 14), so this woodcut is a conscious departure from tradition— a sprightly, even mirthful reinterpretation of a serious theme.

1  This motif is also seen in a woodcut illustration by Baldung for the *Hortulus animae*, published in 1511 (M. 392), where the Magdalen stands upright, her feet supported by a prone angel, as in the drawing.

## 29

*Christ as Man of Sorrows
(Ecce Homo)*

DATED 1511

Woodcut
124 × 83 mm. (4⅞ × 3½ in.)
B. 41; G. 80; H. 54; Karlsruhe 1959, II H 13; M. 27
Lent by the Metropolitan Museum of Art,
Harris Brisbane Dick Fund, 1926

The theme of Christ's suffering during the Passion was of great importance during the late Middle Ages and the early Renaissance, inspiring a continuous tradition of invention in both narrative and devotional art. Within this tradition the devotional image of Christ as the Man of Sorrows forms a major subgroup: Christ is presented to the beholder in a guise typifying his suffering or death, usually in a manner designed to elicit the viewer's compassion.[1] Images of this type show considerable variety as creative artists continually modified and reinterpreted the subject to emphasize different aspects of the fact of Christ's death and its significance within the Christian scheme of Redemption. Thus, while all representations of the Man of Sorrows refer explicitly to the torments of the Passion, many simultaneously proclaim his victory over death and display his body for veneration as the symbolic embodiment of the Eucharistic sacrament. Baldung's interest in this theme, and his original approach to it, are shown in, among others,[2] his drawing of the *Dead Christ* of c. 1508 (Cat. No. 17) and in two of his best known prints from the period c. 1515–17 (Cat. Nos. 50–51). The present work draws upon visual traditions already established in Baldung's time, but also testifies to the artist's skill in transforming and revitalizing earlier pictorial types.

Baldung's 1511 *Christ as Man of Sorrows* is essentially a conflation of two types of devotional image, that of the *Ecce Homo*[3] and of the so-called *Angels' Pietà*.[4] From the former (Ill. 29a) Baldung took the figure of Christ crowned with thorns with his arms bound before him; from the latter (Ill. 29b) he took the notion of angels supporting or exhibiting the body of Christ in a cloud-bordered or heavenly environment. In combining these types Baldung also departed from the two traditions. Whereas devotional images of the *Ecce Homo*, for example, invariably represent Christ alive and observing the viewer, Baldung shows us a helpless Christ, represented as if dead. True, Christ's sacrificial death is usually alluded to in representations of the *Angels' Pietà* by the presence of the wounds of the Crucifixion. But Baldung

leaves unclear in this print whether or not the Crucifixion has taken place by modeling Christ's hands and right side in such a way that the wounds, if they are there, are only partly legible. As a result, we are presented with an image that seemingly presupposes Christ's death, but that also evokes the course of the Passion and of Christ's suffering prior to the Crucifixion. In this context the inscription *Ecce Homo* is no longer limited to its historically determined reference to the display of Christ to the crowd outside of Pilate's house, but assumes the character of an imperative exhorting the viewer to respond to the totality of Christ's sacrifice.[5]

Baldung also departs from earlier devotional images of the *Ecce Homo* and the *Angels' Pietà* in the realism and dramatic urgency of this representation. The focus of the print is the head of the tormented Christ, with its large and viciously barbed crown of thorns, its partially closed and sightless eyes, and its mouth hanging pathetically open, all seen in foreshortened view from below. Although this type of anguished face appears frequently in Baldung's art (e.g., Cat. Nos. 27, 30–32), in this instance Baldung appears to have been inspired by Dürer. A drawing by Dürer of the *Head of Christ* in the British Museum (Ill. 29c), dated 1503— the same year Baldung entered Dürer's shop— may be presumed to underlie Baldung's moving representation. Pariset, who first called attention to the relationship between the present print and the drawing in London, actually attributed the drawing to Baldung.[6] Although we do not follow him in this suggested reattribution, it is easy to see why— given Baldung's temperament— this keenly emotive aspect of Dürer's style would have moved Baldung to imitation.

In the print Baldung has utilized this expressive head as well as the bloated faces of the weeping angels and Christ's slightly elevated arms, whose bulging veins suggest the tightness of his bonds, to evoke the viewer's pious and empathetic response. Much of the power and immediacy of the image also results from the manner in which the figures are pushed toward the surface of the picture. Only a narrow fringe of clouds separates Christ's body from the lower margin, a proximity which—together with Christ's truncated left hand and right arm— gives the impression that the figure projects beyond the surface of the page into the viewer's space. The harsh lighting and strong dark and light contrasts likewise contribute to this impression, with such spotlighted areas as Christ's left shoulder and arm and the face of the angel who holds Christ's head in the upper left advancing forward from the dark background. Through the combination of the actively mourning angels, of strongly contrasted dark and light areas, and of relatively short but incisive modeling lines, Baldung further animates and dramatizes the repre-

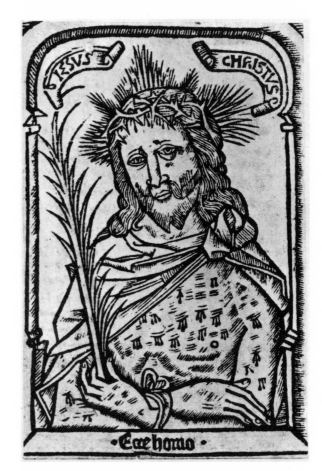

29a. Lower Rhenish, «Ecce Homo,» c. 1500, woodcut.

sentation. The print may show Christ as if exalted in heaven, but the principal impression created by Baldung is of a turbulent lament over his human sacrifice. Ultimately it is this contradiction between Christ's divine nature and the harshness of his human torment that underlies the poignancy of this and Baldung's other representations of the Man of Sorrows or the Dead Christ. The haunting power of Baldung's representations of the suffering Savior resides in his unswerving insistence upon the fact of Christ's death and the magnitude of his suffering.
—C. R.

1   *See* G. Schiller, *Iconography of Christian Art*, II, Greenwich, Conn., 1972, pp. 197ff., with additional bibliography.
2   See also the panel, dated 1513, of the *Man of Sorrows with the Virgin* in Freiburg (Curjel, pl. 17) and another from Baldung's shop of the *Man of Sorrows with Angels* in Stuttgart (Karlsruhe 1959, no. 81; Schiller, *Iconography*, fig. 749).

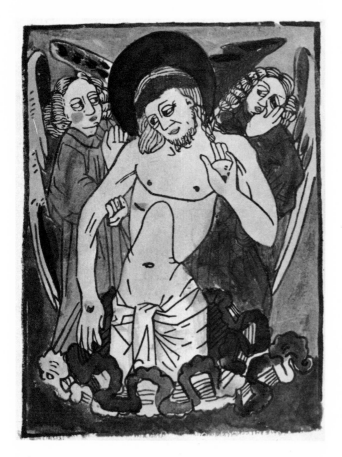

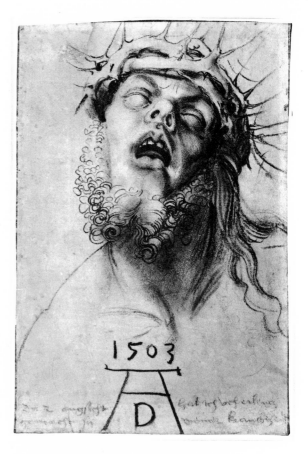

*29b. Upper German, «Man of Sorrows with Angels,»
c. 1470, hand-colored woodcut.*

*29c. Albrecht Dürer, «Head of Christ,» 1503, chalk,
British Museum, London.*

3  See K. A. Wirth and G. von der Osten in *Reallexikon
zur deutschen Kunstgeschichte*, IV, Stuttgart, 1958, cols.
674ff., esp. 692–97, s.v. "Ecce Homo."

4  See G. von der Osten in *Reallexikon zur deutschen Kunst-
geschichte*, V, Stuttgart, 1967, cols. 601–21, s.v. "Engel-
pietà," and idem, "Zur Ikonographie des Hans Baldung
Grien," *Festschrift für Herbert von Einem*, Berlin, 1965,
pp. 179ff., esp. 181–84.

5  The inscription has a similar function in fifteenth-cen-
tury prints of such devotional images as Christ before the
column of the Flagellation (S. 892a) and Christ seated
on Calvary awaiting the Crucifixion (S. 908–09).

6  Pariset, pp. 153–54.

29

## 30

*Death of Lucretia*

C. 1511

Woodcut
127 × 88 mm. (5 × 3½ in.)
G. 120; H. 231; Karlsruhe 1959, II H 72; M. 72
Lent by the Museum of Fine Arts, Boston,
Horatio Greenough Curtis Fund

Livy, in his *History of Rome*, relates the story of a virtuous Roman woman, Lucretia, whose much lauded beauty prompted Sextus Tarquinius to rape her. Overwhelmed with shame, Lucretia stabbed herself in the heart. In revenge, her husband's family drove the Tarquin kings into exile (c. 510 B.C.). Lucretia was much revered by the Romans, and during the Middle Ages came to be considered an exemplar of feminine and even proto-Christian virtue.[1]

The suicide of Lucretia was a popular theme in North Italian art of the fifteenth and sixteenth centuries. In Germany, Lucretia was sometimes depicted in cycles of the "Nine Heroes and Nine Heroines" (six good Christians, six good Jews, and six good pagans) dressed in contemporary clothing in the manner of a martyred saint.[2] German precedents for the suicide of a partially nude Lucretia include Dürer's 1508 drawing (W. 436) and several panel paintings by Lucas Cranach.[3] Cranach's images are the most likely source for Baldung's print because of their half-length format.

Even more than Dürer and Cranach, Baldung emphasizes classical aspects of the subject matter, capping his figure of Lucretia with a tablet inscribed in a version of Roman straight-line capitals (*capitalis quadrata*) as well as with antique garlands.

The dating of Baldung's *Lucretia* is problematic. Geisberg assigned it to about 1519, while Koch argued for the first half of the 1520s. Mende dates the woodcut about 1519–20, comparing it to Baldung's drawings of Lucretia bearing dates of those years (Koch 116, 117). However, the size of the print, the cutting style, and the dramatic chiaroscuro of the *Lucretia* suggest a strong link between this print and a group of woodcuts of similar size from 1511–12 (Cat. Nos. 26–29, 31, and M. 30). The hatching of the *Lucretia*— particularly the dense modeling of the background, with which the brilliantly lighted figure is so dramatically contrasted— is close to that of the 1511 *Christ as Man of Sorrows* (*Ecce Homo*) (Cat. No. 29). Indeed, the composition, size, and format of the *Lucretia* resemble those of the *Man of Sorrows* so closely

that one is led to speculate that the two prints were intentionally interrelated, or, possibly, were intended for a projected series of small prints of half-length figures. Each of the two prints depicts a half-length nude turned slightly to the left; Christ's torso emerges from a border of clouds and Lucretia's from the robes about her waist. Christ's hands are bound in front of him; although Lucretia's are not bound, her bracelets are remarkably rope-like, and both pairs of arms fold across the body in a similar fashion. The heads of the two figures reflect one of Baldung's favorite formulas for representing anguish: head upturned and mouth open (see Cat. Nos. 31, 33; Koch 47). An identifying tablet, partly cut off by the upper border of the print, is suspended above the head of each figure. Thus it seems possible that the *Lucretia* was designed, if not executed, at the same time as the *Man of Sorrows*, around 1511. If not, then it is certainly a retrospective work: its formal characteristics are too closely related to those of the *Man of Sorrows* to be coincidental.
—C.R.

1  G. Voigt, "Über die Lucretia-Fabel und ihre literarische Verwandten," *Berichte über die Verhandlungen der königlichen sächsischen Gesellschaft der Wissenschaften zu Leipzig*, Leipzig, 1883, pp. 1–36.
2  *Hans Burgkmair: Das graphische Werk*, exhibition catalogue, Staatsgalerie Stuttgart, 1973 (text by Tilman Falk), no. 111.
3  See Friedländer/Rosenberg, no. 42 (c. 1510–13) and later works, nos. 55, 121, 122, 166, 235–37, and 397.

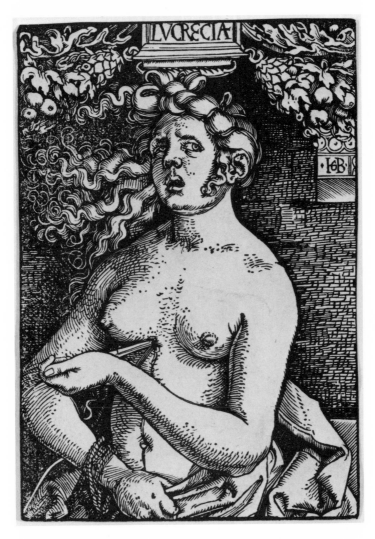

30

*St. Sebastian*

DATED 1512

Woodcut
127 × 88 mm. (5 × 3⁷⁄₁₆ in.)
B. 36; G. 114; H. 129; Karlsruhe 1959,
II H 61; M. 29
Lent by the Kunstmuseum Basel, Kupferstichkabinett

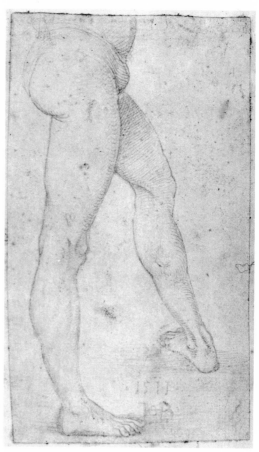

*31a. Hans Baldung, «Life Study,» 1511,
silverpoint ( from the Karlsruhe Sketchbook),
Staatliche Kunsthalle Karlsruhe.*

In his *St. Sebastian* of 1512, Baldung represents the saint accompanied by grieving angels who untie the ropes that bind him to the tree and withdraw and collect the arrows with which he was shot. Although according to legend, Sebastian survived this attempted martyrdom, only to be beaten to death subsequently with clubs, by adding mourning putti Baldung seems to suggest that the saint is already dead, thereby departing from his own earlier woodcut (Cat. No. 10) and from many other earlier and contemporary representations of the saint. The pathetic character Baldung imparts to the scene parallels that of another print of similar size and date, the *Man of Sorrows* of 1511 (Cat. No. 29), and foreshadows larger prints of the Freiburg period (Cat. Nos. 49–51), including a *St. Sebastian* of 1514 (Cat. No. 48). The 1512 *St. Sebastian* shares with the 1511 *Man of Sorrows* such features as harsh, mood-setting dark and light contrasts, suggestions of extreme physical distress in the upturned heads and bulging veins of the arms, and angels who actively mourn the martyrs.

For the figure of St. Sebastian, Baldung revised his earlier representations of the saint. There are reminiscences of the single-sheet woodcut of c. 1505–07 (Cat. No. 10) in the fluttering loincloth and contrapposto pose, but these features are now exaggerated for greater expressive impact. Baldung also recalls a modest woodcut book illustration of c. 1505–07 (M. 300) and his St. Sebastian Altarpiece of 1507 (Fig. 4) in the right-angled positioning of Christ's feet, but here too he emphasizes the pathos of the figure by increasing the torsion of the stance. In so doing, Baldung made use of a life study, for his sketchbook in Karlsruhe contains a silverpoint drawing, dated 1511, of the lower portion of a male figure in an analogous pose (Ill. 31a).[1] Baldung departs from his earlier representations of St. Sebastian by adding a rope tied tautly about the saint's midsection that squeezes his stomach, as if supporting much of his weight, and by exploiting more fully formal analogies between the broken form of the figure and the dead branches of the tree. Clearly, Baldung's aim in this print was to produce an image that expresses the suffering of St. Sebastian in powerful and evocative terms. The active forms of the saint's body and of the ministering angels, as well as the harsh contrasts of dark and light areas invest the image with uncommon dramatic force.[2]

1 See Koch 90 and K. Martin, *Skizzenbuch des Hans Baldung Grien: "Karslruher Skizzenbuch,"* Basel, 1950, fol. 14v.
2 There are echoes of Baldung's figure of St. Sebastian in one of the artist's most dramatic representations, his panel of c. 1513 depicting *Death and a Fleeing Maiden* in the Bargello, Florence (Curjel, pl. 61). As the positions of the maiden's legs and upraised arm correspond roughly with analogous forms in the St. Sebastian, but are reversed (and viewed from a somewhat different angle), Baldung may have referred to his study for the woodcut when composing the panel painting.

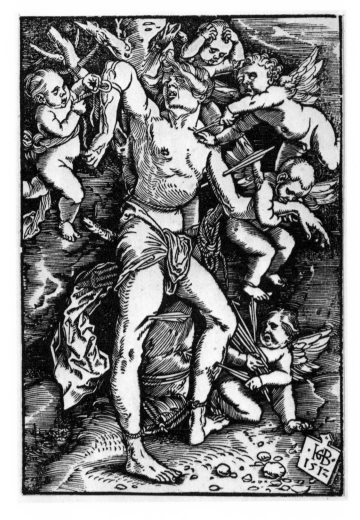

31

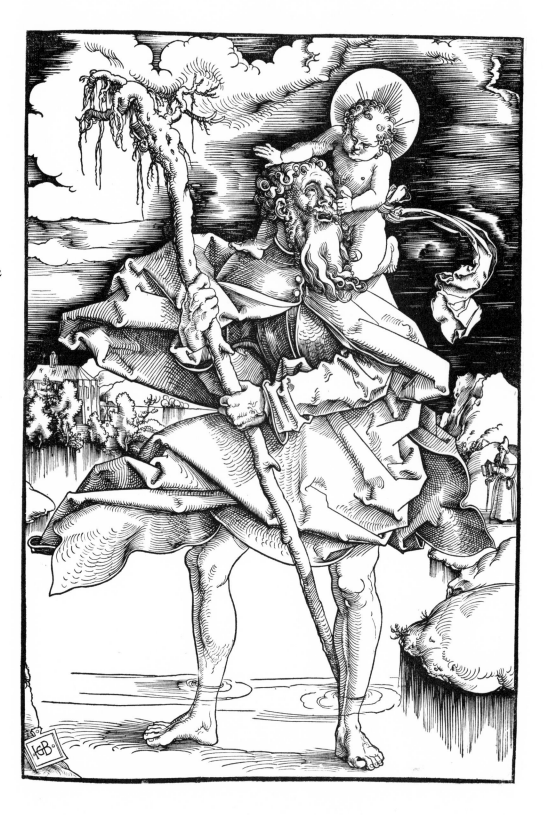

32

## 32

*St. Christopher*

C. 1511

Woodcut
385 × 265 mm. (15¼ × 10⁷⁄₁₆ in.)
B. 38; G. 104; H. 116; Karlsruhe 1959,
II H 51; M. 24
Lent by the Trustees of the British Museum

St. Christopher (from the Greek *Christophoros*, "bearer of Christ"), patron saint of travelers and protector against the plague, was also invoked for protection against dying without benefit of the sacraments. St. Christopher was said to be a giant who resided by a dangerous river and assisted travelers by carrying them across the waters on his powerful shoulders. One night, as he was carrying a child, the weight became unbearably heavy. On the far shore, the child revealed himself as Christ, instructing the saint to plant his staff in the earth, where it miraculously sprouted. Christopher is usually shown striding across the river with his walking staff, the Christchild upon his shoulders. The Child frequently carries an orb, for as the legend recounts, Christ told St. Christopher that he bears the weight of the world upon his shoulders; a monk with a lantern sometimes appears on the bank to guide the saint.

In this print, Christopher halts in midstream and turns his head toward the Christchild, his anguished expression reflecting the labors of his divine burden, and the effort he must exert to meet the challenge. As is appropriate for the representation of a giant, Christopher is shown here in monumental scale, in a woodcut equaled in size only by a few other Baldung prints from the same period (Cat. Nos. 18, 20–22). Since it was thought that anyone who looked on the image of St. Christopher would be protected against harm for that day, his image often appears as a giant fresco on the interior walls of South German churches (e.g., the Cathedral of Augsburg). One of these oversized murals may have inspired Baldung's monumental figure. Indeed, the relatively short proportions of his legs and the smallness of his feet compared to his mighty hands suggest that Baldung took inspiration from an image intended to be seen from below, such as a wall painting. The large size and the hieratic character of this image make it clear that the print was intended to be mounted on the wall to safeguard its owner, unlike smaller prints which could be carried or packed with belongings for protection on a journey. Although St. Christopher appears here primarily in frontal view, as in an iconic image, Baldung energizes the representation through the saint's dramatically furled mantle and through the loincloth which flies into the air from Christ's waist. The vigorous, differentiated interior modeling of the forms and the strong dark and light contrasts of the background underscore the dramatic intensity of Baldung's representation.

The broad unmodeled areas— the water in the lower half and the sky at the upper left— make the print seem incomplete and lead to the conclusion that this image was conceived as the key block for a chiaroscuro woodcut;[1] the awkward way in which the sprouting tree abuts the clouds might be more easily understood with the addition of appropriate color, as would the modeling at the base of the earthen bank in the lower right, which seems illogical in its present state. Circumstantial evidence supports this hypothesis, for the St. Christopher is comparable in size and style to Baldung's other large chiaroscuro woodcuts (Cat. Nos. 18, 19, 22). Moreover, the nocturnal effects provided by an added color tone block would have been particularly appropriate for a representation of Christopher's nighttime journey. Unfortunately, as no chiaroscuro impressions have been recorded, it is impossible to know if they have not survived or if Baldung never executed the requisite tone block.

1 Curjel, p. 158, no. 20.

## 33

*St. Christopher*

DATED 1513

Pen and ink, heightened with white,
on brown tinted paper
281 × 192 mm. (11¹⁄₁₆ × 7⁹⁄₁₆ in.)
Koch 35; Karlsruhe 1959, no. 131
Lent by the Staatliche Kunsthalle Karlsruhe

In his monumental woodcut of c. 1511 (Cat. No. 32), as in a drawing of 1520 (Koch 111), Baldung represented St. Christopher as if momentarily halting on his journey to observe or converse with the Christchild on his shoulder. In this drawing of 1513, similar to one of the woodcuts designed for the *Hortulus animae*, published in 1511 (M. 359), the saint is shown forging ahead through the river. The last two representations also agree in such details as the bandanas around the saint's hair and forehead and the water rushing about his ankles, but the drawing is considerably more successful in conveying an impression of Christopher's prodigious effort to ford the stream. The saint leans heavily upon his tree-staff as he strides into powerful currents that send the waters rising in waves about his legs and staff and roiling up before him. Baldung had represented Christopher's robe flying in the air as if windblown in the woodcut of c. 1511 (Cat. No. 32), but here the saint's robe flies out in a more logical direction, blown behind him by the same wind that streams through his hair and helps to impel the waters from left to right. Christopher's journey is thus interpreted as a dramatic struggle against the elements, an effect underscored by the marvelously energetic and vibrant heightening of the drawing with fluid passages of white. As in the print of c. 1511, which we believe was originally conceived as a chiaroscuro woodcut, the chiaroscuro technique was again deemed appropriate for a representation of the nighttime journey of the giant saint.

The attribution of this drawing to Baldung has been questioned because of the quatrefoil flourish that appears beneath the date in the lower right corner. Similar flourishes occur in three other drawings dated 1513, that is, the Basel copy of the Innsbruck *Lamentation* (Cat. No. 46) and the figures of *Christ* and *God the Father* related to the Freiburg Altarpiece (see Cat. No. 44), and in a 1515 sketch in Karlsruhe of *Christ on the Cross*.[1] Peter Halm first put forth the suggestion that the quatrefoil flourish might represent the signature of an assistant in Baldung's shop.[2] More recently, Tilman Falk has proposed that the five drawings might be attributable to Georg Koch of Basel, basing his hypothesis upon the initials GK that ap-

pear below the quatrefoil flourish in the 1515 drawing of *Christ on the Cross*.[3] While the *Lamentation* in Basel and the figures of *Christ* and *God the Father* may all be the work of one or more copyists, the *St. Christopher* is a significant stumbling block to this hypothesis. It is not, like the other three drawings, related to an extant panel painting by Baldung, and it seems to us to differ fundamentally from the somewhat stiff and labored graphic styles of the other three, and, indeed, of the *Christ on the Cross* in Basel that bears the presumed monogram of Georg Koch. None of these drawings approaches the powerful expression or the exuberance and vibrancy of line of the *St. Christopher*, and in none do we find features so characteristic of Baldung as the troubled, almost pouting Child upon the saint's shoulder[4] or his delicate and lacy halo (see Cat. No. 23). Despite some heavily worked passages in the black cross-hatching of Christopher's robe, the drawing as a whole appears too masterful in conception and execution for a copyist. If the quatrefoil flourish is indeed a form of signature of a member of Baldung's shop, we would prefer to see this work either as an autograph Baldung acquired and signed by the assistant, or as one in which Baldung allowed his assistant to collaborate with him in parts of the sketch. As neither of these hypotheses is entirely satisfactory, however, we should perhaps be cautious about interpreting the quatrefoil flourish as the signature of a member of Baldung's shop.

1  See Basel 1978, no. 34, fig. 42, and the actual-size reproduction in Térey, *Zeichnungen*, I, no. 2.
2  Halm, p. 129.
3  Basel 1978, pp. 61–62, no. 34.
4  See the putti in the *Man of Sorrows with the Virgin* in Freiburg, also of 1513 (Curjel, pl. 17), or in the Freiburg Altarpiece (Fig. 9).

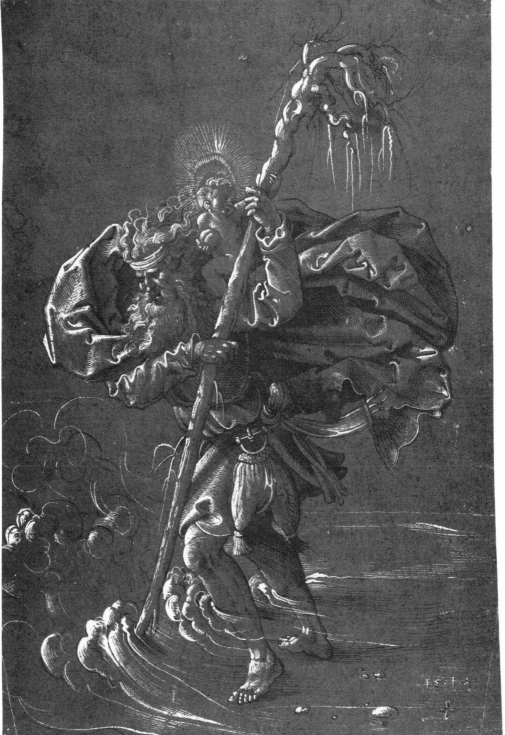

33

## 34

*Groom Bridling a Horse*

C. 1510–12

Engraving
334 × 211 mm. (13¼ × 8⁵⁄₁₆ in.)
B. 2; H. 7; Karlsruhe 1959, II K 5; M. 548
Lent by the Museum of Fine Arts, Boston,
S. P. Avery and Special Print Funds

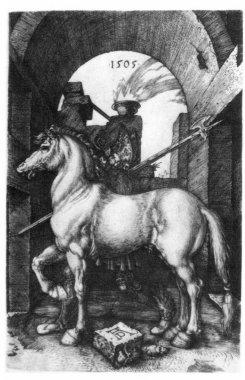

*34a. Albrecht Dürer, «Small Horse,» 1505, engraving.*

Although he was a prolific designer of woodcuts, Baldung made few engravings. He can be credited with, at most, six works in the medium,[1] of which the *Groom Bridling a Horse* is the most ambitious. Baldung's earliest engraving appears to be an *Unequal Lovers* (Ill. 19a) dated 1507, from his Nuremberg period. The *Groom,* because it employs a three-letter monogram,[2] is usually thought to date from after his move to Strassburg. The print should probably be placed near the beginning of this period, because of its close ties to Dürer. The composition is based on that of Dürer's *Small Horse,* an engraving of 1505 (Ill. 34a), as is the fluent modeling of the animal's body. Dürer's horse was intended as a paradigm of perfect equine proportions, based on Italian models,[3] and the more muscular character of Baldung's horse recalls another of Dürer's engravings from this year, the *Large Horse* (B. 97), as does the stone wall in the middle ground. The tree and the distant landscape are based on motifs common to a number of Dürer's engravings of the later 1490s, such as the *Unequal Lovers* (Fig. 3), the *Penance of St. John Chrysostom* (B. 63), and the *Promenade* (Ill. 1a). The tiny flock of birds circling the crenellated tower recalls a similar motif in Dürer's *St. Eustace* (B. 57) of c. 1500–01. The groom himself is a characteristic Baldung type and could be compared with the figures in the *Martyrdom of St. Sebastian* (Nuremberg), a painting of 1507 (Fig. 4).

It has been suggested that the engraving might date from around 1534, the year of the *Wild Horses in a Wood* (Cat. Nos. 83–85),[4] but the close relationship to works by Dürer from a much earlier period makes this unlikely. Baldung's print is surely meant as a mildly satiric reworking of Dürer's *Small Horse* and presupposes the viewer's knowledge of the prototype.[5] Dürer had costumed his attendant in fantastic classical armor, perhaps intending to characterize him as Perseus or Mercury. Dürer's composition, according to Panofsky, is to be interpreted as "animal sensuality restrained by the higher powers of the intellect," since the horse commonly symbolized violent and irrational passion, while the flame bursting from a vase in the background would have stood for "illuminating reason."[6] Baldung recasts the allegory in more purely physical terms. The horse is a massive and unruly animal, and the groom, himself a contemporary figure, is forced to dig in his heels in an attempt to restrain him. The horses's bulging eye recalls that animal's common affiliation with witchcraft and the forces of darkness, a theme also alluded to in Baldung's woodcuts of 1534 (Cat. Nos. 83–85). —J. A. L.

1  K. T. Parker, "The Engravings of Hans Baldung Grien," *The Print Collector's Quarterly*, XII, 1925, pp. 419–34; Mende, p. 65.
2  Baldung neglected to reverse the letter "G" on the plate, so that it is backwards in the printed impressions.
3  National Gallery of Art, *Dürer in America: His Graphic Work*, exhibition catalogue, ed. C. W. Talbot, Washington, D.C., 1971, p. 134.
4  Parker, "The Engravings of Hans Baldung Grien," p. 424.
5  It is tempting to speculate that Baldung was competing with Dürer, asserting his own ego to some degree in making an engraving so obviously modeled on one by Dürer. For an artist who worked so little with the burin, this print is extremely accomplished technically. Baldung has even tried to rival aspects of Dürer's technical virtuosity. For example, the bridle which is so prominently displayed here recalls the similarly complex and textured form in Dürer's *Nemesis* (Fig. 27).
6  Panofsky, I, p. 88; and *Dürer in America*, p. 134.

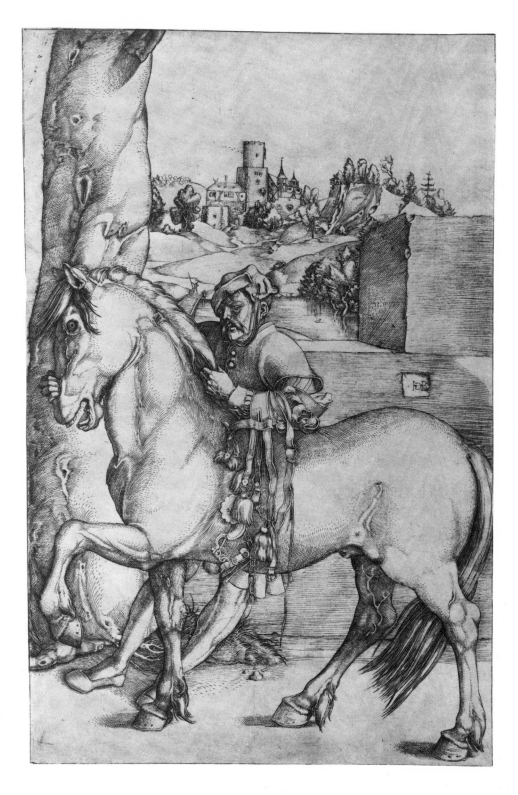

34

## 35

*Lamentation*

C. 1512

Engraving
Diameter 56 mm. (2¼ in.)
H. 3; Karlsruhe 1959, II K 1; M. 546 (Reproduced
in reverse)
Lent by the National Gallery of Art,
Rosenwald Collection

The composition of this tiny engraved roundel appears to
be derived from at least two sources, Baldung's own small
woodcut of the *Lamentation* from the *Hortulus animae*, pub-
lished in Strassburg in 1511 (M. 339) and Dürer's
*Lamentation* in the Alte Pinakothek in Munich, painted
around 1500-05 for the Nuremberg goldsmith Albrecht
Glimm (Ill. 14a). The painting was doubtless executed
by Dürer during Baldung's apprenticeship, since Bal-
dung returned to it for inspiration on several occasions
(cf. Cat. Nos. 46-47).

The present engraving is usually dated around
1512, and there is evidence to support this view. For in-
stance, the kinds of halos found in this print relate to Bal-
dung's drawing of *Christ and the Doubting Thomas* in
Strassburg (Koch 30), usually dated between 1511 and
the beginning of 1513. In addition, the fine, closely laid
parallel hatchings of the *Lamentation* roundel relate it to
Baldung's engraved *Groom Bridling a Horse* (Cat. No. 34),
convincingly dated by Parker between 1510 and 1512.[1]

The unusual format of Baldung's engraved *Lamen-
tation* is not without parallel among his single-leaf graphic
works; he also engraved a slightly smaller roundel of
*Christ at the Column*— known only by a unique impres-
sion in Vienna (M. 545)— which is similarly contempla-
tive in mood and spiritualized in expression. These small
devotional prints may have been intended to grace the
inside covers of religious codices or, perhaps, the inner
lids of rosary boxes.[2] —G.C.

1  K. T. Parker, "The Engravings of Hans Baldung
   Grien," *The Print Collector's Quarterly*, XII, 1925, pp.
   424-25 and p. 432, cat. no. 2.
2  For an example of the kind of box which might have
   accommodated such a circular print, see the French
   tooled-leather box of around 1500 measuring 11 centi-
   meters in diameter in the Deutsches Ledermuseum in
   Offenbach, illustrated in Günther Gall, *Leder im euro-
   päischen Kunsthandwerk*, Braunschweig, 1965, p. 143,
   fig. 105.

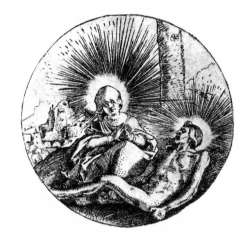

35

36

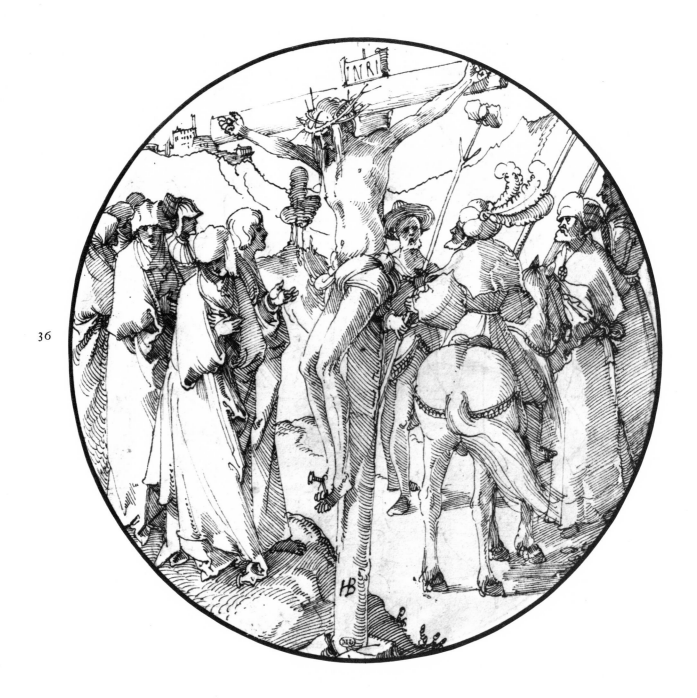

## ❧ 36

### *Crucifixion*

C. 1513–14

Pen and ink
197 mm. (7¾ in.) diameter
Koch 80; Karlsruhe 1959, no. 231
Lent by the Cabinet des Dessins, Musée du Louvre

As in the chiaroscuro woodcut *Crucifixion* of c. 1511–12 (Cat. No. 24), the cross in this pen-and-ink roundel is placed in the immediate foreground and at an angle to the picture plane to avoid an iconic interpretation of the subject and to emphasize the psychological relationship of Christ to the viewer and to the assemblage of holy mourners at the left. Baldung situates the base of the cross at the front of the picture plane, implying by its oblique angle and truncated crossbar that its forward edge projects in front of this plane into our space. The illusion of our proximity to Christ is also emphasized by disparate viewing angles: while Christ and the cross are seen from below, as if looming up before us, the landscape and attendant figures in the background are represented at eye level. The effect of these compositional devices is similar to that in the woodcut of c. 1511–12: Baldung partly disengages the figure of Christ on the cross from its narrative context to establish an intimate link with the observer.

The pen style in this drawing is as schematic as Baldung's mode of graphic expression ever becomes. It consists of long, light, sketchy contour lines which are understated, rapidly executed, and fluid. The internal forms are not really modeled; instead, Baldung employs angled parallel strokes to create a rhythm of planar shaded and lighted surfaces. This abstract, non-descriptive graphic style has its closest counterpart in Baldung's *oeuvre* in the marginal drawings done by the artist for the *Prayerbook of Maximilian I* in 1515 (Ill. 36a). In the *Prayerbook*, Baldung's use of methodical parallel strokes can be understood as an aesthetic accommodation to the field of the margins of the manuscript; there Baldung employed a non-illusionistic graphic style that would not violate the two-dimensional plane of the page. But this does not explain the use of a similarly abstract style in the present drawing, where all internal modeling is reduced to geometricized zones of light and dark, where detail is neglected, and the structure of human figures is left unclear. Koch[1] believed that the summary character of this drawing was due to its intended use as a design for stained glass.[2] Yet, it is hardly analogous to those drawings by Baldung known to be made for the guidance of stained-glass painters (see Koch 69–79, 81–84), and it is difficult

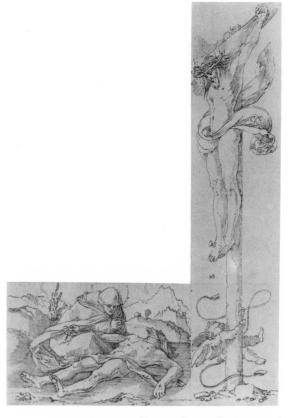

36a. Hans Baldung, «*Christ on the Cross,*» and «*Lamentation,*» marginal sketch from the «*Prayerbook of Maximilian I,*» c. 1515, pen, Library, Besançon.

to be certain about the reason for Baldung's choice of this technique. It might be that Baldung experimented with this style to endow his representation with a sense of immobilized form and ordered regularity, as if to reimpose sacral qualities upon a narrative depiction by using a fixed, spare, and restrained technique that would communicate the otherworldliness of this event. Whatever the purpose, this is a virtuoso drawing, apparently sketched rapidly but with such discipline and fixity of form that the solemnity and sacral character of the subject is intensified.[3]

1 Koch, p. 86.
2 Perseke, pp. 100–01, found the "notational" character and tentative outlines of this drawing alien to Baldung's spirit and doubted his authorship, suggesting that it might be a glass painter's tracing of an original drawing by Baldung.
3 The fragment of an outline drawing on the reverse of this sketch (not by Baldung), identified by previous authors as a section of an *Ecce Homo*, is in fact a detail of the lower portion of Christ from a scene of the *Crowning with Thorns* or the *Mocking of Christ*.

37

## 37

*Aristotle and Phyllis*

DATED 1513

Woodcut
333 × 238 mm. (13⅛ × 9⅜ in.)
B. 48; G. 119; H. 232; Karlsruhe 1959,
II H 71; M. 31
Lent by the Staatliche Museen Preussischer Kulturbesitz,
Kupferstichkabinett, Berlin-Dahlem

Well known in the literature of the late Middle Ages, the legend of Artistotle and Phyllis was popularized by a thirteenth-century cleric, Jacques de Vitry, who used it to discredit Aristotelian philosophy and to warn against taking classical authors too seriously.[1] According to the legend, Aristotle admonished his student, usually identi-fied as the young Alexander the Great, for devoting too much time to his wife and too little to his studies. An-gered by Aristotle's attempt to distract her husband's at-tentions, the wife (in some accounts Alexander's mistress) decided to take revenge. By promenading suggestively in the garden beneath Aristotle's window, Phyllis suc-ceeded in arousing the aged philosopher, provoking his sexual interest. The focal point of the narrative— illus-trated in most representations of the legend— occurs when in return for the promise of her favors, Phyllis demands and receives a ride about the garden on the philosopher's back. Aristotle's humiliation thus provides Alexander— who witnesses the entire scene— with a salient lesson about the spiritual and physical vulnerability of even the most learned philosopher.

Aristotle and Phyllis was one of several stories illus-trating the power of women over men which enjoyed great popularity in literature and art from the thirteenth through the sixteenth centuries; these include, among others, Samson and Delilah, David and Bathsheba, and Virgil in the Basket. Such subjects were represented either as independent images or together in sculptural groups, stained glass, and other decorative arts.[2] Baldung's print, the second image in his *oeuvre* to treat the subject, was intended as an independent work. In his first version, a drawing dated 1503 (Fig. 2), Baldung dispensed with several basic narrative elements in order to focus on the psychological relationship of the two protagonists, alone in a landscape, emphasizing the contrast between the coy young maiden and the anguished scholar. In the present woodcut, by contrast, Baldung concerns himself more with the narrative details of the legend, adding a few idio-syncratic elements to make it more personal and poignant. He places the action within a walled garden; Alexander

is at the top center, peering down at the sadly ludicrous scene below. To make the sexual implications of the story even more pointed, and Aristotle's humiliation more complete, the philosopher is shown totally naked, while Phyllis wears only a stylish hat. She holds the bridled Aristotle in rein, her control of the situation further un-derscored by the whip in her right hand. The model for Baldung's representation of the naked Aristotle on all fours may have been the minuscule figure in Dürer's en-graving of *St. John Chrysostom* (B. 63, D. 12) of c. 1496-97. Indeed, Baldung's use of this source may have been stimulated by the iconographic parallel, since both repre-sentations concern the infatuation of venerable older men with younger women. A jug, placed in a niche in the wall, is a common motif in Love Garden illustrations, suggesting inebriation and loss of reason.[3] The two naked figures are flanked by trees, the one behind Phyllis leafy and laden with apples, reminiscent of the trees in Cra-nach's woodcuts, notably the *Fall of Man* of 1509 (Jahn, p. 292; G. 21). The combination of the apples and the erotically suggestive concavity in the side of the tree im-plies that this is a "tree of knowledge"— like that in the Garden of Eden, an allusion to man's susceptibility to the wiles of women. The tree on Aristotle's side is barren and there is also a stump, perhaps reflecting the old man's im-potence. Or is it a visual pun, suggesting that his involve-ment with Phyllis will bear him no fruit? While there were also two trees and a stump in the drawing of 1503 (Fig. 2), Baldung artfully uses them here to reinforce the meaning of the scene.

Of all Baldung's characterizations of male-female relationships, this is the most anecdotal and sardonic. Nonetheless, the message is clear: carnal temptation is an underlying force in the degradation of human dignity.
—F.C.

1  *Reallexikon zur deutschen Kunstgeschichte*, I, Stuttgart, 1937, cols. 1027-40 s.v. "Aristoteles." Jane Hutchison, "The Housebook Master and the Folly of the Wise Man," *AB*, XLVIII, 1966, pp. 73-78.
2  *Reallexikon, loc. cit.*: for other versions in various media, see R. Van Marle, *Iconographie de l'Art Profane*, II, The Hague, 1932, figs. 509-20; P. Boesch, "Aristotle und Phyllis auf Glasgemälden," *ZAK*, IX, 1947, pp. 21-30.
3  Note the inclusion of this motif in the *Large Garden of Love*, an engraving by the anonymous Master of the Gardens of Love (L. 126); see also C. Cuttler, "Bosch and the Narrenschiff: A Problem in Relationships," *AB*, LI, 1969, pp. 272-76.

## ~ 38-41

## Four Woodcuts
## of the Fall and the Incarnation

Although the stylistic affiliation of these four woodcuts has long been recognized, and the first three are conventionally assigned to the same year as the dated *Nativity* of 1514 (Cat. No. 41), there has been surprisingly little commentary about the purpose or meaning of the four prints and their relationship to one another. Part of this may be related to the opinion, reflected in the literature on Baldung, that the artist created single-leaf prints only as independent images, reserving narrative cycles for illustrations in printed books.[1] But three of Baldung's prints of Passion subjects, produced in Nuremberg c. 1505–07, may well have been intended as a narrative ensemble (Cat. Nos. 7–9), and this group of four woodcuts also merits consideration as a thematically unified sequence.

Baldung's four prints, of essentially identical dimensions, correspond in subject matter to those that introduce Dürer's *Small Woodcut Passion*, issued c. 1509–11 (Ills. 38a–d). As Baldung echoes not only the graphic style of Dürer's series but also aspects of his compositions of the *Fall*, the *Expulsion from Paradise*, and the *Annunciation*, we may assume that he knew part or all of Dürer's series, which was issued in book form, containing thirty-seven prints, in 1511, and that the parallels in subject matter between the four prints are therefore more than coincidental.

Dürer's four woodcuts, possibly added after the core of the *Small Passion* was complete,[2] give his cycle an explicit overall focus on the theme of redemption. Commencing with the *Fall* and the *Expulsion*, which necessitated Christ's mission, Dürer then moves through scenes of the Incarnation and the Passion itself before concluding with representations of *Pentecost* and the *Last Judgment*. There is no evidence that Baldung intended his four prints as the beginning of a similar comprehensive series, but like Dürer, he may well have produced the four to exemplify and juxtapose the overall themes of the Fall and the Incarnation. In so doing, Baldung would have been drawing not only on Dürer's precedent but also on a rich literary and artistic tradition that elaborated these themes through the antithesis of Eve and Mary.[3] In this analogy, Eve was castigated as the instrument of man's Fall from Grace and for causing the loss of paradise, while Mary was extolled as God's chosen instrument to initiate the process that would redeem mankind and bring about the return to paradise.

All four of the events represented in Baldung's series figure prominently in this theological and pictorial tradition, which frequently focuses, as here, upon the juxta-

position of the scene of the angel expelling the original parents with that in which another angelic messenger announces the coming of the Savior. Thematic and formal emphases in the prints support the hypothesis that Baldung conceived the group of woodcuts as a unified set. In Dürer's corresponding representations, which introduce an extensive narrative cycle, the lines of composition, perspective and action are all directed from left to right. Baldung's prints, in contrast, are symmetrically focused: in the first and last (the *Fall* and the *Nativity*), the principal diagonals run from the lower outside corners up, and simultaneously somewhat back into space, toward the center; in the *Expulsion* and the *Annunciation*, the lines of motion are horizontal, with the two angels facing a central axis and the directional emphasis of the horizontally extended arms of the angel and Eve in the *Expulsion* answered by the accentuated parallels of Gabriel's lowered scepter and his dramatically pointed forefingers. (Eve's extended right arm is, in fact, at precisely the same level as Gabriel's scepter, and it is noteworthy that the two angels are of the same facial type.)

Baldung also increases the emphasis in his prints upon the roles of Eve and Mary. Thus, where Dürer represents Eve with her back turned to the viewer in the *Fall* and the *Expulsion*, Baldung makes her a more active figure who confronts us; and where Dürer's *Nativity* shows Mary as a diminutive figure set back into the picture space, Baldung singles her out by her placement and scale, and by the white halo that spotlights her head. Baldung establishes an anti-narrative order that also underscores the contrasting themes through the static character of the individual compositions and their opposition in groups of two. The scenes of the *Fall* and the *Expulsion* are composed of like vertical elements flanking the axis of a tree, while the *Annunciation* and the *Nativity* are constructed about stable triangular forms. He further contrasts the lush, primeval forest of the first two subjects with the constructed forms of the last two that are filled with radiances of a supernatural character: the glowing aureole about the dove of the *Annunciation* and the dramatic moonburst of the *Nativity* imply a world now sanctified by divine presence.

One final observation may also serve to confirm Baldung's aims and associations in designing this set of prints. In his representation of the *Fall*, Baldung did not employ the dramatic and overtly erotic type introduced in 1511 (Cat. No. 19) and repeated in later prints (Cat. No. 75) and panels (Fig. 50; Ill. 75a). Rather, he reverted to a more traditional composition that he had employed in a woodcut designed for *Der beschlossen Gart des Rosenkranz Mariae*, published in Nuremberg in 1505 (Ill. 38e). The reversion is significant because the print of 1505 is explicitly ideological in character, focusing upon the sac-

rifice of Christ and its symbolic reenactment in the Mass as essential paths to redemption from original sin. Baldung's quotation from this composition sets the tone for this series, which appears to have been designed to illustrate Christian doctrine concerning the interrelated themes of the Fall and the Incarnation.

These four prints are also among the earliest in which Baldung adopts a new graphic style to achieve tonal effects. He takes inspiration here from Dürer, who in works created following the second trip to Italy (1505–07) developed what Panofsky has characterized as a "graphic middle tone" in which "a system of parallel hatchings of medium density" establishes "a middle tone in relation to hatchings of greater density— particularly cross hatchings— and to the blank paper."[4] There are intimations of this technique in Baldung's woodcut of the *Three Fates* of 1513 (Fig. 31), but it appears in developed form only in this series of 1514, perhaps under the direct influence of Dürer's *Small Woodcut Passion*. The technique is used to create a tripartite tonal, plastic, and spatial scale: the foreground forms, composed of large areas of white with relatively few and short hatching strokes, are most fully rounded; forms in the middle ground, modeled by even and only slightly curved parallels that establish the "gray middle tone" are less plastic; and the background forms, represented by passages of dense cross-hatching or by solid areas of black, read as altogether flat.[5] Panofsky has compared this style to that employed in chiaroscuro drawings or prints, in which the middle tone is established through colored paper or a tone block, and areas of light and dark are then played off against this ground to denote shading or luminous heightening. Here the same effects are achieved through purely linear means, on uncolored paper, and it is surely no coincidence that the appearance of this style in Baldung's work follows closely his final experiments with chiaroscuro woodcuts (c. 1510–12). Perseke has detected a growing sophistication in the use and expressive range of this technique in the four prints of the *Fall* and the *Incarnation*, as if they were executed in narrative sequence.[6] Baldung developed the expressive potential of the style even further, however, in such works as his monumental prints of *St. Sebastian* (Cat. No. 48) and the *Conversion of St. Paul* (Cat. No. 52). —F.W.

1 Perseke, p. 144.
2 Walter L. Strauss, *Albrecht Dürer: Woodcuts and Woodblocks*, New York, 1980, p. 404, no. 137.
3 See E. Guldan, *Eva und Maria: Eine Antithese als Bildmotiv*, Graz and Cologne, 1966, pp. 55ff. and *passim*.
4 Panofsky, p. 134.
5 See the detailed analysis of Perseke, p. 155.
6 Perseke, pp. 154–57.

## 38

*Fall of Man*

c. 1514

Woodcut

220 × 153 mm. (8⅝ × 6 1/16 in.)

B. 1; G. 57; H. 1; Karlsruhe 1959, II H 1; M. 33

Lent by the Yale University Art Gallery

In this print, Baldung appears to have reworked elements from three different representations of the Fall of Man. Dürer's engraving of 1504 (Fig. 15) may have helped to inspire the dense landscape background and is certainly the source for the deer— a reinterpretation of Dürer's elk— that appears behind the tree at the lower center of the composition. Because Baldung alters the type of animal and omits the accompanying ones that form part of a coherent program of allusions to the four humors or temperaments in Dürer's representation,[1] the deer in Baldung's print may not serve a specific symbolic purpose. Dürer's woodcut from the *Small Passion*, datable c. 1509–11 (Ill. 38a), provides a close parallel for Baldung's graphic style here and is a likely source for such details as the large and scaly serpent with a crested head that is wrapped about the central tree trunk, and possibly also for the placement of the tablet with the artist's monogram in the lower right corner. The source for Baldung's grouping of Adam and Eve is one of the woodcuts he designed for *Der beschlossen Gart des Rosenkranz Mariae*, published in Nuremberg in 1505 (Ill. 38e). Baldung repeats the basic profile and three-quarter views of the respective figures flanking the tree, but he revises their facial types and gestures somewhat and demonstrates significantly improved understanding of human anatomy, particularly in the Eve. In fact, Baldung's sketchbook in Karlsruhe contains a silverpoint drawing of a nude female figure— certainly a life study— whose stance is close to that of the Eve, although in reverse, as one would expect for a figure subsequently printed from a woodblock (Ill. 38f). Koch omitted this sketch from his catalogue of Baldung's drawings, considering it weaker and later than those he accepted as autograph,[2] but Martin finds it close enough to his invention to consider it a copy after Baldung, perhaps by Nicolaus Kremer.[3] However that may be, the drawing apparently is or reflects Baldung's model for the revised figure of Eve, as is evident in a detail such as the leg extended in the foreground, which is angled at the knee joint in the 1505 woodcut, but pointed and straight in the sketchbook and the later print. Although the viewing angle differs somewhat for the figure in the sketchbook

and the Eve in the print of c. 1514, Baldung similarly altered the viewpoint of the life study from the sketchbook (Ill. 31a) that he reworked in his 1512 *St. Sebastian* woodcut (Cat. No. 31).

By reverting in this print to the composition of his 1505 woodcut (Ill. 38e), Baldung departed from the overtly erotic interpretation that he employed in many earlier and later representations in panel paintings and prints (see Cat. Nos. 19, 75). He did so, we have suggested (p. 172), because of the doctrinal associations of the woodcut of 1505, explicit in the conjunction of the *Fall of Man* with the *Crucifixion* and a representation of the Mass; the later series of four prints, of which the *Fall* of c. 1514 is the first, focuses upon the doctrinally important themes of the Fall from Grace and the Incarnation. Despite its echoes of the earlier print, the revised version of this composition of the *Fall of Man* possesses its own formal and dramatic emphases, some of which are related to its position within a thematically interrelated ensemble. Thus, in the woodcut of c. 1514, Adam's extended right arm establishes an initial lateral movement that directs our vision from the first print of the series rightward to succeeding subjects that continue or echo the line of this arm, and the placement of Eve somewhat back into space helps to create an arched compositional link between the *Fall* and the *Expulsion from Paradise* (Cat. No. 39).

Baldung draws a significant contrast between Adam and Eve in this version of the *Fall of Man*. While Adam is represented in pure profile as a conspicuously stiff and awkward figure, utterly lacking volition, Eve is in three-quarter view, purposefully extending one leg and actively reaching for an apple on the tree. Baldung thus contrasts Adam's passivity with Eve's more active role in the Fall, an idea reinforced by the directional alignment of Eve's head with that of the serpent, facing Adam. Although in this print Baldung develops a distinctive figural formula to comment upon the differing roles of Adam and Eve, the overall notion of Eve's greater responsibility as the active protagonist in this event reflects medieval teaching on the subject and is expressed— if through different formal and compositional means— in his other representations of this subject (Cat. Nos. 19, 75). —F. W.

1 Panofsky, pp. 84–85.
2 Koch, p. 42, n. 7.
3 K. Martin, *Skizzenbuch des Hans Baldung Grien: "Karlsruher Skizzenbuch,"* Basel, 1950, p. 75, fol. 66r.

38

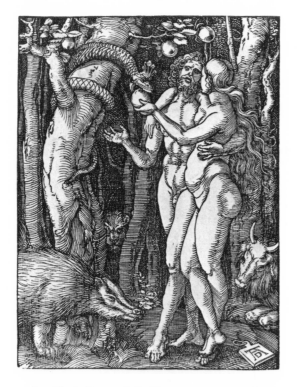

38a. Albrecht Dürer, «Fall of Man,» c. 1509–11, woodcut.

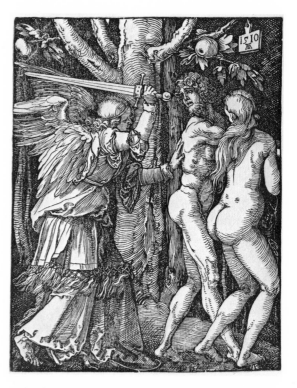

38b. Albrecht Dürer, «Expulsion from Paradise,» 1510, woodcut.

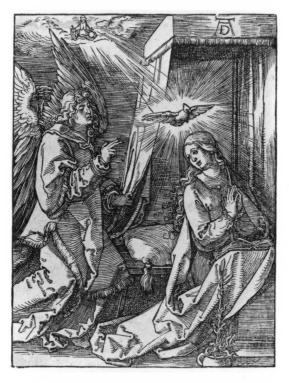

38c. Albrecht Dürer, «Annunciation,» c. 1509–11, woodcut.

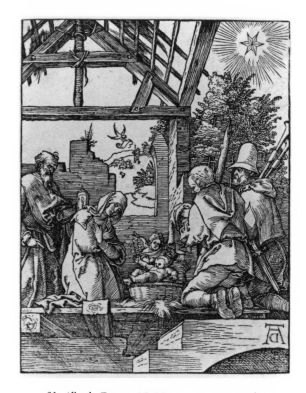

38d. Albrecht Dürer, «Nativity,» c. 1509–11, woodcut.

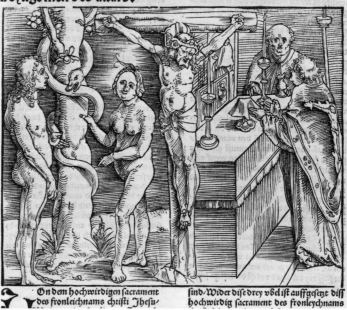

38e. Hans Baldung, «Christ on the Cross flanked by the Fall of Man and the Sacrament of the Mass» (from «Der beschlossen Gart des Rosenkranz Mariae,» Nuremberg, 1505), woodcut.

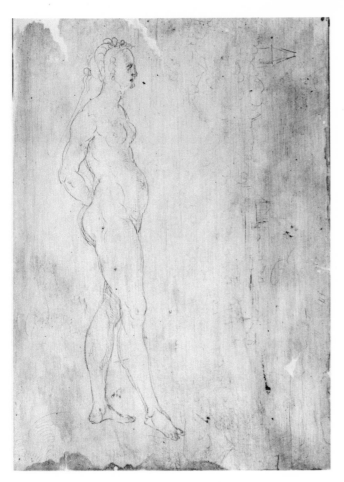

38f. Hans Baldung (?), «Life Study,» silverpoint (from the Karlsruhe Sketchbook), Staatliche Kunsthalle Karlsruhe.

39

## 39

*Expulsion from Paradise*

C. 1514

Woodcut
220 × 155 mm. (8⅝ × 6⅛ in.)
B. 4; G. 60; H. 4; Karlsruhe 1959, II H 4; M. 34
Lent by the Metropolitan Museum of Art,
Harris Brisbane Dick Fund, 1932

The *Expulsion from Paradise*— Baldung's only known version of this subject— is modeled upon the corresponding print in Dürer's *Small Passion*, dated 1510 (Ill. 38b). Baldung repeats Dürer's general arrangement of the principal forms, as well as such specific features as the rhythmically cadenced legs and cut-off arms of Adam and Eve and the monogrammed tablet suspended from a branch of the tree. Eve is given greater prominence in Baldung's print, facing rather than turned from the viewer, presumably because of her significance as the antithesis of Mary in the overall thematic program of Baldung's four prints. Baldung also introduces elements of emotional force and drama in his representation through the flying hair of Eve and the angel and particularly through the elongated form of the latter figure, who— with his upraised sword and somewhat elevated position— seems to tower over the first parents. The angel's robe is also more dynamic than the one worn by Dürer's angel, both in contour and in its interior modeling, which is composed of rhythmically patterned, curved lines rather than Dürer's more rectilinear ones. The excited forms of the angel and his robe suggest the influence upon Baldung of Grünewald, whose Isenheim Altarpiece was painted not far from Freiburg during the years 1510 to 1515. Grünewald's influence has been hypothesized in other works of Baldung's Freiburg period, but seems especially evident in his representations of angels in this print and the following one of the *Annunciation* (Cat. No. 40), and in the painted *Annunciations* of the Schnewlin and Freiburg Altarpieces (Curjel, pls. 21, 30).[1] —F.W.

1 See Pariset, pp. 148–49, 153 and *passim.*

*Annunciation*

C. 1514

Woodcut
219 × 155 mm. (8⅝ × 6⅛ in.)
G. 61; H. 6; Karlsruhe 1959, II H 5; M. 35
Lent by the Metropolitan Museum of Art,
Rogers Fund, 1918

Baldung's *Annunciation* recalls the corresponding scene in Dürer's *Small Passion*, datable c. 1509-11 (Ill. 38c), only in minor details. There are precedents for the type of *prie-dieu* at which the Virgin kneels and for her pose with crossed arms in woodcuts designed by Baldung for books printed in 1505 and 1511 (M. 130, 305, 333) and in the panel of the *Annunciation* of the Schnewlin Altarpiece (Curjel, pl. 22), which is contemporaneous with this print. Motifs possibly inspired by Dürer's woodcut include the rectangular canopy above the Virgin's head (although of different construction) and the radiant halo emitted by the dove of the Holy Spirit. Baldung's composition is more static than Dürer's, presumably because of its intended place within a cycle of prints illustrating a doctrinal relationship between the events of the Fall and the Incarnation. The figures of Gabriel and Mary are placed at the same approximate height and form the base of a stable triangle that has its apex in the frontal dove. The hieratic rigidity of the composition— reinforced through the geometrically subdivided forms of the background architecture— differentiates it from Dürer's print and from Baldung's other representations of this event, and allies it with the *Nativity* of this series (Cat. No. 41), which is similarly constructed about a stable triangular form. Baldung's composition also reverses the general orientation of Dürer's, with the result that the figures of Mary and Gabriel symmetrically mirror the angel and Eve in the *Expulsion from Paradise* (Cat. No. 39), again presumably for doctrinal reasons. A formal relationship between the two representations is also implied by the horizontal elements of the extended arms of the angel and Eve in the *Expulsion*, which are echoed in the extended hands and scepter of Gabriel in the *Annunciation*.

In placing his figures within a classical architectural interior, Baldung may not only have wished to reflect contemporary taste, but might also have intended an association with Italy. The purpose would be to relate the event of the Annunciation to the eternal life of the Church by associating it with the classical and Renaissance traditions. Baldung fills this simple bedroom with figures of evident divine origin. He spiritualizes the scene through the prominent radiance about the frontal dove

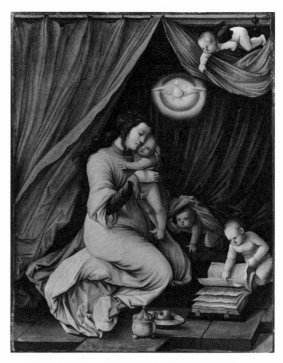

40a. Hans Baldung, «Madonna and Child with Angels,»
c. 1516, panel, Los Angeles County Museum of Art.

and through the figure of Gabriel, who seems almost to hover above the ground, rather than rest upon it. In this feature, as well as in such motifs as the windblown hair and the dramatically extended forefinger of Gabriel, it is possible to see the influence of Grünewald's Isenheim Altarpiece of c. 1510-15.[1]

Baldung apparently recalled the original design for this print when creating his composition of the *Madonna and Child in an Interior with Angels*, known in a panel dated 1516 in Nuremberg (Curjel, pl. 44) and an undated replica in Los Angeles (Ill. 40a). The figure of the Virgin in the panels echoes the zig-zag form of Gabriel in the *Annunciation*, incorporating even such elements from the latter figure as the position of the foreground arm and the stiffly bunched folds of the robe that encircle the elbow. There are also reminiscences in the panels of the pulled-back curtains of the canopy above the Virgin. The relationship between the two compositions is confirmed by the dove— represented in frontal view in both— which is iconographically anomalous in depictions of the Madonna and Child in an interior, but appropriate in an *Annunciation*. As most of the reproduced elements are represented in reversed orientation, Baldung apparently retained his original studies for the *Annunciation* and drew upon them again for his composition of the *Madonna and Child in an Interior with Angels*. —F. W.

1   See Cat. No. 39, n. 1.

40

41

*Nativity*

DATED 1514

Woodcut

223 × 154 mm. (8¹³⁄₁₆ × 6¹⁄₁₆ in.)

G. 62; H. 7; Karlsruhe 1959, II H 6; M. 36

Lent by the Staatliche Museen Preussischer Kulturbesitz, Kupferstichkabinett, Berlin-Dahlem

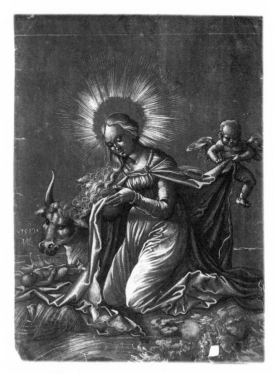

*41a. Nikolaus Kremer, «Nativity,» 1519, chiaroscuro drawing, Staatsgalerie, Stuttgart.*

The *Nativity* is the only one of Baldung's four woodcuts of the Fall and Incarnation to show no significant points of contact with Dürer's corresponding print in the *Small Passion* of c. 1509–11 (Ill. 38d). Instead, Baldung draws upon compositional and figural motifs found in a series of his own prints, sketches, and panels dating from c. 1510 to 1514 (see M. 306, Koch 23, Curjel, pls. 12, 31), including a lost study for the central figural group which is thought to be reflected in a chiaroscuro drawing of 1519 by Nikolaus Kremer (Ill. 41a).[1] The general format also recalls Martin Schongauer's *Nativity* engraving of about 1470–75 (L. 5; Baum, pl. 5). As Baldung's four prints were designed to contrast the roles of Eve and Mary, this final print of the group focuses upon the Virgin, represented in a stable triangular mass that recalls the composition of the *Annunciation* (Cat. No. 40). The depiction is further stabilized by the architecture that structures the scene, by the pier behind the Virgin, and by the vertical axis established by the alignment of the moon or starburst in the sky and the Virgin's bright halo. Baldung thus creates a hieratic composition quite dissimilar from Dürer's scene in the *Small Passion*.

Although Baldung did not normally make use of complex symbolism in his art, the *Nativity* contains a conspicuous group of details interpretable as references to the coming of Christ. The broken, classical column base in the right foreground, for example, is a common symbol of the replacement of the Old Order by the New.[2] A similar contrast is implied by the representations of the ox and the ass: whereas the faithful ox, a symbol of the Church, keeps watch over the Christchild, the ass, a common symbol of *Synagoga*, or the Old Law, ignores Christ to bray with contempt or to eat from the straw carried by Joseph.[3] Other symbolic details include: the grotesque figure of a wild man sitting on the pier behind the Virgin, who probably functions as a symbol of heathenism since, according to medieval tradition, he cannot know God;[4] the arched opening of an underground grotto over which the Virgin kneels and which may refer to the prison in which Christ was later kept during his Passion;[5] and the exceptionally bright radiance of the moon or star in the sky, which dramatically proclaims the presence of the Divine. All these references to the Old and New eras and to the significance of the coming of Christ complement the overall theme of Baldung's four prints— the juxtaposition of the Fall from Grace with the beginning of man's redemption at the Incarnation.
—F.W.

1 See Karlsruhe 1959, no. 292, and P. Wescher, "Nicolas Kremer of Strassburg," *AQ*, I, 1938, pp. 204–11, fig. 3.
2 See. G. Schiller, *Iconography of Christian Art*, I, Greenwich, Conn., 1971, p. 81. See also the broken columns in Koch 23 and a presumed copy by Jörg Schweiger after a lost Baldung *Nativity* in Basel (Basel 1978, fig. 36).
3 For the symbolism, see E. Panofsky, *Early Netherlandish Painting*, Cambridge, Mass., 1953, p. 470, n. 1. Although it is unclear if the ass in this print is braying or eating, that in a woodcut contributed by Baldung to the *Leien Bibel*, published in Strassburg in 1540, is clearly braying (M. 521). By representing the ass with its eyes obscured by the wall at the right, Baldung also alludes to the blindness of the Old Law.
4 See R. Bernheimer, *Wild Men in the Middle Ages*, Cambridge, Mass., 1952, p. 12.
5 See G. Bandmann, "Höhle und Säule auf Darstellungen Mariens mit dem Kinde," *Festschrift für Gert von der Osten*, Cologne, 1970, pp. 130–48. As Bandmann notes, in some traditions the underground grotto refers to the site in which the Virgin gave birth to Christ.

42

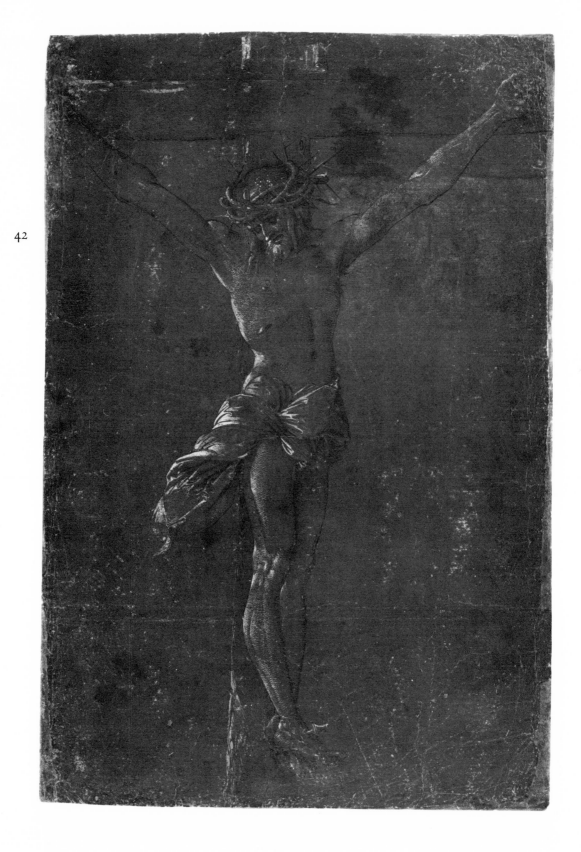

## 42

### *Christ on the Cross*

c. 1514–15

Pen and ink, heightened with white,
on dark red-brown tinted paper
310 × 213 mm. (12¼ × 8⅜ in.)
Koch 36; Karlsruhe 1959, no. 141
Lent by the Staatliche Graphische Sammlung,
Munich

In this sober and understated representation of *Christ on the Cross*, Baldung takes advantage of the three-dimensional possibilities inherent in the chiaroscuro drawing technique,[1] integrating the black outline, delicate system of white highlights, and dark background to create a convincing corporeal presence in an abstract space. In perfect harmony with the tranquil, introspective mood and the gentle contrapposto, the gossamery web of white hatching endows the surface of Christ's body with a glimmering radiance.

    Hans Möhle suggests that this drawing was heavily influenced by Grünewald's Isenheim Altarpiece,[2] as were many of Baldung's works from his Freiburg period, 1512–16. The extreme elongation of the figure, the exaggerated length of the arms (which could reach to the knees), the cramped toes, and the inordinately large and spiny crown of thorns may have been inspired by Grünewald. But the mood is quietly personal, and this drawing has none of the brutality of Grünewald's *Crucifixion*. The figure in the drawing more nearly approximates the crucified Christs in Baldung's own Calvary scenes (see, for example, Cat. No. 24), especially the one on the verso of the Freiburg Altarpiece (Ill. 42a). As with most Baldung drawings, this one cannot be said to relate to any specific painting, and it is not certain whether it was made as an object in its own right or as a study. Both the painting and the present drawing, however, clearly come from the same period in Baldung's career; and in both works Baldung twists the figure of Christ slightly askew to avoid the iconic character of more hieratic formulations.

1  See discussion under Cat. Nos. 13, 23, 33, and 59.
2  Hans Möhle, review of Koch's *Die Zeichnungen Hans Baldung Griens, ZfK*, X, 1942, pp. 215, 218.

*42a. Hans Baldung, «Calvary» from the Freiburg Altarpiece, c. 1516, panel, Münster, Freiburg.*

43

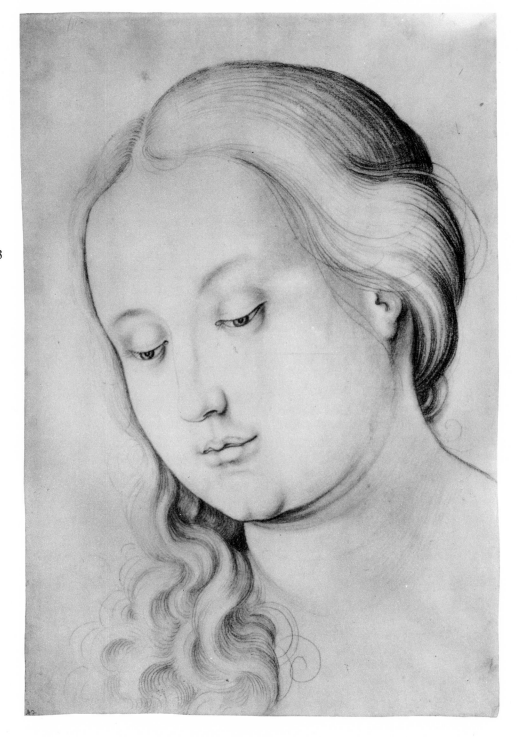

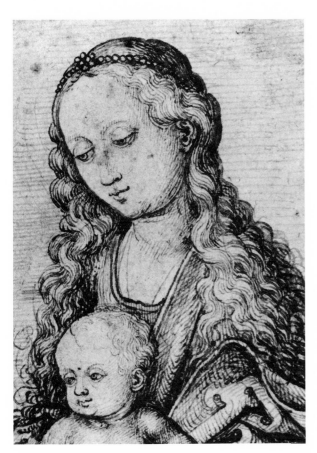

*43a. Martin Schongauer, «Madonna and Child with the Carnation» (detail), c. 1475, pen, Staatliche Museen, Berlin.*

~ 43

*Head of a Young Woman
with Lowered Glance*

C. 1513–15

Red chalk
315 × 220 mm. (12⅜ × 8⅝ in.)
Koch 43, Karlsruhe 1959, no. 135
Lent by the Kunstmuseum Basel, Kupferstichkabinett

Masterfully executed in red chalk, slightly rubbed or stumped to achieve subtle modeling, this virtuoso drawing presents the ultimate refinement of Baldung's ideal female type. Unlike Dürer's drawings of female faces, with their insistent emphasis on details, little attention is given here to individualized treatment. The smooth, unblemished face is punctuated only by the large spherical eyes with their scarcely perceptible brows, by the nose, the cupid-bow mouth, and the hint of a double chin, itself composed of two roundish forms. The rather severe geometry of the head is softened by the intentionally blurred contours, the gentleness of expression, and the shy downward glance. This face appears with minor variations as a Madonna or female saint in many Baldung paintings, drawings, and prints, but it is not elsewhere described so tenderly or with such clarity (cf. the Madonna in the *Coronation* from the Freiburg Altarpiece [Fig. 9]; the drawings, Koch 25, 26, and 32; and the woodcuts Cat. Nos. 22, 27, and 40). In most other versions of this facial type (see Cat. No. 23), Baldung endows the visage with a vivacious, even saucy quality, but here a quiet dignity— somewhat unusual in Baldung's *oeuvre*— prevails.

Baldung's awareness of and reliance upon Upper Rhenish prototypes of the fifteenth century is suggested in the discussion of Cat. No. 45. The work of Martin Schongauer of Colmar, the most prominent and influential Alsatian painter and printmaker of the later fifteenth century, seems to have had special meaning for Baldung. Indeed, the female type in this drawing is a descendant of the sweet, youthful Madonna type invented by Schongauer some forty years earlier (Ill. 43a). Baldung's image, tempered by knowledge of Dürer's Madonnas, is both a more ample and more convincing presence than Schongauer's, but the shape of the head and the simplicity and relative proportions of the facial features place Baldung's work squarely in the Upper Rhenish tradition.

44

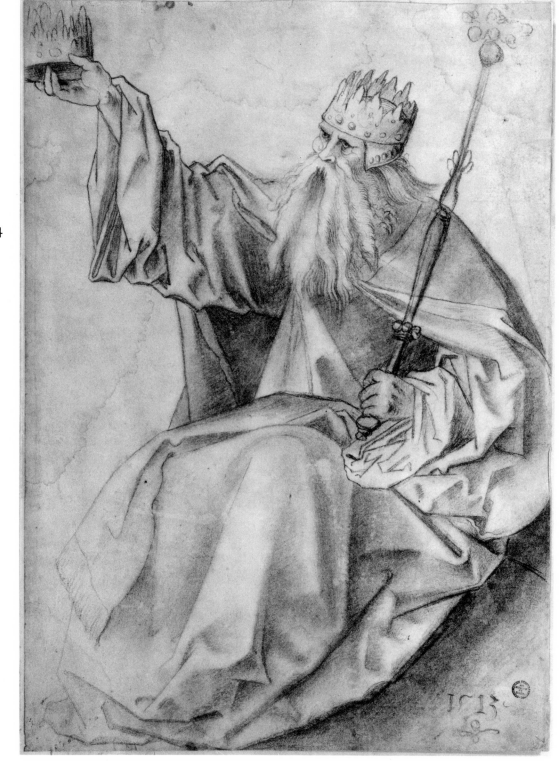

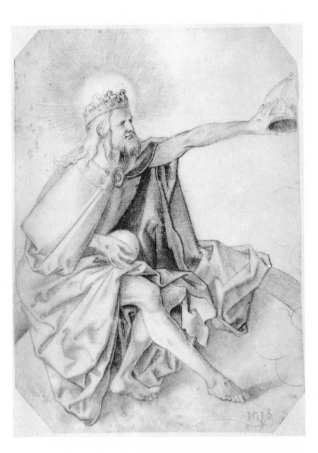

*44a. Hans Baldung (shop), «Christ,» 1513, chalk, Staatliche Kunsthalle Karlsruhe.*

❧ 44

*God the Father*

DATED 1513

Black chalk
305 × 221 mm. (12 × 8¹¹⁄₁₆ in.)
Koch 40; Karlsruhe 1959, no. 129
Lent by the Kunstmuseum Basel, Kupferstichkabinett

The figure in this drawing is very close to that of God the Father in the *Coronation of the Virgin*, the central panel of Baldung's most important commission, the Freiburg Altarpiece of 1512–16 (Fig. 9).[1] The drawing differs from the painted version in a number of details: in the position of the fingers of both hands, the arrangement of the drapery over the left knee, the design of the crowns, and the conception of the left sleeve, where the hastily sketched folds suggest that the artist was still perfecting his idea— the mark of a working drawing rather than a copy. The most striking difference, however, is in the facial expression. In the drawing, the beard covers the upper portion of the cheek, obscuring the upper lip, and the crown sits slightly lower upon the forehead. As a result the eyes are more accentuated; the expressive contours of the brow further amplify the intensity of the gaze.

Not all scholars, however, have agreed with the attribution of this drawing to Baldung; some, including Perseke and Halm, have ascribed this work to the hand responsible for the related drawing of the *Christ* from the Freiburg *Coronation*, universally considered a student's copy (Ill. 44a).[2] They believed that the two drawings are by the same artist since they have a common provenance, are executed on similar paper, and are of comparable size.[3] But these factors do not necessarily confirm the identity of the hands, only that the drawings originated in the same workshop. Moreover, the treatment of the drapery is fundamentally different. In the present drawing, the broad and simply massed folds are modeled with a consistent pattern of angular shadows,[4] reminiscent of Grünewald's contemporaneous drawings. In the drawing of Christ, the folds seem by comparison fussy and more studied, not as monumental in effect— the product of a less decisive and less competent hand. The construction of the extended arm and awkwardly crossed legs also betray the hand of a copyist, doubtless one of Baldung's assistants in Freiburg.

The quatrefoil flourish that appears in the sketches of *God the Father* and *Christ* also occurs in two other drawings in Baldung's style dated 1513: the *Lamentation* (Cat. No. 46) and *St. Christopher* (Cat. No. 33). Halm and Falk have proposed that the insignia is the signature of a single student.[5] The stylistic evidence does not support this view, since we have already noted that *God the Father* and *Christ* are dissimilar. The *Lamentation* has little in common with either, and the exquisite *St. Christopher* is surely Baldung's own, in keeping with several other chiaroscuro drawings firmly attributed to him and dated, or datable, around 1513 (see Koch 30, 31, 36–39). It therefore seems likely that the copyists responsible for the *Christ* and the *Lamentation* adopted the insignia from their master just as they did the respective images.

The attribution of *God the Father* to Baldung nonetheless remains problematic. The soft tonal modulations in the drapery are not found in other Baldung drawings of the period. In addition, there is no evidence that Baldung used preparatory drawings for details of his paintings, and the present drawing is the only candidate for such a role in his *oeuvre*. Perhaps the size and importance of the Freiburg commission created a special circumstance which prompted Baldung to make detailed preliminary drawings. But such a hypothesis is purely speculative. The best arguments for the attribution to Baldung are the strength of certain details in the face and beard, the fact that the drawing deviates from the Freiburg painting (something one would not expect in the work of a copyist), and in the power of the characterization of this venerable figure. —D.L.

1    The source for this figure— and for the entire composition of the *Coronation*— is Dürer's lost Heller Altarpiece of c. 1508–09, preserved in a copy in Frankfurt (Ill. 17a).
2    Halm, p. 129; Basel 1978, pp. 57–58; Perseke, p. 208, first tentatively suggested that *God the Father* was a student's copy of an original Baldung sketch.
3    Basel 1978, p. 57.
4    Falk (ibid., p. 58) contends that the artist's failure to indicate the anatomical forms beneath the drapery militates against the drawing's originality. However, Baldung's conception of drapery usually endows the folds with an independent pictorial effect regardless of underlying anatomical structure.
5    See Cat. No. 33, nn. 2, 3.

## ↝ 45

*Death of the Virgin*

C. 1512–16

Black chalk
428 × 311 mm. (16⅞ × 12¼ in.)
Koch 42; Karlsruhe 1959, no. 140
Lent by the Kunstmuseum Basel, Kupferstichkabinett

The composition of this drawing is based on Martin Schongauer's engraving of about 1470–75 (Ill. 45a), confirming that Baldung was familiar with the Upper Rhenish tradition reaching well back into the fifteenth century. As in the Schongauer print, the twelve Apostles cluster about the bed of the dying Virgin. Although the compositional borrowings are obvious, the spirit which permeates the two works could not be more different. Schongauer is still essentially a medieval artist who recapitulates a familiar religious theme with appropriate discretion and dignity. For Baldung the subject provided an opportunity to translate Schongauer's language into his own expressive idiom, and in so doing to reveal his own, private, intensely felt religious emotions. Whereas Schongauer's print seems carefully orchestrated, with ornate and elegant folds of drapery carefully disposed to present a rhythmically decorative but stable composition, Baldung's drawing appears to be the product of a sudden burst of inspiration. The subject, which is usually rendered as solemn and serene, is here invested with pulsating energy and drama. The cross on the tall staff held by St. Philip at the left and the prominent bed curtain along the right edge of Schongauer's scene— vertical compositional elements which lend stability— have been eliminated in Baldung's drawing, giving the scene a more improvised, random, and somewhat unsettled character. In addition, the tightly spaced parallel lines of the curtain behind and above the heads of the Apostles grouped at the right become a torrent of undulating lines in Baldung's version. Finally, Baldung has carefully modeled some parts of the scene, but left other areas blank; he has lightly sketched in the Apostles in the left foreground, whereas the other two Apostle groups are vigorously executed with emphatic contours. These factors cause the eye to jump from one part of the scene to another, contributing to the sense of restlessness the drawing emanates. The faces of the Apostles, although partly individualized, are treated in an abbreviated manner with quick, simple strokes of the chalk representing eyes and mouths. This gives a pallid, cadaver-like appearance to some of the figures, adding to the unreality and mystical quality of the

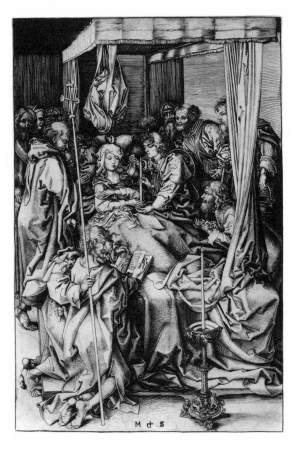

*45a. Martin Schongauer, «Death of the Virgin,» c. 1470–75, engraving.*

scene. The Apostle reading at the lower left of Schongauer's engraving kneels in a graceful and relaxed pose. The analogous figure in the drawing seems to lunge forward, the diagonal created by his body and his awkwardly protruding leg more emphatic than that created by the foreshortened bed. It is hard to imagine how the anatomy of this figure might be accounted for under his robes. Hunched in an unnatural position, he calls to mind several chalk studies by Grünewald in which falling men, swathed in ample cloaks, are seen from odd angles;[1] it is likely that Grünewald's influence accounts not only for the pose of this one figure, but also for Baldung's intensely spiritualized, expressive, and unconventional rendering of the subject. Other Baldung drawings and prints from his Freiburg period, equally affected by Grünewald's powerful works, share this kind of intense and emotion-laden interpretation of religious subjects (see Cat. Nos. 46–53).

1  Eberhard Ruhmer, *Grünewald Drawings*, New York, 1970, cat. V, pl. 6; cat. VI, pl. 7.

45

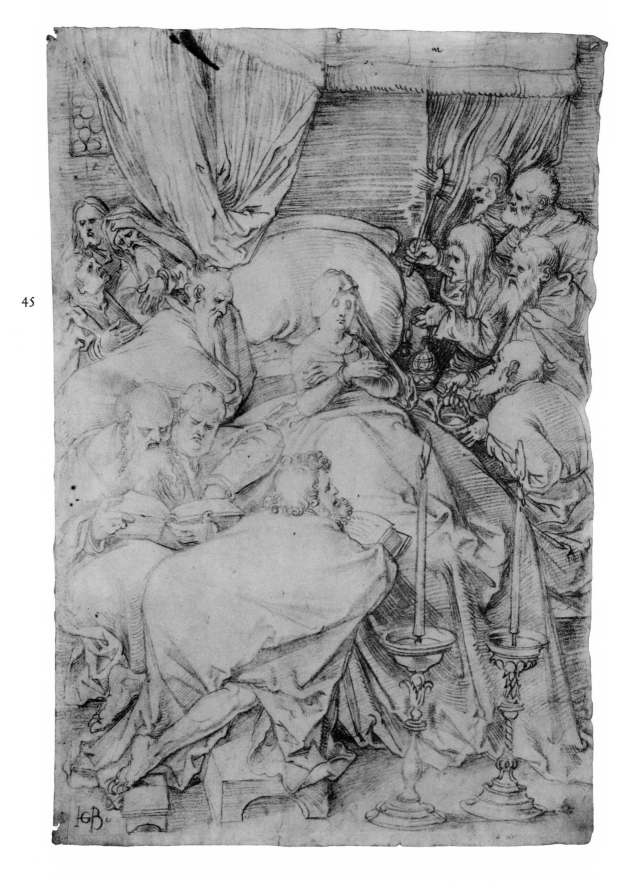

## 46

### Lamentation

DATED 1513

Pen, brush, and ink
325 × 224 mm. (12¹³⁄₁₆ × 8¹³⁄₁₆ in.)
Koch 34; Karlsruhe 1959, no. 130
Lent by the Kunstmuseum Basel, Kupferstichkabinett

## 47

### Lamentation

DATED 1513

Pen, brush, and ink
316 × 224 mm. (12⅞₁₆ × 8¹³⁄₁₆ in.)
Not in Koch
Lent by the Metropolitan Museum of Art,
Robert Lehman Collection

These two drawings, both dated 1513, are virtually iden-
tical in all essential compositional details to Baldung's
painted *Lamentation*, also dated 1513, in the Ferdinand-
eum in Innsbruck (Ill. 46a). How, then, do these two
drawings relate to each other; scholars have ques-
tioned whether one or both are preliminary to the paint-
ing, if the drawings are copied after the painting, whether
one drawing is a copy of the other, or, indeed, if either
was done by Baldung.

Certain elements of the three works appear to be
derived in part from a number of disparate sources. Wil-
helm Vöge observed that the figures of Christ, St. John,
and the two Marys in the Innsbruck painting are similar
to the analogous figures in the sculpted *Lamentation* group
executed by Nikolaus von Hagenau for the predella of
the high altar of Strassburg Cathedral around 1501, when
Baldung was still presumably apprenticed in that city.[1]
A more immediate source for the modeling and compo-
sitional arrangement of the Virgin, the shrouded body of
Christ, and the bearded, turbaned mourner— either
Nicodemus or Joseph of Arimathea— whose hands can
be discerned through the cloth under Christ's armpits in
Baldung's *Lamentation*, was probably Dürer's *Lamentation*
in Munich (Ill. 14a), painted around 1500.[2] The motif
of the Magdalen kissing Christ's feet may have been in-
spired by Dürer's *Lamentation* drawing of 1504 from the
*Green Passion* (Ill. 46b), or by the woodcut *Lamentation*
from the *Small Passion* of 1511 (B. 43, K. 249). The dense
glade and "thicket" of crosses which define the middle
ground of Baldung's *Lamentation*, as well as the distant

view of wooded foothills and the alpine peaks visible between them, suggest a familiarity on Baldung's part with earlier works by Albrecht Altdorfer, such as the *Satyr Family* panel of 1507 or the 1509 drawing of *Christ on the Mount of Olives*, both of which employ similar landscape elements.[3] Baldung's relationship to the Danube School, often implied in scholarly literature, has never been fully analyzed.

The authenticity of the *Lamentation* drawing in Basel (Cat. No. 46), first attributed to Baldung in the late nineteenth century, was called into question in a review of the 1959 Karlsruhe exhibition by Peter Halm, who pointed out the drawing's general weakness and declared it to be after, not preparatory to, the Innsbruck panel.[4] In the same review, Halm also doubted the authenticity of the little-known Lehman version (Cat. No. 47), although he had apparently not examined the original. In a study published six years later, however, Reinhold Hohl[5] judged the Lehman *Lamentation* to be the original Baldung, an opinion since accepted, with reservations, by Tilman Falk[6] and unreservedly by George Szabo.[7] A line-by-line comparison of the two drawings reveals them to be relatively precise replications of each other. Indeed, if allowance is made for the narrow strip missing from the upper edge of the New York *Lamentation*, the two drawings are identical in size, which raises the possibility that one was partly traced from the other. Furthermore, minute examination of passages of the two drawings— in discrete, isolated segments of modeling, in shaded pockets of drapery, the edges of an arm or hand or, to be specific, in the group of parallel lines descending from Christ's chin over the center of his chest— reveals in most instances exactly the same number of hatches in both drawings. Finally, in Cat. No. 47, the right hand of Christ lacks the wound found in both Cat. No. 46 and in the Innsbruck painting. It is unlikely that such an important detail would be missing from Baldung's preliminary drawing for the painting, but it might have been accidentally omitted from a copy. Exacting comparison of the two drawings is made difficult by the fact that they both combine pen and brush work on the same sheet. If one is a pen tracing of the other, the high degree of similarity one would expect to be immediately evident might be masked by the independent brush strokes in the two.

The question still remains whether Baldung's hand is evident in either drawing. On the basis of comparisons of the two *Lamentations* with other roughly contemporaneous drawings by Baldung, we are inclined to believe that the two drawings are the work of another hand. There is a disparity, for example, between the strong, confident line and nervous energy of drawings such as Baldung's *Eve* of 1510 in Hamburg (Fig. 17) and the weak, cautious line and hesitant character of both the Basel and Lehman *Lamentations*, between the surging, "electric" shoots sprouting from the end of the staff of Baldung's *St. Christopher* of 1513 (Cat. No. 33) and the slack, listless shoots dangling from the tree behind the Virgin in the two *Lamentations*, and between the windblown curls of St. John in the painted *Lamentation* in Innsbruck and the lifeless hair of the saint in the drawings. An especially telling comparison can be made between the abbreviated foliage in the upper left of these two drawings and the similar foliage in the background of Fig. 17.

Although the identity of the artists responsible for the Basel and New York drawings remains uncertain, the appearance of quatrefoil flourishes— like that inscribed on the bottom edge of the Basel *Lamentation*— in at least three other drawings produced in Baldung's Freiburg workshop in 1513 suggests that the master of the Basel and New York drawings was at least a member of Baldung's atelier.[8] If this hypothesis is correct, and Baldung was not the author of either drawing, then one or both of the *Lamentations* may have served as a shop record of the painting in Innsbruck. —G.C.

1  Wilhelm Vöge, *Niclas Hagnower: Der Meister des Isenheimer Hochaltars und seine Frühwerke*, Freiburg, 1931, p. 78 and pl. 39, 1.
2  See George Szabo, "Content and Form: Notes on Drawings by Albrecht Dürer and Hans Baldung Grien," *Drawing*, I, 1979, p. 3.
3  For the *Satyr Family*, see Franz Winzinger, *Albrecht Altdorfer: Die Gemälde*, Munich and Zurich, 1975, pp. 73–74, cat. no. 5, and fig. 5. The drawing *Christ on the Mount of Olives* is catalogued and illustrated in Winzinger, *Altdorfer Zeichnungen*, p. 69, cat. no. 13, and fig. 13.
4  Halm, pp. 128–29.
5  Reinhold Hohl, "Aus Baldungs Werkstatt in Freiburg. Ein neues Dokument zur Entstehung des Gemäldes 'Die Beweinung Christi' in Innsbruck," *Neue Zürcher Zeitung*, April 10, 1966, "Literatur und Kunst" section, pp. 1–2.
6  Basel 1978, p. 28.
7  Szabo, "Content and Form," p. 3.
8  Two of the three other drawings of 1513 bearing this quatrefoil flourish, *God the Father* and *St. Christopher*, are included in the present exhibition (Cat. Nos. 44 and 33). For the third drawing, a *Christ* from a Coronation scene, in Karlsruhe, see Ill. 44a. The most recent discussion of the quatrefoil flourish is found in Basel 1978, p. 62.

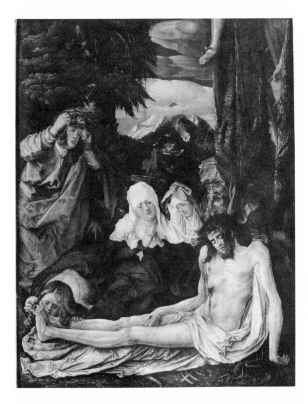

46a. (Left). Hans Baldung, «Lamentation,» 1513, panel, Tiroler Landesmuseum Ferdinandeum, Innsbruck.

46b. (Below). Albrecht Dürer, «Lamentation» (from the «Green Passion»), 1504, pen on green tinted paper, Albertina, Vienna.

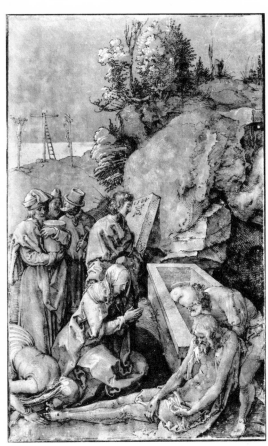

46

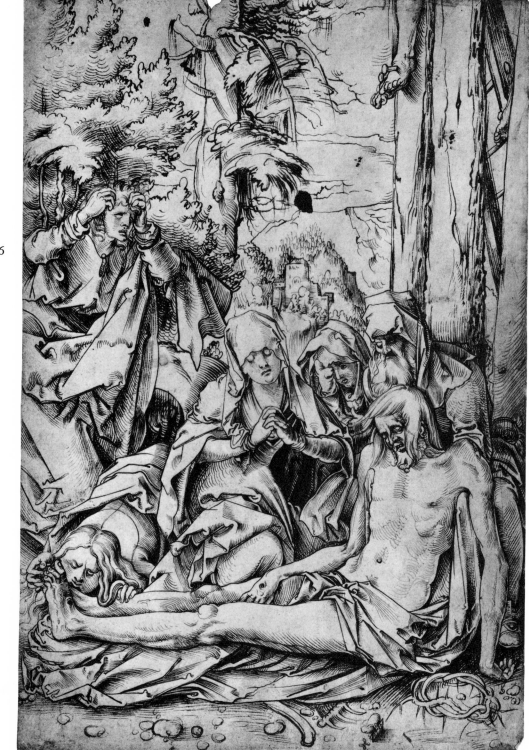

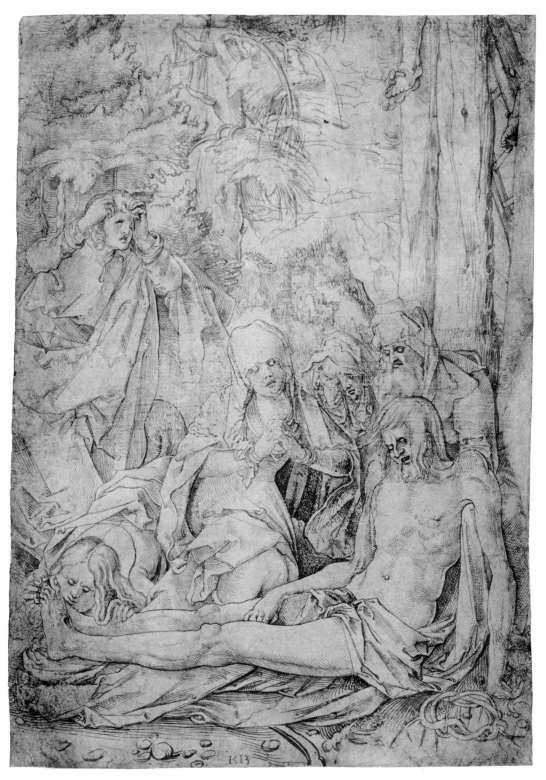

48

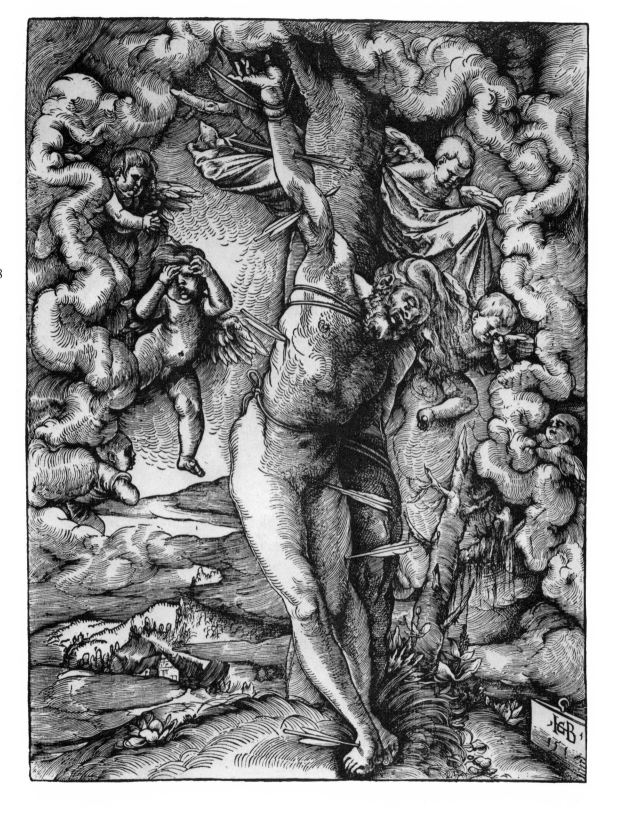

## 48

*St. Sebastian*

DATED 1514

Woodcut
311 × 232 mm. (12¼ × 9¼ in.)
B. 37; G. 113; H. 128; Karlsruhe 1959,
II H 62; M. 38
Lent by the Museum of Fine Arts, Boston,
Maria Antoinette Evans Fund

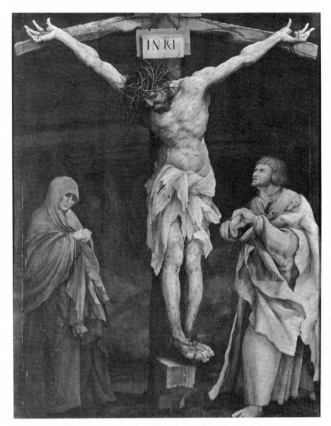

*48a. Matthias Grünewald, «Crucifixion,» c. 1523–24, panel, Staatliche Kunsthalle Karlsruhe.*

Hans Curjel referred to this powerful woodcut as the "German Laocoon,"¹ because of the contorted pose of the nude figure, its monumental scale and expressive pathos. Characteristic of Baldung's prints of the Freiburg period (1512–16), the expressive impact of this woodcut is due in part to the influence of Grünewald and in part to Baldung's highly inventive and somewhat idiosyncratic use of clusters of energized line to convey a sense of tautly charged atmosphere. The violently twisted and outstretched right arm of the saint, with the hand in a contorted gesture, is clearly based on Grünewald's model (Ill. 48a), as are the slightly puffy, overlapping feet, the drooping head and slumped body. Baldung also extends the saint's body so his toes virtually touch the bottom margin line; this heightens the immediacy of the image by seemingly projecting the saint into the viewer's space. The earth drops away suddenly behind the saint, emphasizing his visual prominence and increasing the sense of unease, a feeling which is underscored by the sudden shift in scale from the foreground to the small house in the distant landscape seen through rifts in the jagged clouds at the bottom left. One rope binding him to the tree cuts into his torso, while another wraps around and bites into his wrist. With his usual perversity, Baldung depicts Sebastian with an arrow stuck in the pubic region. The saint, appearing moribund, slouches over, his incredibly long hair flowing off to the right and merging with the forms behind, just as does the Madonna's hair in Cat. No. 53.

The entire scene is enframed by intestine-like storm clouds populated by grieving putti, who hold their heads, wring their hands in anguish, or wipe away tears. The band of clouds hides from view the uppermost section of the tree and functions, as Pariset has noted, almost like a mammoth crumpled curtain, about to be dropped at the end of a drama.² In his introductory essay, Alan Shestack has commented on the tension caused in this print by the ambiguous use of modeling lines which sometimes enhance the corporeality of forms and sometimes have an independent, non-descriptive role, serving as a vehicle for the abstract expression of a dramatic, highly charged moment. Baldung's woodcut technique is surface-oriented, with an emphasis on agitated contours and energized hatching lines which add to the mood of uncontrolled grief. There is no clear difference in graphic treatment between foreground and background. All action takes place in the foremost plane. Indeed, the print resembles relief sculpture against a fabric of graphic hatching, with the highest points illuminated and the most recessive areas in total darkness.

1 Curjel, p. 85.
2 Pariset, p. 152.

49

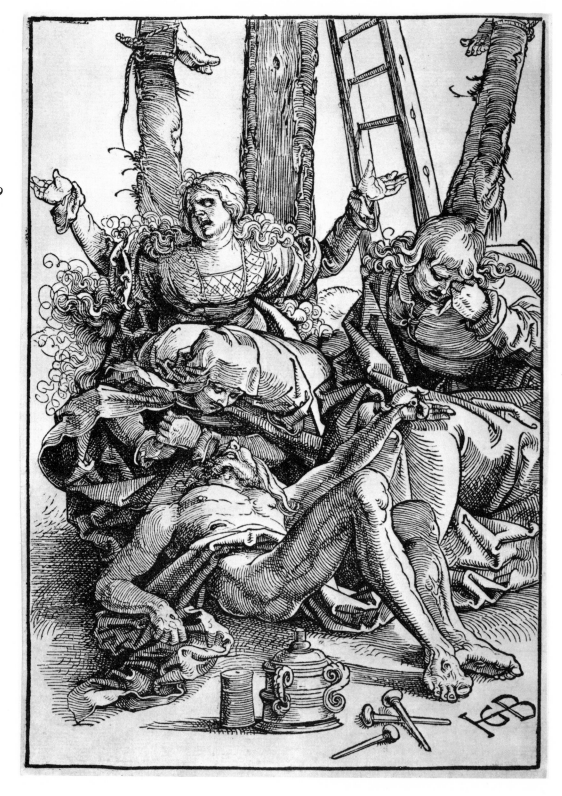

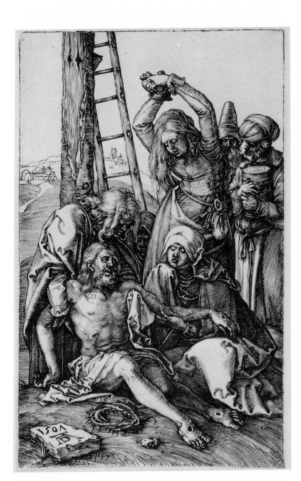

*49a. Albrecht Dürer, «Lamentation,» 1507, engraving.*

~ 49

*Lamentation*

C. 1515–17

Woodcut
223 × 156 mm. (8¾ × 6⅛ in.)
B. 5; G. 77; H. 53; Karlsruhe 1959, II H 12; M. 40
Lent by the Metropolitan Museum of Art,
The Elisha Whittelsey Collection,
The Elisha Whittelsey Fund

This is one of three woodcuts with virtually identical dimensions and a similarly forceful and expressive cutting style which portray the dead Christ, the other two being the *Christ Carried to Heaven by Angels* (Cat. No. 50) and the *Man of Sorrows before the Column* (Cat. No. 51). Baldung appeals openly to the viewer's emotions in these works, all of which are focused upon the broken and helpless body of the Savior. Although the *Lamentation* is the most overtly dramatic of the three prints, its devotional intent is made clear by the prominent display of instruments of the Passion in the foreground and by the suppression of landscape details behind the truncated crosses in the background. Baldung fills the area between these two zones with the overlapping forms of Christ and the mourners, the latter expressing impassioned grief in their urgent gestures; he draws us into the scene by the foreshortening and low viewpoint of the figures, and he dramatizes the whole by means of active line and powerful dark and light contrasts. The accomplishment of this print can be gauged by comparing it with Baldung's woodcut of c. 1505–07 (Cat. No. 8) and his engraving of c. 1512 (Cat. No. 35): whereas the earlier works are notable for their stable compositions and their restrained expressions of grief, here Baldung seeks to move us by means of a dynamic composition and figures who are overcome by Christ's death.

Although Grünewald has been cited as a likely source of influence for this highly emotional print,[1] Baldung seems to have drawn upon diverse sources. The germ of this composition is traceable to Dürer's engraved *Lamentation* from the *Small Passion*, dated 1507 (Ill. 49a). Baldung increases the foreshortening and the dramatic gestures of his figures, but he still retains reminiscences of Dürer's print in such features as the cross and ladder behind the mourners and the shaggy-haired figure of St. John bent forward over Christ.[2] Italian influence is likely in the figure of the Magdalen in Baldung's print, which recalls that in Mantegna's engraving of the *Entombment of Christ* (Ill. 49b). There are Italian precedents as well for

the dramatically foreshortened figure of Christ— among them works by Mantegna, Fra Bartolommeo and Luca Signorelli[3]— but this figure more likely goes back to Dürer's drawing of the *Dead Christ* in Cleveland, dated 1505 (Ill. 49c). Baldung also makes use of motifs from his own works: the truncated crosses of the thieves appear in the Innsbruck *Lamentation* of 1513 (Ill. 46a), and a figure of the Virgin bending over the corpse of her son occurs in one of the drawings in the margin of the *Prayerbook of Maximilian I*, datable c. 1515 (Ill. 36a).

Baldung's success in integrating these disparate elements is related to his increased command of line. Although the print is animated by dense and vigorous angular and curved forms, the parts are articulated and interrelated by means of a complex rhythm of dark and light passages. In this regard, the drawing presupposes such tonal works as the large *St. Sebastian* of 1514 (Cat. No. 48) and approximates the *Man of Sorrows before the Column* of 1517 (Cat. No. 51). —G.C.

1   Pariset, p. 158.

2   See also the drawing Koch 37, which reflects additional details of Dürer's print.

3   See National Gallery of Art, *Dürer in America: His Graphic Work*, exhibition catalogue, ed. C. W. Talbot, Washington, D.C., 1971, pp. 53-55, no. XIII.

*49b. Andrea Mantegna, figure of the Magdalen,
detail from the «Entombment,» c. 1465-70, engraving.*

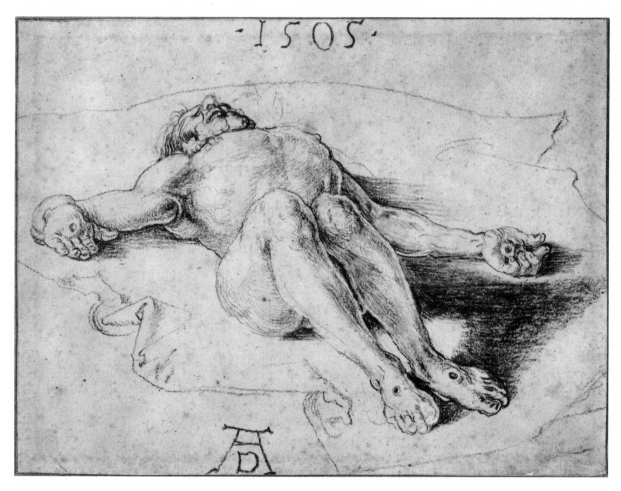

49c. Albrecht Dürer, «Dead Christ,» 1505, chalk, Cleveland Museum of Art.

50

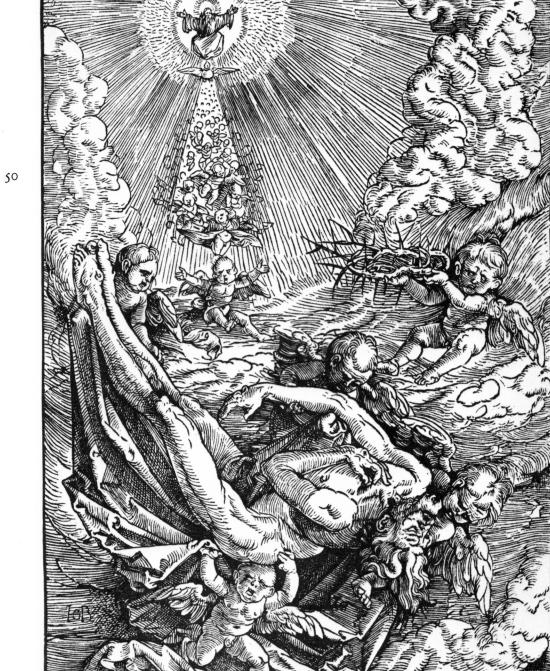

*Christ Carried to Heaven by Angels*

C. 1515–17

Woodcut
223 × 153 mm. (8¾ × 6 in.)
B. 43; G. 82; H. 56; Karlsruhe 1959, II H 15; M. 39
Lent by the Staatliche Kunsthalle Karlsruhe

This iconographically innovative print shows four angels carrying the corpse of Christ heavenward beneath a radiance containing the figures of God the Father and the dove of the Holy Spirit. Within the halo of light, the Father spreads his arms as if to welcome or reveal the body of the Son in a gesture repeated by the outstretched wings of the dove and by the arms of the cherub found at the bottom of a stream of angels which descends from the heavenly aureole toward the body of Christ. In striking contrast to the celestial splendor at the top of the composition, the lower section depicts the pathos of the dead Son: Christ is shown in a harshly awkward position, with his legs raised high and his lifeless head cast back. The distended wounds in Christ's hands and legs and the winding sheet with which he is carried are visible reminders of his death on the cross; the large and acutely barbed crown of thorns borne by an angel to the right of center recalls another of the torments of the Passion.

The subject of this print is unprecedented insofar as it seemingly represents the heavenly ascension of a dead rather than a living Christ. Yet this is no representation of the canonical event of the Ascension, nor, for that matter, of any other traditional scene of biblical narrative. Possible literary sources have, therefore, been sought in other areas. Feurstein, for example, has adduced a passage in the *Revelations* of St. Bridget of Sweden (2,21) where there is a description of "angels numberless as rays of the sun giving honor and adoration to the Savior taken down from the cross."[1] Bridget's text, however, seems to refer to an adoration of Christ on the earth, rather than in heaven, and makes no mention of the interaction of the members of the Trinity which is so important in this print by Baldung. Other scholars have considered the representation as a Eucharistic allegory, relating it to a portion of the Canon of the Mass where the celebrant prays for God "to command that these things [i.e., the Eucharistic offerings] be carried by the hands of thy holy angels to thy heavenly altar, in the presence of thy divine majesty."[2] Eucharistic allusions may, indeed, underlie many representations of the *corpus domini*, or the body of the Lord, in art of the late Middle Ages and the early Renaissance, including this one. But Baldung's image contains no explicit references to the symbolism of the Mass, such as a representation of the grave or an altar, or of the sacramental blood. Accordingly, this print should be viewed as another of Baldung's highly creative devotional images of the Man of Sorrows, with Eucharistic associations merely implicit in the theme. Related works by Baldung include the drawing of the *Dead Christ* of c. 1507 (Cat. No. 14), in which the artist again evokes the rigors of the Passion in Christ's awkwardly posed body; the 1511 woodcut of the *Ecce Homo* (Cat. No. 29), in which angels again support and display the body of Christ in a heavenly setting; and the *Man of Sorrows before the Column* of 1517 (Cat. No. 51), in which a solitary angel supports the dead Christ, again accompanied by instruments of the Passion. There are relationships also with Baldung's panel paintings, most notably a depiction of the *Man of Sorrows with the Virgin* in Freiburg, dated 1513 (Curjel, pl. 17), in which a group of mourning angels supports the Savior in a heavenly setting that includes representations of God the Father and the dove of the Holy Spirit.

In creating this striking devotional image, Baldung drew upon diverse traditions. There are echoes of the so-called *Angels' Pietà*,[3] as well as of the image known as the *Gnadenstuhl*, or Throne of Grace, a form of the Trinity in which God the Father, accompanied by the dove of the Holy Spirit, holds the dead Christ. These two themes had actually been combined by the early fifteenth century,[4] and Baldung may well have known these or more recent examples, such as Dürer's masterful woodcut of 1511 (Fig. 47), in which Christ's body is also represented in a harshly broken pose, although held vertically by the Father. What chiefly distinguishes Baldung's work from these representational traditions, however, is his avoidance of their familiar and iconic compositions in favor of a depiction of greater pathos and drama. In the foreground of a heavenly setting of turbulent clouds and funnel-shaped space, Baldung's angels labor to carry the jack-knifed and cadaverous body of Christ. The weighty corpse almost appears to be sinking downward, in a motion reminiscent of the lowering of Christ into the grave in scenes of the Entombment. Associating weight and corporeality with death, Baldung vividly contrasts, as Berliner states, "human destruction" and the "grandeur of heaven."[5] This unresolved juxtaposition of the vision of a cosmic heaven and the harsh reality of Christ's ignominious death constitutes the expressive core of the print; by boldly accentuating the inherent contradiction between Christ's divine nature and his suffering humanity, Baldung gives visual form to one of the central mysteries of the Christian faith.

Grünewald's influence has been seen in this print in such features as the brutally awkward pose of the figure of Christ, the jagged drapery folds, the powerful move-

ment, and the explosive emotion.[6] The tonal character of the work may also reflect study of Grünewald's panels, for here Baldung goes beyond the chiaroscuro effects of his earlier works of the Freiburg period to suggest something of the shimmering and atmospheric quality for which Grünewald is justly famed. In the flecks of line that surround the figure of God the Father in the heavenly aureole, and in the quick dashes and circles with which he represents the uppermost cherubs that emerge from this nucleus, Baldung produces an impression of the dissolution of form in light. Elsewhere too, Baldung employs rough and jagged lines of irregular length, density and curvature to create an impression of light flickering over the surface of the forms. Of all of Baldung's woodcuts, only the large *Conversion of St. Paul*, also of c. 1515–17 (Cat. No. 52), achieves the "painterly" effects of the *Christ Carried to Heaven by Angels*. These two works, similar also in their juxtaposition of dramatically posed and heavy foreground figures with an active, light-filled sky, are the culmination of Baldung's experiments with tonal effects during the Freiburg period. If the *Christ Car-*

*ried to Heaven by Angels* is the better known of the two, it is not because of its distinctive stylistic features, but rather because of the bold invention of Baldung's vision of a heavenly lament over the dead Savior. —L.J.

1 See H. Feurstein, *Matthias Grünewald*, Bonn, 1930, p. 51.
2 See G. von der Osten in *Reallexikon zur deutschen Kunstgeschichte*, V, Stuttgart, 1967, col. 603, s.v. "Engelpietà;" idem, "Zur Ikonographie des Hans Baldung Grien," *Festschrift für Herbert von Einem*, Berlin, 1965, p. 182; and Basel 1978, p. 72.
3 See the works by von der Osten, cited above, n. 2, and Cat. No. 29.
4 See a panel attributed to "Master Hans" (Hans von Tübingen) in Vienna, Österreichische Galerie; reproduced by A. Stange, *Deutsche Malerei der Gotik*, XI, Munich and Berlin, 1961, fig. 9.
5 R. Berliner, "The Freedom of Medieval Art," *Gazette des Beaux-Arts*, XXVIII, 1945, p. 264.
6 See O. Fischer, *Hans Baldung Grien*, 2nd ed., Munich, 1943, p. 34, and Pariset, p. 161.

## ❧ 51

*Man of Sorrows before the Column*

DATED 1517

Woodcut

223 × 153 mm. (8¹¹⁄₁₆ × 6 in.)
B. 42; G. 81; H. 55; Karlsruhe 1959, II H 15; M. 41
Lent by the Museum of Fine Arts, Boston,
Anna Mitchell Richards Fund

As in the *Ecce Homo* of 1511 (Cat. No. 29) and the *Christ Carried to Heaven by Angels* (Cat. No. 50), Baldung here merges ideas from different traditional devotional images to create a fresh and moving representation of the Man of Sorrows. Baldung draws upon representations of the Man of Sorrows standing in front of the column of the Flagellation, as exemplified by Dürer's engraving of 1509 (Ill. 51a),[1] and of the so-called *Angels' Pietà*. The combination of elements from these two iconographic types is unusual and highly expressive; by placing the helpless Christ of the *Angels' Pietà* in the setting usually occupied by a living and standing Man of Sorrows, Baldung creates a startling vision of the dead Savior.

The differences in the interpretations of Baldung and Dürer are telling ones, for while Dürer's living Christ implies his victory over death, Baldung stresses only the pathos of the sacrifice. Thus, Baldung not only represents the wounds of the Crucifixion and the familiar instruments of the Passion (the crown of thorns, the column, and the whip), but evokes the agonies of the Passion through the image of Christ's broken and sunken form, with its dramatically splayed limbs and clenched hands. And while Dürer's Christ is a fundamentally stable figure, there is urgency in the tenuous position of Baldung's, with the Savior's body thrust to the right of the central axis and his stiff left arm pressing against the right border. This powerful movement to the right is only partly counterbalanced by the drapery that flies out to the left, establishing an equilibrium that is precariously maintained by the solitary angel who struggles to prevent Christ's collapse. Even the architecture contributes to the intensity of Baldung's print; in place of the logically disposed and stabilizing architectural elements of Dürer's print, which incorporates a view to a distant, open landscape, Baldung employs planar and precipitously receding forms that are abruptly and awkwardly juxtaposed, conveying an oppressive mood through their heavy and unrelieved murality.

Von der Osten and Mende have interpreted this scene as a Eucharistic allegory, the former claiming that

the theme of the *Angels' Pietà* constitutes a realization of the prayer from the Canon of the Mass in which God is beseeched to receive the Mass offering borne by angels.[3] Baldung's print, however, lacks overt references to the celebration of the Mass, such as the blood of Christ or a chalice. Thus, while sacramental allusions may be implicit in the subject, this work, like Cat. Nos. 29 and 50, is primarily a devotional image, meant to stimulate feelings of compassion—and thus of emotional identification with Christ.

This emotional current is predominant in the mature woodcuts of the Freiburg period, in subject matter, as well as in graphic form, in which Baldung cultivates the expressive potential of light effects. During this period, Baldung's graphic style evolves from the densely patterned line of the 1514 *St. Sebastian* (Cat. No. 48), which suggests the influence of the chiaroscuro technique, through the rough and choppy lines of the *Conversion of St. Paul* (Cat. No. 52) and the *Christ Carried to Heaven by Angels* (Cat. No. 50), both of c. 1515–17, which produce distinctive atmospheric effects. In the *Man of Sorrows before the Column* of 1517 and the *Lamentation* (Cat. No. 49), which also parallel one another in size, monumental figure style, complex drapery folds, and strongly differentiated areas of light and dark, Baldung shows increased concern with spatial clarity and plastic form. In both these works Baldung begins to shift from the loose strokes and the painterly effects of Cat. Nos. 50 and 52 to the more complexly patterned cutting and sculptural forms that characterize his late woodcut style. —L.J.

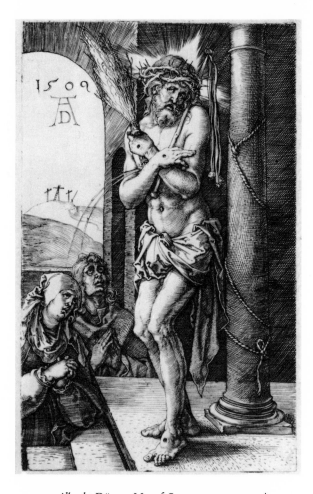

*51a. Albrecht Dürer, «Man of Sorrows,» 1509, engraving.*

1   Dürer's engraving was used alternatively as a frontispiece or a concluding scene to the *Small Engraved Passion*; see National Gallery of Art, *Dürer in America: His Graphic Work*, exhibition catalogue, ed. C. W. Talbot, Washington, D.C., 1971, pp. 138–40. For fifteenth-century antecedents of this iconographic type, see S. 651, 885a, 899 and 899a.
2   See Cat. No. 29, with bibliography, n. 4.
3   For von der Osten, see Cat. No. 29, n. 4, and No. 50, n. 2; Mende, p. 47, no. 41.

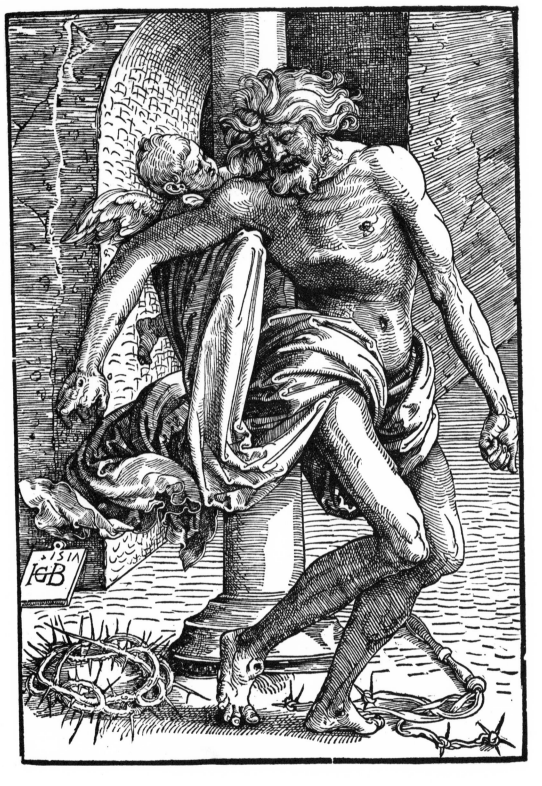

## 52
### Conversion of St. Paul

C. 1515–16

Woodcut
296 × 196 mm. (11⅝ × 7¾ in.)
B. 33; G. 111; H. 125; Karlsruhe 1959,
II H 59; M. 42
Lent by the National Gallery of Art,
Rosenwald Collection

St. Paul's conversion on the road to Damascus, a dramatic story related in the Acts of the Apostles (9:1–25), was frequently represented in Baldung's time. Paul had been an eager participant in the persecution of Christians, and at the moment of his conversion was about to carry out the destruction of a small Christian community; Christ appeared in a great blazing light which threw Paul from his horse and left him blinded. Rebuked by Christ, Paul was instantly converted. Christ then instructed him to take the faith to the Gentiles, and Paul became a missionary in Asia Minor and Greece. Later he was imprisoned in Rome, where he suffered martyrdom. During the pre-Reformation period, the theme of conversion must have been of major interest, and prints such as this may actually have been understood as exhortations to conversion. At the very least, the subject would have appealed to the Protestant philosophy, since it is a reminder of the dynamic personal relationship between the individual and Christ.

Baldung represented this subject on two other occasions, in a rather pedestrian woodcut from the period of his Nuremberg apprenticeship (Ill. 52a) and in a tapestry design of c. 1535–40.[1] In each case, Baldung in-

cluded most of the traditional narrative details: the mounted St. Paul, either alone or with two companions; the thundering vision of Christ with the cross; and the otherworldly rays of light. The present print, however, is unrivaled in its intensity and emotional power.

Baldung represents the moment of religious transformation as a dramatic confrontation between the divine and human spheres. The diagonal rays of light emanating from the sky exert an almost physical pressure. Paul is the figure on his back in the immediate foreground. He has dropped his lance, and he shields his eyes from the blinding light of Christ's appearance. He and his horse are virtually pressed to the ground. The intensity of the scene is increased by the contortions of the horses and the agitated gestures of Paul's companions. The pose of the man with raised arms, the straining profile of the horse on the right, and the unstable configuration of the horses— colliding and pressing against one another— all convey the frenzied reaction to the celestial apparition.

Baldung stresses Christ's role in this event. Represented as a stern figure with a long beard, more typical of a God the Father, Christ gestures toward Paul. Christ is shown holding the cross, a motif rare in previous representations of this subject, although it later became a standard feature in scenes of Paul's conversion. Its meaning is traceable to the well-known biblical injunction uttered by Christ: "If any man would come after me, let him deny himself and take up his cross and follow me" (Matthew 16:24). Here, the cross is aligned on the diagonal with the rays that strike Paul and his entourage; the cross itself seems to be the source of this powerful emanation. Baldung focuses on the dramatic action by reducing the landscape background and placing the densely packed group of men and horses on the picture plane where they completely fill the lower section. The sense of extreme crowding is enhanced by the elimination of space between the three interlocked horses. The density of the bottom half of the composition contrasts with the open expanse of the dark, brooding sky at the top. This structural division, corresponding to the polarity between the earthly and heavenly realms, further underlines the extraordinary nature of the events which occurred at the moment of Paul's conversion. Part of the pictorial tension is due to the struggle between depth and surface. Baldung has fused the forms and jammed them against the picture plane in such a way that they read as a space-filling pattern, although the powerful, multi-directional modeling lines remind us of the three-dimensionality of the disparate elements. Using line also to convey the atmospheric effects of light flickering over the surface of the forms, rather than to delineate the forms themselves, Baldung endowed this work with a "painterly" character. The scene is made all the more dramatic through the effects of light and the explosive energy contained within the convulsive lines and shapes, in the way the sinuous curves of the horses' backs are pitted against the sharp rays of light which hurtle down from the upper left corner. As Linda Hults has noted, both of these linear movements are stabilized by the horizontal lines in the sky.[2] As is often the case in Baldung's woodcuts from his Freiburg period, the violent expressionism, tonal richness, and emphasis on light (see *Christ Carried to Heaven*, Cat. No. 50 and *St. Sebastian*, Cat. No. 48), are underscored by the jagged and agitated modeling lines that collide and create directional forces which convey some of the power of the image. —L.J.

1  Reproduced in Curjel, pl. 94.
2  Hults-Boudreau, p. 188.

52

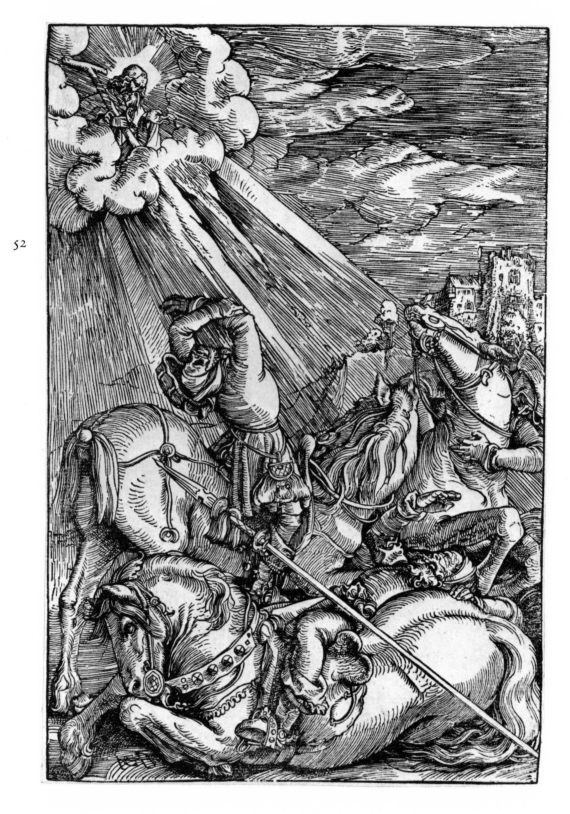

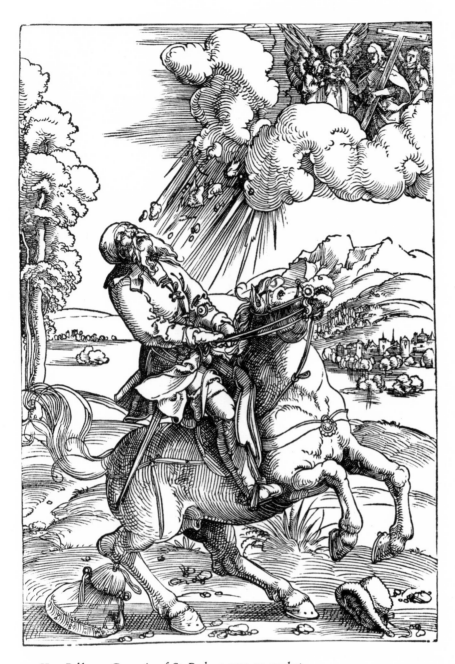

52a. Hans Baldung, «Conversion of St. Paul,» c. 1505–07, woodcut.

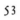

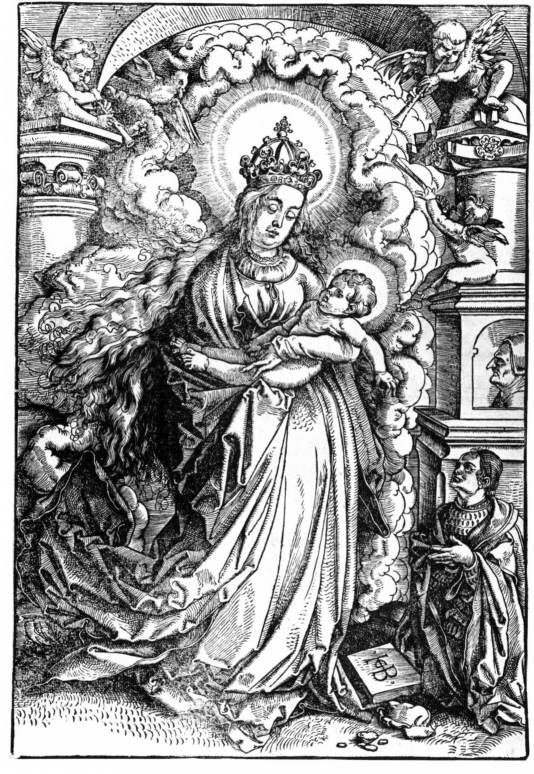

## 53

*Madonna and Child with Donor*

C. 1515-17

Woodcut
378 × 261 mm. (14⅞ × 10¼ in.)
G. 85; H. 64; Karlsruhe 1959, II H 21; M. 43
Lent by the Universitätsbibliothek
Erlangen-Nürnberg, Graphische Sammlung

As Baldung's most grandiloquent representation of the Madonna and Child, this large woodcut depicts the Virgin's miraculous appearance to an unidentified gentleman kneeling at the lower right. His devout pose, disproportionately small size, and location in the corner relate him to the traditional donor portraits found in commissioned religious paintings of the fifteenth and sixteenth centuries. Since prints were inexpensive to make and are not normally known to have required financial patronage, the traditional designation of the figure as a donor may therefore be incorrect. Perhaps the print was conceived in conjunction with a local cult or for a devotional use unknown to us.

Angels play trumpets to proclaim the Virgin's presence as she alights on the ground, materializing in a burst of light and billowing vermicular clouds. Her broad face, luminous halo, and agitated drapery are similar to those of figures in Grünewald's Isenheim Altarpiece; her impressive mass and ample robes specifically recall Grünewald's angel of the Annunciation, who is similarly swathed in swirling drapery. As in most Baldung woodcuts of the Freiburg period (see Cat. Nos. 44–52), Grünewald's powerful expressionism is a major stylistic influence. Typical of Baldung's expressive, mannerist style is the way subsidiary elements call attention to themselves, and the way complex forms, obscure in meaning,

come into conflict with expressionistic immediacy.[1] In Baldung's prints at this time, there is also characteristically a tension between nervous linear movement and emphatic volume (see Cat. Nos. 48, 52), between a strong surface pattern or rhythm and legibility of form. In *Madonna and Child with Donor* there are conflicts of line and form which create a sense of explosive energy. The Madonna is set in an archway flanked by columns surmounted by fanciful capitals of different designs. Baldung orchestrates shapes and lines to produce a rich linear configuration of concentric, intricate and loop-like forms. Hults has noted that "the curves of the drapery move into the ring of clouds above. This in turn seems to determine the curved posture of the Child, and an even tighter spiral is begun."[2]

The unease and ambiguity of the linear arrangement (the way the Madonna's hair merges with the clouds, for example) is equaled by the ambiguity of the setting. The column at the left disappears behind the clouds and the Virgin's windblown hair, and appears to be unattached to anything solid below, adding to the ethereal mood. The elaborate architectural form suggests an indoor space, but just below the slab with Baldung's monogram and the "donor's" cap are a few stones, and at the bottom left, a few wisps of grass or weeds can be discerned. Since Mary wears an elaborate crown, indicating her role as Queen of Heaven, it could be that Baldung's intention was to suggest that her appearance takes place at the heavenly gates. The locale remains vague, however, as does the identity of the "donor" and the profile face presumably carved into the column at the right. Max Geisberg's suggestion that the donor is a self-portrait of Baldung with his father's epitaph seems implausible.[3]

1  Hults-Boudreau, p. 186.
2  Ibid., p. 188.
3  See caption of plate XVI in *Westfalen*, XXVI, 1941, following p. 193.

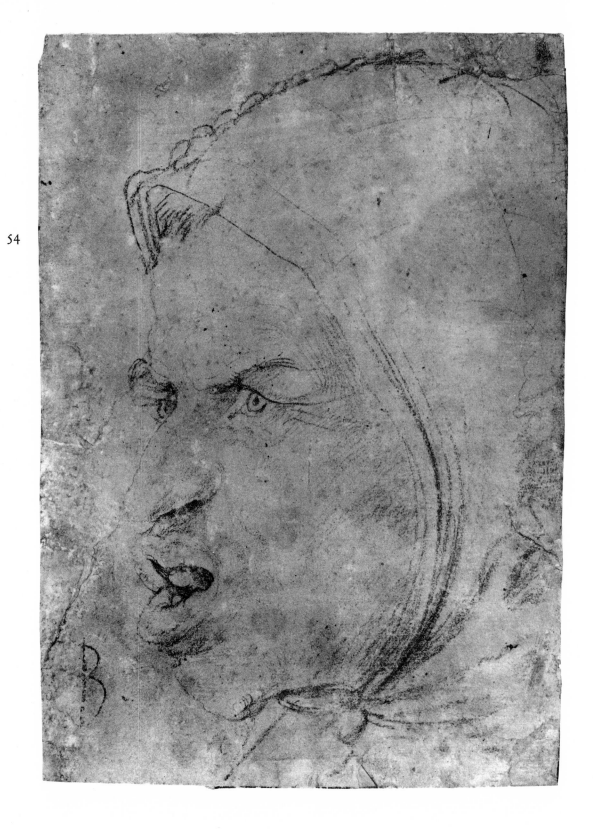

## ❧ 54

*Head of a Fool*

C. 1516

Charcoal

265 × 189 mm. (10⅜ × 7⅞₆ in.)

Not in Koch

Lent by the Trustees of the British Museum

Like many of Baldung's drawings, this head of a fool was probably made as a study for a painting, most likely for the head of one of the ignorant and malicious tormentors of Christ in a Passion subject. This character type, dull-witted and loutish, appears frequently among the throngs of Christ's persecutors in scenes of the Mocking of Christ or the Crucifixion in Northern art of the fifteenth and sixteenth centuries. The grossly exaggerated facial features find few analogies in other Baldung drawings. However, the ill-proportioned nose, thick fleshy lips and fish-like mouth, as well as the receding chin and beady eyes, relate the drawing to a figure in the *Crucifixion* on the verso of Baldung's Freiburg Altarpiece (Ill. 54a), namely, the "demented" person who peers out from behind the cross, symbolizing the odiousness and bestiality of those who caused Christ's suffering.[1]

Although parts of the drawing are stiff and halting— especially the lines which define the front edge of the cap as it arches over the brow— Baldung's authorship is confirmed by the forceful outline of the face which powerfully suggests the three-dimensionality of brow, nose, and mouth, and by the expert, energetic drawing of the expressive eyes with a few bold strokes. The connection to the Freiburg Altarpiece suggests a date of about 1516 for the drawing. This proposal is strengthened by similarities in draftsmanship to two drawings, the *Saturn* in Vienna, dated 1516 (Ill. 55a) and the *Head of a Bearded Man* in Paris (Koch 49), also usually dated about 1516.

Traces of the influence of Baldung's great contemporary, Grünewald, can be found in many of Baldung's works of the second decade of the sixteenth century, especially in paintings and drawings made during his Freiburg years, 1512–16, when Grünewald was working on the Isenheim Altarpiece in nearby Alsace. Comparison of Baldung's *Fool* with a Grünewald drawing such as the *Trias Romana* in Berlin[2] reveals similar distortions of physiognomic structure and features for the sake of heightened expressiveness, and similar manipulation of the chalk or charcoal line in the drawing of contours and shadows. Grünewald's pathos and intensity must have

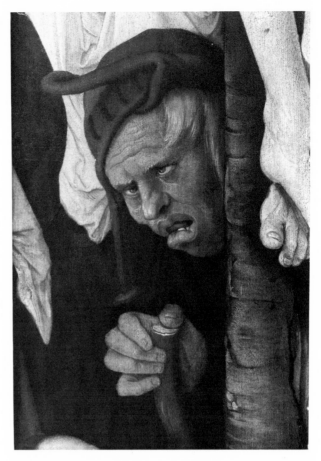

54a. Hans Baldung, «Head of a Fool,» detail from the Freiburg Altarpiece, c. 1516, panel, Münster, Freiburg.

left a deep impression on Baldung, affecting the character of his work and its artistic spirit.

The attribution of this drawing to Baldung was made as early as 1898 by Joseph Meder,[3] but thereafter the drawing was apparently forgotten. It was omitted from Koch's 1941 catalogue raisonné of Baldung's drawings, and not published in this century until 1959, after Koch saw it in the collection of Edmund Schilling in London.[4]

1  This comparison was first made by Carl Koch, "Kopf eines Narren, gezeichnet von Hans Baldung Grien," *Festschrift Friedrich Winkler*, Berlin, 1959, pp. 197–200.

2  Reproduced in Eberhard Ruhmer, *Grünewald Drawings*, New York, 1970, cat. XXXIV, pl. 39.

3  J. Schönbrunner and J. Meder, *Handzeichnungen alter Meister aus der Albertina und anderen Sammlungen*, Vienna, 1896–1908, III, no. 253.

4  Koch, "Kopf eines Narren."

55

## 55

### Head of an Old Bearded Man

C. 1512–16

Black chalk
317 × 219 mm. (12½ × 8⅝ in.)
Koch 110; Karlsruhe 1959, no. 206; Basel 1978, no. 36
Lent by the Kunstmuseum Basel, Kupferstichkabinett

55a. Hans Baldung, «Head of a Man» («Saturn»), 1516, chalk, Albertina, Vienna.

The *Head of an Old Bearded Man* has been universally re-garded as a copy since the late nineteenth century.[1] The contouring of the face, the rendering of the hair, the dec-orative stylization of the curls at the jowl, and the model-ing of cheeks and eyes differ substantially from the sensitive style of Baldung's masterful study executed in 1516, the so-called *Saturn* (Ill. 55a). Whereas in the *Sat-urn* the tousled hair, wafted upward as if by a supernatural force, lends resonance to the intense expression of the face, the hair in the Basel drawing appears more intentionally stylized. The difference between these two works lies not only in what might appear to be the inherently dissimilar qualities of an original and a copy, but also in their di-vergent modes of creation. While the *Saturn* is probably a study taken directly from a model, the present drawing appears to be a physiognomic study done from memory, either by Baldung or by one of his followers.[2] The inter-play of features— the unusually arched eyebrows con-trasted with the long, prominent nose, framed by Bal-dung's standard curly beard[3]— recalls the group of physiognomic studies of bearded heads in three-quarter view,[4] of which one is dated 1519 (Koch 109). The en-tire group, including the present work, seems to have been created as a repertory of expressive visages of old men, perhaps in preparation for various religious paint-ings or woodcuts executed in Baldung's workshop.

Perseke believed, however, that this drawing and several related copies or adaptations of heads of bearded men, also in the Basel Print Room,[5] were made for stained glass.[6] He considered them enlargements from designs for glass paintings (*Visierungen*), which, when assembled, could serve as a full-sized cartoon from which the glass painter could transpose the design onto glass. The puta-tive functional association with stained glass was evi-dently inspired by Schmid's characterization of the present drawing as possessing the "same degree of originality as Baldung's glass paintings,"[7] an analogy which reflects the rather dated view that glass panels were executed by second-rate craftsmen using designs or cartoons by first-rate artists.[8] Perseke took at face value what Schmid in-tended only as a comparison, removing the production of the Basel copies from Baldung's workshop to that of a Strassburg glass painter. His designation of the Basel copies as parts of cartoons appears to be based on their large size and their execution in chalk, the technique fre-quently but not exclusively employed for such a purpose. Displaying no more than a head, in some cases with a slight indication of shoulder, the Basel copies, however, look quite different from the surviving cartoons of the period. For example, even a fragment of a charcoal car-toon by Dürer for the *Pentecost* window in Nuremberg[9] includes entire torsos of the Madonna and Child. The concentration on the face alone in the Basel drawings ren-ders them incomplete and thus impractical as cartoons. Unlike Dürer, Baldung seems not to have furnished full-sized cartoons to glass painters.[10]

Perseke overlooked the evidence nearest at hand: the use of the Basel sketches in panel paintings. As Falk re-cently demonstrated, the head of an Apostle recorded in another of these drawings appears in the *Death of the Virgin*, a workshop painting in St. Maria im Kapitol in Cologne.[11] Another of the heads, the only youthful one, with curly hair, reappears without the foreshortened view in a workshop panel of *St. Lawrence*, today in Colmar.[12] The connections to panel paintings indicate that the Basel drawings were records of physiognomic studies and practical aids which workshop assistants occasionally in-corporated into paintings.

The question, then, is whether this image and the following one (Cat. No. 56) fall into this category— good copies by workshop assistants after lost Baldung originals— or whether Baldung himself executed these works as studies for his own subsequent paintings or for those of artists in his shop. The present drawing is clearly superior to those cited below (nn. 11, 12). It is more expressive, and more sensitively and competently drawn. The differences between it and the *Saturn* may, in fact, reflect a difference in intended function rather than the presence of a different hand. —c.a.

1 The first scholar to so designate it was H. A. Schmid, reviewing Térey, *Zeichnungen*, in *Rep.*, XXI, 1898, p. 308.

2 Koch, p. 131.

3 Térey (*Zeichnungen*, no. 18) and Falk (Basel 1978, no. 36) observed a similarity of facial type between the Basel copy and unspecified figures in the Freiburg Altarpiece.

4 See Cat. Nos. 56, 57.

5 Basel 1978, nos. 37–49. Although further removed from Baldung's style, a study in Vienna of a head of a bearded man with windblown hair and beard, previously published as a work of Lucas Cranach the Elder, also belongs in this group. See *Katalog der Handzeichnungen alter Meister aus dem Kupferstichkabinett der Akademie der bildenden Künste in Wien*, Zurich, 1960, no. 7, and Hugelshofer's attribution to the circle of Wolf Huber in *Schweizer Monatshefte*, XL, 1960, p. 207.

6 Falk (Basel 1978, p. 63) disagrees with Perseke's view (pp. 106 and 111–12), but does not state his reasons.

7 Schmid must have meant glass paintings executed from Baldung's designs rather than glass paintings by the artist himself (see Karlsruhe 1959, p. 113). My translation of Schmid as quoted by Perseke, p. 112.

8 For a more realistic view of glass painters' procedures and division of labor, see Gottfried Frenzel, "Entwurf und Ausführung in der Nürnberger Glasmalerei der Dürerzeit," *ZKw*, XV, 1961, pp. 31–59.

9 Ibid., figs. 13, 14 and Winkler, *Dürer Zeichnungen*, no. 551.

10 Baldung was quite prolific, however, in his production of designs for small-scale secular windows (*Kabinettscheiben*), designs which are quite different from cartoons in technique and general appearance. See Koch 69–84 and 144–59.

11 Basel 1978, no. 37 and fig. 45. For an illustration of the panel, see *Zeitschrift für Christliche Kunst*, V, 1892, pl. VI.

12 Ibid., no. 38 and fig. 46. The panel is the right half of a diptych, which bears the coats of arms of Jean d'Orliac and Guido Guersi, who commissioned the Isenheim Altarpiece. Like it, the diptych was made for the Isenheim chapel. See Perseke, fig. 47 (where the subject of the panel is incorrectly identified as St. Stephen).

## 56

*Head of a Bearded Man*
(Study for St. John the Baptist)

DATED 1516

Black chalk
336 × 291 mm. (13¼ × 11⁷⁄₁₆ in.)
Not in Koch
Lent by the National Gallery of Art,
Pepita Milmore Memorial Fund

Recently acquired by the National Gallery, this hand-some drawing was unknown until it emerged on the London art market in 1973.[1] Like the similar Basel draw-ing (Cat. No. 55) it raises questions of both function and authorship; its attribution has been the subject of contro-versy, but predominant scholarly opinion now accepts it as an autograph Baldung. Jan Lauts, organizer of the Baldung exhibition in 1959, believes that the attribution will never be certain, leaving open the possibility that it is by a highly gifted workshop assistant. Most Baldung scholars and connoisseurs of German art, however, in-cluding Tilman Falk, Dieter Koepplin, Johann von Borries, John Rowlands, and Gert von der Osten, have expressed no doubt that the drawing is authentic.[2] To be sure, there are labored passages in some of the contours (around the nose, for example) and some of the individ-ual lines appear hesitant when compared to the elegance of line in a drawing such as the *Saturn* (Ill. 55a), executed contemporaneously in the same technique. It is difficult, though, to imagine a workshop assistant dexterous enough to make so faithful a copy of the configuration of the ear, for example, or of the curling lines of the hair and beard, the ornamental quality of which is in full accord with Baldung's style and spirit. A workshop copy could not have the visual impact of this drawing.

The strong contrasts of light and shade in the draw-ing (on the side of the nose and under the lip, for ex-ample) suggest a connection to panel painting. In fact, the facial type of this sketch recalls that of Baldung's rep-resentations of St. John the Baptist in panels of *St. Anne, the Virgin and Child with John the Baptist* in Washington, datable c. 1511 (Ill. 56a),[3] of the Schnewlin Altarpiece of c. 1516 in Freiburg (Ill. 56b), and of the *Baptism of Christ* of the St. John Altarpiece in Frankfurt, generally dated 1519–20 (Fig. 12).[4] Mende and Eich[5] consider the Washington drawing a preparatory sketch for the figure of St. John in the Frankfurt *Baptism*, but it lacks the fur-rowed brow and the upward glance of this figure and shows a more ample beard. Its role as a study for the Frankfurt panel is also contradicted by its date of 1516,

which places it at least three years too early, and by the reversed direction of the image. If the date of 1516 on the present drawing is genuine, the chronological evidence would point to an association with the earlier *Baptism* from the Schnewlin Altarpiece. But in view of Baldung's occasional use of the same facial type in different contexts, and even for different personages,[6] and of the similarity of type between this drawing and the figure of the Baptist in the earlier panel of c. 1511 (Ill. 56a), it is clear that the drawing records a facial type employed by Baldung at several points in his career for representations of the Baptist.

1  Sotheby and Co., London, *Important Dutch, Flemish and German Drawings*, March 21, 1973, no. 31.
2  These opinions were rendered by letter or verbally to the National Gallery. It should be pointed out that a strip of paper not original to the drawing has been pasted on at the left. Although an effort was made to draw continu-ous lines over the seam, these lines have less rhythmic order and fluency than the lines elsewhere in the draw-ing, and are clearly by a different hand.
3  See Karlsruhe 1959, no. 14, and the recent analysis of the altarpiece to which this panel belongs by Gert von der Osten, "Ein Altar des Hans Baldung Grien aus dem Jahre 1511— und eine Frage nach verschollenen Werken des Malers," *ZDVK*, XXXI, 1977, pp. 51–66.
4  Paul Eich's recent arguments in favor of an earlier dating of the Frankfurt Altarpiece are not convincing. In "Der Johannesaltar von Hans Baldung Grien," *Städel Jahrbuch*, N.F., V, 1975, pp. 85–96, Eich disputes the traditional provenance of the Frankfurt Altarpiece from the Dominican church in that city because none of the older inventories mentions it, but ignores the fact that the altarpiece's exterior wings show the same four male saints to whom one of the chapels of the Dominican church was dedicated. His attempt to establish an earlier dating for the altarpiece is based on the difference of style between the central panel and a chiaroscuro copy, a drawing in Stuttgart dated 1520, and on the date 1516 on the Washington chalk study. Eich advances equally unconvincing arguments for his view that the wings and central panel of the Frankfurt Altarpiece did not origi-nally belong together.
5  Mende, p. 32; Eich, "Der Johannesaltar," p. 91.
6  A striking example is Baldung's use of the same facial type for St. Bartholomew and St. John in two wood-cuts (M. 41, M. 71), for St. Wendelin on a wing of the St. John Altarpiece in Frankfurt (illustrated in *Städel Jahrbuch*, N.F., V, 1975, p. 86, fig. 2) and for St. John in a stained-glass panel from the Carthusian monastery at Freiburg (Karlsruhe, Badisches Landesmuseum, inv. no. C7885), all executed around 1519.

56a. Hans Baldung, Head of St. John the Baptist, detail from «St. Anne, the Virgin and Child, with John the Baptist,» c. 1511, panel, National Gallery, Washington.

56b. Hans Baldung, «Baptism of Christ» from the Schnewlin Altarpiece (detail), c. 1516, panel, Münster, Freiburg.

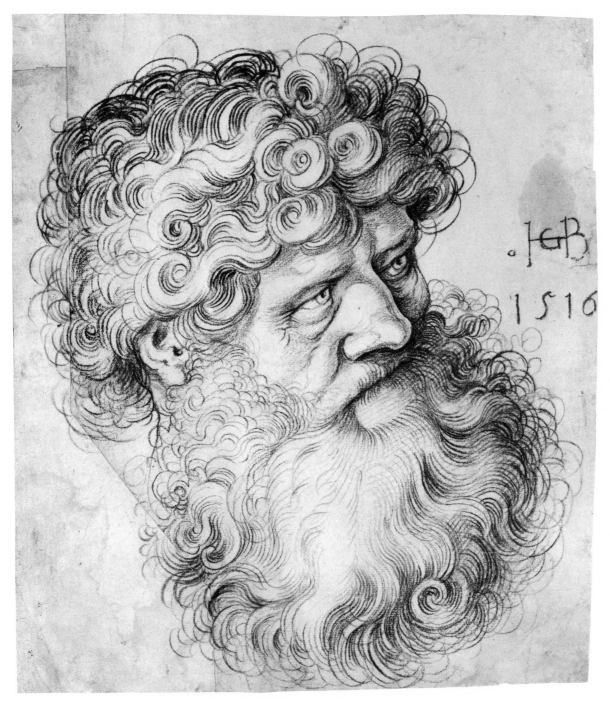

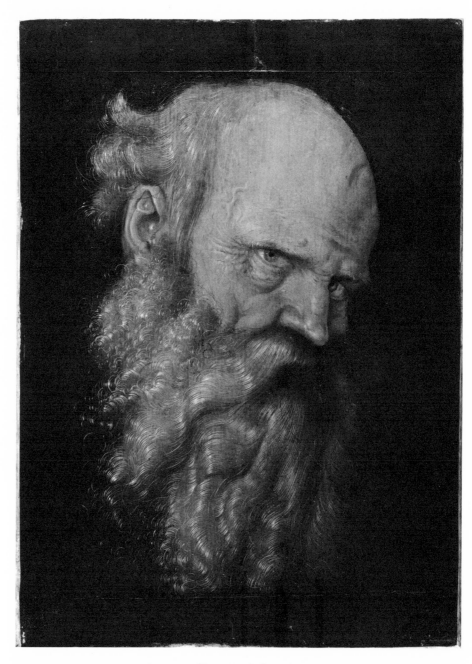

58a. Hans Baldung, «Head of an Old Man,»
c. 1517–18, panel, Staatliche Museen, Berlin.

## 57

*Head of an Old Bearded Man*

c. 1518–19

Black chalk
151 × 112 mm. (5¹⁵/₁₆ × 4⅜ in.)
Not in Koch; Karlsruhe 1959, no. 155
Lent by the Metropolitan Museum of Art,
Gift of Mrs. John H. Wright, 1949

## 58

*Head of an Old Bearded Man*

c. 1518–19

Woodcut
111 × 75 mm. (4⅜ × 2¹⁵/₁₆ in.)
G. 131; H. 277; Karlsruhe 1959, II H 83; M. 70
Lent by the Metropolitan Museum of Art,
The Elisha Whittelsey Collection, the Elisha
Whittelsey Fund, 1960

By 1518–19, Baldung had become interested in the problems of depicting, as independent subjects, the heads of old men with flowing beards, and a considerable number of these drawings and paintings survive (cf. Cat. Nos. 55, 56, and especially 59; and Koch 106–09). This concern may have been stimulated in part by Baldung's need to devise a dozen different patriarchal facial types for his woodcut *Apostle* series of c. 1516–19 (Cat. Nos. 60–72)— powerful or venerable faces characterizing the Apostles' different personalities and endowing them with appropriate dignity or zealousness. It was a task Baldung must have undertaken with enthusiasm since it required him to delve into a favorite artistic problem, namely, how to conceive the human face in spiritually exalted or otherwise deeply emotional states. This issue clearly engaged his attention from an early moment in his career (Cat. No. 16) and remained a preoccupation throughout (Cat. Nos. 29, 48, 49, etc.). Even if the requirements of the Apostle woodcuts had not stimulated Baldung to undertake these drawings of elderly men, he still might have produced them, for the subject enabled him to explore the expressive potential of wrinkled and impressively bearded faces, as well as to exercise his pen or chalk in the creation of wavy ringlets and locks— to engage in a kind of linear gymnastics.

The representation of the head of an old bearded man, Cat. No. 58, is clearly a character type rather than a portrait, and more like a study than a finished work. It is hard to explain why a sixteenth-century artist would make a print of a character type, and what purpose it would have served. Indeed, Baldung may have realized that there would be little demand for this woodcut and, accordingly, printed a very small edition. Only a few sheets survive.

In 1949, the Metropolitan Museum acquired Cat. No. 57, a previously unknown drawing which was immediately attributed to Baldung. A. Hyatt Mayor published it in 1950[1] as a preliminary study for the woodcut, Cat. No. 58, an assertion that has since found general acceptance. Certainly it is tempting to see the drawing— which reverses the direction of the woodcut— as a preparatory sketch for the print. The heads have similar proportions, the same receding hairline, and a similar long mustache and beard. The head in the drawing, however, has a vacant expression, lacking the intensity and the chilling sidelong glance of the one in the print. Furthermore, the man in the drawing has a rounded nose with flared nostril and a rounded ear, while the man in the woodcut has a squared-off nose and a slightly pointed ear. The configuration of hair in the upper left of the print and along the bottom edge of the beard bears no relation to the analogous parts of the drawing. Finally, the drawing is a full one-third larger than the print; it seems curious that an artist, knowing the size of the woodblock he was about to use, would make a preliminary study which would have to be scaled down in the final cutting of the woodblock. Baldung was, of course, capable of amending and improving an image in the course of developing an idea, but the relationship of the print and drawing in this case is not especially compelling and must remain a question.

The character type shown here is close to that of a Baldung painting in Berlin (Ill. 58a), usually thought to be a study for a St. Joseph, although like most of Baldung's studies, it can not be specifically related to any of his other works.

1 A. Hyatt Mayor, "Prints Acquired in 1949," *Metropolitan Museum of Art Bulletin*, VIII, 1950, p. 160.

58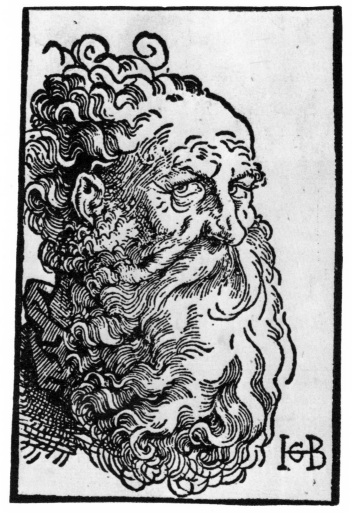

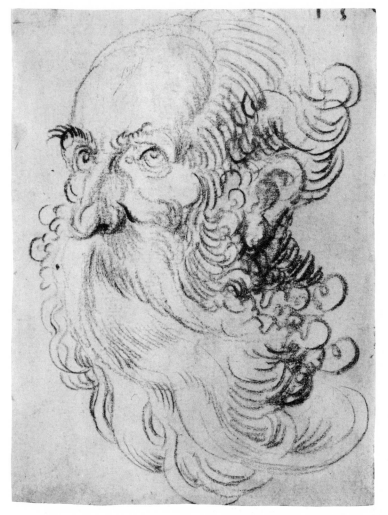

57

59

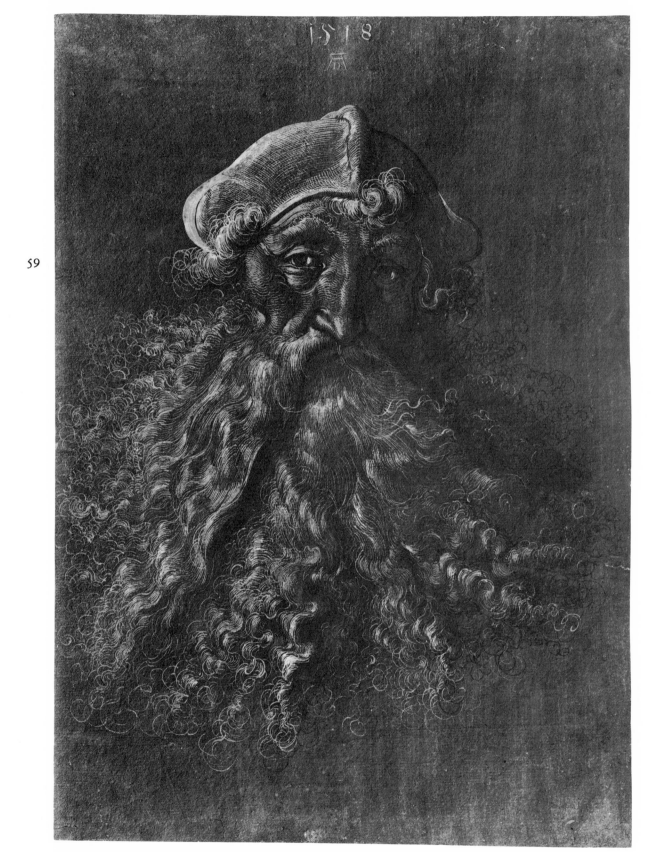

## 59

*Head of an Old Bearded Man*

1518

Pen and ink, heightened with white and pink,
on brown tinted paper
265 × 190 mm. (10⅞₆ × 7½ in.)
Koch 105
Lent by the Trustees of the British Museum

This imposing drawing is a fine example of Baldung's mature graphic style, a virtuoso display of shimmering light and rhythmic contour. As a striking portrayal of old age, of the somber psychological state often associated with it, and a study of the expressive potential of a great beard, it is also a prelude to the *Apostles*, Baldung's woodcut series of c. 1516–19 (Cat. Nos. 60–72; see also discussion under Cat. Nos. 57, 58). The old man's gaze, slightly averted to the left, seems pensive if not melancholy, recalling the sober, inward expressions of several of the Apostles (cf. Cat. Nos. 62, 67, 72).

Baldung favored the medium of chiaroscuro drawing, first experimenting with it during his early years in Nuremberg and employing it frequently in the following decade. The juxtaposition of bright areas of highlighting with areas of deeply colored shadow produces the flickering and richly coloristic effect apparent in this drawing. The combined use of white and pink highlights is somewhat unusual, but not unprecedented, appearing in the early *Self-Portrait* on green-tinted paper (Fig. 1). In the face and hat, curvilinear parallel hatchings of pink and white combine to model form, creating a delightful undulation of surface. The locks of the beard produce an organic rhythm which gradually disperses into calli-

graphic flourishes around the edges, where the nervous play of white and black strands, silhouetted against the brown ground, creates a decorative effect.

Dürer is the ultimate source for Baldung's patriarchal type; the most telling comparison is with the series of preparatory drawings Dürer made for the Heller Altarpiece, heads of Apostles on colored paper (c. 1508; W. 448–52). Indeed, the present drawing, long considered to be by Dürer, whose false monogram appears at the top, was first tentatively attributed to Baldung by Parker in 1928.[1] However, the technique, style, and facial type are entirely consistent with Baldung's graphic work around 1518. Baldung departs from his master in two significant ways. First, in Dürer's drawings light and line serve an essentially descriptive function, indicating the careful study of a model, whereas Baldung's spontaneity and use of decorative elements create a private and somewhat fanciful rendering of types alive only in the artist's imagination. Second, Dürer's preliminary studies were made for specific works and appear in the finished version with only slight modifications; by contrast, there is rarely a one-to-one correspondence between Baldung's initial studies and his finished works.[2] Rather, the facial types before his mind's eye evolved gradually so that close parallels between studies and finished works are extremely rare. Indeed, to refer to the present drawing as a "study" is somewhat misleading, since there is nothing to indicate it is not itself a finished work. —D. L.

1  K. T. Parker, *Elsässische Handzeichnungen des XV. und XVI. Jahrhunderts*, Freiburg, i. Br., 1928, p. 34.
2  The exception is *God the Father* (Cat. No. 44), apparently a preparatory sketch for the central panel of the Freiburg Altarpiece. Yet even in this case the facial details in the finished painting differ appreciably from those in the drawing.

### Christ and the Twelve Apostles
### (The Large Apostle Series)

Lent by the Universitätsbibliothek Erlangen-Nürnberg, Graphische Sammlung

Baldung's woodcut series of Christ and the twelve Apostles takes its place within a tradition of Apostle prints by German artist-printmakers of the fifteenth and sixteenth centuries, among them the Master E.S., Martin Schongauer and Lucas Cranach the Elder. Baldung himself designed three other woodcut cycles of the Apostles, but of modest quality and on a smaller scale.[1] The present series constitutes his major graphic treatment of the subject, exceeded in size and importance only by the panels of the *Apostles* on the wings of the Freiburg Altarpiece (Ill. 60a).

Although the *Large Apostles* contains reminiscences of Schongauer's types in the *Savior* (Cat. No. 60) and the *St. Philip* (Cat. No. 65),[2] in its size and expression the series more closely reflects the emerging desire on the part of early sixteenth-century German printmakers to invest these figures with new monumentality and depth of character. Precedents for this sixteenth-century type are found in woodcut series by the Master DS of Basel[3] and by Lucas Cranach the Elder (G. 567–80), both of which are notably larger in format than comparable series of the fifteenth century, and represent the Apostles with new breadth and vitality; indeed, Cranach's prints of the *Savior* (G. 567) and *St. Andrew* (G. 569) have been seen as probable sources of inspiration for Baldung's representations of the same figures.[4]

Baldung's prints are smaller than those by the Master DS or Cranach, but surpass them in figural scale and in intensity of expression. Baldung's figures fill the fields, their radiant halos and some of their attributes cut off by the margins. The robes are massive, organized in harshly angular and sculptural folds. Baldung individualizes the figures not only by physiognomic type but also by attitude: *St. Simon* (Cat. No. 70), for example, is imperturbably statuesque in his broad and geometrically solid form; *St. Paul* (Cat. No. 72) seems transfixed in his frozen zig-zag stance; *St. Bartholomew* (Cat. No. 66) confronts the viewer with his stern, hypnotic gaze, barely grasping the knife that is aligned with one of the intersecting diagonals that crisscrosses the vertical axis of his body; and *St. Peter* with his giant key (Cat. No. 61)— partly reminiscent of his fiercely intense counterpart in the Freiburg Altarpiece (Ill. 60a)— is a study in purposeful determination, emphasized by his directed gaze and forceful stride. Even the less dramatically posed figures partake

of the intense spiritualization that characterizes the series due to the luminous radiances they seem to emit. Although Baldung may have drawn inspiration for these dramatic aureoles from prints by Dürer following the second Italian trip, particularly from an incomplete series of engraved Apostles begun in 1514 (see B. 48, 50; D. 76–77),[5] he departs from Dürer by altering the radiances from one print to the next, using graphic forms which range from short, flick-like strokes to large and angled ones that appear almost as perforations in order to achieve varied effects of glowing or pulsing waves of light. The intense spirituality of Baldung's Apostles, their sense of purpose and their distinct character as embodiments of deeply experienced faith— all aptly described in the introductory essay by Linda Hults[6]— is thus a result of the massive and powerful form of the figures, of their grave countenances and luminescent glories, and of the assured and bold graphic style with which all these elements are realized and integrated.

The *Large Apostles* series is customarily assigned to 1519 because of the date inscribed on the *St. Matthew* (Cat. No. 67). It is significant, however, that the graphic style of this print, and even the type of halo, differ from the remainder of the series. The linear system of the *St. Matthew* is composed of relatively straight, evenly spaced parallel lines organized primarily into solid zones of shading with little cross-hatching. This contrasts with the finer, more curved lines in the other *Apostle* prints, all of which make greater use of cross-hatching. The *St. Matthew* has a stylistic counterpart in a second Baldung woodcut of the *Savior*, also dated 1519 (Cat. No. 73), which is slightly larger than the prints in the series. The difference in graphic technique between the prints dated 1519 and the others is so pronounced as to suggest a change in the cutter of the woodblocks (the *Formschneider*), a change in Baldung's woodcut style, or both. As the date of 1519 appears only in the two prints executed in the broader and more angular linear technique, we think it likely that the two modes reflect different dates of origin and therefore imply a change in Baldung's woodcut style. The finer linear technique of the undated *Apostles* (Cat. Nos. 60–66, 68–72), with their more subtle and complex light and dark contrasts, seems to ally them with Baldung's works created during or just after the Freiburg period; examples include the large *St. Sebastian* of 1514 (Cat. No. 48; see the *Savior*, Cat. No. 60) or the *Madonna and Child with a Donor*, usually dated c. 1514–17 (Cat. No. 53). The style of the *St. Matthew* (Cat. No. 67) and of the 1519 *Savior* (Cat. No. 73), on the other hand, with their relatively straight and more broadly spaced parallel lines, is found in Baldung's *Small Apostles* series (M. 58–68), two of which are likewise dated 1519 (M. 60, 68); in the *Drunken Bacchus* (M. 75),

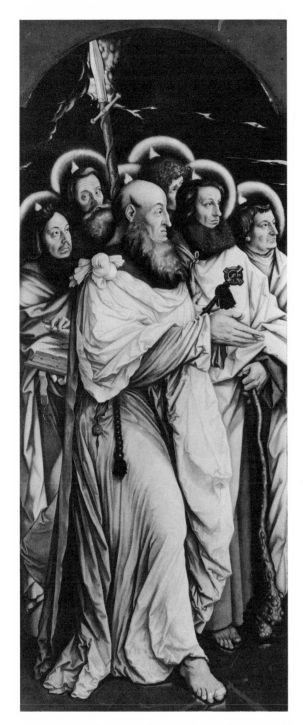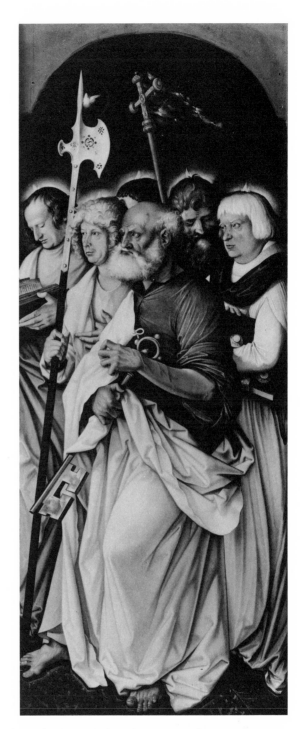

60a. Hans Baldung, «The Apostles,» wings of the Freiburg Altarpiece, c. 1516, panel, Münster, Freiburg.

which all recent authors have placed c. 1520; and in an extensive series of prints designed by Baldung for books published in the early 1520s (M. 435–60). This style of parallel hatching seems to appear in Baldung's prints only in 1519— perhaps first in the *Fall of Man* (Cat. No. 75) which seems to combine aspects of both styles, and might therefore be seen as a transitional piece. At this time, the parallel hatching style replaces the finer and more tonal style that characterized Baldung's work of the Freiburg period.

If this hypothesis is correct, then all the prints of the *Large Apostles* series, save the dated *St. Matthew*, precede 1519. While it is difficult to estimate the date of inception of the series, we can provisionally suggest the period from c. 1516 to 1519, perhaps corresponding with Baldung's relocation from Freiburg to Strassburg in 1516–17.[7] We can only speculate that the *St. Matthew* was executed in 1519 to complete the series, and that the *Small Apostles* (M. 58–68) were done at the same time to take advantage of a different market. One might also suggest that Baldung's change of style to a broader graphic system could have been stimulated by his search for a woodcut technique of simpler and more durable characteristics, particularly after his earlier fascination with chiaroscuro and luminous effects had run its course. Unfortunately, insufficient comparative material exists to fully evaluate these hypotheses, since Baldung's production of prints— particularly single-sheet woodcuts— virtually ceased in the 1520s; only a very few woodcuts were made during the last decade of his life, c. 1534–44 (Cat. Nos. 81–85, 87).

1 See prints for *Der beschlossen Gart*, published in 1505 (M. 206–17), for the *Hortulus animae*, published in 1511 (M. 365–76), and of the so-called *Small Apostles* series (M. 58–68), of which two are dated 1519.

2 See O. Hagen, *Hans Baldungs Rosenkranz, Seelengärtlein, Zehn Gebote, Zwölf Apostel*, Munich, 1928, p. 51. Hagen's discussion (pp. 48–52) is still the fullest treatment of the *Large Apostles* series.

3 See L. Fischel, "Neue Mitteilungen über den Basler Monogrammisten DS," *MüJb*, V, 1954, pp. 111–19.

4 See Mende, p. 20, text ills. XVII–XX.

5 Pariset, p. 163.

6 See above, pp. 43–44.

7 The revised dating of Baldung's prints has ramifications for our understanding of a problematic series of *Apostles* dated 1518 and attributed variously to the Dürer school (G. 791–97), Hans Vischer (in the original edition of Geisberg), and— most convincingly— to Master GZ, possibly identifiable as Gabriel Zehender (see A. Stange, "Ein Doppelbildnis von Gabriel Zehender," *ZfK*, XX, 1957, pp. 260–67, esp. 261–64). As Stange and others have noted, GZ's *Apostles* show borrowings from Cranach's *Apostle* series of c. 1510–15 (G. 567–80), but they also contain full and intense radiances somewhat analogous to those in Baldung's *Large Apostles*. Stange correctly notes that GZ was also influenced by Baldung; thus the revised dating of Baldung's *Large Apostles* to c. 1516–19 is consonant with a hypothesis of GZ's dependence upon Baldung, rather than vice versa.

❧ 60

*The Savior*

C. 1516–19

Woodcut
212 × 127 mm. (8⅜ × 5 in.)
B. 6; G. 88; H. 79; Karlsruhe 1959, II H 37; M. 45

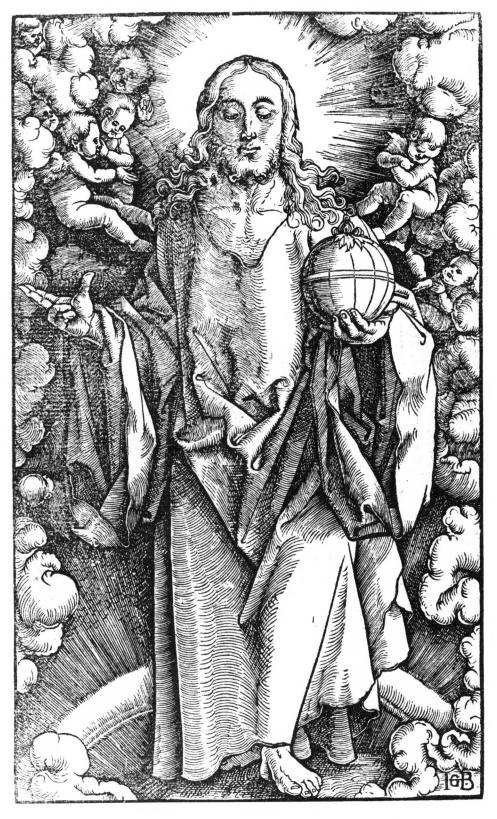
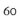

60

## 61

*St. Peter*

C. 1516–19

Woodcut
210 × 125 mm. (8¼ × 4¹⁵⁄₁₆ in.)
B. 7; G. 89; H. 80; Karlsruhe 1959, II H 38; M. 46

## 62

*St. Andrew*

C. 1516–19

Woodcut
210 × 125 mm. (8¼ × 4¹⁵⁄₁₆ in.)
B. 8; G. 90; H. 81; Karlsruhe 1959, II H 39; M. 47

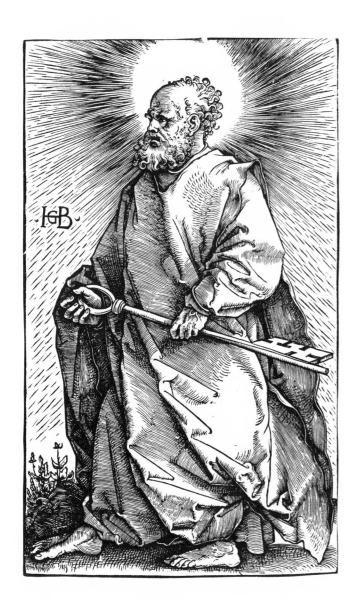

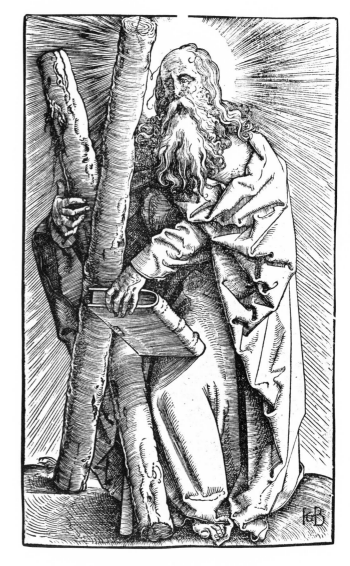

## 63

*St. James Major*

C. 1516–19

Woodcut
210 × 125 mm. (8¼ × 4¹⁵⁄₁₆ in.)
B. 9; G. 91; H. 82; Karlsruhe 1959, II H 40; M. 48

## 64

*St. John*

C. 1516–19

Woodcut
210 × 125 mm. (8¼ × 4¹⁵⁄₁₆ in.)
B. 10; G. 92; H. 83; Karlsruhe 1959, II H 41; M. 49

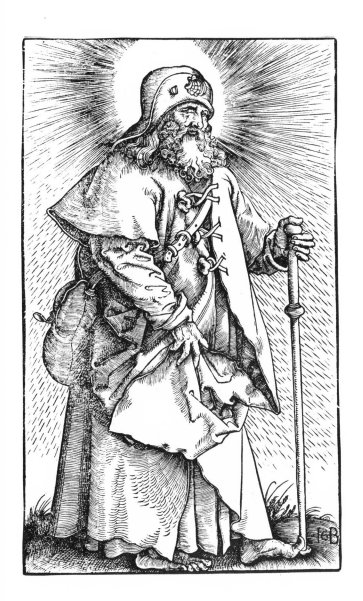

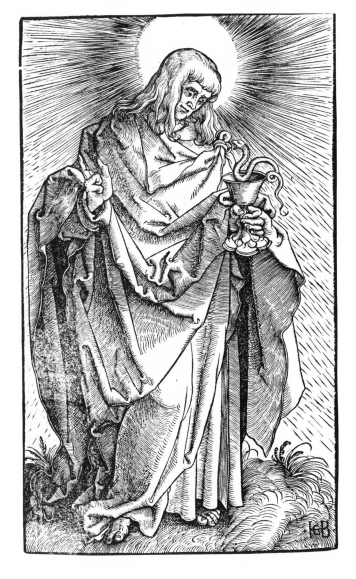

## 65
### St. Philip

C. 1516-19

Woodcut
210 × 125 mm. (8¼ × 4¹⁵⁄₁₆ in.)
B. 11; G. 93; H. 84; Karlsruhe 1959, II H 42; M. 50

## 66
### St. Bartholomew

C. 1516-19

Woodcut
210 × 125 mm. (8¼ × 4¹⁵⁄₁₆ in.)
B. 12; G. 94; H. 85; Karlsruhe 1959, II H 43; M. 51

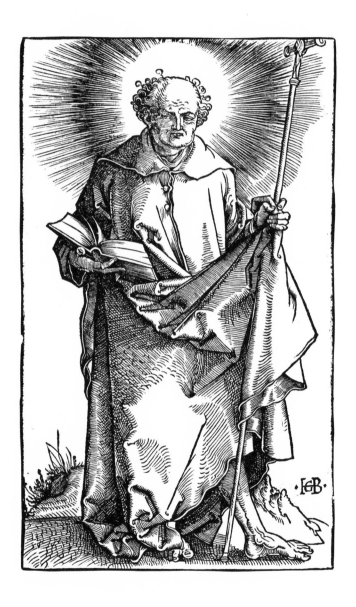

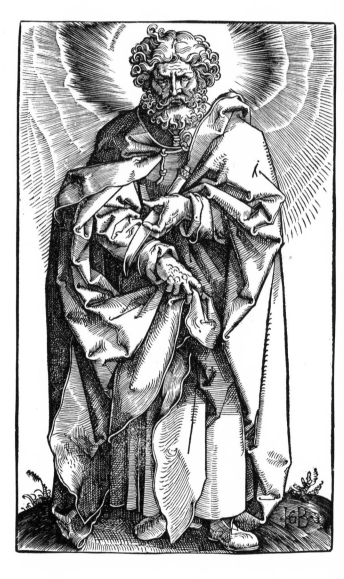

**✌ 67**

*St. Matthew*

DATED 1519

Woodcut
210 × 125 mm. (8¼ × 4¹⁵⁄₁₆ in.)
B. 13; G. 95; H. 86; Karlsruhe 1959, II H 44; M. 52

**✌ 68**

*St. Thomas*

C. 1516–19

Woodcut
210 × 125 mm. (8¼ × 4¹⁵⁄₁₆ in.)
B. 14; G. 96; H. 87; Karlsruhe 1959, II H 45; M. 53

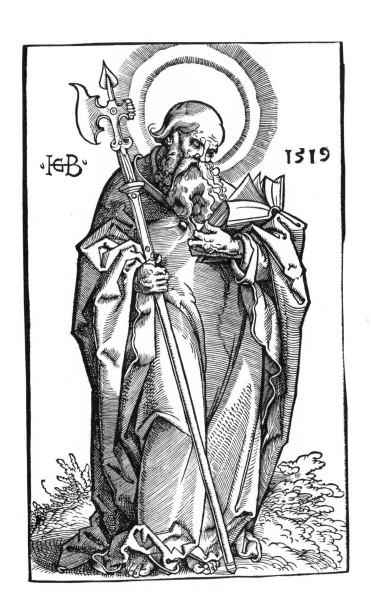

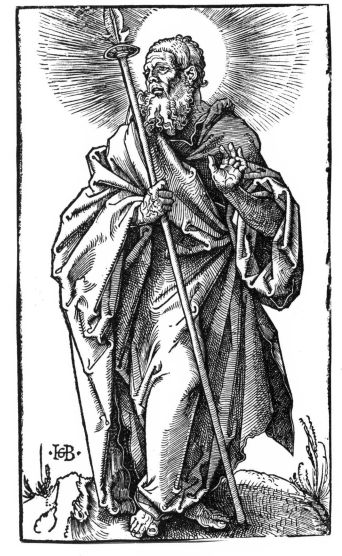

~ 69

*St. James Minor*

C. 1516–19

Woodcut
210 × 125 mm. (8¼ × 4¹⁵⁄₁₆ in.)
B. 15; G. 97; H. 88; Karlsruhe 1959, II H 46; M. 54

~ 70

*St. Simon*

C. 1516–19

Woodcut
210 × 125 mm. (8¼ × 4¹⁵⁄₁₆ in.)
B. 16; G. 98; H. 89; Karlsruhe 1959, II H 47; M. 55

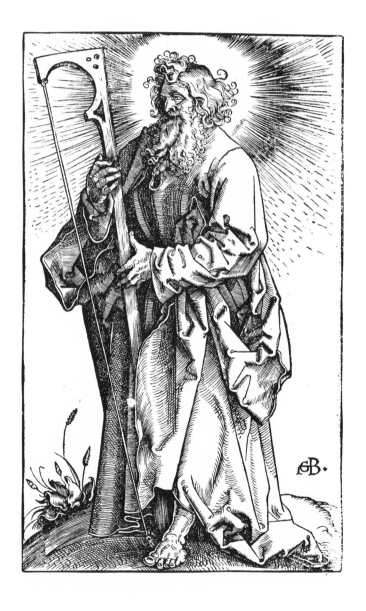

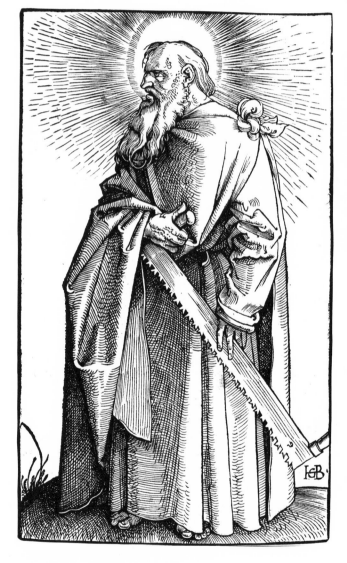

**~ 71**

*St. Judas Thaddeus*

C. 1516–19

Woodcut
210 × 125 mm. (8¼ × 4¹⁵⁄₁₆ in.)
B. 17; G. 99; H. 90; Karlsruhe 1959, II H 48; M. 56

**~ 72**

*St. Paul*

C. 1516–19

Woodcut
210 × 125 mm. (8¼ × 4¹⁵⁄₁₆ in.)
B. 18; G. 100; H. 91; Karlsruhe 1959, II H 49; M. 57

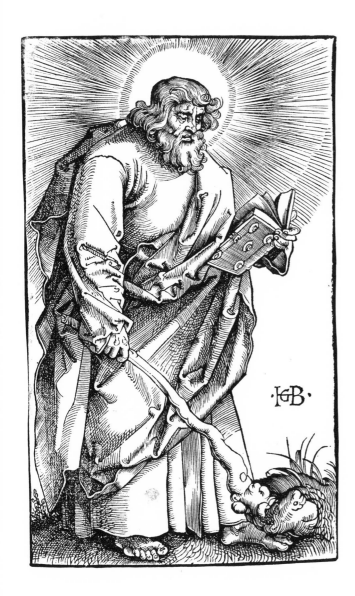

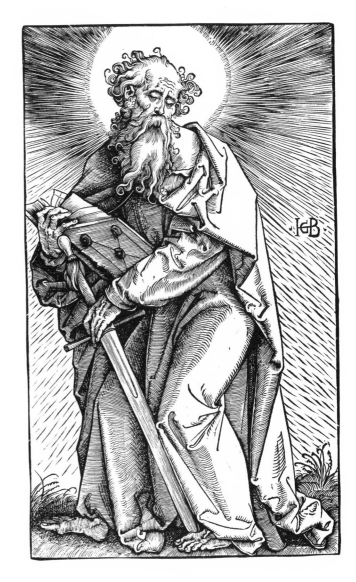

73

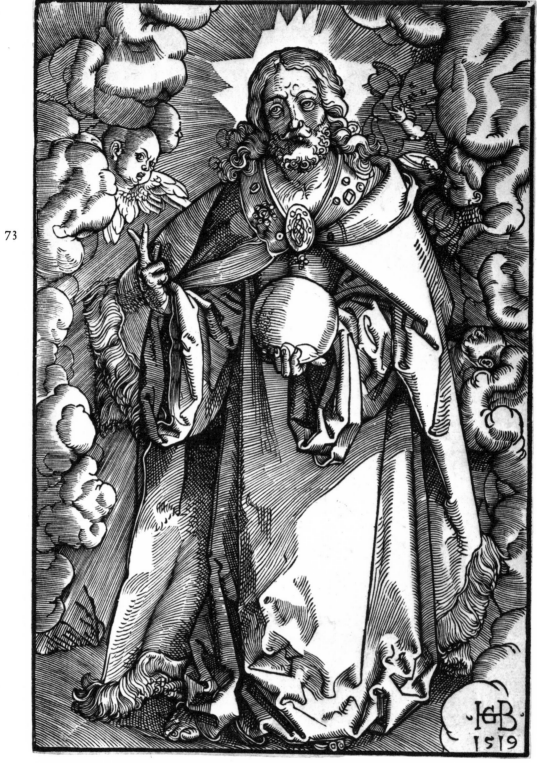

## 73

*The Savior*

DATED 1519

Woodcut
222 × 153 mm. (8¾ × 6¹⁄₁₆ in.)
B. 40; G. 78; H. 57; Karlsruhe 1959, II H 16; M. 44
Lent by the Trustees of the British Museum .

See the discussion for Cat. Nos. 60–72.

## 74

*St. John the Baptist*

C. 1518–19

Woodcut
200 × 140 mm. (7⅞ × 5½ in.)
B. 31; G. 109; H. 114; Karlsruhe 1959,
II H 55; M. 71
Lent by the National Gallery of Art,
Rosenwald Collection

During the late Middle Ages and early Renaissance, non-narrative representations of John the Baptist generally show the saint standing or seated in a landscape. In many Northern European representations of the seated type, panoramic landscapes dominate as the artists transform ostensible depictions of the historical episode of John's sojourn in the desert into poetic evocations of his harmonious union with nature. Baldung's print retains something of the idyllic character of this tradition in the unfocused gaze of the Baptist, shown as if deep in thought, and in the care with which he protectively shelters a diminutive lamb in his lap (the *Agnus dei,* or "Lamb of God," the appellation employed by St. John for Christ in John 1:29 and 36). But Baldung nearly fills the field of his composition with the figure of the saint, and he additionally forgoes a depiction of a detailed or panoramic landscape in favor of the radiance that streams from John's head to the edges of the image.

Just as in Baldung's *Large Apostle* series (Cat. Nos. 60–72), with which this work is closely related in style and date, the artist employs monumental form and a visually prominent radiance to spiritualize the holy figure. But Baldung's departure from the iconographic norm leads one to speculate on the existence of additional levels of meaning in his singular representation. In fact, in the Gospel of John, Christ himself notes that the Baptist

"was a burning and a shining light [or lamp], and you were willing for a time to rejoice in his light" (John 5:35). Although this biblical metaphor was important enough to have crystallized into representations of the Baptist carrying a lantern or a candle in Netherlandish art of the fifteenth and sixteenth centuries, Baldung's representation is clearly independent of the Netherlandish pictorial tradition, perhaps inspired by the biblical text itself or by its echoes in the liturgy or in such well-known collections of saints' lives as the *Golden Legend*.[1] The possible metaphorical resonance should in any case be seen only on an associational level, for Baldung's powerfully focused image succeeds as a self-sufficient representation of the Baptist's sanctity and intense spiritualization.

1  For the pictorial and textual traditions, see J. Marrow, "John the Baptist, Lantern for the Lord: New Attributes for the Baptist from the Northern Netherlands," *Oud Holland,* LXXXIII, 1968, pp. 3–12; LXXXV, 1970, pp. 188–93.

74

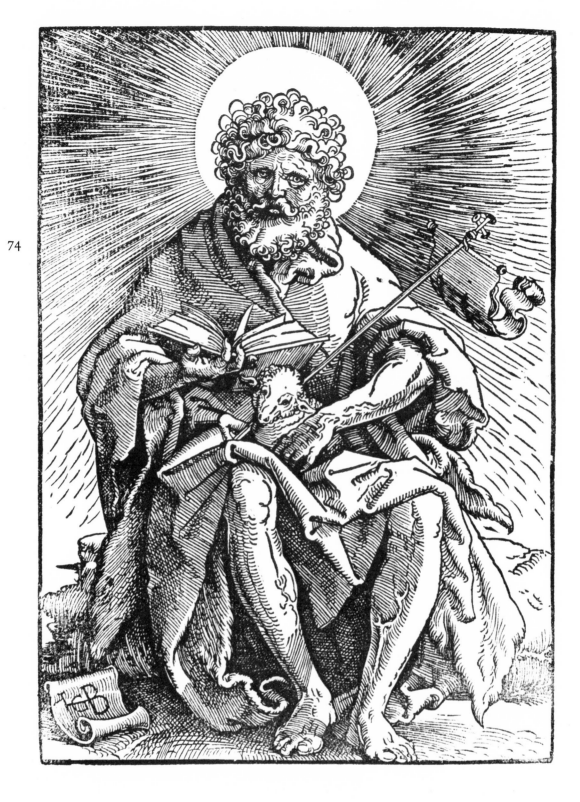

# 75
## Fall of Man

DATED 1519

Woodcut
250 × 95 mm. (9¹³⁄₁₆ × 3¾ in.)
B. 2; G. 58; H. 2; Karlsruhe 1959, II H 2; M. 73
Lent by the Staatliche Museen Preussischer Kulturbesitz,
Kupferstichkabinett, Berlin-Dahlem

In his third and last single-leaf woodcut of the *Fall of Man*, dated 1519 (cf. Cat. Nos. 19, 38), Baldung shifts the focus of his representation to the figures of Adam and Eve. The broad and detailed landscapes of the earlier prints are suppressed in this depiction in favor of a figure-dominated composition of unusually tall and narrow format.[1] The moment captured here also differs from the earlier prints, for by omitting the menacing snake and the gestures of the figures reaching for the fruits, Baldung implies a time following the actual incidents of the Temptation and Fall; the real subject of this print is the subsequent impact of the Fall upon Adam and Eve.

As in the chiaroscuro woodcut of 1511 (Cat. No. 19), Baldung again uses the physical proximity of the two figures to refer to the sexual implications of the Fall. But he alters the character of their interaction, replacing the open sensuality of the earlier work, which is explicit in such details as Adam's grasp of Eve's breast and her coy and seductive smile, by elements of ambivalence and tension. Thus, although Adam rests one hand on Eve's shoulder, his gesture lacks passion, and his face, cast in shadow, strongly suggests inner reflection. Eve's stance lacks the easy grace of the earlier representation, for she seems to twist her upper torso away from Adam, simultaneously raising her right elbow as if to ward him off; this suggestion of recoil is then underscored by the decidedly distasteful expression on her face. Baldung thus presents us with an ambivalent image of mutual attraction and psychological distance. There is nothing paradisical about this representation of the first parents, for they are shown as if already reflecting upon the implications of their act.

Baldung introduces new interpretations in this print, but he also reiterates elements from his earlier versions of the subject. Eve is again compositionally more prominent than Adam, implying her greater responsibility for the Fall. And Adam's position behind Eve, first represented by Baldung in the chiaroscuro woodcut of 1511 (Cat. No. 19) and subsequently in a panel of the 1530s in Lugano (Ill. 75a), has a significant echo within his *oeuvre* in his representations of maidens grasped or attacked from

behind by Death (Figs. 6, 35). The formal analogy—which associates the Fall with human mortality (see Cat. No. 19)— is particularly provocative in the print of 1519, for its tall and narrow format and figure-dominated composition recall Baldung's panels of *Death and the Maiden* of c. 1513 and 1517 (Florence, Uffizi, and Basel, Kunstmuseum; Curjel, pls. 61 and 59, respectively).

Baldung introduces a novel detail into this representation by showing Eve standing with one foot on the tablet with his monogrammed initials. Noting the absence of a serpent in this depiction, Jean Wirth has related this gesture to the biblical text in which God curses the serpent after the Fall and tells him that the woman (Eve) "shall crush thy head" (Genesis 3:15); he further relates this image to Baldung's print of *Wild Horses* of 1534 in which a monkey, symbol of the Devil, holds the tablet with Baldung's signature (Cat. No. 84). Wirth concludes that Baldung might have employed these conceits to identify himself with the Devil, perhaps reflecting a heightened sense of the artist's self-consciousness of the manner in which his vocation as an image-maker rivals the work of the Creator.[2] The motif might also function on a confessional level of lesser sophistication, however, for the stance is a timeless symbol of domination that Baldung might have employed simply to allude to his personal susceptibility to the power of women.

1   A similar format appears only twice previously in Baldung's prints, in devotional images of *St. Roch* (M. 14) and a *Madonna and Child* (M. 15), both from c. 1505–07.

2   See the introduction by J. Wirth to *Diables et diableries: La représentation du diable dans la gravure des XVe et XVIe siècles*, exhibition catalogue, University of Geneva, Cabinet des Estampes, 1976, pp. 9–10.

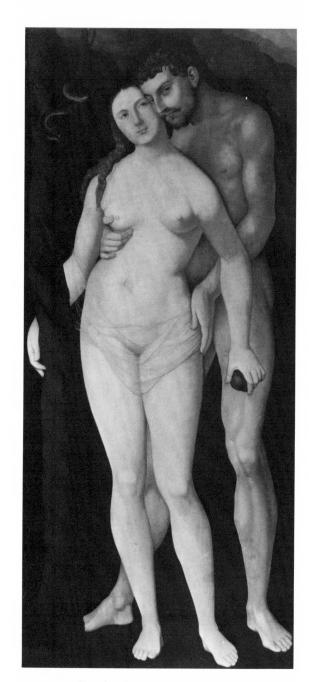

*75a. Hans Baldung, «Fall of Man,» c. 1530–40, panel, Thyssen Collection, Lugano.*

75

## Nude Young Woman Holding an Apple ("Venus")

c. 1525

Pen and brown ink
298 × 166 mm. (11¾ × 6⁹⁄₁₆ in.)
Koch 126; Karlsruhe 1959, no. 167
Lent by the Staatliche Museen Preussischer
Kulturbesitz, Kupferstichkabinett, Berlin-Dahlem

This seductive nude is one of Baldung's finest drawings of the 1520s, impressive for its simple economy of line, for its delicate but decisive contouring, and for the harmony between body and drapery. The modeling is characterized by carefully spaced parallel strokes devoid of all cross-hatching, a technique Baldung first used consistently in his drawings decorating the *Prayerbook of Maximilian I,* probably executed in 1515 (Koch 51–58). The present drawing is stylistically analogous to but earlier than Baldung's *Reclining Lovers* (Koch 129), dated 1527; in the former the artist's masterfully subtle and disciplined line renders the drapery as a complement to the body rather than as a contrast.

In his introductory essay, Talbot has suggested that this nude is modeled after Dürer's *Nemesis* of about 1501–02 (Fig. 27). Baldung's early training must certainly have included close study of Dürer's famous engraving, one of the earliest full-length renderings of a female nude in German art; however, by the 1520s, Baldung had undoubtedly assimilated what he had learned from Dürer and had developed his own canon of feminine beauty. Baldung's figure is more youthfully lithe, and the artist is unconcerned with the musculature so pronounced in Dürer's *Nemesis.* Koch's view that Baldung's figure reflects his study of a living model[1] is only partially convincing; given the curious posture of the back, it is not certain whether this drawing was sketched directly from life.

In this drawing Baldung returns to the erotic themes which occupied him earlier in the *Fall of Man* (Cat. Nos. 19, 75), *Death and the Maiden* (Fig. 5), and later in the series of *Wild Horses in a Wood* (Cat. Nos. 83–85). The fig-

ure's coquettish sidelong glance, the coy, cross-legged pose, and her nudity, which the drapery enhances rather than conceals, reveal her lascivious nature. Once interpreted as Eve,[2] she is now generally regarded as the victorious Venus holding the apple of Paris. The more recent literature bases this re-interpretation on the presence of the drapery,[3] which, it is implied although nowhere stated, would be inappropriate for Eve. This designation by default overlooks the fact that representations of Venus shown in possession of her trophy are very rare in German art of this period. Venus normally appears along with Juno and Minerva in the Judgment, or with Cupid or, less commonly, with Mars. Moreover, limiting the choice to Eve or Venus seems unnecessarily narrow. Nude female figures do appear independent of biblical or mythological contexts, for example, in the nearly contemporaneous sketch of two nude women by Jörg Schweiger, a goldsmith working in Basel during the first third of the sixteenth century (Ill. 76a). In Schweiger's drawing, a nude girl, identified as a virgin by her free-flowing hair and wreath, offers the viewer an apple while pointing to her genitals. Her companion, wearing a matron's bonnet, seems equally interested in amorous pursuits, as she demonstrates by the offer of a flower.[4] If we regard the apple not as a mythological attribute, but rather as a symbol of amorous invitation, as Schweiger and his public clearly did, Baldung's drawing acquires a more direct and thus more overtly erotic meaning.

Such interpretations raise broad questions about Baldung's work, and indeed, the work of his entire generation. The existing literature is quick to overlook the more personal forms of expression for which drawing as a medium is so highly valued. For example, in his discussion of Baldung's *Reclining Lovers* (Koch 129), Koch suggests that the drawing may illustrate an as yet unidentified mythological theme.[5] But there is no logical basis for touting the Renaissance as a period of greater personal expression in art while automatically relegating the products of an artist's erotic imagination to remote allegorical realms.

The amorous association of the apple held by Baldung's nude woman dates back to classical antiquity.[6] During the Christian era its meaning survived, evidently related to Eve's role as temptress. Eve's temptation of Adam with an apple engendered the use of apples in

other biblical scenes of seduction: Bathsheba, for example, is often represented holding an apple while bathing.[7] In secular art, apples proliferate in the courtly *Minne* imagery of the late Middle Ages, whose repertory of pictorial metaphors of lovemaking includes lovers picking apples together.[8] Two pendant drawings by a faithful copyist of Niklaus Manuel Deutsch render the erotic implications of the apple quite explicit: in one of the roundels, a woman offers an apple to the gentleman shown leering at her in the other.[9] In Baldung's drawing the erotic invitation is directed to the viewer.

The nude figure's coquettish glance and cross-legged pose reinforce the apple's message. In the sixteenth century, "body language" was much more specific in meaning than it is today. Eye contact between the sexes was forbidden in contemporary codes of conduct, usually written for women. In the *Ship of Fools* of 1494, Sebastian Brant requires women to keep their eyes modestly lowered, because the eyes betray the feelings of the heart.[10] In his *Gowk's Meadow* of 1519, Thomas Murner more candidly explains that women's glances incite lust in men.[11] The sidelong glance was such a well-established sign of erotic intent that in Niklaus Manuel's play of 1522, *On the Pope and His Priests*,[12] a prostitute is assigned the stage name "Sybilla Furtive-glance."

We may assume that the seductive message conveyed by the eyes of Baldung's figure was also recognized by the artist's contemporaries in the arrangement of her legs. Apart from the sexual connotations of the feet and legs, well known in German folklore,[13] this supposition is supported by the contexts in which the crossed legs appear and by the fact that this pose seems to detract from rather than contribute to the figure's balance, indicating that it has a significance beyond physical support. In the more or less overtly erotic paintings which Cranach the Elder and his workshop produced in many versions for an evidently enthusiastic public at the Saxon court, this pose is consistently employed to enhance the appeal of female nudes. It appears in almost all versions of the *Fountain Nymph*,[14] that curious reclining nude who keeps her eyes open despite the inscribed warning to the viewer not to disturb her sleep. Cranach also employs this pose in numerous representations of Venus.[15] The most closely comparable examples, however, with the feet placed side by side and the legs crossed at the ankles, appear in three of Cranach's paintings of *Eve*, the earliest dating from about 1510–12[16] and the latest from 1533.[17] In Baldung's own *oeuvre*, the crossed legs appear in another work executed about the same time as the present drawing, the life-size *Judith* of 1525 (Fig. 23), whose nudity emphasizes the attractions with which the heroine insinuated herself into Holofernes' tent rather than the civic virtues which saved her people. —C. A.

1   Koch, p. 138.
2   Max Friedländer and Elfried Bock, *Handzeichnungen deutscher Meister des 15. und 16. Jahrhunderts*, Berlin, 1921, p. 10, no. 2171, and Friedrich Winkler, *Hans Baldung Grien: Ein unbekannter Meister deutscher Zeichnung*, Burg b. M., 1939, p. 15 no. 11.
3   Koch, p. 36 and Karlsruhe 1959, no. 167. In a footnote Koch refers to his no. 141 citing Venus' drapery; however, it is not a distinguishing characteristic since Pallas wears a similar garment.
4   Gifts of fruit or flowers were universally understood as offers of love; see Christiane Andersson, "Urs Graf und Niklaus Manuel," *ZAK*, December 1980 (in press).
5   Koch, p. 141.
6   *Reallexikon zur deutschen Kunstgeschichte*, I, Stuttgart, 1937, col. 748, s. v. "Apfel."
7   Margaret Longhurst, *Catalogue of Carvings in Ivory*, II, Victoria and Albert Museum, London, 1929, Inv. no. 2/2/3–1855, pl. LXXIV.
8   Betty Kurth, *Gotische Bildteppiche aus Frankreich und Flandern*, Munich, 1923, pl. 67.
9   Max Friedländer, *Handzeichnungen deutscher Meister in der herzogl. Anhaltschen Behördenbibliothek zu Dessau*, Stuttgart, 1914, pls. 49a, b.
10  Cited in *Sebastian Brants Narrenschiff*, ed. Friedrich Zarncke, Leipzig, 1854, p. 34, lines 25ff.
11  Thomas Murner, *Die Geuchmat,* ed. Eduard Fuchs, in *Thomas Murners Deutsche Schriften*, V, Berlin and Leipzig, 1931, p. 136, lines 2957ff.
12  "Hur Sibilla Schilöugli," Niklaus Manuel, *Vom Papst und seiner Priesterschaft* (1522), ed. Jacob Bächtold, p. 61, 1.797.
13  E. Hoffmann-Krayer and H. Bächtold-Stäubli, *Handwörterbuch des deutschen Aberglaubens*, III, Berlin and Leipzig, 1930–31, cols. 224ff.
14  Friedländer/Rosenberg, pls. 119, 120, 402, 404.
15  Ibid., pls. 241, 242, 398–400.
16  Ibid., p. 78 and pl. 43.
17  Ibid., p. 108 and pl. 196.

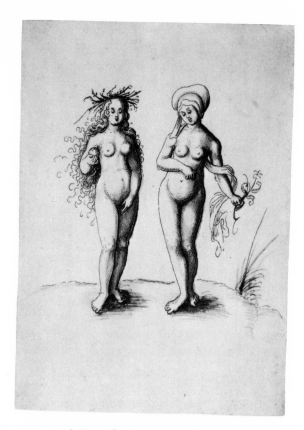

*76a. Jörg Schweiger, «Two Nude Women,»*
*c. 1520–30, pen, Kunstmuseum Basel.*

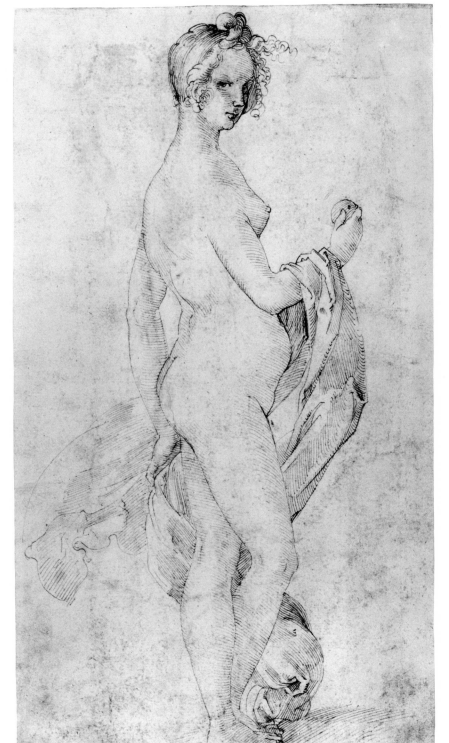

76

77

*Madonna Enthroned*

C. 1530–33

Pen and brown ink, brush and gray wash
409 × 278 mm. (16⅛ × 10¹⁵/₁₆ in.)
Koch 158; Karlsruhe 1959, no. 243
Lent by the Staatliche Kunsthalle Karlsruhe

The Madonna and Child were considered the protectors of the city of Strassburg; tradition has it that as early as the twelfth century a mammoth city banner (4 × 3½ meters) was created, showing an enthroned Madonna with arms upraised in a gesture of benediction as patroness of the city.[1] The official city seal also shows this motif in a Romanesque architectural setting. By the time Baldung made this drawing in the sixteenth century, the concept of the Virgin in her special relationship to Strassburg was well established, and it is thus not surprising to find the coat of arms of the city superimposed at the base of the drawing, which is generally agreed to be a design for a stained-glass window.[2]

Seated on a massive Italianate throne with somewhat incongruous Gothic ornamentation, the youthful Madonna offers a pear to the Child, who turns away to tug playfully at his mother's wavy tresses. The modest downward glance of the Madonna and her sweet facial features recall in general terms several other Baldung drawings, namely, the demure young woman in Basel (Cat. No. 43), and, more specifically, the female type represented in the *Hercules and Omphale*, dated 1533 (Fig. 14). A date in the early 1530s for the present work is further supported by the general similarities between it and an anonymous Baldung school drawing dated 1533 in the Vienna Academy (Koch A13).

Unusual in Baldung's *oeuvre* is the combination of a figure inspired by fifteenth-century prototypes (the seated Madonnas of Schongauer and Holbein the Elder, which thus must have seemed old-fashioned to viewers at the time) and an exaggerated architectonic setting which manifests the increasingly mannerist attitude that characterizes Baldung's work in the early 1530s.

1   This famous banner was destroyed in the late eighteenth century. For a discussion of the iconographic sources of the Strassburg Madonna type and for an engraved copy of it dated 1736, see Paul Perdrizet, "La Vièrge aux Bras Étendus," *Archives Alsaciennes*, I, 1922, pp. 1–29, pl. 1.
2   Koch, p. 161 and K. T. Parker, *Elsässische Handzeichnungen des XV. and XVI. Jahrhunderts*, Freiburg i. Br., 1928, p. 31.

~ 78

*Hercules and Antaeus*

C. 1530

277 × 157 mm. (8⅝ × 6³/₁₆ in.)
Koch 137; Karlsruhe 1959, no. 172
Lent by the Cabinet des Estampes, Musée des Beaux-Arts, Strasbourg

According to legend, Hercules, upon his return from the Hesperides, encountered the evil giant Antaeus, son of the earth goddess Gaia and the sea god Poseidon. Since he was born of the earth, Antaeus was invincible as long as he touched the ground. He forced men to wrestle with him and used their skulls to build a temple to his father. By lifting him off the ground, Hercules was able to destroy Antaeus in his vise-like grip. Hercules was an embodiment of Virtue, and his victory over the bestial, earthbound giant may be interpreted as the victory of Virtue over the lower passions of man.[1]

Despite the spurious Dürer monogram and date of 1517 in the lower left, this drawing of Hercules, clothed in the skin of the Nemean lion and glaring victoriously as he squeezes the life from his enemy, is unquestionably from Baldung's late period. It is very closely related to a painting in Cassel, signed and dated 1531 (Ill. 78a). Although the drawing has many similarities to the Cassel painting (the heads of the two combatants, the exaggerated musculature, the placement of figures against a dark background), it is clearly not a preparatory drawing, but an independent conception of the subject.[2] Strangely, Hercules' pose in the drawing appears to be a modified version of Antaeus' pose in the panel, but the drawn and painted figures are quite different, and the drawing is complete in itself. Koch remarks that the two works represent different stages in the battle— in the painting Hercules has not achieved unequivocal victory— and that the drawing shows a more naturalistic approach to the nude than the more stylized painting.[3]

The struggle of Hercules and Antaeus gave late Renaissance artists a theme ripe for aesthetic exploitation, an opportunity to display strained, over-articulated muscles and unusual poses. Bussmann, who has made the most thorough study of Baldung's late work and his relationship to stylistic currents of international mannerism, has pointed out that Baldung probably knew Italian engravings based on Pollaiuolo's several versions of the Hercules and Antaeus theme.[4] But there is no trace of quattrocento style in Baldung's depictions. Fascinated by the bizarre, Baldung eagerly adopted mannerist traits, especially the exaggeration of anatomical details (often to

the point of caricature), and an arbitrary, non-naturalistic approach to figure and space.

Like Baldung's female nudes of the 1520s, *Hercules and Antaeus* is a study in which swelling contours and a robust plasticity are stressed, complex poses explored and contrasted, and isolated figures often underscored by the contrast of pale or muscled flesh against dark backgrounds (Figs. 23, 50). Interior definition, much more extensive in Baldung's male figures, articulates the congealed muscles of Hercules' back and Antaeus' chest, neck and arm, but remains subordinate to contour. In characteristically mannerist fashion, anatomical accuracy is less important than the abstract pattern of muscles and the profusion of limbs, all forced to the picture plane and not truly integrated with surrounding space. The drawing shows an essentially formal and intellectual approach to the human form, independent of observed nature. Antaeus' left leg, for example, is not convincingly connected to the rest of his body. This leg completes a shallow arc which intersects with the arc created by Hercules' body, and its position is compositionally, not anatomically, determined.

Perhaps the most strikingly manneristic aspect of *Hercules and Antaeus* is its expressive peculiarities. While the figures in the Italian sources suggested by Bussmann show physical strain but psychological neutrality, Baldung assaults us with the hero's direct, unnerving glance, which suggests stress and certain victory at the same time. The artist's presentation of physical strain is exceptionally exaggerated. Antaeus' flesh ripples in Hercules' grip, his distorted face confirms his imminent demise, and his toes convulsively pinch Hercules' calf. In the Cassel painting, a rivulet of blood trickles from Antaeus' ear— a detail we are spared in the drawing but which emphasizes Baldung's essentially eccentric approach to the theme. The allegorical meaning, the triumph of Virtue over the vice of the flesh, is undermined by a thoroughly mannerist capriciousness. Hercules and Antaeus seem to belong not to the world of classical gods and heroes but to the grotesque world of the circus side show. —L.C.H.

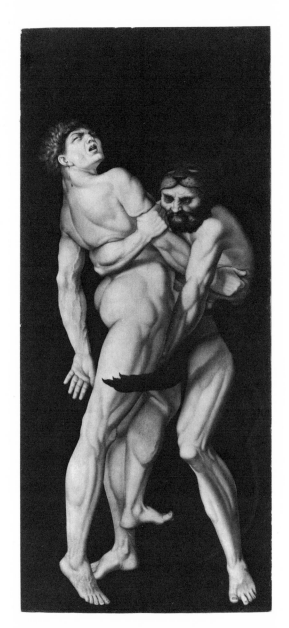

*78a. Hans Baldung, «Hercules and Antaeus,» 1531, panel, Staatliche Kunstsammlungen, Cassel.*

1　For an account of this myth in ancient literature, see Apollodorus, *On the Gods*, II, 5. 11. On Boccaccio's interpretation of Hercules' triumph over Antaeus as the triumph of Virtue (*Genealogia deorum*, I, 13), see J. Seznec, *The Survival of the Pagan Gods*, New York, 1953, p. 223. The association of Virtue and sacrifice appears in a group of five Baldung paintings, including a *Hercules and Antaeus* in Warsaw, dating from 1530–31 and probably commissioned as a series by the same humanistic patron; see Karlsruhe 1959, I 59 and Bussmann, pp. 76, 86.

2　W. Hugelshofer, who first published this drawing ("Eine Herkules-und-Antäus-Zeichnung aus Hans Baldungs Spätzeit," *Pantheon*, VIII, 1931, pp. 441–45), suggested that it was a cabinet picture, made to be kept and admired by one of Baldung's humanistic patrons (possibly the same one who commissioned the above-mentioned mythological and historical series). In addition, there is a third version of this subject by Baldung, a painting of 1530 in Breslau which Koch (p. 147) considered to be earlier than the present drawing.

3　Koch, p. 146, no. 137, and p. 39.

4　Bussmann, p. 35. See also F. Hartt, *A History of Italian Renaissance Art*, 2nd ed., New York, 1979, pp. 316–17, figs. 347 and 348; L. Ettlinger, *Antonio and Piero Pollaiuolo*, London, 1978, pls. 78, 79–82, 92.

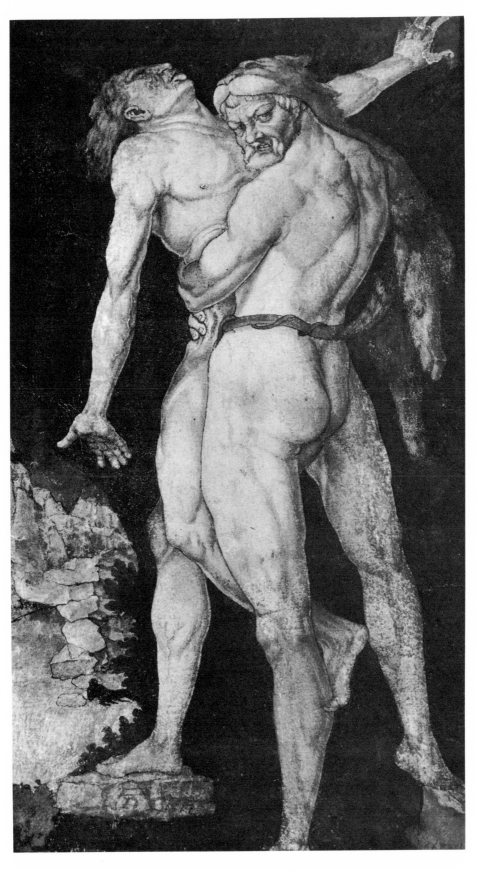

78

79

## Margrave Christoph I von Baden

DATED 1511

Woodcut
178 × 102 mm. (6¾ × 4⅛ in.)
B. 59; G. 127; H. 266; Karlsruhe 1959,
II H 81; M. 28
Lent by the Staatliche Graphische Sammlung,
Munich

79a. Hans Baldung, «Margrave Christoph I von Baden,» 1515, panel, Alte Pinakothek, Munich.

Margrave Christoph I, founder of the dynasty of Baden, was an important patron of Baldung during the early years of his artistic activity. The artist produced four likenesses of Christoph. Except for the shaven upper lip, this woodcut of 1511 resembles the portrait in a panel of 1510, in which the Margrave is shown along with his family, venerating St. Anne, the Virgin and the Christchild (Curjel, pl. 13; Karlsruhe 1959, I 12). Christoph's salient features— his large, hooked nose, unusually straight mouth and prominent chin— and signs of his age (fiftyeight years) are emphasized in the woodcut, where strong contours define the features, and the creases around the eyes and mouth are heavily delineated. The powerfully modeled hat and the active, curly lines of the beard frame the face and draw attention to the firm resolve therein. A stability and balance, unusual in Baldung's portraiture, is attained through the indirect glance, the erect posture, and the broad, monumental treatment of the upper torso. This is a straightforward, "official" portrait of a ruler, not intended to reveal inner life so much as to convey general notions of political power and personal strength. The prominence of the inscription underscores the basic purpose of the image— to spread the fame of the sitter. As Möhle points out, Baldung's portrait of Christoph, dated 1511, is the earliest known independent woodcut portrait.[1] The tradition was continued by Baldung in such later images as *Johannes Rudalphinger* (Cat. No. 81), or by Dürer in his dynamic, almost baroque likeness of the imperial adviser, Ulrich Varnbüler (K. 326).

Baldung's woodcut portrait of Christoph and his silverpoint likeness of 1512 (Koch 86), both expressing generalized qualities such as leadership and firmness, may be contrasted to a 1515 painting (Ill. 79a). The silverpoint drawing was a preparatory sketch for this painting, but the two works are very different in expression. In the interim period, the Margrave had begun to go mad. His condition must have fascinated an artist so concerned with the aberrant side of human behavior. Baldung conveys the change in Christoph's mental state through physiognomic distortions in the painting. The whole head is elongated; the furrow in the brow is de-emphasized, altering the expression from one of concentration to blankness. The disjunction of the eyes and the rigidity of the mouth are exaggerated. In the year this portrait was painted, Christoph abdicated to his sons, Philipp, Ernst and Bernhard. He died in 1527, never having recovered from his illness.[2] —L.C.H.

1  H. Möhle, review of Karlsruhe 1959 exhibition, in *ZfK*, XXII, 1959, p. 127.
2  On Christoph's life, see F. Wielandt, in *Zeitschrift für die Geschichte des Oberrheins*, N.F. XLVI, 1933, pp. 527ff.

80

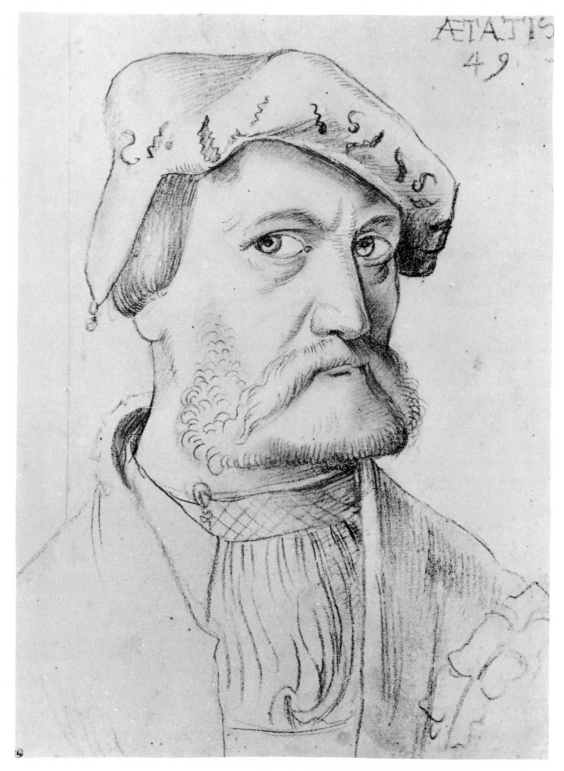

## 80

*Self-Portrait at Age Forty-nine*

1534

Black chalk
248 × 183 mm. (9¾ × 7¼ in.)
Koch 138; Karlsruhe 1959, I 179
Lent by the Cabinet des Dessins, Musée du Louvre

Although Baldung represented himself as a bystander in some of his major religious panels,[1] he seems to have produced few independent self-portraits. This is curious, considering the heritage of self-portraiture and artistic self-awareness that he must have known from Dürer.[2] Perhaps the pen drawing in Basel (Fig. 1) and the present preparatory drawing with its resultant woodcut (Ill. 80a) represent only a portion of the self-portraits that Baldung actually produced. These few works, however, are remarkable for what they reveal about the artist— the youthful independence suggested in the Basel drawing and the almost fanatical strength of purpose conveyed by this one. The present self-portrait, moreover, inscribed AETATIS/49 in the upper right corner and made in preparation for a woodcut dated 1534, is the primary piece of evidence by which we fix Baldung's birthdate in 1484-85.

The small woodcut made from this drawing was printed alongside a portrait of the musician and composer Johannes Rudalphinger on the title page of a book of musical compositions eulogizing the composer Thomas Sporer (see M. 465-66). The very presence of Baldung's portrait on this title page suggests that his musical comrades held him in great respect. Moreover, the similarity in style implies a strong personal rapport between the artist and Rudalphinger.[3] Both portraits express an aggressive integrity: the eyes burn with purpose, the jaws are squared and the mouths held tight in resolution; the hands are cubically simplified, and the lower edges of Rudalphinger's jowls and the artist's beard conform to horizontal lines; the contour lines of the head and features are rigid and continuous, further underscoring the stark expression.

Despite its strength of expression, the small woodcut self-portrait is less subtle than Baldung's drawing, and we may question whether the cutting of the block was closely supervised by the artist. While determination and forcefulness of personality are certainly present in the drawing, these qualities are mitigated by a softer treatment of the face, beard and clothing. The artist's head is revealed in a harsh light, which blots out details on the right cheek and causes the nose to cast a strong shadow,

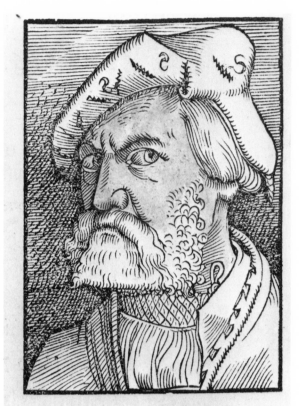

Præsens Baldungum facies imitatur agentem Annos bis, supra ter tria lustra, duos.

80a. Hans Baldung, «Self-Portrait» from «Epicedion Thomae Sporeri,» 1534, woodcut.

subtly rendered by smeared chalk, on the left. Always sensitive to linear pattern, Baldung plays the vertical folds of the shirt and the more openly spaced modeling lines on the coat against the diamond patterns. The linear ornamentation of the hat and sleeves helps to cushion the disturbing impact of the artist's glance. Baldung's late drawing style (see also Cat. Nos. 77, 86) is beautifully represented here. It is a "shorthand" style— pure, economical, with graceful, rounded contours and reduced interior modeling— developed by an artist for whom line alone could condense and express a lifetime of visual experience.

The stylistic and expressive similarity of this self-portrait to woodcut portraits from Baldung's late period— Indagine (Fig. 37), Rudalphinger (Cat. No. 81), Hedio (Cat. No. 82), and Brunfels (Fig. 39)— suggests that the artist was part of a circle of prominent humanists, many of whom were also involved in religious reform.[4] If we may judge from Baldung's interpretation of himself

in *Self-Portrait at Age Forty-nine*, and of his friends in the woodcut portraits, these men shared a common point of view, a sense of being in the intellectual and spiritual vanguard of their time. —L.C.H.

1   See the *Martyrdom of St. Sebastian* (Fig. 4); the *Adoration of the Magi* (1507; Gemäldegalerie, Staatliche Museen, Berlin-Dahlem), and the *Crucifixion* from the Freiburg Altarpiece (1512–16; Ill. 42a).
2   On Dürer's self-portraits, see W. Waetzoldt, "Self-Characterization," in *Dürer and his Times*, London, 1950, pp. 15–28, and M. Levey, "Dürer and the Renaissance," in *Essays on Dürer*, ed. C. R. Dodwell, Toronto, 1973, pp. 1–22.
3   T. Gérold, "Hans Rudolfinger et ses amis artistes," in *L'Humanisme en Alsace*, Paris, 1939, pp. 205–14.
4   For elaboration of this, see my essay, "Baldung and the Reformation," above, p. 39–42.

# 81

## *Johannes Rudalphinger*

DATED 1534

Woodcut
187 × 122 mm. (7⅜ × 4¹³⁄₁₆ in.)
G. 130; H. 276; Karlsruhe 1959, II H 82; M. 74
Lent by the Staatliche Graphische Sammlung, Munich

Johannes Rudalphinger was Chaplain at the Cathedral of Strassburg and a well-known musician and composer. Although he was twenty years older than Baldung, he seems to have been among the artist's closest friends.[1] On the title page of Sixt Dittrich's book of musical compositions eulogizing Thomas Sporer, Baldung pictures himself along with Rudalphinger in small woodcut portraits (see M. 465–66).

This single-sheet likeness of Rudalphinger is among Baldung's finest woodcut portraits. Like *Caspar Hedio* (Cat. No. 82), it represents a powerful synthesis of the formal and expressive principles stated more tentatively in Baldung's earlier portrait of Johannes Indagine (Fig. 37). The sitters have a strong three-dimensional presence and a psychological energy that projects beyond the weak, recessive frames. Baldung exploits this tension between the sitter's image and the framing elements that neither contain nor effectively complement the image to generate a sense of physical and psychological power.

Despite his recessed spatial position, Rudalphinger overwhelms the bordering elements of slender branches, foliated at the top. Broad areas of light and dark give the shoulders a massiveness that is exceeded only by the head, which juts uncomfortably forward. Rudalphinger's bulbous features, even his sagging jowls and the drooping skin around his eyes, are given a formidable vitality by Baldung's treatment in broadly conceived masses, articulated by emphatic, continuous contour lines. The expressive impact of the head is enhanced by the curving forms of the hat and collar, which frame and concentrate the scrutinizing glance, and by the contrast of the strongly lighted face against the neutral graphic tone of the background. Rudalphinger's hand, seemingly disconnected from the body, pushes forward to hold the inscription. Neither the ledge, nor the frame, nor the picture plane itself, controls the intense energy directed toward the viewer. —L.C.H.

1   T. Gérold, "Hans Rudolfinger et ses amis artistes," in *L'Humanisme en Alsace*, Paris, 1939, pp. 205–14.

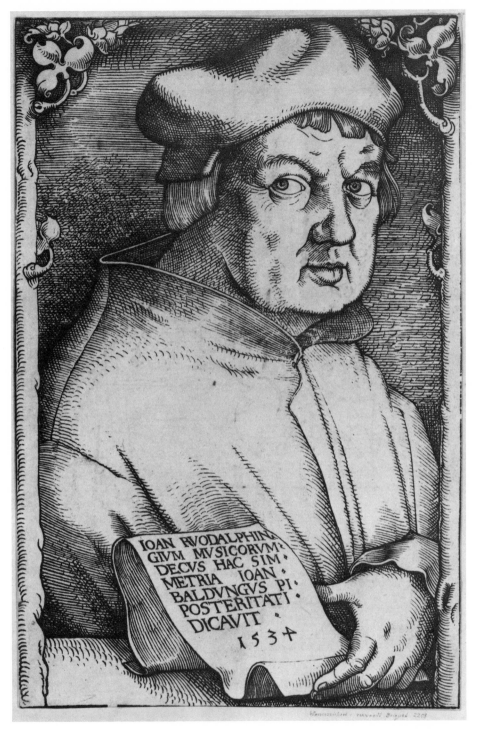

## 82

*Caspar Hedio*

1543

Woodcut
175 × 138 mm. (6⅞ × 5⁷⁄₁₆ in.)
G. 128; H. 268; Karlsruhe 1959, II B LII; M. 544
Lent by the Germanisches Nationalmuseum,
Nuremberg

Caspar Hedio, preacher at Strassburg Cathedral and Protestant theologian, was born in 1494 in Ettlingen in Baden. There is a strong possibility that Baldung's acquaintance with Hedio was of long standing— Hedio had attended the University of Freiburg where Baldung's brother was a professor, and Baldung himself lived in Freiburg between 1512 and 1516. In Basel, Hedio became friends with the theologian Wolfgang Capito and came under the influence of Lutheran and, more strongly, Zwinglian writings. Despite his Protestant sympathies and with the recommendation of Capito, then Chancellor of the Archdiocese, Hedio was summoned to Mainz by Archbishop Albrecht to work as court chaplain. However, as Albrecht's court became increasingly constraining for those with Protestant proclivities, both Hedio and Capito left in 1523 for the more tolerant atmosphere of Strassburg. Hedio accepted the post of preacher in the Cathedral and became one of the most important religious leaders in the city. Like other Strassburg theologians, he tried to mediate between Lutheran and Zwinglian factions, emphasizing the need for compromise and unity.

Perhaps as important as his theological work were his efforts to improve and reorganize Strassburg's schools. Hedio died of the plague in 1552.[1]

Although Hedio was described as a practical mediator, generous and broad-minded,[2] Baldung's portrait characterizes him as a fiery preacher and a zealous, indeed militant, Reformer. The print appeared in Hedio's *Selected Chronicle of the World, from its Beginnings until the Year 1543*. In this year, Hedio, Martin Bucer (Strassburg's most eminent theologian), and Philip Melanchthon were engaged in an effort to bring the Reformation to Cologne.[3] This effort ultimately failed, but it may help to explain the aggressive quality of this portrait.

Baldung made a preparatory drawing for this print in silverpoint (Ill. 82a). Although the delicate silverpoint technique does not lend itself to strident value contrasts, the drawing has an unexpectedly harsh expression that is only increased in the woodcut by Baldung's relentlessly vigorous woodcut line. As Koch points out, the naturalism of the drawing is stylized and abstracted in the print; the facial features are hardened and sharpened.[4] Note, for example, the ecclesiastical collar, so stiffened in the woodcut that it seems to hold the head and neck permanently in position. Hedio glares out at the viewer, while his hand, like Rudalphinger's (Cat. No. 81), seems to acquire a life of its own and moves furtively toward the book on the ledge. As in the portrait of Rudalphinger, Baldung contrasts the strong linearity and massiveness of the sitter's form to a thin, recessive leafy border. The oddly curved hatching to the right of the head seems to press in upon the sitter, and even the folds of the coat and the pronounced diagonal lines of the collar are active, expressive forms. *Hedio* is one of Baldung's strongest, and most subjective portraits, where one aspect of the sitter's personality is hyperbolized at the expense of other qualities. Intensity is not tempered with restraint, determination with adaptability, nor strength with any measure of human vulnerability.

The extraordinary force of Baldung's woodcut style toward the end of his life is exhibited particularly vividly in this portrait and in the *Bewitched Groom* (Cat. No. 87). Both of these prints reveal an almost systematic linear control: hardened, homogeneous contour lines course around solid forms. Yet the regularity of the line is belied by overall conflicts in linear direction. Equally powerful masses press upon one another and lock together in stalemated contests for power. In the *Bewitched Groom*, an abrupt spatial recession is pitted against the assertive plasticity of the horse and its outward-directed, demonic energy. Powerful linear patterns (the hay in the stall, the curling lines of the torch and of the horse's mane and tail) vie for attention. In *Hedio*, Baldung produces analogous effects by the spatial conflict between the sitter and frame, the volumetric hatching pressing on Hedio's head, and by directional contrasts. The lines of the coat, moving diagonally upward, are counteracted by the downward weight of the hat and by the piercing, projecting force of Hedio's glance. —L.C.H.

1 For a discussion of Hedio and other Strassburg Reformers, see W. Tillmanns, in *The World and Men around Luther*, Minneapolis, 1959, pp. 202–19. A biography of Hedio is found on pp. 216–18.
2 Ibid., p. 218.
3 Ibid., pp. 216–17.
4 Koch, p. 183.

82

82a. Hans Baldung, «Caspar Hedio,» 1543, silverpoint,
(from the Karlsruhe Sketchbook), Staatliche Kuntshalle Karlsruhe.

≈ 83-85

## Wild Horses in a Wood

≈ 83

### Wild Horses Fighting

DATED 1534

Woodcut
230 × 344 mm. (9⅛ × 13⅝ in.)
B. 56; G. 123; H. 238; Karlsruhe 1959,
II H 78; M. 77
Lent by the Metropolitan Museum of Art,
Harris Brisbane Dick Fund, 1933

≈ 84

### Stallion Approaching a Mare
### with Ape and Man Looking On

DATED 1534

Woodcut
225 × 332 mm. (8⅞ × 13⅛ in.)
B. 57; G. 124; H. 239; Karlsruhe 1959,
II H 79; M. 78
Lent by the Metropolitan Museum of Art,
Rogers Fund, 1922

≈ 85

### Stallion Attempting to Mate

DATED 1534

Woodcut
228 × 339 mm. (9 × 13⅜ in.)
B. 58; G. 125; H. 240; Karlsruhe 1959,
II H 80; M. 79
Lent by the Los Angeles County Museum of Art,
Museum Purchase with County Funds

This unusual cycle of woodcuts, for which no pictorial precedents appear to exist, depicts a herd of wild horses engaged in frenzied activity in a dark, wooded setting. Although all three scenes take place against similar backdrops, there is no satisfactory way to combine the prints to form a unified composition.[1] It seems most reasonable to think of the woodcuts as a series, perhaps representing successive stages of the horses' mating behavior.[2] The first presents a confused tangle of fighting horses, in which the central group is a stallion attacked by two of his fellows. The second and third prints portray explicitly sexual subject matter: in the former, an already excited male approaches a mare, who is eating grass at the right; in the latter a stallion, perhaps the protagonist of the second print, ejaculates before he is able to mount the mare he has chosen, who is shown kicking up her hind legs at the right.

Baldung's obvious command of equine anatomy reflects careful studies from life, and a number of his silverpoint drawings of horses are in fact preserved in Karlsruhe (Koch 195–99). None of these sheets could unequivocally be called a preparatory study, and there is no independent proof that the drawings are even contemporary with the woodcuts. There is little doubt, however, that similar studies underlie such naturalistically rendered figures as the mare feeding in the foreground or the reclining horse at the left of the *Stallion Approaching a Mare*. Even the awkwardly posed stallion at the center of the *Horses Fighting*, leaping over the horse lying beneath him, suggests a life study, presumably of an animal in a more nearly static pose. A silverpoint drawing of an ape is also preserved in Karlsruhe (Koch 242), close in type although not in pose to the creature in the second of the three woodcuts.

Baldung's interest in fighting horses can be traced back at least as far as 1515, for the subject forms the motif of one of his marginal decorations in the *Prayerbook of Maximilian I* (Koch 51). He returned to the theme in a drawing of 1531 in Karlsruhe (Koch 131) and in another sheet known only from a copy in Basel (Koch A20). Once again, the similarities between the drawings and the prints are only general; neither of the latter two sheets could be called preparatory for the woodcuts.

The graphic style of these woodcuts enhances the feeling of violent motion conveyed by the figures. The prints have much of the immediacy of pen drawings, an effect quite different from the studied, pictorial quality of

the *Bewitched Groom* (Cat. No. 87). The parallel modeling lines, as they delineate the play of light and shade, trace the underlying contours of the horses' bodies, while small flicklike strokes add to the effect of movement.[3] Even the drawing of the grassy forest floor contributes to the sense of drama, as small, hooked lines create patches of vibrant motion. Dense crosshatching is reserved for the very deepest shadows and for the impenetrable darkness of the backdrop; the range of tones, from full highlight to shade, is unusually extensive.

There have been no attempts in the literature to delve very deeply into the subject matter of these woodcuts, although the general contours of an interpretation have long been clear— thus Koch has suggested that the prints represent "the amorous passion and amorous bitterness of [all] creatures."[4] The compositions contain a few explicit clues: the human onlooker in the background of the second print wears contemporary dress, a probable indication that the subject does not involve a scene from classical mythology or history. The presence of the ape grasping Baldung's signature plaque, on the other hand, suggests that the composition is much more than a literal rendering of a herd of wild horses in a Northern forest.[5] The ape, a creature with a long and varied history of symbolic use in literature and art, is here undoubtedly included as an embodiment of sexual potency, a role it played in Dürer's wellknown *Affentanz* drawing of 1523.[6] Like the horse, the ape was associated with the hot, sanguine temperament.[7]

In the zoological literature available during the sixteenth century, which consisted of a variety of classical sources and subsequent compilations by the medieval encyclopedists, horses were renowned for their sexual appetites. According to Aristotle, "after human beings, the horse, both sexes, is the most salacious of all animals."[8] He notes that they revel in the sexual act, which some other animals find burdensome. Mares are often described by these authors as particularly lustful, running madly across the countryside in their time of heat.[9] They are even capable of spontaneous impregnation by the wind:

> *Indeed, in some regions, there is no doubt that the mares are affected by such a burning desire for intercourse, that, even though there is no stallion at hand, owing to their continuous and excessive passion, by imagining in their own minds the pleasures of love they become pregnant with wind. . . .*[10]

The males are especially prone to sexual stimulus, and, if kept near the females but unable to mount them, may "harm themselves through excitement due to their desires."[11] One Roman authority suggests tying the mare before breeding, so that "the stallions do not, in their eagerness, eject the seed to no purpose."[12] Stallions are also said to betray great sexual jealousy during the breeding season; according to Albertus Magnus, a male may gather a group of females about himself and then fight repeatedly with any stranger who tries to mate with them.[13]

This traditional scientific literature clearly figures among Baldung's sources, but there is an intensity to the horses' actions that goes far beyond the descriptions of Aristotle and Albertus Magnus. The bulging eyes and anguished expressions, as well as the frenzy of their combat, suggest another source that has little to do with the classical tradition. The horse also played a role in folklore as a creature of darkness, as Baldung's own woodcut of the *Bewitched Groom* (Cat. No. 87) makes abundantly clear. A horse could be the victim of a witch's spells, or the witch might herself appear in the guise of a horse. The dreaded *Nachtjäger*, a ghostly hunter, raced through the countryside on a devil's steed.[14] Baldung's horses are held in thrall not by any supernatural power, but by the force of their own sexual nature. Excited almost to the point of frenzy by this overwhelming drive, the animals race through the dark forest, fighting with their rivals and frightening the females whom they seek. They are able to find no release; gratification ultimately eludes them.

That Baldung's woodcuts refer, ultimately, to the human condition is indicated not only by the onlooker in the background of the second print, but also by the presence of the ape. A venerable symbol of man's Fall from Grace, this creature appears in a number of sixteenthcentury depictions of the Fall, a catastrophe credited in large measure to man's own inability to resist his sexual impulses.[15] The irresistible power of erotic desire is clearly not restricted to the animal world. And yet there is nothing overtly moralistic in Baldung's approach to the subject. The sexual force is depicted as both relentless and inevitable— a pessimistic viewpoint which probably accounts for the presence, in the background of the second woodcut, of the elk, a traditional representative of the melancholy humor.[16]

Such an explicit portrayal of animal sexuality might surprise us in the works of most other sixteenthcentury German artists. In Baldung's *oeuvre*, however,

physical passion— especially in its sinister aspect— is a central theme. It is evident in his lifelong preoccupation with witchcraft, and it is the real subject of many of his depictions of the Fall of Man.[17] In *Wild Horses in a Wood* Baldung created a group of unique and unforgettable images of the sexual drive itself. —J.A.L.

1 For example, the relatively deep space in Cat. Nos. 84 and 85 is not comparable to the much shallower foreground plane of Cat. No. 83. It seems significant in this regard that Baldung chose to sign and date each print separately.

2 We are indebted to A. Kent Hieatt for this interpretation.

3 Baldung uses similarly transparent modeling in his pen drawing of *Christ on the Cross*, dated 1534, in Vienna (Koch 134).

4 Carl Koch, "Über drei Bildnisse Baldungs als künstlerische Dokumente vor Beginn seines Spätstils," *ZKw*, V, 1951, p. 68.

5 A later sixteenth-century literary source attests to the presence of herds of wild horses in Alsatian forests; see Karlsruhe 1959, p. 281.

6 H. W. Janson, *Apes and Ape Lore*, London, 1952, esp. pp. 261–76. For the Dürer drawing, see Winkler, *Dürer Zeichnungen*, IV, no. 927.

7 Raymond Klibansky, Erwin Panofsky, and Fritz Saxl, *Saturn and Melancholy*, New York, 1964, p. 378.

8 Aristotle, *Historia Animalium*, 2, trans. A. L. Peck (Loeb Classical Library), Cambridge, Mass. and London, 1970, p. 319 (VI:xxii).

9 Albertus Magnus, *De Animalibus Libri XXVI*, ed. H. Stadler, Münster i.W., 1916, p. 483.

10 Lucius Junius Moderatus Columella, *On Agriculture II*, trans. E. S. Forster and Edward H. Heffner (Loeb Classical Library), Cambridge, Mass. and London, 1954, pp. 191–93 (VI:xxvii). There is a more famous passage on this same subject in Virgil's *Georgics*, Book III; see *Virgil*, trans. H. Rushton Fairclough (Loeb Classical Library), Cambridge, Mass. and London, 1960, pp. 173–75.

11 Columella, *On Agriculture*, pp. 193–95.

12 Marcus Terentius Varro, *On Agriculture*, in Marcus Porcius Cato and Marcus Terentius Varro, *On Agriculture*, trans. William Davis Hooper (Loeb Classical Library), Cambridge, Mass. and London, 1934, p. 387 (II:vii).

13 Albertus Magnus, *De Animalibus*, p. 484.

14 E. Hoffmann-Krayer and Hanns Bächtold-Stäubli, *Handwörterbuch des deutschen Aberglaubens*, VI, Berlin and Leipzig, 1934–35, cols. 1637–40, 796–802.

15 Janson, *Apes and Ape Lore*, pp. 107–36.

16 Klibansky, Panofsky, and Saxl, *Saturn and Melancholy*, p. 378. The elk appears as the embodiment of the melancholy humor in Dürer's engraving of the *Fall of Man* (Fig. 15).

17 See especially his woodcut of 1519 (Cat. No. 75) and his paintings in Budapest and Lugano (Fig. 50 and Ill. 75a).

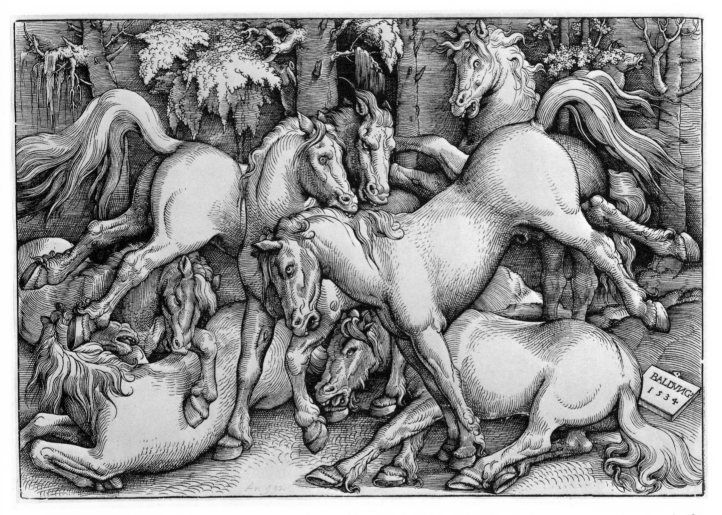

83

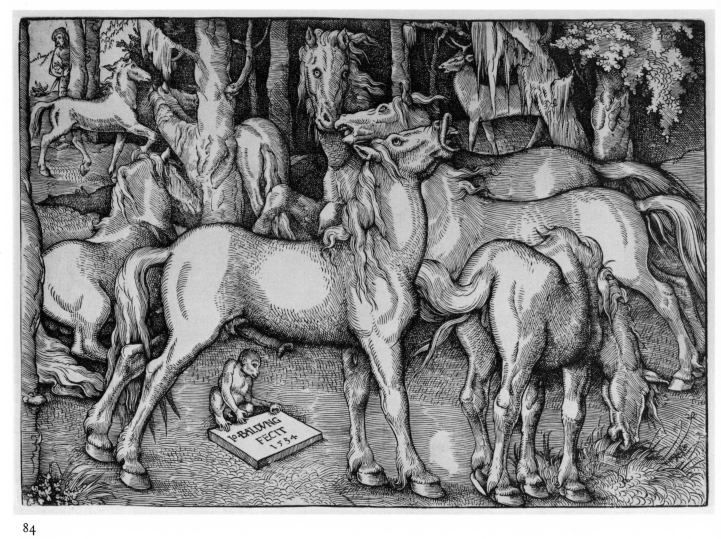

84

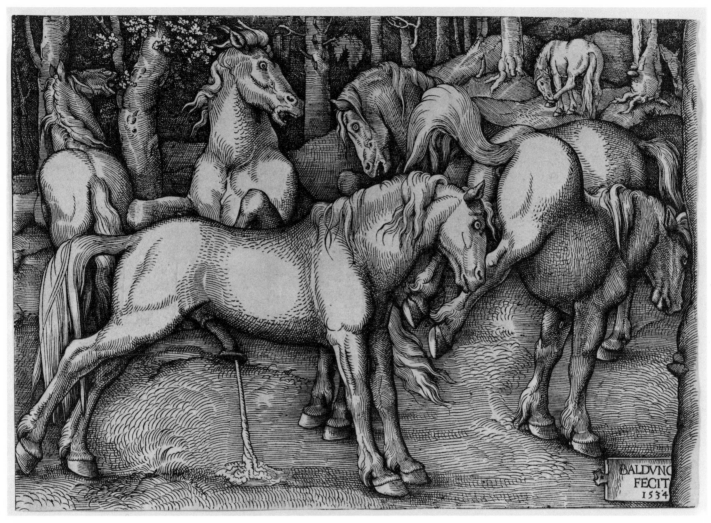

85

86

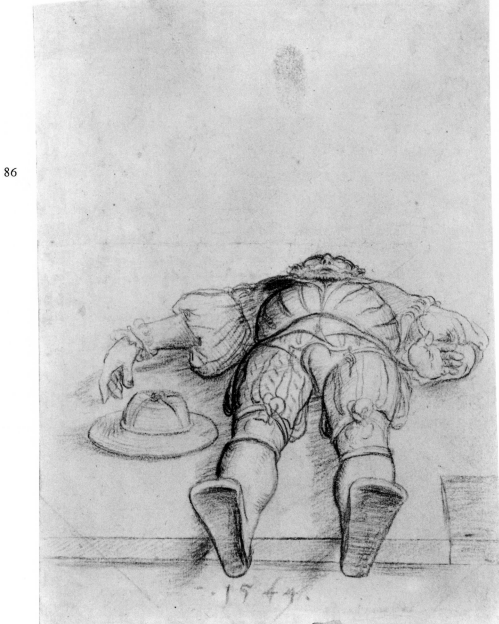

## ◆ 86

*Study for the Bewitched Groom*

DATED 1544

Black chalk
220 × 160 mm. (8¹¹⁄₁₆ × 6⁵⁄₁₆ in.)
Koch 143; Karlsruhe 1959, no. 182
Lent by the Kunstmuseum Basel, Kupferstichkabinett

Ernst Buchner first questioned the authenticity of this in‑
triguing sketch,[1] believing the figure to be a copy after
Baldung's celebrated woodcut (Cat. No. 87). There can
be little question, however, as more recent authorities
have concluded,[2] that the drawing is a genuine study for
the print. Incised lines and circles still visible on the sur‑
face of the sheet reveal the underlying perspective con‑
struction, a preparatory step which would have been
unnecessary for a copyist. The awkwardness of the figure's
proportions does not result from any lack of skill on the
artist's part; the distortions are dictated by the unusual
viewpoint he chose.[3] By the time Baldung transferred the
figure to the woodcut, he had decided to raise the eye level,
since the extreme foreshortening in the drawing, although
optically correct, was visually disturbing. He therefore
enlarged the relative size of the head, thighs and stomach,
making the figure appear less truncated. He also altered
details of the costume and changed the position of the left
hand (the right hand in the woodcut), allowing it to rest
on the handle of the pitchfork he placed beneath the fig‑
ure. The curious round hat, finally, was replaced in the
print by a currycomb. —J.A.L.

1  Buchner, review of Curjel, in *Beiträge zur Geschichte der
   deutschen Kunst*, I, Augsburg, 1924, p. 300. Buchner's
   opinion was recently seconded by Mende, p. 48, no. 76.
2  Koch; Falk in Basel 1978, pp. 54–55.
3  See Robert Smith, "The Foreshortened Figure in the
   Renaissance," *Gazette des Beaux‑Arts*, LXXX, 1974,
   pp.239–47.

87

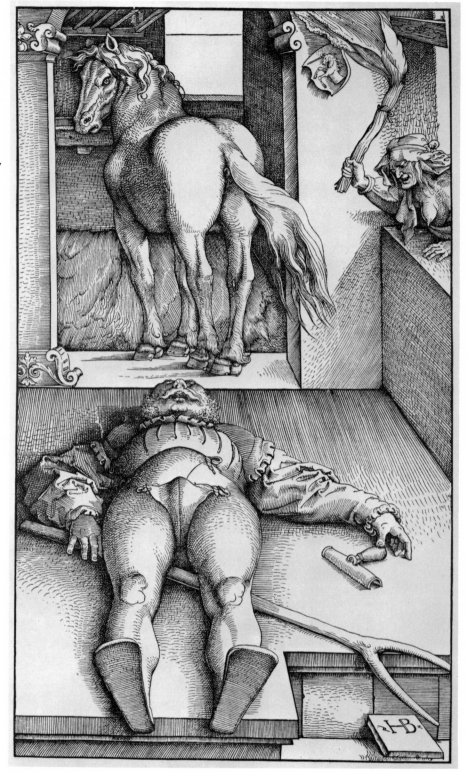

## 87

*Bewitched Groom*

C. 1544

Woodcut
338 × 198 mm. (13⁵⁄₁₆ × 7³⁄₁₆ in.)
B. VIII, p. 470, no. 15 (as Hans Brosamer);
G. 122; H. 237; Karlsruhe 1959, II H 77; M. 76
Lent by the Cleveland Museum of Art,
Mr. and Mrs. Charles G. Prasse Collection

In this enigmatic composition a bearded groom, seem-
ingly unconscious or dead, lies rigidly on the floor of a
stable, having dropped the tools of his trade, the pitchfork
and currycomb. A hag holding a torch, clearly a witch,
grins down upon him from a window ledge, while a
horse at the threshold of a stall glowers back at his fallen
attendant. The woman appears to be the cause of this
misfortune: did she bewitch the man herself, or did she
command the horse to kick him? Baldung has supplied
us with few visual clues to the content of the drama.

We are on firmer ground in the matter of dating the
print, since a preparatory drawing is preserved in Basel, a
life study for the figure of the groom (Cat. No. 86). The
sheet is dated 1544, and the woodcut should be assigned
to about the same year.

Ernst Buchner, followed most recently by Mende,[1]
has disputed the authenticity of the Basel drawing and
has dated the woodcut a decade earlier, to the period of
the *Wild Horses in a Wood* (Cat. Nos. 83–85). But this
approach indicates a misunderstanding both of Baldung's
intentions in the study sheet and of the development of his
woodcut style. The awkward proportions of the figure in
the drawing, far from revealing the hand of a copyist, are
the very proof that the sheet is genuine. Faithful to the
dictates of the unusual viewpoint he had chosen, Bal-
dung drew the figure with a compressed lower torso and
thighs and a very small and extremely foreshortened head.
Although optically accurate, the effect is disturbing,
since the ordinary observer would unconsciously correct
for such distortions. In the woodcut, in which the figure
appears reversed and is seen from a higher viewpoint, Bal-
dung sacrificed correctness to legibility and increased the
relative size of the head, stomach and thighs.

Although there is an undeniable thematic relation-
ship between the *Bewitched Groom* and *Wild Horses in a
Wood*, the prints are clearly distinguishable on the basis of
technique. The modeling in the *Horses* has a calligraphic
buoyancy that gives the woodcuts the unmistakable effect
of pen drawings translated into print. In the *Groom*, Bal-
dung's intentions are altogether different. The modeling

*87a. Hans Baldung, «Coat of Arms of the Baldung Family,»*
*c. 1350, woodcut, British Museum, London.*

lines are more disciplined, subordinated to the task of defining architectural space and creating fully rounded figures. The result could be described as pictorial, a composition dependent more on perspectival effects and contrasts of light and shade than on the rhythm of the artist's line.

A number of attempts have been made to interpret Baldung's subject matter, none of them wholly satisfactory. Gustav Radbruch noted thematic analogies between the *Groom* and an earlier book illustration by another artist and termed the woodcut an "Allegory of Anger":[2] according to this interpretation the witch, by means of her torch, has enraged the horse, causing him to kick his attendant and thereby fatally wound him. Other authors have regarded the woodcut as a personal statement by the aging artist, aware that his life was quickly drawing to a close.[3] They have pointed to the fact that the unicorn in the escutcheon at the upper right was part of his family coat of arms (Ill. 87a) and have claimed to see a facial resemblance between the groom and earlier self-portraits by Baldung.[4] Hults has suggested several possible interpretations in this vein: the artist's meditation on his final illness; an allegory of sleep, with the witch conjuring up lustful images in the unconscious groom's mind; and an allegorical self-portrait of the artist, dominated by the forces of Saturn.[5]

All of these attempts at explanation are essentially speculative, and in the absence of more concrete evidence, the subject of Baldung's woodcut must remain an enigma. It may well be that its true meaning is to be sought in a very different direction. It seems entirely possible that the composition is not primarily allegorical, but that it is related in some explicit way to one of the many folk tales concerning witches, horses, and demonic possession that can be traced back to sixteenth-century Germany. — J.A.L.

1   Buchner, review of Curjel, in *Beiträge zur Geschichte der deutschen Kunst*, I, Augsburg, 1924, p. 300; Mende, p. 48, no. 76.
2   G. Radbruch, "Hans Baldungs Hexenbilder," *Elegantiae Juris Criminalis*, 2nd ed., Basel, 1950, pp. 39–41.
3   See Hartlaub, pp. 22–24; and Hults-Boudreau, p. 136.
4   The resemblance does not seem convincing.
5   Hults-Boudreau, pp. 137–41.

88

## ∾ 88

### Study Sheet with Unicorn

DATED 1544

Brush drawing, heightened with white,
on pale blue-gray tinted paper
200 × 265 mm. (7⅞ × 10⁷⁄₁₆ in.)
Koch 142
Lent by the Trustees of the British Museum

A unicorn appears on the coat of arms of the town of Schwäbisch-Gmünd, ancestral home of the Baldung family; it is known that the artist's forebears adopted this heraldic device for their own escutcheon.[1] Baldung depicted his coat of arms in two woodcuts which can be dated on stylistic grounds to the 1520s (H. 264, M. 81) and the 1530s (Ill. 87a).[2] He clearly intended the unicorn in this drawing to appear atop a helmet in a heraldic composition, since the unicorn's forequarters emerge from a swirl of drapery similar in form to that in the woodcuts. A fragment of a second piece of drapery appears at the right margin of the drawing.

Because the date of this sheet (1544) makes it contemporary with the preparatory study for the *Bewitched Groom* (see Cat. Nos. 86, 87), Koch assumed that it was a sketch for the unicorn that appears on the shield at the upper right corner.[3] To us it seems unlikely that Baldung would have executed an elaborate chiaroscuro study for such a small detail. Rather, it was surely intended to function in an independent composition similar to those in the two heraldic woodcuts.

This rare example of Baldung's very late work shows a manner of drawing which is more abstract and stylized than his earlier work, possibly in keeping with its heraldic intention. The unicorn is seen in pure profile, its head reduced to a few distinctive features. The modeling of the unicorn as well as of the richly highlighted drapery fragments is subjected to systems of brushstrokes which tend to sacrifice linear excitement in favor of control and formality. —J. A. L.

1 For a discussion of the Baldung coat of arms, see R. Stiassny, *Wappenzeichnungen Hans Baldung Griens in Coburg*, Vienna, 1895.
2 For the dating of the two woodcuts, see Karlsruhe 1959, pp. 285–86.
3 Koch, p. 151.

89

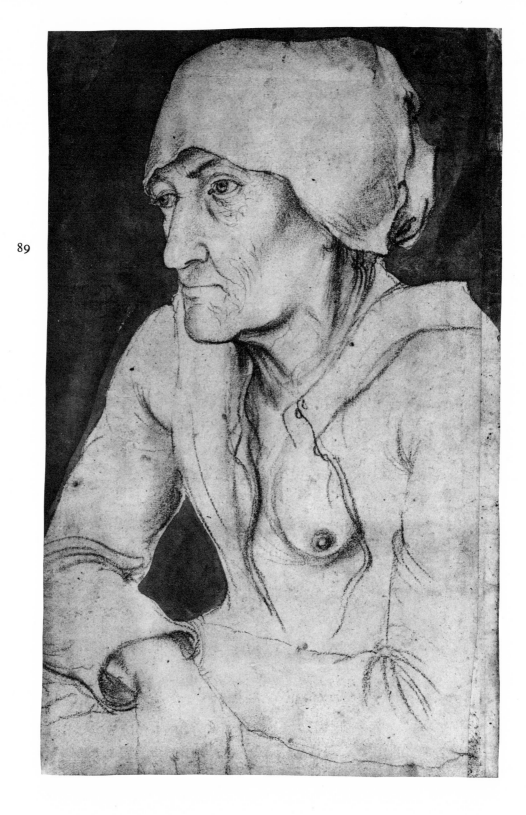

## 89

### Study of an Old Woman (The Hag)

C. 1535

Black chalk and green wash
396 × 248 mm. (15⅟₁₆ × 9¾ in.)
Not in Koch
Lent by the National Gallery of Art,
Gift of Edith G. Rosenwald

As has been noted in previous entries (Cat. Nos. 55, 56), Baldung often made drawings from life of interesting facial and character types which could later be adapted for use in paintings. Making and saving such drawings was a well-established workshop practice in the early sixteenth cenury. Hans Holbein the Elder, for example, executed numerous life studies in silverpoint, not in preparation for specific portraits, but as a record of expressive visages some of which might be used later for the subsidiary figures in altarpieces. The haggard and solemn elderly woman in the present drawing, usually called *The Hag* or *Witch*, appears to be a life study of this genre. She is generally analogous to the witch at the window in the *Bewitched Groom* (Cat. No. 87), to the turban-clad hag in the Rennes copy after Baldung's lost *Ages of Women*,[1] to the second figure from the right in the Leipzig *Ages of Women* (Fig. 32), and most strikingly, to the nude elderly woman in *Death and the Ages of Women* in Madrid (Fig.

34). It must have been with this kind of subject in mind that Baldung sketched the old woman in this drawing.[2]

Unfortunately, the Washington drawing has not survived in its original form. The sheet was cropped at the left, right, and bottom; strips of paper were then added at the right and at the top left corner; and, finally, the greenish-blue wash was applied. The rather careless handling of the wash along and overlapping the contours of the figure reveals that the color was added by a later, less skilled hand, perhaps to give the drawing a more finished appearance, and hence to make it more saleable.

The spare use of chalk lines to articulate the face, and the rubbing to create shaded areas to enhance the plastic effect recall the technique used in the *Self-Portrait* of 1534 (Cat. No. 80), suggesting a date in the mid-1530s for the present drawing.—C. A.

1  Reproduced in Bussmann, fig. 25.
2  The unusual presentation of the old woman, with one breast revealed and her hair covered by a scarf, suggests the possibility that Baldung envisaged using the study in a brothel scene, since the figures of procuresses in German and Flemish art of the sixteenth century occasionally appear in this manner. Compare the brothel scenes by Hans von Aachen in Linz and by Jan Sanders van Hemessen, the latter reproduced in K. Renger, *Lockere Gesellschaft*, Berlin, 1970, fig. 81. These images relate to an older moralizing tradition in which old women with their hair concealed and their breasts bare symbolize the transience of feminine beauty.

# PHOTO CREDITS

AUGSBURG: Staats- und Stadtbibliothek, Ill. 80a
BASEL: Kunstmuseum Basel, Cat. Nos. 1, 2, 13, 27, 28, 31, 43–46, 55, 86; Figs. 1, 7, 28, 35, 36; Ills. 28b, 76c
BERLIN: Jorg P. Anders, Cat. Nos. 3, 12, 19A, 20, 37, 41, 75, 76; Figs. 6, 13, 42; Ills. 43a, 58a
BOSTON: Museum of Fine Arts, Cat. Nos. 7, 18B, 24, 30, 34, 48, 51; Ill. 4d
BREMEN: Kunsthalle, Ill. 13a
CLEVELAND MUSEUM OF ART, Cat. No. 87; Ill. 49c
COMPIEGNE: Musée Vivenel, Ill. 12a
COPENHAGEN: Statens Museum for Kunst, Cat. Nos. 17, 23
DARMSTADT: Hessisches Landesmuseum, Fig. 49
DRESDEN: Gemäldegalerie, Ill. 24a
ERLANGEN: Universitätsbibliothek, Cat. Nos. 53, 60–72
FLORENCE: Galleria degli Uffizi, Ill. 2a
FRANKFURT: Historisches Museum, Ill. 17a. Städelsches Kunstinstitut, Figs. 12, 20; Ill. 20b
FREIBURG: Bildverlag, Fig. 9; Ills. 42a, 54a, 60a
HAMBURG: Kunsthalle, Fig. 17
INNSBRUCK: Tiroler Landesmuseum Ferdinandeum, Ill. 46a
KARLSRUHE: Staatliche Kunsthalle, Cat. Nos. 25B, 26, 33, 50, 77; Fig. 38; Ills. 31a, 38f, 44a, 48a, 82a
KASSEL: Staatliche Kunstsammlungen, Ill. 78a
LEIDEN: Rijksuniversiteit, Ill. 21a
LEIPZIG: Museum der bildende Künste, Fig. 45
LONDON: British Museum, Cat. Nos. 18C, 21, 25A, 32, 54, 59, 73, 88; Fig. 40; Ills. 29c, 87a.
    National Gallery, Fig. 8
LOS ANGELES COUNTY MUSEUM OF ART, Cat. No. 85; Ill. 40a
LUGANO: Foto Brunel, Ill. 75a
LUNEBURG: Pressefoto Makovec, Fig. 16
MADRID: Museo del Prado, Figs. 33, 34, 51
MARBURG: Bildarchiv Foto Marburg, Fig. 50
MODENA: Galleria Estense, Ill. 13b
MUNICH: Bayerisches Nationalmuseum, Ill. 27a. Bayerische Staatsgemäldesammlungen,
    Figs. 24, 25; Ills. 14a, 79a. Staatliche Graphische Sammlung, Cat. Nos. 42, 79, 81; Fig. 49
NEW HAVEN: Joseph Szaszfai, Cat. Nos. 18A, 38, 82; Figs. 3, 10, 11, 15, 19, 27, 37, 39,
    44–46; Ills. 1a, 4a, 4b, 7c, 8b, 10a, 18a, 22a, 24b, 26a, 28a, 29a, 34a, 36a, 38a–e
NEW YORK: Metropolitan Museum of Art, Cat. Nos. 5, 9–11, 14, 22, 29, 39–41, 47, 49,
    57, 58, 83, 84; Ill. 52a
NUREMBERG: Germanisches Nationalmuseum, Cat. No. 80; Figs. 4, 23, 29, 43, 48; Ill. 8a
OTTAWA: National Gallery of Canada, Fig. 18
PARIS: Clichés des Musées Nationaux-Paris, Cat. Nos. 15ʳ, 15ᵛ, 16, 36, 80; Fig. 2; Ill. 18b.
    Photographie Giraudon, Fig. 14; Ill. 9a
STRASBOURG: Jupp Franz, Cat. No. 78
STUTTGART: Staatsgalerie, Ill. 41a. Württembergische Staatsbibliothek, Fig. 41
VIENNA: Bildarchiv der Osterreichischen Nationalbibliothek, Figs. 21, 22, 26, 30.
    Kunsthistorisches Museum, Fig. 5. Lichtbildstelle Alpenland, Ills. 7b, 46b, 55a
WASHINGTON: National Gallery of Art, Cat. Nos. 4, 19B, 35, 52, 56, 74; Fig. 15;
    Ills. 2b, 3a, 4c, 4e, 20a, 20c, 45a, 56a
WINDSOR: Royal Library, Ill. 15ᵛa.

The Monotype Poliphilus and Blado types in this catalogue
were composed at the Press of A. Colish in Mount Vernon, New York.
The Meriden Gravure Company of Meriden, Connecticut, printed
on papers from the Mohawk Mills of Cohoes, New York,
while the Mueller Trade Bindery in Middletown, Connecticut—
using Multicolor endleaf— completed the books;
all at the direction of the Yale University Printing Service.